Women's Studies Quarterly, a peer reviewed, theme-based journal, is published in June and December by the Feminist Press at the City University of New York, 365 Fifth Avenue, New York, NY 10016; www.feministpress.org.

Forthcoming Issues

Gender and Culture in the 1950s, edited by Deborah Nelson, University of Chicago

Submission Information

For the most up-to-date guidelines, calls for papers, and information concerning forthcoming issues, write *Women's Studies Quarterly* at the Feminist Press at the City University of New York or visit our Web site.

Advertising

For information on display ad sizes, rates, exchanges, and schedules, please write to the Advertising Manager, *Women's Studies Quarterly* at the Feminist Press at the City University of New York.

Subscriptions

Individuals: $40.00 for 1 year, $90.00 for 3 years. Institutions: $50.00 for 1 year, $120.00 for 3 years. *Subscribers outside the U.S.* Individuals: $50.00 for 1 year, $120.00 for 3 years. Institutions. $80.00 for 1 year, $140.00 for 3 years. To subscribe, contact the Feminist Press at the City University of New York.

Cover design by Dayna Navaro. Typesetting by Lisa Force

Cover art: "Woman Prisoner Inside Jail Cell" by Ewing Galloway. Reprinted by permission of Index Stock Imagery.

Printed in the United States of America

ISSN. 0732-1562 ISBN: 1-55861-486-9

Women's Studies Quarterly

An Educational Project at the Feminist Press at the City University of New York in Cooperation with Rochester Institute of Technology

Guest Editor for Current Issue
LaVerne McQuiller Williams, Rochester Institute of Technology

Editor
Jean Casella, the Feminist Press and the Graduate School and University Center, CUNY

Publisher
Jean Casella, the Feminist Press and the Graduate School and University Center, CUNY

Editorial Board
Lynne Derbyshire, University of Rhode Island
Jean Douthwright, Rochester Institute of Technology
Lisa Freeman, Kansas State University
Edvige Giunta, New Jersey City University
Dorothy O. Helly, emerita, Hunter College and the Graduate School, CUNY
Barbara Horn, Nassau Community College, SUNY
Alice Kessler-Harris, Columbia University
Wendy Kolmar, Drew University
Linda Layne, Rensselaer Polytechnic Institute
Tobe Levin, University of Maryland, European Division, and J.W. Goethe University, Frankfurt am Main, Germany
Kit Mayberry, Rochester Institute of Technology
Carol J. Pierman, University of Alabama
Nancy Porter, *Editor Emerita*, Portland State University
Lee Quinby, Hobart and William Smith Colleges
Carol Richardson, Rochester Institute of Technology
Deborah S. Rosenfelt, University of Maryland, College Park
Sue V. Rosser, Georgia Institute of Technology
Carole Anne Taylor, Bates College
Mari Boor Tonn, University of Maryland
Janet Zandy, *Editor Emerita*, Rochester Institute of Technology
Bonnie Zimmerman, San Diego State University

Managing Editor
Stacy Malyil

Poetry Editor
Edvige Giunta

Copy Editor
Timothy Krause

Editorial Assistants
Elizabeth Afton, Jennifer Gieseking, Stephanie Pekarsky, Michelle Rodriguez

Contents

BOOKS REVIEWS

Editorial

Women, Crime, and Criminal Justice

LaVerne McQuiller Williams

Throughout most of our nation's history, women who suffer criminal victimization, women who break the law and women professionals working in the criminal justice system have been largely ignored. The plight of victimized women was overlooked for centuries because of institutionalized sexism within the legal system. Women offenders and criminal justice professionals have largely remained invisible, laboring under the excuse that females make up a small percentage of offenders and professionals in the criminal justice system.

Recently this logic been undermined as women's participation in all areas of the criminal justice system has dramatically increased. For example, today a growing number of women work in all parts of the criminal justice system as lawyers, judges, and police officers. Feminist lobbying efforts have strengthened the laws dealing with crimes against women such as sexual harassment, sexual assault, battering, and stalking. As offenders, recent attention has been given to women because the number of women imprisoned in the United States has increased six-fold in the past two decades.

Using a feminist perspective, this collection of essays, reviews, syllabi, and teaching materials identifies issues unique to women in the criminal justice system, including their disadvantaged status as a result of their gender, race and class. This "multiple marginality" is manifested within the criminal justice system in several ways. First, as offenders, researchers have consistently concluded that African-American women experience harsher treatment in the criminal justice system from the decision to arrest through sentencing than white women. Moreover, changes in governmental policy regarding drug offenders have disproportionately affected women, especially poor women of color in terms of prosecution and incarceration. Second, because of men and women's different locations in the hierarchies of race, class, and gender, women's experiences of victimization are not uniform.

Lastly, as criminal justice professionals, access to positions in the jus-
tice system differ as a result of women's personal characteristics.

Women and the Culture of Incarceration: Prisons, Programs, and Punishments

Over the past two decades, a correctional system that has long
ignored women suddenly confronted a population explosion for
which they were totally unprepared. The soaring rates in the
women's prison population have been fueled primarily by changes in
criminal justice policies and practices over the last ten years. The
increased rates of incarceration for drug law violations and other
lesser offenses, changes in judicial decision making, and legislative
mandatory sentencing guidelines have drawn women into jails and
prisons in unprecedented numbers.

Unfortunately, this increase in the number of incarcerated women
has not been matched by equal attention to specialized programs
geared particularly for women—such as medical care, drug treat-
ment, mental health treatment, and counseling for prior victimiza
tion from sexual assault or battering. This is especially true in light of
the criminal justice system's focus on a more punitive philosophy.
Women prisoners have experienced a history of neglect in the devel-
opment and implementation of programming specialized to their
experiences. Historically, programs for women offenders were based
on male models without a thought about their appropriateness for
women. Thus, little evidence exists about what works for incarcerated
women.

The essays in this section focus on the myriad of issues facing incar-
cerated women and examine their lives before, during, and after
incarceration. The characteristics of women in prison reflect a popu-
lation that is marginalized by race, class and gender. The majority of
imprisoned women are poor, disproportionately African-American
and Latina, undereducated, and unskilled. Moreover, they are mostly
young mothers with personal histories of drug abuse, mental illness,
unemployment, and physical and sexual abuse.

To a large extent, the imprisonment of women is tied directly to
their status under patriarchy (Kurshan, 1992). Stating that prisons
are used for social control for both men and women, Kurshan argues
that the imprisonment of women "as well as all aspects of our lives,
takes place against a backdrop of patriarchal relationships." (230)
With few exceptions, women's crimes are largely embedded in the

conditions of their lives and their attempts to struggle with survival. Often marginalized outside of conventional institutions, many women conduct this struggle outside legitimate enterprises (Owen, 1998). The story of women in prison reflects their status in society— a status that reflects ingrained racism and sexism.

The lead essay "25 Years to Freedom: An Interview with Betty Tyson" reveals how racism, sexism, and decreased economic opportunity propelled the wrongful conviction of an African-American heroin-addicted prostitute. As New York's longest-held female prisoner, the articulation between her life and pathways to criminality prior to her wrongful conviction, and the response of the justice system to the factors that contributed to her imprisonment for a quarter of a century, are explored with the aim of engendering an awareness of the cultural dimension of a woman's experience of prison.

Several authors address the issue of what can and should be done to address the needs of women prisoners. Barbara H. Zaitzow explores how women's prisons increase women's dependency, stress women's domestic rather than employment role and may indirectly intensify the pains of imprisonment. Zaitzow challenges these practices and argues the need to reform current policies and programs which tend to reinforce women offenders' dependency upon the system in practical ways.

The two essays that follow underscore the importance of describing treatment programs that are responsive to women's needs and particular situations. This information can be used to think about the issues of imprisoned women in terms of both the problems of individuals and the problems of society. Susan Marcus-Mendoza explores the need for feminist interventions in prisons and the challenges facing feminist therapists working in prison. She argues that programs for incarcerated women have been based on stereotypes of women and programming for men rather than addressing the circumstances that led women to prison. Conversely, the author discusses how feminist therapy offers an alternative viewpoint which helps women resist societal and cultural norms and the benefits of such therapy for incarcerated women.

This issue covers correctional strategies for women offenders once they leave prison, and Mark B. Borg, Jr. and Jennifer McCarroll discuss the Women's Prison Association (WPA) of New York City. The WPA aids women prisoners as they face the numerous challenges of transitioning from prison back to their communities. The authors describe three criteria that define a feminist, community building as crime prevention approach, and discuss how the WPA meets

those criteria.

The next essay attempts to take three traditional crime theories—theories that have typically excluded women—and tests their ability to explain female criminality. Janice Proctor uses strain, differential association, and social control to explain women's involvement in crime and discusses the important role of sexual and physical victimization to female criminality. The results from analyzing two life-history survey data sets suggest that some of the ideas contained in Extended Strain Theory may offer insights into more serious female criminality and that further research is warranted into this theory's ability to predict more serious female offending. Implications for effectively managing and helping women in prison are also examined.

As a group, readers will find that the essays in this section reveal that incarcerated women have needs that are quite different from men's. Whether depicting the abuse suffered by Betty Tyson or describing programming for incarcerated women, the pervasiveness of physical and sexual victimization among incarcerated women is the thread that ties these essays together. In the final essay in this section, "Sexual Revictimization and Retraumatization in Prison," Danielle Dirks examines how prison procedures that disempower women are likely to resemble the abuse dynamics for previously victimized women, thus perpetuation of women's further revictimization and retraumatization. The author also discusses how sexual assault and sexual exploitation within the prison contribute to this cycle and calls for a feminist framework by which to view these issues.

Taken together the essays in this section propose a broad range of fruitful questions for feminist approaches to crime. Who is in prison? What do we know about this population? How do women get caught up in the criminal justice system? What is the prison experience like for women? What are the program and treatment needs of women in prison? What characterizes women's pathways to crime?

Women and the Culture of Abuse: Victims, Survivors and Relationships

Our understanding of women and the criminal justice system is one-sided without a perspective on the victimization of women. The essays in this section focus on the various aspects of crimes committed against women. The victimization of women interpersonally is matched by the oppression of women in the wider society. Women's victimization, whether in the form of sexual assault, battering, sexual harassment, and stalking, are about male power and control. More-

over, as will be discussed in greater detail in this section, culture and society tend to support gender roles that encourage the likelihood of male violence against women.

While male violence against women has been historically constant, recognition of the epidemic proportions of these crimes has been relatively recent. The term "battered woman" did not appear until 1974 (Schechter, 1982, 16), while sexual harassment was not labeled behavior until one year later (Evans, 1978). Similarly, it was not until the 1980s that acquaintance rape and the sexual abuse of children were recognized as social problems (Belknap, 1996).

Today as a result of feminist theory, feminist activism, and researchers working with agents of the criminal justice and legal systems, changes such as the establishment of sexual assault treatment centers, the criminalization of domestic violence, and the recognition of stalking as a distinct offense demonstrate the recognition of the serious nature of such crimes. The 1994 Crime Act included the Violence Against Women Act, which provided additional rights to victims of stalking, domestic violence, and sexual assault.

Although research on the victimization of women is finally being systematically examined, battering and sexual victimization remain the most underreported crimes in the United States. Moreover, many women are stilled blamed and blame themselves for their treatment. The essays in this section take up some of these issues and other various aspects of crimes committed against women.

For example, when acknowledging the various issues facing female survivors of violence, it is important to recognize the overlap of this category with that of female offender. This section highlights how women do not always fit neatly into categories of offenders and victims. Instead there is overlap between the two. Given the prevalence of violence against women in the United States, it should not be surprising that among women offenders are survivors of male crime.

A major theme connecting the first and second section of this issue is the role of sexual and physical victimization in the lives of women offenders. Indeed as several authors point out, women often engage in criminal activity as a survival strategy in response to physical, psychological, and sexual abuse. Angela M. Moe takes up this theme by focusing on the ways in which different criminal offenses within the context of intimate partner violence can be understood as an extension of a women's efforts to survive their victimization. Relying on qualitative interviews with residents at a domestic violence shelter, the findings reveal that battered women commit crime in

order to cope with abuse, maintain an abusive relationship and/or to appease their batterers, and for survival.

When violence against women was considered essentially a private matter, many offenders could commit their crimes with impunity. Although the last several decades have witnessed progress in this area, classism, racism, and sexuality often exacerbate public condemnation of women survivors. Natalie J. Sokoloff's essay offers a provocative analysis of the intersectionality of race, class, gender, and sexuality in order to understand the lived experiences and contexts of domestic violence for marginalized women in the U.S., and the relationship of battering in the family to violence against women (and men) by larger systems of socially structured inequality in poor and racialized communities. Sokoloff argues that while culture is key in explaining violence against women, it is important to not make "culture" the scapegoat in an analysis of violence against women nor to downplay the strengths of different cultures available to battered women.

Paula C. Barata and Frank Schneider's essay explores the advantages and disadvantages of mandatory arrest policies from the prospective of the battered women. This research fills a gap in prior research by focusing on views of battered women on mandatory arrest policies by examining whether mandatory arrest laws decrease violence, empower the battered women, and recognize the importance of treating domestic violence as a serious crime.

Elizabeth Cramer examines the usefulness of addressing intimate partner violence within a criminal justice framework, discussing both the strengths and weaknesses of this approach. Alternative models to the traditional criminal justice approach are also examined.

Although significant progress has been made in the area of violence against women, the four essays in this section reveal that much remains to be done. Feminists have led these reforms and continue to be at the forefront of struggles to prevent and address all forms of violence against women in this country and globally. However, the challenge is for all of us to develop more effective preventions and interventions for the serious problems of crimes against women.

Women and the Culture of Bias: The Courts, the Media and the Press

The three essays in this section explore the perceptions and treatment of women in and by the criminal justice system. As the readings reveal, the images and portrayal of females within American society,

through the courts, media and press, impacts the manner in which they are treated as participants in the criminal justice system.

The first essay in this section addresses the issues of how gender intersects with heterosexism to increase women's likelihood of conviction. Discussing the connection between gender, sexuality and crime, Ruthann Robson's essay, "Lesbianism and the Death Penalty: A Hard Core Case" explores the case of Bernina Mata, a woman sentenced to death in Illinois in 1999, based largely upon proof of her lesbianism. According to the prosecutor in the case, Ms. Mata's lesbianism was her motive for murder. In seeking her pardon, the author offered expert evidence regarding bias against lesbians, offered in the form of an affidavit, which is included in the essay.

Rebecca Hyman explores the roles of culture, class, and marital status in the media's treatment of Andrea Yates. Hyman surveys the way in which the details of Yates's life and crime were appropriated and made to support arguments about the relationship among second-wave feminism, postpartum depression, and the role of the suburban housewife. She then contrasts the feminist reception of the Yates case to that of conservative writers, who read Yates as a criminal who had committed murder. By exploring how the Yates case was used both to undermine and to buttress feminist discourse, Hyman argues, we can understand contemporary anxieties about the contradictions between motherhood and maternal ideology. In examining the jury's verdict and sentence in the Yates case, moreover, we can see that the law is both an instrument of universal justice and a vector through which a jury may express the contemporary public will.

In the final essay in this section, Gray Cavender and Nancy C. Jurik offer a provocative analysis of media representations of the confluence of race and gender in the film Prime Suspect 2. The authors develop an ideal type model of progressive moral fiction to assess Prime Suspect's 2 challenge to existing gender and race hierarchies. The authors conclude that the film effectively portrays the barriers for women in the workplace, and offers compelling examples of individual and institutional racism.

Resources for Teaching and Learning

In the past thirty years, since the introduction of the first women's studies courses on U.S. campuses, we have witnessed the advent and establishment of new areas of research. As such, sharing syllabi is one way for scholar-activists to witness the vitality of feminist scholarship. Therefore, in the tradition of Women's Studies Quarterly, the essays

in this issue by Nancy-Lewis Horne, Marylee Reynolds, and Amanda Davis with accompanying syllabi underline the continued need to share resources and alternative approaches to teaching issues surrounding women, crime, and the criminal justice system. Nancy-Lewis Horne's essay presents her course Women and Crime, in which she explores the role of gender in both criminality and social responses to crime. The course places specific emphasis on feminist explanations of the relationship between women and the criminal justice system as offenders, victims, and the social construction of masculinities leading to violence against women. Marylee Reynolds' essay examines the criminal and civil consequences of a felony conviction for women, including how legislative policies penalize women, particularly women of color. Amanda Davis' essay describes her course, Incarcerated Women: Their Autobiographies and Prison Writings, in which she uses creative writings and narratives written by women in prison or about women in prison to explore the myriad of issues surrounding women offenders.

The diverse range of essays, strategies, and teaching resources collected here describe the continuing stereotypes and discrimination experienced by women in all areas of the criminal justice system. Although the underlying causes of discrimination are easier to describe than to change, it must be said that there are no quick solutions or easy answers. This issue also recognizes that there is a need for thorough analysis of the interaction of gender, race, class, sexuality, and the like if we are to work effectively on the problems of women in regard to the criminal justice system. Hopefully, exposure to the perspectives presented by the authors in this issue will help sensitize readers to a fuller understanding of the issues that need to be considered in formulating a comprehensive understanding of the issues facing women, crime and justice.

REFERENCES

Belknap, J. (1996). The Invisible Woman: Gender, Crime, and Justice. Belmont: Wadsworth Publishing Co.

Evan, L. (1978). "Sexual Harassment: Women's Hidden Occupational Hazard." In J. Roberts-Chapman and M. Gates (Eds.), *The Victimization of Women* (pp. 202-223). Beverly Hills, CA: Sage.

Kurshan, N. (1992). "Women and Imprisonment in the U.S." In Churchill and J. VanDer Wall (Eds.), Cages of Steel (pp.331-358). Washington, DC: Maisonneuve Press.

Owen, B. (1998). In the Mix: Struggle and Survival in a Woman's Prison. Albany: SUNY Press.

Schechter, S.(1982). Women and Male Violence. Boston: South End Press.

25 Years to Freedom: An Interview with Betty Tyson

Interview by LaVerne McQuiller Williams

At 24 years old, Betty Tyson was a heroin addict selling her body to pay for her next fix. A spiraling chain of events would wrongly send her to prison for a quarter of a century and rob her of more than half her life. It was 1973. The Watergate hearings were underway. The Vietnam War was winding down. And Betty Tyson's life was about to change forever. It was May 25, 1973 when a man walking his dog in an alley in Rochester, New York found the body of a white Philadelphia businessman named Timothy Haworth. Haworth was choked by his own necktie and was bludgeoned to death with a brick. Protruding from Haworth's mouth was a sheaf of weeds. Days later, Tyson, along with a male transvestite, was arrested for the murder of Haworth, who was believed to had been with a prostitute and fresh tire tracks were found at the scene of the crime. Tyson was the only prostitute in town with a car. Two teenaged witnesses said they saw her with Haworth on the night of the murder. And, most damaging of all, Betty Tyson confessed. A jury of 12 white men found her guilty and she was sentenced to 25 years to life in prison. Almost 25 years to the date of her conviction, Tyson was released from the Bedford Hills Correctional Facility in Westchester County after the judge ruled that police had withheld evidence that could have led to her acquittal, making Tyson the longest-held female inmate in New York State at the time of her release in 1998. The city of Rochester awarded Tyson 1.2 million dollars in compensation. Following is Tyson's story about triumph over tragedy and her life before, during and after her wrongful imprisonment.

Betty, the most damning evidence against you was your signed confession admitting your involvement with the murder. Why would you confess to taking part in a murder if you were innocent?

I was forced to sign that police statement that I knew nothing about. I was handcuffed to two arms of a chair and beaten by the police. They kicked me, punched me, and yanked my hair. Every time they would stop beating me, they would say, "Sign it, you black bitch." At first I refused to sign the statement, but the longer I refused the worse the beatings got. Finally after 12 hours of beatings, I signed a confession typed up by the officer in charge, William Mahoney. I was in so much pain. I never thought the police could do such a

thing. To make matters worse I was going through heroin withdrawal. I had gone without a fix for 12 hours and was sick from withdrawal. That statement full of lies was the only evidence against me.

Did you realize that you would go to trial and face murder charges after signing this confession?

No, I didn't. I just thought that I can get up there on the stand and tell them that the police beat me up and forced me sign the statement. But as it was, it didn't work.

Why didn't it work?

Because Detective Mahoney found two teenage witnesses, both transvestites, who both said at trial they saw me and Bertha [Jon Duval] with the guy [Haworth] on the night of the murder. To make sure these kids would testify, Mahoney put them both in jail and kept them locked up for six months as material witnesses right up until my trial started.

Was there any physical evidence against you?

There were no fingerprints, not even a piece of hair from me. The tire tracks in the alley that the police swore were mine were proven by a police lab report not to match the tracks on my car. I even had three witnesses who testified during my trial that I was with them at the time of the murder, but the jury didn't believe them since they were heroin addicts like me.

I mean there was evidence but the evidence was on my side. I had been beaten and framed by Mahoney. Even the jail counselors saw the welts and bruises, but that didn't come up in court. I thought the jury would hear my story and help me. But the jury didn't care. Even the judge didn't care. But why would these folks believe me over their own?

What do you mean over their own?

Over officers. Cops. You have 12 white guys in 1973 hearing about this rich, white guy who was killed. Then you have me—a black heroin addict with a $300-dollar-a-day habit selling her body. Who would believe me over the cops? Who would believe that the police would beat me and get those 2 kids to lie?

Why do you say the jury and judge didn't care?

Because a jury of 12 white men from the suburbs found me guilty. You never saw black people on juries back then in Rochester. Then the

white judge sentenced me to 25 years to life behind bars. These folks didn't see me. They just saw the way I was living. I was vulnerable.

Why were you vulnerable?

I feel that because I was black, uneducated, naïve, and a woman I was very vulnerable. I was uneducated so why not take this bitch off the street and that's what the police did. I was on the streets using drugs and selling my body and I had a criminal record.

What crimes were on your record?

Well I had 16 arrests: petty larceny, grand larceny, disorderly conduct, contempt of court, and drug stuff. But I didn't have anything violent. I started stealing when I was 8. You see I come from a family of 8, and my mother was my mother and my father. There are 4 girls which are the oldest, and then the boys are next. All of the boys have a criminal history.

We grew up in a household where we were real poor. The first week we got the welfare checks we ate real good. The next week forget it. I remember times when we had to eat PB & J on cornbread or we didn't eat. There was days we ate just plain beans once a day. As far as stealing we didn't have any food in the house. I would go to the grocery store with 2 bags and fill up the grocery bags and go out the side door and take it home and my mother would never say anything.

One night my mother had left and she went out. My mother would leave us from Thursday until Monday morning and she would leave like five dollars on the dresser and would be out partying. I was walking home with these two big old shopping bags and I was my walking past my aunt's house and she said, "What's that?" I said, "Groceries" and she said, "Where'd you get it from?" I said, "From the store" and she said, "Did you pay for it". I said, "No maam". She marched me right back up to that store and made me give it back and apologize. An hour later I was back in that same store and got the same items that I took. I guess the man in the store knew that we were starving because he never did bother me. He knew I was doing it just so my brothers and sisters could get by- just survive. I mean I was stealing so my family could eat. And from stealing food, I went to clothes. I did get caught for stealing after I dropped out of high school and spent a couple of years in reform school.

How did you feel when you heard the verdict?

I remember like it was yesterday. The juror stood up and said GUILTY. I said "THAT'S IMPOSSIBLE!" But I didn't say it out loud.

I said it to myself. They didn't believe me. They believed all those lying-ass detectives that got up there and told lie after lie. 7 counts of guilty. It was so much that I couldn't hold it in any longer. I just screamed in the room. I jumped up and...but I wasn't trying to run away. I just couldn't breathe in that room with those 12 white men that found me guilty for a crime that I didn't commit. I let out a holler that I think would have woke up the dead. I'm like it had to be a conspiracy.

Why do you say there had to be a conspiracy?

You got white judge, white cops, white judge; even the man who was my attorney was white and didn't give a damn about me. The lawyer just took my mom's money. Listen to this. When you're in court and the judge stops the trial and tells the detective "You better get this witness straight" because the witness said something different than he said before, what is that telling you? Something in the milk is not right. But let's get real. I was a trick turner. I have never been arrested for prostitution so that's not on my record at all, but the cops still knew what I did. To boot, I was a poor, black woman in the 1970s in New York. Why would anyone give a shit about what happened to me?

Can you explain what you mean when you say you were a trick turner?

You see there is a difference between a trick turner and a prostitute. A trick turner sells her body for money but doesn't suck dick. A prostitute does everything. Has sexual intercourse for money and sucks shit. I was a trick turner because I wouldn't suck nobody.

You are convicted of second murder. You are sentenced and know you will spend 25 years to life in prison. What are you thinking?

Suicide. I just I can't see myself being locked up for 25 years. It's just unthinkable. I was 24. I'm saying to myself in prison, "Who can I see so I can buy some pills so I can overdose?" I bought some pills from this girl and tried to kill myself.

How many times did you try to kill yourself?

Three times. Three different times I took a bunch of pills and I still woke up. I just finally decided God had a mission for me. But I was still sacred about going away for 25 to life.

What were you scared of?

I was scared because I didn't know how to hustle. I was in prison

before and I starved. I could hustle on the streets, but in prison I
made about seven cents a day. I probably made in one week a pack of
cigarettes and nothing else. But I still needed my lotion and my tam-
pax tampons and real food since I wouldn't eat that shit they called
food in the mess hall.

Who had to buy tampons?
They give you two-dozen Kotex heavy liners. Anything after that
you have to buy. Tampons you definitely don't get. You have to buy
them. What the state gives you is about six rolls of toilet tissue a
month, two packages of sanitary napkins, two bars of soap, three
bras, four pair of panties, four shirts, either a skirt or a pair of pants
or two pair of pants. You get a robe and slippers, a winter coat, and
pajamas, a raincoat and a bonnet. That's it. You didn't hear me say
anything about deodorant, because you don't get that. You have to
buy that with your own money.

So you were scared because you didn't know how to hustle in prison?
Yeah. I didn't have no hustling ability at the first because I didn't
know what the ins and outs were of the prison system. You get to know
an officer or somebody and you'd be alright—somebody to go out and
come in. Then you can sell drugs, you can sell clothes, get food...

Inmates would sell drugs in the prison?
OH PLEASE! And who brings it in? The officers. Sure you can
get drugs in off of a visit, but the officer brings it in too. It's not
uncommon for you to pay an officer double the amount to bring a
pound of weed in or 2 eight balls of coke. It's easy. Just ask. And you
know where to go.
Then of course, you can make calls because you know a lot of
people that are there for drugs and they still have connections. So if
you know them then you can call their people. You can have them
bring you whatever you want; your drug of choice. There is a lot of
crack there and heroin. There's a lot of cocaine too.

What steps did you take to adjust to prison?
I can say that I think I really wanted to get my life together. It
happened over time. I got there in February and by May I was in a
Photography class. By June I was taking pictures, and it was so amaz-
ing that I could develop my own film. I put it in my camera, but to
see my picture that I shot to come up in the developer was...was
amazing. I'm proud because this is something positive that I did.

That started it. It built up my self-esteem. I never knew by just hold-ing a camera that could change a person. I made sure I took pic-tures. I sent everybody pictures. I loved those days. I soon became a teacher's aide and I wanted to learn. Being a teacher's aide, I soon started teaching the advanced classes. I ran the class and I taught color. Before this, I didn't really know Betty.

What do you mean you didn't really know Betty?
Because the Betty I knew during those times was a very confused person. I didn't know who she was, what she wanted to do. If I knew who I was I wouldn't have been a trick turner. Or a drug addict. But I didn't know. So, there is where I found the whole person, in Bed-ford Hills. It took some work but I found her. I can say I completely found myself in '79 because that's when I started reaching out to help other people and I know in order to help other people you have to know yourself and I had that inner peace within myself. Even though at night I was an angry bitch because I was in prison for a crime that I didn't commit, but I let that go. I can just say that God helps those who help themselves. I felt good about myself for the first time in my life.

You never felt good about yourself when you were growing up?
Hell no. I guess I was the black sheep of the family. Nobody else would do anything, but I would get my brothers and sisters to do things. Bad things sometimes. So I would get a beating. They talk about child abuse today, but when I was growing up I got a beating every other day. I mean I got beaten 'til I was bleedin'. My mother used to take me and tie me to the bed and just strip me and just beat me until she got tired. She beat me up until I was 17, until I got mar-ried and got outta the house. Me and my husband only stayed together for 6 months. I didn't love him. The marriage was just a convenience for me. But that was the purpose of me finding a hus-band to get OUT OF HER HOUSE, so I didn't have to be abused. But I'd never say abused because I mean my mother loved me dearly but it was just that I was too much like her so she beat me too much.

And I didn't have a very good childhood because as a child I would get picked on in school. I was called bald-headed and all kinda nicknames and I just felt like I was nothing. My mother called me "stupid," "bald headed bitch" and would say "you ain't gonna amount to anything. Of course I'm thinking the same thing because this is an everyday thing. So I started running away at the age of 12. I was into bars and bar scenes and hanging out.

You described how photography helped you discover yourself and build your self-esteem. What other programs and educational opportunities were available?

When I first got there, there were all kinds of programs that we could take. Video classes, photography. We had all kinds of programs. Today they have cosmetology, a printing class, electronics, and they have GED and ABE.

What's ABE?

It's an adult basic center. It's for people who can't read and write. We don't have anything now. There's a writing workshop that if you join it helps to pay for your tuition, not tuition but for your books and for the teachers to come in. So, Eve Ensler of the Vagina Monologues is the person that does the writing workshop. She gets the actresses to come in to go to different places and speak about different things that the women got to do. So this is how they pay for their education. It's sad because they had TAP [Tuition Assistance Program] at one time.

What did you get involved in?

Photography. I did photography for a year. Basic, intermediate, and advanced. Then I started teaching it. Then I went into printing. I stayed in printing for 11 years. I also got my GED.

What other services are available to women?

There is counseling. Everybody has a counselor. You know you have a guidance counselor and you have a parole officer. Whether you see them is a different thing. It has to be an extreme emergency. You have a family emergency you write to your counselor and occasionally you can have your officer call to see if your counselor will see you. Sometimes they say yes and sometimes they say no. It all depends.

There are a few drug programs but they're not effective. They had Reality House and had Fortune Society. They had AA, and they had a network program. But you have to be there "x" amount, I think it's about a year or something like that before you can get there. But even if you are there for "x" amount, often there's not enough room. They only allow so many people.

Then there are also religious services. You know just every Sunday they have church. They have Catholic service first then they have Protestant service. You have your Jewish services and you have your Muslim services. There are also parenting classes.

Did you become conscious of issues affecting women when you were in prison?

Yes, especially the health issues. The health issues as far as women complaining about stomach problems, urinary infections, and no treatments. For me, I had a hysterectomy when I was 36. I asked them if I could get another opinion and they did give me one. That was the doctor at the facility and his friend who worked at Westchester thus the second opinion you know. I had fibroid tumors and they were getting bigger. I needed surgery for them to come out. When I had the surgery I'm was ringing and ringing and ringing for the nurse but nobody came for hours. I was finally taken from this to another room and I see that they had just wheeled a dead body out of this other room. A body! The sheet's over the head and everything. I'm looking at the officer. She said, "This is your room." I'm looking to see if somebody is going to clean this room. The nurse comes pulls me right in the room and says, "Alright get in the bed." I said, "Get in this bed? You just pulled a body out of here. Oh hell no!" "Call the facility I'm signing myself out of here." She said, "Why?" I said, "You think I'm going to sleep? Look at the dust bunny under there. The blood? I'm not gonna sleep in here." I signed myself out.

I was told later that I did not have to have that surgery. I see a lot of people that have fibroid tumors still intact. They took away my chance to have kids. They like to cut when they want to cut. Everything is butcher, butcher, butcher. A second opinion you can get it, but it's coming from the doctor's friends. Physicals were once a year if they didn't overlook you. I'm telling you, I remember when I was complaining about my cramps I had to tell the nurse that I had green shit coming out of my cunt. That's how I got to see a doctor.

But most of the doctors that work in the facility are quack doctors. They don't have a license. I've seen three of them that didn't even have licenses. They've been brought up on charges. I don't know what happened to them. They probably practicing someplace else. In order to get to a doctor, it's sad to say, you had to first go to a nurse's screening. You have to get up out your bed at 4 in the morning to go downstairs and sit down and wait for the nurse to come if you could see her at all. And forget about a skin doctor. That's out of the question. That's impossible. You have to jump through hoops and write grievances against the people so you can see a doctor. Sometimes you write to the superintendent and complain or complain to the sergeants. But you have to have an officer that's on your side that knows how to get you in. If the officer doesn't like you, you

won't get permission to go no matter how sick you are. But I got there because I was a well-respected person.

How did you gain that respect?

Because I'm the type of person that whatever they called me I didn't fuss. I never cursed the officers out. If somebody cursed me like an officer or somebody that didn't know me, they might say, "Fuck you bitch," and I would say. "Oh excuse me sir? That's not nice. How would you feel if someone would say that to you?" I taught most of the officers how to deal with women. "Treat us with respect and most times you would get it back," I'd tell the officers.

There have been several lawsuits regarding the medical conditions at Bedford Hills that have been brought and won? Did the medical conditions improve after the lawsuits?

Even after the lawsuits the medical conditions were the same. Nothing changed. I mean they want to think that it's changed but it really hasn't. Unless you're pregnant you get better treatment because you have prenatal care. You have the Children's Center. And the Children's Center is a non-profit organization. They make sure that their mothers are taken care of as far as getting medical treatment and stuff like that.

If you have AIDS there is a doctor that comes in. I'll say that over 60% of the population in prison were HIV-infected. An infectious disease doctor comes in and that means that everybody knows that he's the infectious disease doctor so they all know that you got AIDS whether you tell them or not. But they would get all right treatment if they're down in IPC.

What's IPC?

IPC is In Patient Care Unit. And you have to be almost dying to get in there. I think it has 14 beds and it's always full. You have all kinds of illnesses down there. You have hepatitis, cancer. And the nurses that are in there are so standoffish. You have patients that you need to change their pampers. The nurses don't change them. They'll call the inmates that work down there to change them. "I'm not changing nobody's shitty diaper," they'll say. I didn't care. I would change them, I clean them, I dressed them and I feed them. I had a lot of friends that had the AIDS virus that died. Some died in my arms. I just said you know they don't have anybody down there. So I just start volunteering to go down there and counseling and talking to the women. I started going morning, noon, and night.

Aside from issues with health care, did you become concerned with other issues facing women in prison?

Yes. I was concerned about justice. There were a lot of women in prison like me who didn't commit crimes. I was also concerned about why the guards was bringing in drugs and the racial divisions.

Was there a lot of racial division in the prison?

Yes. It's a lot of prejudice in prisons, especially the one that I was in. White inmates get the better rooms so that officers could watch them better. White women don't come out and call you nigger but the way they look at you is like don't come near me. But eventually some of the women turn around and they sort of get into the groove because they don't want to be beat up. Many of the white women are scared of the black ladies.

Officers they don't change. You are a black bitch and you will always be a black bitch. So, it hard. It's there. The officer's attitudes are like you're black and beneath me. Not saying that I got bad treatment because I was well respected all around the board. Unfortunately, no, fortunately, nobody ever disrespected me.

You also see racial tension in the gangs here. There are lots of gangs. The Crips, the Bloods—its mostly the Spanish people and they try to get some of their best black friends in there with them. Some of them fall for it and some of them don't. You know, but it's a lot of gangbanging up in there. And the officers know about it, but they don't do anything about it.

What do you mean by gangbanging?

Meaning, if they want to jump on somebody or if they have a beef with somebody, four of them will confront the person and just beat them down or worse.

What do you mean by worse?

Well some women get raped. They see a fine girl and just take it. Some of the women are caught, and some of them ain't because the women won't talk about it. They just say, "I fell or I bumped my head, and that's why I have a black eye" or a busted lip or something like that. Broken glass in a sock, broomsticks—these are what women rape with.

But it ain't only gang women who rape. Women who ain't in a gang will take it too. Women will be teasing them, throwing up their dresses and saying, "You'll never get this stuff. Ha-ha-ha". And the other women say, "Oh yeah? You don't think so?" And they take it. It

could be early in the morning, when you're in the bed preparing to
get up. They will sneak down the corridor or if they live on your cor-
ridor they just ease in your room and one of their friends will tell the
officer to lock that door. So the officer will lock it. Somebody got
their hands over your mouth so you can't scream and they just take it.
But after it's over with, you can't say so-and-so raped me. You can't
tell the guards because they rape a lot of women too.

Is it common for officers to rape women?
 Hell yes. OK, I remember just before I left prison this officer, I
don't remember his name but he supposedly, not supposedly,
allegedly raped this individual. She saved the sperm and took it to
the main building. He then got suspended without pay, OK. What
happened after that was that he lost his job. He lost his job there but
he was sent to a male facility to work.
 Other times officers would tell the prisoners that the only way they
could get toothpaste and soap was to have sex with them. That's always
the thing—gum, cigarettes, packages. But sanitaries are the worst.
The prison only brings out two packs of sanitaries for everybody, and
that's like 240 of sanitaries every month for all the women.
And if you run out you have to wait or you use a rag or toilet paper.
Anyway, the guards will find somebody that's not getting visits and can't
call home to get these things and trades this stuff for a blowjob or sex.
It's common. Many folks don't think this is rape. But when an officer
is dangling toilet paper, a sanitary, or food in your face and you don't
have any, how can people think that the woman is giving it up freely?

Did you have a lot of visitors?
 I had visitors every month, because my mother came, you know.
In the beginning it was my sisters and brothers up until they got of
age and they started smelling their asses and started going in the
street using drugs. But then my mother continued to come up. She
used to come once a month every month. Up until the very end she
couldn't make it because she had developed emphysema and they
use to smoke on the bus and I used to tell her then don't worry about
it. I hadn't seen her in about eight months when I got out. That's
the only thing that I had to look forward to in the beginning. Talk-
ing to her, hugging her, and seeing her.

**Apart from your relationships with people from outside of the
prison, what relationships did you have inside the prison?**
 Well I had my family in prison and I had my lovers.

Can you explain your prison family and the role you played in your family?

Once you are in prison, you don't have to belong to some particular clique. Prison is a family orientated thing. When you come in, it's crazy because you see somebody that looks something like your aunt or your uncle or your mother-somebody that's real nice and you say, "Maybe I'll make her my mother" and that's how we do it. Mother, brother, sister, uncle, father, your whole family is there. It's common. M. was my mother. I never had a father because nobody cared to be my father. But I had sisters and brothers and I got children. I have children there. I still go up to see them.

You also mentioned you had lovers in prison. Were these other women?

Yep. Well first most women in the prison system are gay. You don't come in gay, but you end up being gay, at least for the old-timers. I'm not going to say that I wasn't gay because apparently I had the gay tendencies. I became gay in there. But I know a lady who did 15 years with me and did not ever have a female. When I left she hooked up with a girl and I'm like, "K., what are you thinking about?" She was like, "You don't understand, I'm lonely." Then I said, "I understand because we're all women."

What was the view among other inmates about same-sex relationships?

It was common. It didn't matter. Nobody questioned it. It wasn't any question because you had families up on the units. Whole families—mother, father, sister, brother, aunts, uncle—were there and didn't care. The only women who cared were the ones who got cheated on left for another woman. That was my first fight, I'm telling you. Because I left B. to go with T. She got mad she said, "So you mess with that cock-eating bitch!" I said, "Excuse me, well, you don't want to do it right, so I got to move on." She came at me so I got my cup. I turned around I started whaling her with the cup and she pulled my sweater over my head and I was punching her. And we went into the rock; she got 14 days, I got seven days. We didn't go to SHU [Special Housing Unit] because this was in 1974 and we were locked in our units. You're locked in the cell and you can't come out except you're allowed one hour for recreation and you can have a shower. But now, if you're in locked in you get a shower Monday, Wednesday, and Friday. They bring you a bucket of water on the other days to wash up in. You even have a toilet hooked on to the sink where you have to drink the water from.

Did you see yourself the same way as you did when you first came in?

I changed dramatically. When I first went in, I had no regard for anybody but me. When I got there it was the unwanted Betty, the person you look down upon opposed to in years to come, I became the Betty you looked up to. My first years at Bedford I was resentful and angry. It took five years before I realized I couldn't hold onto this or I would stay bitter.

I was a tree, and I just grew and blossomed. And everything around me blossomed. Not only did I blossom, I made the other women blossom too because I made them feel good about what they were doing with their time. You have to be busy. You can't just sit around and do nothing. This is what I tried to instill in them. Keep busy so you don't think.

Did you see a difference in the women coming into prison over the 25 years you were in?

When I first got to prison there weren't even 200 women in prison. The difference was women weren't committing the crimes that they are committing now. I can say that they had mixed the teenagers with the adults because now teenagers were committing the crimes that the adults were committing. When I left in '98...well I left and there was like 850 there. The crack is really the main reason the women are in there. And you got a lot of women in there because of their men. It's crazy. Kids... I mean there was a time I seen this little girl, she looks like she is 13, and she was 13. I talked to her and she talks like a kid. I said, "Honey where is your momma?" She said, "She's at home." I said, "Where's home?" She said ,"Brooklyn." I asked, "What are you here for?" She said, "Because I was smoking crack. I was prostituting for my boyfriend and I hurt a man." But come on. How are you going to put a 13-year-old with people that are 16, 17, and 18? Talk about a change in the times!

Have women changed since you have been in prison?

Yeah because you know what? They are not respected. When crack came in that's when a lot of cursing came in. The women came in "Oh, mother-fuck." "You bitch." "That ain't right. Who she talking to?" This is ridiculous. And these are young kids. The more they came, the more they were cursing, and the more they brought the officers out of character. Do these women ever change? Not really, because the only way they change is that they stay there for x amount of years. If they do a year they go right back out to the crack and they come right back. The same thing. It's a revolving door. The chang-

ing has to be people, places and things and this is what I tell the majority of the young kids that I talk to. I say "it's alright to go back home to mommy, but you gotta change. You got to move on because you got to find some place else to go, find some new direction, find you a job." I always tell these young girls, "You got to be tired of coming in here where they strip you of everything-you have nothing. You know, aren't you tired?" "Yeah, I am," they always say. "Well act like it. Get involved in things that's gonna benefit you once you get out in the street. Even if it's a little certificate, take it with you. It means something. It means that you were trying to do something to help yourself. Rehabilitation don't come from these walls. It comes from within." Some of them get it and some of them don't. A lot of times these young girls just need to talk to someone and someone to listen.

Did you have that?

No I didn't because I was on the streets. I've been smoking since I was nine and drinking at I think it was 11. I thought I knew everything. I was in a gang called the Upsetters. We always was fighting with the other gangs. But it was fun because we gave parties a lot at different people's houses. We fought mostly with the Untouchables, another black gang. We also smoked cigarettes together and like to get drunk together. Nobody could really tell me shit. Then I started selling my body and using drugs.

In your case, why do you think the criminal justice system was unable to correct itself for 25 years?

I really don't think that they really cared. I think they felt that it was just an open-and-shut case. You have to remember that a person died and they got somebody that they thought fit the crime so therefore why not keep it like this. I was black. I was a woman. I was a drug addict. I was a prostitute, no, I don't consider myself a prostitute, because I don't suck dick. I'm a flat-backer from way back.

How did you get into prostitution, I mean trick turning?

I had this friend who told me that it's a lot of money out there on the street. She told me she sold her body for money. I told her she was crazy. But one day, about a month later, she had so much money I was jealous. I didn't have a dime. I told myself, "I know what I'm gonna do tomorrow, I'm gonna watch her and everything she do I'm gonna do." The next day I went with H.. She was switchin' down the street and I was switchin' right along with her. Cars was beeping, and she stopped a car. Then I stopped a car. This man took me to a

motel and I took of my clothes got butt-naked. He got butt-naked too and said come on. I'm in bed and he started doing it. I said, "Wait a minute, where's my money?" He gave me 20 and we had sex and he left. Then I picked up another guy. I said to myself "I'm gonna make me some money today." That night I had about 200 dollars and some change. I had cigarettes. I had pop. I had food. I felt so good about not having to depend on anybody to do anything for me and then trickin' just came as a natural.

Was trick turning ever dangerous for you?

 I ran into two tricks that tried to misuse me. One did. Another guy did misuse me but he wasn't a trick. Anyway, I told this trick we can do it in the car. We get into an alley someplace and as soon as he puts in the car in park his knife came out. I'm like "Oh my God." Now my 007 [my knife] is on the inside of my leg. He found my knife in my boot and he unzipped it and he took my knife. His knife came out and he tells me I'm going down on him. I said, "Oooh no I'm not. You just gonna have to kill me." You see, I don't care about intercourse but I can't suck nothing. He then said fuck it and had sex with me about three times. I never saw him again.

 Then there was another one. A black guy, tall and skinny. I never propositioned him or anything. I saw him on the street. He saw me go into my house and he followed me in. He said, "You gonna give me some?" I said, "Hell no". He then told me he was Jesus and then came at me with a butcher knife. I started hollering and the neighbors knocked on the door. The man ran out the front door. When he left, I left.

 Then there was a white guy. So I guess it was three times not just two. I got into his car and he told me I was gonna give him some sex and he wasn't gonna pay for it. Then he pulls out this knife and I'm like, "Ooohkay." I started shaking. He says, "What's the matter?" I told him I gotta go to the bathroom. I got out the car to squat down, naked mind you because he done took off all my clothes. I'm pretending like I was pissing. He asked if I needed tissue and I said "yeah". When he went for the tissue, I ran to away. Mind you I'm stark naked running down the street. Then I start looking for something to hit him with. He drives off. I caught him at the light and as I ran up to the car I had a 2x4 and I just started busting up that window. He eventually stopped the car and got out. I took that car from him and I rammed the car into a gas-station wall. I tore that car up then I kicked his ass and took his money and walked away. I left him right there.

You mentioned earlier that another man who wasn't a trick had misused you. Can...

Yes. One day my mother said she was going out and she'd be late. When my mom left, me and my sister snuck out the house and went to a party. Me and my sister was drinking and I come back home. I'm drunk and I lay down and dozed off. Then I realized somebody was on top of me. I started pushing this guy away and I opened my eyes and said, "What are you doing?" I knew him because he was a friend of my uncle's and came by the house a few times. He didn't say nothing and he's trying to pull down my panties. I'm fightin' him off of me. Well, he didn't get my panties down, but he got his dick in between me by sliding my panties to the side. I was scared to say anything cuz I was drinking. I was not a virgin anymore. A month went by, I get my period and as always I'm cramping, cramping... and my mother says "Why you cramping so long?" I say, "I don't know." I could not walk I could not go to school. I couldn't do anything, or even hold anything on my stomach. One day I ended up passing out. When I woke up, I was in Strong Memorial Hospital. My mother was on the side of me and says, "Who have you been messin' with?" "Messin' with?" She says, "Yeah?" "Nobody momma," I says. Then she said, "You got to be messing with someone because you got syphilis".

How old were you?

I was 13. Then she says it was a sexual disease and the only way you can get it is from intercourse. I told her about the guy then and she said well "You shouldn't have let him in." Anyway, we call the cops and he went to jail for it. He was like 20 something years old. Even today if I see him...well he just disgusts me.

You also mentioned that you were addicted to drugs. What drugs did you get involved with and when?

I can say that when I started trickin'. I had so much money I didn't know what to do with it. I'd buy Robitussin but I'd be so mean and evil when I was coming down, I'd need something to bring me back up. Then I took dope. I did heroin and I did coke. Each one led me to something different, and in the end it was a mixture of cocaine and heroin. If I had the coke I needed dope. I didn't like to be down. I liked to be in the middle.

Did you start on heroin or cocaine first?

Heroin.

How did you get on heroin the first time?

I'm at a hotel with this guy and I'm watching him getting off. I
don't want to get on Robitussin because it's making me mean and
evil. He shoots something in his arm but I don't know what he shot .
I said "Give me some of that." I was out for the count on my very first
time. "I want some more" was the first thing I said when I came up. I
liked the way it made me feel. Then I got my own works, you know,
needles and stuff.

What was the hardest thing you had to deal with in prison?

Not being able to talk to my mother every day.

Was there a point when you thought you would ever come out?

At first I thought every year "I'm coming home, I'm coming
home". I thought this until 1979. Then I thought "I'm never coming
out". That's when I buckled down and started helping other women.
Women with AIDS and young girls who came in scared and alone. I
helped a lot of people along the way. I knew at the end of that tunnel
that there was a light shining bright for me. But I did have hope
again when I heard about Mahoney's conviction.

**Mahoney. He was the detective who beat you and forced you to sign
the confession correct?**

Yes.

What was Mahoney convicted of?

I think it was in 1980. He was convicted of faking evidence in a
case about mobsters. When I heard about this I contacted my
lawyers. But they told me this didn't apply my case.

What led to the overturning of your conviction?

Several things. A Rochester reporter heard about my story and
found one of those counselors who was at the jail in 1973 after I was
beaten. She told him that she believed I was beaten. In fact, she told
him she ain't never seen a black person that bruised before. Then a
year before I got out one of the kids who testified against me came
forward and said that Mahoney had put a gun to his head and forced
him to lie at my trial. Then there was a paper from one of the teens
that said he never saw me with Mahoney-completely different then
what he said at trial. I guess by law the police had to give this paper
to my attorney and because they didn't I was released.

What was the hardest thing to adjust to since your release?

Several things. Being free for one. You know, I'm use to hearing "Count!" It was really hard at first. I was looking for permission for everything. At Bedford we had to ask the officers to use the bathroom and for toilet paper. We had to wait for an officer to turn the lights on and off. This was my life for 25 years. Treated like a child for 25 years.

Also in prison you know everybody. Here it's like oh my God, I don't know nobody. Today I don't like crowds. If I'm in a crowd I prefer to be in a prison where I know people. But worst of all was that I lost my mother. She died a month after I got out.

How have you changed over the 25 years in prison?

Before I was a thorn, today I'm a flower. I was miserable. Miserable and un-in-touched. Out of it. Today I know Betty. I did not know Betty then. I was uneducated then. I can truly say that prison not only saved my life but it made me get more in touch with who I am. That's what happened to me. I found Betty, who Betty Tyson really is. And she's not that confused person that was out in the street rippin' and runnin', fightin' and using drugs.

Why do you say prison saved your life?

Because a lot of my friends are dead that were out there when I was out there. You have to think about the AIDS virus. I was shootin' drugs. I was selling my body. If I was on the streets I probably would have been killed, got AIDS, or overdosed. I got to prison in '74. I think I started blossoming in' 79 because in order to help other people I had to help myself first. In '79 is when I started coming out and reaching out to other people to help them. And in helping them I was helping me too.

Do you think that most women who come out of prison come out better like you did?

I don't know about most women because some women continue to go back and forth. I feel that the ones that do over five years, yes, anything less no because they really don't know the depth of the crime and the depth of themselves. You really don't get in touch with reality, because you don't have enough time to think about it. I mean two years, that's cut time—that's nothing. I mean it's time away from home but it's not good because when you get out you go back to the same shit that brought you to prison in the first place.

What are you doing now?

I volunteer in the housekeeping department. But I want a job. After prison you've got a strike against you, even though my conviction was overturned. I know a lot of people that have Masters' that can't even get a job. I don't even have a Masters'. Yet I am graphic artist from Albany. I'm a certified apprentice. But I can't get a job. One man told me, "I don't have enough work for you". I said, "What?" He said, "What I'm saying is that you are overly qualified." I mean what do you do? Some people take it and they lie on their application. I mean I'm not a convicted felon. It's just because I'm "Betty Tyson" and they know who I am. It's hard.

Do you speak publicly about your experiences in prison?

You know I do since I come to your women's [Women and Crime] class every year, in prisons, churches, anywhere. I talk about what it's like to be behind bars all that time and what my life was like before that. I also talk about how important it is for black people to be on juries. We have to take it more seriously.

Do you have any words that you would like to leave with us?

Yes. We really need to start looking at why women are in prison. Is it drugs? Maybe they're selling for their man whose pimping them out. You just can't stick a person in prison and expect them to rehabilitate. There needs to be alternatives for women with problems to get real help not punishment for something they can't help.

LaVerne McQuiller Williams is an assistant professor of criminal justice at Rochester Institute of Technology (RIT). Her research interests include victimization, particularly violence against women, therapeutic jurisprudence, and feminist theory. Prior to joining the faculty at RIT, Ms. McQuiller-Williams was an Assistant District Attorney specializing in sexual assault and domestic violence cases.

Pastel Fascism: Reflections of Social Control Techniques Used With Women in Prison

Barbara H. Zaitzow

The increased use of imprisonment for women offenders has been attributed to changes in legislative responses to the "war on drugs," changing patterns of drug use, and judicial decision-making. Increasingly, women who are incarcerated in this country are there for non-violent, drug-related offenses that account for the largest source of the total growth among female inmates (Mauer, Potler, & Wolf, 1999). The popularity of imprisonment as a sanctioning tool has significant implications for corrections, which traditionally has allocated few resources for institutional or community-based programs for female offenders.

Often overlooked is the fact that personal and social problems are imported into the prison setting and become a part of the intricate web of the prison culture through which women negotiate their daily existence. It would not be fair to say that imprisonment is worse for women than it is for men, but imprisonment is definitely different for women because women are different from men. At the same time, there is a need to address how institutional rules and programmatic opportunities available to women in prison contribute to the continuation of the disadvantaged status of women prisoners. After all, women's prisons increase women's dependency, stress women's domestic rather than employment role, aggravate women's emotional and physical isolation, can destroy family and other relationships, engender a sense of injustice (because they are denied many of the opportunities available to male prisoners), and may indirectly intensify the pains of imprisonment.

The gender stereotypes that influenced the first women's reformatories— instilling feminine values by providing domestic training to incarcerated women to facilitate their acceptance of their expected social role of homemaker— continue to affect the treatment, conditions, and opportunities of incarcerated women today. Because the overall proportion of women prisoners is still small relative to the total prison population, the special problems of women

prisoners, while creating a wide range of recent individual and social concerns, continue to be minimized. Without providing these women the necessary individual as well as social skills with which they may become viable contributors to and for society, their chances for successful assimilation, as well as day-to-day survival, will be impeded. Thus, a reevaluation of the purpose(s) of imprisonment as well as the reconsideration of the special needs of women offenders should be an ongoing process.

Characteristics of Female Offenders

As in any examination of women prisoners, the first point is to note that they constitute a small percentage of the total number of people incarcerated in the United States, contributing in part to their being labeled the "forgotten offender." And while their relative proportions are small, the growing numbers of women being sent to prison is disproportionate to their involvement in serious crime. Women imprisoned in state and federal correctional institutions throughout the United States totaled 94,336 at mid-year 2001, representing 6.6% of the total prisoner population (Beck & Harrison, 2001). This represents twice the number of incarcerated women held in jails and prisons one decade earlier. Moreover, the impact on women of color has been disproportionately heavy. The incarceration rate for African-American women is eight times that for white women; for Latinas, it is almost four times greater (Beck, 2000), circumstances that reflect issues not only of race, but also of poverty.

Female inmates are young (about two-thirds are under thirty-four years old), minority group members (more than 60%), unmarried (more than 80%), undereducated (about 40% were not high-school graduates), and underemployed (Beck & Mumola, 1999). Most research about the parental status of prisoners has echoed the finding that about four-fifths of incarcerated women are parents, and about two-thirds are parents of dependent children (Belknap, 2001). Moreover, a distinguishing characteristic of incarcerated females is their significantly increased likelihood of having survived sexual or physical violence (or both), particularly by a male relative or intimate partner (Greenfeld & Snell, 1999). Research also shows that women in prison have experienced unusually high rates of extremely abusive "discipline" from parents, involvement in drugs, and prostitution, whether they were imprisoned for these crimes or not (Harlow, 1999). Female criminal behavior appears to be the product of continuing personal and social problems—the impact of

physical and emotional abuse and extreme disadvantage, exacerbated by economic problems as well as drug and alcohol abuse.

Historical Overview of the Treatment of Women in Prison

Discussions about the evolution of punishment in the United States is an important prelude to understanding the plight of women in today's jail and prison institutions. Correctional philosophies and operations tend to be created, utilized, and discarded after a period of time, and then resurrected, reutilized, and eventually again dropped from the repertoire of programs, functions, and attitudes. The reexamination of the history of women's imprisonment in the United States can help people understand these cycles.

The history of penology in this country presents a dismal picture of the treatment of all criminal offenders. Until penal reforms were instituted in the middle of the nineteenth century, men, women, children, mentally-ill persons, and every form of degenerate were frequently locked up together. No consideration was given to age, type of offense, or circumstance (Pollock-Byrne, 1990). Since women's crimes were predominantly restricted to sex offenses and drunkenness, a criminal woman was considered disgraced, dishonored, and pathetic (Giallombardo, 1966, p, 7). Those women who were involved in criminal offenses were not considered dangerous, and often their male partners took the total blame, thus precluding their imprisonment (Chandler, 1973, p. 3). With the exception of a few private and often religious experiments, men and women prisoners were housed in the same institutions until the 1870s in the United States. These prisons usually provided separate rooms for women and men, though both sexes were under the supervision of male guards and wardens. While most historical accounts of this practice suggest similar treatment, the differences that existed were significant, particularly women's high risk of rape. When instances of sexual abuse of women prisoners resulted in pregnancy, it was not uncommon for the woman to be beaten or flogged until she died (Feinman, 1983). Moreover, services for incarcerated women were substantially limited relative to those of incarcerated men. "Unlike men, they were not marched to workshops, mess halls, or exercise yards. Food and needlework were brought to their quarters, where the women remained day in and day out, for the years of their sentences" (Rafter, 1985, p. xx). Interestingly, this black mark in the history of corrections is rarely included in most introductory corrections texts. A cloak of silence has shrouded the abuses that

imprisoned women have endured throughout history.

Reformers in the United States were particularly motivated by a concern with the sexual abuse of incarcerated women by male officials in institutions housing both sexes. Middle- and upper-class white women led the reform movement, which tended to reflect traditional views of women's role in society. While they recognized that women offenders were often not deviant per se but rather victims in a male economic and crime-processing system, they strove to "purify" and control "fallen women," whom they viewed as a threat to society. This notion of rehabilitation has undoubtedly been the single most damaging influence on female corrections, largely because the idea of "treatment" for women entailed the fostering of sexual morality, the imposition of sobriety, the instilling of obedience, and the prescribing of the sex-role stereotype of mother and homemaker (Chandler, 1973, p. 7; Freedman, 1981).

Social-Sexual Environment

Historically, the women's correctional system was not to replicate that of the men's; rather, it was to differ along a "number of key dimensions, including its historical development, administrative structures, some of its disciplinary techniques and the experience of inmates" (Rafter, 1983, p. 132). The reformists demonstrated their philosophy in the architecture of prisons for women. Instead of the massive, fortress-like penitentiary housing used for men—which had high concrete walls, armed personnel, and gun towers—the "domestic model" for women provided each woman her own room in "the home":

> "The home" planned for women was a cottage that was built to house twenty to thirty women, who could cook their own food in a "cottage kitchen." Several similar cottages would be arranged in quadrangles on green, tree-filled lawns. The cottages in most states were built to contain a living room, dining room and one or two small reading rooms. The idea was that a domestic atmosphere would help the women learn the essential skills of running a home and family (Burkhart, 1973, p. 367).

This was the first "cottage" penal facility for women. Since that time three additional types of women's prisons have developed. The "campus" plan is designed to resemble a college campus. Grass and trees surround numerous buildings, each with separate functions and sep-

arated by grassy court areas. In the "complex" model several build-
ings—which may contain one or more functions, such as living areas,
dining halls, vocational training facilities, or classrooms—cluster
around the central administration building. The "single-building"
style consists of one major facility that houses all of the prison func
tions (Glick & Neto, 1977, p. 20).

Today, women's facilities have changed little from those at the
beginning of the twentieth century. Females compose a small per-
centage of the total prison population; hence, women's prisons
appear to be smaller and fewer in number (Pollock-Byrne, 1990, p.
97). The end result is that prisoners may be housed at considerable
distance from their families, friends, and legal support. Further, the
relatively small number of women in prison and jail is used to 'justify'
low levels of specialization in treatment and a failure to segregate the
more serious and mentally ill offenders from the less serious offend-
ers" (Ibid).

And the one commonality that institutions of the past share with
modern facilities are the "traditional values, theories, and practices
concerning a woman's role and place in society...The staffs, architec-
tural design and programs reflected the culturally valued norms of
women's behavior" (Feinman, 1986, p. 38). Penal institutions built
for women "established and legitimated a tradition of deliberately
providing for female prisoners treatment very different from that of
males" (Rafter, 1983, p. 148). The differential treatment of women
prisoners—also known as the "chivalry factor"—meant that women
should be treated more leniently than men. Yet, as noted by many
criminologists (Belknap, 2001, pp. 63, 190; Van Wormer & Bartollas,
2000, p. 62; Owen, 1998), once a woman enters the correctional facil-
ity, she has not necessarily benefited from the benevolence of the
criminal justice system. In fact, she may be treated worse than male
prisoners.

Deception of the Prison Appearance

Most women's institutions retain the traditional categories of mini-
mum, medium, and maximum security differentiated by the degree
of surveillance, the number of security-check body counts, the fre-
quency of room searches or "shake downs," freedom of movement,
and architectural design. However, one of the biggest differences
between facilities for men and women is the relative absence of cus-
tody-graded institutions for women. Because there are still fewer
facilities for women, custody grade has little meaning. In reality, most

women, regardless of the risk they present, are subject to medium-
and maximum-security measures because of the few who need them.
Owen (1998, p. 64), for instance, found that more than 75% of the
women in the California prison system are classified at the two lowest
classification levels (compared to 58% of men). But, many of these
women serve time in facilities with maximum-security classification
measures.

On the surface, most women's prisons are more attractive than
men's. Some have been converted from country mansions or chil-
dren's homes and the obvious aspects of security (such as gun tow-
ers) are often lacking. Indeed, it has been acknowledged by various
Departments of Correction (personal communications with adminis-
trators in California, 1976-1980, Virginia, 1983-1987, Illinois, 1988-
1993, and North Carolina, 1994-present) that security considerations
for women offenders do not loom so large because there is less
public anxiety and fear when women escape from custody. Yet, as the
inmates point out, there is only the appearance of a campus. Repres-
sion is every bit as strong as in men's prisons; it is simply much more
subtle. The social control in women's prisons is best described as
"pastel fascism": control glossed over and concealed by a superficial
facade of false benevolence and concern for the lives of inmates.
Despite the less-threatening appearance of women's prisons, the
conditions for women prisoners are usually worse than those for
male prisoners. For example, women prisoners have more restricted
access to legal libraries, medical and dental care, and vocational and
educational opportunities. What few possessions they have are often
confiscated or destroyed, and they are subject to arbitrary body
searches at any time (Cambanis, 2002; personal communications
with women inmates housed in a maximum security prison in the
southeast, 1994-present). When women in prison fail to conform to
expectations, physical control is quickly instituted.

Upon Entry Into Prison

The objectives of the correctional system and the crimes of female
offenders notwithstanding, once women enter the institution they
often go from being a victim of justice to a victim of injustice. Cruel
and unusual punishment is not supposed to exist today; however, one
would never know by observing life in women's penal facilities. After
arriving at her assigned correctional home, the new female prisoner
must go through a series of orientation or "reception" procedures.
She may come in handcuffed and be refingerprinted and repho-

tographed for institutional records. She soon loses all remaining dignity when she is stripped and searched for contraband, showered, and issued prison attire and bedding. When she is given her prison number, she is officially "Property of the State":

> Being processed was like an assembly line. Each person had a job to do. You go in there, you weren't a person anymore, you weren't human anymore, they could care less. About forty-two of us came in together. They threw us all in the same room, and we, four of us, shower together, it was awful. We were in orange jump suits, with no underwear. For some girls, it was that time of the month. One girl had to keep a pad on with a jump suit with no panties on. That's just the way it is. And they don't care. The phrase is always, "Welcome to the real world" (Vanessa at the Central California Women's Facility, in Owen, 1998, p. 77).

Over the next two to six weeks the incarcerated woman, who is relegated to a communal segregation living unit during this period, goes through medical and psychiatric examinations for everything from venereal disease to mental illness. Most women describe this experience as stressful, frightening, and dehumanizing (DeGroot, 1998; Girshick, 1999; Owen, 1998).

By the time she joins the general prison population, she has been instilled with the extensive rules and regulations of her confinement, including her new status of "institutional dependency." Although women's prisons are usually not the maximum-security fortresses that men's prisons are, some suggest that the rules women must abide by are stricter (Carlen, 1994). While the rules and regulations—as well as disciplinary actions for infractions—vary from one institution to another, many female inmates view the rules and regulations of prisons as willful efforts to "diminish their maturity" by "treating them like children and fostering dependency" (Mann, 1984:210):

> From the day we are "received," we been gradually adapting to the loss of our identity and respect. We become accustom to the chaos and lurking danger because we have to. We are forced to accept absurd rules and cope with insane reasoning (Christy Marie Camp at Valley State Prison for Women, in Camp, 2000).

Female inmates make adjustments to prison life. For many, faced with years behind walls, life becomes a strategy of survival. The most

obvious fact of life in women's prisons is that women are dependent on the officers for virtually every daily necessity, including food, showers, medical care, feminine hygiene products, and for receiving "privileges" such as phone calls, mail, visits, and attending programs. To ask another adult for permission to do things or to obtain items of a personal nature is demeaning and humiliating. Their attempts at survival often mean that, compared to male inmates, women are more likely to be rule-breakers. Correctional officers describe female inmates as more emotional and manipulative. They are perceived by guards to be more difficult to supervise than men because they are seen as less respectful to authority and more willing to argue (Pollock, 1986). They are written up for twice as many infractions as men, but usually the infractions are less serious than those committed in men's prisons (Lindquist, 1980; McClellan, 1994).

A woman inmate's feeling of inadequacy is heightened by the constant surveillance under which she is kept. The prisoner is confronted daily with the fact that she has been stripped of her membership in society at large, and then stands condemned as an outcast and outlaw such that she must be kept closely guarded and watched day and night. She loses the privilege of being trusted and her every act is viewed with suspicion by the guards. The experience of being incarcerated—of having one's self-esteem stripped away, of being deprived of regular contact with the outside world—plays havoc on one's mental and emotional well-being. Because of prior emotional problems or those induced by the stresses of incarceration, especially the separation from their children or loved ones, female inmates are more likely to engage in self-aggression, including suicide and self-mutilation (Pollock, 1998). The reality of women's prisons is that they create just as much frustration and pain as men's prisons (Freedman, 1981; Giallombardo, 1966, ch. 7; Rafter, 1990).

The Perpetuation of Dependency Among Women Inmates

Numerous historians and researchers have critiqued the tradition and current practice of treating women prisoners as wayward children, as distinct from men prisoners who are at least accorded adult status (Burkhart, 1973; Carlen, 1985). As noted by Watterson (1996), the controls of prison that attempt to regulate lives, attitudes, and behavior are synonymous with those used during infancy. The women prisoners, like children, are told when to get up, how to dress, what to eat, where to go, how to spend their time—in short, what to do and what not to do. The prison—represented by officers,

staff, and administrators—acts as a "parent," imposing rules and sanctions, much like the model of a punitive parent who seeks to control the child through sanctions and punishments. For instance, women have shared instances when they have angered authorities and, as a consequence, were moved from a choice living unit or job (or both) but were told that such actions were "for their own good." Ironically, the closed, punitive prison environment can recreate many of the dysfunctional family and social dynamics many of the women experienced as children and as adults, with the resultant negative self-representations and impulses. This is particularly significant given the large percentage of women in prison who report experiences of physical, sexual, and emotional abuse as children or adults (Girshick, 1999; Zaitzow, 1996).

Some women whose lives were out of control by being caught in a cycle of drugs and violence may, indeed, feel relief from the restraints imposed by imprisonment·

> Where would I be if I hadn't been busted? Probably dead. Everyone I was with out there is either dead of AIDS or in prison. I was in a prison within myself. The drugs controlled my life. If I'd been thinking about my child, I wouldn't be here today,, I loved my child. I did. But that's not what controlled me (Judith Clark at Bedford Hills Correctional Facility, in Clark, 1995, p. 309).

Prison forces that break and provides a "time out" from such destructive behaviors and driven activity as well as a space away from the pressures and problems women faced outside. Although external controls may mask problems, they do not solve them. Moreover, some women become dependent on the controlled prison environment. Forced dependency can undermine a woman's sense of autonomy and responsibility needed to succeed as an individual on the outside.

Special Needs of Female Inmates

All too often we evaluate the prison experience of women in terms of what we think we know about prisons for men. So much more has been written about the far larger number of these institutions for male offenders that it may be unrealistic to expect there to be a significant body of research and other literature on women's prisons. But, it is certainly indicative of a gender bias that our knowledge of inmates' imprisonment experiences is based largely on the experiences of men. Women in prison manifest a number of problems in

common with men —drug dependence, lack of marketable job skills, health problems—but they have certain special needs.

With regard to health, the quality and quantity of health care received by women inmates have been questioned and generally found in need of revamping. Here, access to treatment for general, OB/GYN, and drug-related health problems is seriously limited. Today, female prisoners still receive fewer health care services in comparison to their male counterparts (Acoca & Austin, 1996). Moreover, the health care provided to women is mediocre. It is largely an attempt to "catch up," in that considerable effort is often necessary to raise women's health status to legally-acceptable levels (Maeve, 1999). Finally, women inmates have reported prison medical professionals are under-skilled, often withhold medical care, and show little care or concern for them or their needs (Fletcher, Shaver, & Moon, 1993). In fact, most lawsuits filed by women in prison are for complications in receiving medical services (Belknap, 2001).

Episodes of callous disregard shown to women prisoners who are pregnant or sick is not old news. Throughout the 1980s, a number of lawsuits were filed on behalf of women prisoners who had been seen as "complainers" and denied adequate medical, dental, and psychiatric care. Many of these cases led to consent decrees mandating better medical treatment, but according to Attorney Ellen Barry, the Director of Legal Services for Prisoners in California, a lack of adequate medical care remains one of the most serious problems of women prisoners throughout the country (ACLU, 1997). Throughout her twenty years of work on behalf of women prisoners, she has been aware of examples—from gynecological problems to incorrectly set bones, incorrect medications, and misdiagnosed fatal illnesses—where women in prison have received thoughtless, careless, deliberately malicious, and sometimes barbaric treatment.

There are personnel, including nurses and doctors, who abhor the inhumanity they have witnessed in women's prisons. To fight it, however, means to risk losing not only one's job but also what good effect one does have by being in the institution. In an environment where the priorities are containment and control, security naturally becomes more important than individual concerns. Staff members focus on potential danger and disruption instead of on the personal concerns of women who are sick or who need preventive health care. The inattention to—and serious problems resulting from—women prisoners' health complaints may result from the prevalent attitude that most women are faking illness, and many serious problems are not detected until too late.

With respect to vocational training and placement, the training available in correctional institutions typically "does not necessarily assist women offenders in obtaining meaningful and financially rewarding work" (Prendergast, Wellisch, & Falkin, 1995, p. 242). Historically, the justification offered for the differential programming available to women prisoners was that women's primarily domestic—rather than "breadwinner"—responsibilities did not necessitate a need for remunerative employment. While such views have diminished with time, there is still the theme in prison programming for women to reflect society's bias that the most acceptable role for women is that of wife and mother (Diaz-Cotto, 1996; Zaitzow, 1998). However, we cannot be blind to the fact that there is a growing number of single women who are heads of households. Moreover, assumptions about who "deserves" jobs and programs are often sexist. Excuses offered for the limited number of nontraditional programs for incarcerated women are that women constitute a small portion of prisoners and that they are in prison for shorter periods of time compared to men. The reality of the situation is that specialized and nontraditional programs for women in prison are rare. And when available, the programs do not have the capacity to serve large numbers of imprisoned women necessitating the use of long waiting lists.

The underutilization of nontraditional programs may be due to various issues and concerns: (1) qualifications for program entry which may be too difficult or have disadvantages attached to them that outweigh the advantages (e.g., a particular level of reading which they may not qualify for); (2) it may be that women in prison are more committed to traditional feminine roles when it comes to choosing vocational programs; (3) staff resistance to such programs. Thus, work assignments available to women incarcerated in prisons throughout the United States are not considered prison industries with marketable job skills. Most women's prisons have programs in cosmetology, food service, laundry, sewing, clerical work, and keypunch but few train women in skills to help them become legitimately independent on their release. It seems that few changes have been made in programs and opportunities offered to women prisoners since the beginning of the century.

Toward Change

Much of the treatment and control of women in prison is premised upon the individualization of the women's problems. The women are typically characterized as having in some way "failed" in their adult

responsibilities. While the prison administrators and staff recognize that many of the problems experienced by the women are endemic to their social situation outside prison, they argue, perhaps quite reasonably, that there is little they can do about the wider social problems of poverty, inadequate housing, and unemployment. On the other hand, many stress that a number of the problems presented by the women reflect personal limitations which could be effected by staff intervention, either by means of education and training or by personal interaction and informal counseling.

Although many have noted the corrections experience is significantly different for women than for men (Chesney-Lind & Pollock, 1995; Zaitzow & Thomas, 1999, 2003), it seems to be an unlikely place for women to experience real growth. Although women are relatively safe in prison, and may create some support networks through pseudo- or state families or other relationships, prison is a place where women are completely dependent on the authority figures and have few opportunities to exercise responsibility. Velimesis (1981, p. 133) notes that:

> Under the prison system, dependence on authority figures is maximized, and opportunities to learn and experience responsible personal decision making are minimized. Many women are in prison because of excessive dependence on others, and for them this type of administration does nothing to counter thinking and behavior patterns that are personally destructive and that, in many cases, result in a return to prison.

Women in prison do not necessarily embrace dependency. However, it may be more natural for them to accept dependency (especially on men). However, if they are ever to become emotionally strong and productive members of society, they need to be encouraged to learn independence. This is a difficult challenge in a traditional prison. If we hope to facilitate the reentry of incarcerated women to "free" society, we must attempt to reform current policies and programs, both in prison and in the community, which tend to reinforce women offenders' dependency upon the system.

As Richie (2001, p. 386) notes, "the nature of the reform centers on both enhanced delivery and systemic change especially in low-income communities of color from which a majority of incarcerated female population in this country come from." Here, (1) the provision of comprehensive programs, that utilize a case-management approach, would enable women to deal with multiple gender-specific

and culturally-specific needs; (2) community-based programs need to build linkages with other services to prevent incarceration in the first place as well as provide user-friendly networks by which incarcerated women might avail themselves of services; and (3) beyond expanded services, community conditions need to change in a manner that provides more opportunities for economic and emotional empowerment to facilitate the attainment of individual self-sufficiency. Because women offenders manifest multiple problems that require the services of many different agencies, corrections "needs to move toward a more system-oriented approach...that emphasizes linkages and coordination among programs and agencies, joint planning, shared resource allocation, and continuity for clients" (Prendergast, Wellisch, & Falkin, 1995, p. 254).

Conclusion

Control-oriented rules and regulations, poor diet, neglectful health care, degradation, lack of vocational training and recreational facilities, exploitation, abuse, and unsanitary conditions typify the conditions in many prisons and jails that house women. Although incarceration is not a picnic for anyone (nor, some argue, should it be), clearly on a collective basis female inmates are a great deal worse off than male inmates. For one thing, it is arguable that many of these women should be in prison at all. Often their biggest crime seems to be trying to feed their families or having the misfortune to be pregnant or nonwhite.

Moreover, the impact of institutional regiments of daily life on the prison culture which develops in women's prisons add to the detrimental effects of "doing time" and may not be of benefit to the women upon release from the prison setting. Clark (1995) notes the hypocrisy of a system that makes women dependent, but tells them to be responsible; that calls women girls, but expects them to act like adults; that forces them to become passive and dependent, and then expects them to take on all the problems of living immediately upon release. As a result, women behind bars are saddled with an added level of punishment, which is, of course, not sanctioned by any prison system, but is so overlooked and so common as to be essentially institutionalized.

Women in prison are fighting to maintain a sense of self within a system that isolates and degrades; one that attempts to teach submission through the constant exercising of power, in both serious and petty ways, over prisoners. What is generated is not obedience but

anger, and since a prisoner risks punishment, such as being sent to segregation, if she directs her anger at the system that is hurting her, that anger often gets directed inward or at other prisoners. That anyone survives years in prison is testimony to the resilience of the human spirit. Many people, of course, do not survive. Some will never get out and, therefore, will never have the opportunity to change the direction of their lives. Others have died in prison. Most will be released from prison with a minimal sum of money to their name with either no ride to take them to a destination or no destination from which to celebrate their new-found freedom.

Our task is to learn about and support the struggles of prisoners. Women inside fight back and resist all the time. Support from the outside is a crucial factor in the success of prisoners' campaigns. The knowledge that people outside care about what is happening contributes to prisoners' strength and makes prison administrators respond much more quickly to demands.

REFERENCES

American Civil Liberties Union (1997). "California Women Prisoners Win Improvements to Poor Medical Care." ACLU News - The Newspaper of the ACLU of Northern California [Online]. Available: http://acluweb. best.vwh.net/aclunews/news597/prisoners.html.

Acoca, L., & Austin, J. (1996). The Hidden Crisis: Women in Prison. San Francisco: National Council on Crime and Delinquency.

Beck, A. (2000). Prisoners in 1999. Washington, DC: Department of Justice.

Beck, A., & Mumola, C.J. (1999). Prisoners in 1998. Washington, DC: U.S. Government Printing Office: p. 9.

Beck, A., & Harrison, P.M. (2001). Prisoners in 2000. Washington, DC: Bureau of Justice Statistics.

Belknap, J. (2001). The Invisible Woman: Gender, Crime, and Justice (2nd Ed.). Belmont, CA: Wadsworth.

Burkhart, K. (1973). Women in Prison. New York, NY: Doubleday.

Cambanis, T. (2002). "Ex-prisoner Says She was Strip-searched in View of Men." The Boston Globe [Online]. Available: www.boston.com/daily-globe2/...rip_searched_in_view_of_men+shtml.

Camp, C.M. (2000). "Another Day in Paradise." Cell Door Magazine [Online]. Available: www.celldoor.com/00302/camp00302paradise.htm.

Carlen, P. (1985). "Law, Psychiatry and Women's Imprisonment: A Sociological View." British Journal of Psychiatry, 46, 18-21.

___. (1994). "Why Study Women's Imprisonment? Or Anyone Else's?" British Journal of Criminology, 34, 131-139.

Chandler, E.W. (1973). Women in Prison. Indianapolis: Bobbs Merrill.

Chesney-Lind, M., & Pollock, J. (1995). "Women's Prisons: Equality with a Vengeance." In A. Merlo & J. Pollock (Eds.), Women, Law and Social Control, pp. 155-175. Boston: Allyn & Bacon.

Clark, J. (1995). "The Impact of the Prison Environment on Mothers." Prison Journal, 75(3) (September), 306-329.

DeGroot, A. (1998). "A Day in the Life: Four Women Share Their Stories of Life Behind Bars." Corrections Today (December), 82-86.

Diaz-Cotto, J. (1996). Gender, Ethnicity, and the State: Latina and Latino Prison Politics. Albany, NY: State University of New York.

Feinman, C. (1983). "A Historical Overview of the Treatment of Incarcerated Women: Myths and Realities of Rehabilitation." Prison Journal, 63, 12-26.

___. (1986). Women in the Criminal Justice System. New York: Praeger.

Fletcher, B.R., Shaver, L.D., & Moon, D.G. (1993). Women Prisoners: A Forgotten Population. Westport, CT: Praeger.

Freedman, E. (1981). Their Sister's Keepers: Women's Prison Reform in America, 1830-1930. Ann Arbor: University of Michigan Press.

Giallombardo, R. (1966). Society of Women: A Study of a Women's Prison. New York: Wiley.

Girshick, L.B. (1999). No Safe Haven: Stories of Women in Prison. Boston: Northeastern University Press.

Glick, R.M., & Neto, V.V. (1977). National Study of Women's Correctional Programs. Washington, D.C.: U.S. Government Printing Office.

Greenfeld, L.A., & Snell, T.L. (1999). Women Offenders [NCJ 175688]. Special Report. Washington, DC: Bureau of Justice Statistics.

Harlow, C.W. (1999). Prior Abuse Reported by Inmates and Probationers. Washington, DC: U.S. Department of Justice.

Lindquist, C. (1980). "Prison Discipline and the Female Offender." Journal of Offender Counseling, Services and Rehabilitation, 4(4), 305-319.

McClellan, D.S. (1994). "Disparity in the Discipline of Male and Female Inmates in Texas Prisons." Women and Criminal Justice, 5, 71-97.

Maeve, M.K. (1999). "Adjudicated Health: Incarcerated Women and the Social Construction of Health." Crime, Law, & Social Change, 31, 49-71.

Mann, C.R. (1984). Female Crime and Delinquency. University: University of Alabama Press.

Mauer, M., Potler, C., & Wolf, R. (1999). Gender and Justice: Women, Drugs and Sentencing Policy. Washington, D.C.: The Sentencing Project.

Owen, B. (1998). In the Mix: Struggle and Survival in a Women's Prison. Albany, NY: State University of New York Press.

Pollock, J. (1986). Sex and Supervision: Guarding Male and Female Inmates. New York: Greenwood Press.

___. (1998). Counseling Women in Prison. San Francisco: Sage.

Pollock-Byrne, J. M. (1990). Women, Prison, and Crime. Belmont, CA: Wadsworth, Inc,

Prendergast, M.L., Wellisch, J., & Falkin, G.P. (1995). "Assessment of and Services for Substance-Abusing Women Offenders in Community and Correctional Settings." Prison Journal, 75, 242.

Rafter, N.H. (1983). "Prisons for Women, 1790-1980." In M. Tonry and N. Morries (Eds.), Crime and Justice: An Annual Review of Research, Vol. 5. 129-180. Chicago: University of Chicago Press.

___. (1985). Partial Justice: Women in State Prisons, 1800-1935. Boston: Northeastern University Press.

___. (1990). Partial Justice: Women, Prisons and Social Control (2nd Ed.). New Brunswick, NJ: Transaction.

Richie, B.E. (2001). "Challenges Incarcerated Women Face as They Return to Their Communities: Findings From Life History Interviews." Crime and Delinquency, 47(3), 368-389.

Van Wormer, K.S., & Bartollas, C. (2000). Women and the Criminal Justice System. Boston: Allen and Bacon.

Velimesis, M.L. (1981). "Sex Roles and Mental Health of Women in Prison." Professional Psychology, 12(1), 128-135.

Watterson, K. (1996). Women in Prison: Inside the Concrete Womb. Boston: Northeastern University Press.

Zaitzow, B.H. (1996). "Hurts So Bad: The Impact of Abuse History on Crime Commission by Women Offenders." Paper presented at the American Society of Criminology Meeting, Chicago, Illinois.

___. (1998). "Treatment Needs of Women in Prison." In T. Alleman & R. Gido (Eds.), Turnstile Justice. pp. 159-175. Upper Saddle River, New Jersey: Prentice Hall, Inc.

Zaitzow, B.H. & Thomas, J. (1999). "Re-Assessing Models of Prison Culture: Does Gender Matter?" Paper presented at the American Society of Criminology Meeting, November 1999, Toronto, Ontario, Canada.

___. (2003). Women in Prison: Gender and Social Control. Boulder, Colorado: Lynne Rienner Publishers, Inc.

Barbara H. Zaitzow is an associate professor of criminal justice at Appalachian State University. She has investigated a variety of prison-related topics in Virginia, Illinois, and North Carolina. Zaitzow has been involved in state and national advocacy work for prisoners and organizations seeking alternatives to imprisonment. An executive board member and program evaluator of a local community corrections program as well as an instructor for unit management training, she continues to work with and provide services to local and state officials. She has served on various editorial boards for nationally-recognized journals and has published articles and book chapters on a variety of prison-related topics including HIV/AIDS and other treatment needs of women prisoners and the impact of prison culture on the "doing time" experiences of the imprisoned which appear in the International Journal of Offender Therapy and Comparative Criminology, Journal of the Association of Nurses in AIDS Care, Journal of Crime and Justice, Criminal Justice Policy Review, Journal of Gang Research, and Names. Her co-edited book entitled Women in Prison: Gender and Social Control is currently available.

Feminist Therapy Behind Bars

Susan T. Marcus-Mendoza

Correctional systems in the United States have traditionally reflected the social and moral norms of our society. Women who commit crimes have been seen as fallen women, bad mothers, and unsuitable for polite society. Prison programming has reflected this bias. Programs for women often reflect stereotypes rather than addressing the pressing concerns that led women to prison. Conversely, feminist therapy focuses on societal and cultural norms that harm women, and helps women learn to resist these damaging forces. Therefore, introducing feminist therapy into correctional facilities is a difficult, yet necessary, task. This paper explores the changing perceptions and treatment of women in prison, the need for feminist prison programs, and the challenges of doing feminist therapy with incarcerated women.

The Social and Theoretical Context of Women's Prisons in the United States

In the United States, women's prisons have reflected the societal norms about women's behavior. This predilection is demonstrated in both the crimes for which women are incarcerated as well as the programming provided for them in prison. According to Freedman (1981), urbanization and its resulting crimes and moral reforms led to an increase in female incarceration during the 1800s. Many northern states used prison as the primary way of reducing crime and punishing criminals in burgeoning urban centers. As a result, small numbers of women were incarcerated in prisons, especially after the 1840s. Women were incarcerated for such crimes as disorderly conduct, vagrancy, drunkenness, and prostitution, all of which were contrary to the feminine ideal of the time. Freedman (1981) states that moral codes for women were stricter, so women were more likely to be convicted of such crimes. Also, fewer jobs and lower wages for women resulted in economic marginalization. Women resorted to crimes such as prostitution, especially during wartime, when men could not support their families. Prostitution was often the most readily available way for women to support themselves and their children.

Once convicted or suspected of a crime, women were marginal-

ized by their community. Female criminals were labeled "fallen women," and shunned (Freedman, 1981). Due to this stigma, the female prisoner was neglected and subjected to sexual abuse and harsh treatment by the prison staff. The available programming focused on domestic skills, and was designed to make the inmates "better" women. However, upon release their chances of getting married or getting a domestic position were poor.

This attitude towards women has its roots in our European ancestry. According to Feinman (1980), in classical Greece and Rome and in medieval Europe, the primary function of a woman was to produce heirs for her husband to continue his name and his property line. Therefore, adulterous women were executed because they threatened the legitimacy of the heirs. In seventeenth-century England, unwed mothers were imprisoned because their children were dependent upon the parish. By the end of the seventeenth century homeless women and mothers of illegitimate children were being sent to the American colonies as punishment for their transgression (Feinman, 1980). These same ideals were espoused in colonial America.

In the 1820s, strict moral codes for women and deplorable prison conditions gave rise to the prison reform movement for women. Middle-class women, driven by benevolence and a growing social consciousness, became active in prison reform. To do so, they had to reject the prevailing biases of the era (Freedman, 1981). By the early 1900s, prison reformers such as Dorothea Dix began to focus on such issues as poverty and education, and provided training aimed at helping women support themselves once out of prison (Rafter, 1990). These early reformers also focused on conditions in the prisons and were largely responsible for the establishment of separate prisons for women. Although the reform movement did improve circumstances for women inmates by bringing attention to their plight and encouraging more religious, academic, and vocational training, this approach was still idealist and moralistic and focused on molding women into the embodiment of the feminine ideal (Rafter, 1990). Upon release, women were not prepared to support themselves and many turned to past illegal means of support, such as prostitution, and soon found themselves back in prison. Even if a woman had learned a marketable trade, it was unlikely that she would find a job due to the stigma attached to having been incarcerated (Freedman, 1981).

Unfortunately, the theoretical constructs by criminologists, sociologists, psychiatrists, and others espoused in the 1900s were antithetical to the reform movement, and suggested biological and

psychological bases for female criminality which supported increasingly harsher prison practices (Van Wormer & Bartollas, 2000). Lombroso (1920) posited a biological explanation for women's criminal behavior, arguing that women are more primitive, innately insensitive, and passive. Women criminals, he contended, have inherited male characteristics that predispose them to criminal behavior. According to Lombroso, this combination of female and male characteristics renders them more vicious than male criminals. W. I. Thomas (1907, 1923) suggested both physiological and psychological reasons for female criminality. He argued that girls have higher amounts of sexual energy, and that their needs for love and recognition lead them to prostitution.

At the beginning of the twentieth century, the Progressive Era, women reformers also turned their attention to the etiology of female criminality. They rejected the concept of a physiological criminal type and focused on a sociological hypothesis of female criminality that examined the relationship between mental ability and crime as well as economic factors including poverty, lack of education, and low-wage jobs for women (Freedman, 1981). Many women social scientists conducted research in women's prisons and shifted the emphasis away from the notion of the fallen woman. Reformers focused on solving the social problems that were risk factors for incarceration of women, and on helping women once incarcerated. These new theories led to preventative services for economically marginalized women to discourage them from using criminal activities such as prostitution to solve economic woes (Freedman, 1981).

By the 1950s the emphasis had shifted towards psychological, social, and familial causes of female criminality (Van Wormer & Bartollas, 2000). However, some of the theories posited did not aid the work of reformers. Pollack (1950) argued that women commit more crimes than is generally known but, as they are more deceitful, they are more skilled at hiding their crime. When caught, chivalry by the police and court allows them to get away with behavior that would be considered criminal in men. Pollack also contended that since girls mature earlier than boys, they have more opportunity to engage in criminal and immoral behavior. In addition, he argued that girls with criminal parents or broken homes are more likely to associate with delinquent girls and engage in criminal behavior to compensate for their impoverished home life.

According to Van Wormer and Bartollas, Sigmund Freud's theories supported psychosexual explanations of women's criminality. Freud argued that women are innately inferior to men and therefore

are too concerned with personal matters and have little social sense. Freud's theory of penis envy posits that women are jealous and vengeful since they do not have a penis. These aspects of Freud's theories help support the biological and psychological models of female criminality (Van Wormer & Bartollas, 2000). This period was also marked by an increase in construction of women's prisons (Rafter, 1990). Women were no longer housed in reformatories but in prisons built to resemble those for men. This marked an ideological shift to a more punitive stance towards female inmates (O'Brien, 2001).

Theorists have continued to explore the environmental explanations of women's criminality, and social problems and economics are still at the center of many theories. According to Simon and Landis (1991), there are four major theories of the etiology of women's criminality. The first, based on the work of Adler, is the masculinity thesis. As women have become liberated, free of stereotypes, they have developed male traits such as aggression. Masculinity then leads to criminality. This is similar to Freedman's contention that women in the 1800s were incarcerated for not adhering to social roles assigned to them.

The second theory, the opportunity thesis, states that as women's social roles become similar to men's, so will their criminality. However, opponents of this thesis point out that women still do not have equal access to the job market. Further, Messerschmidt (1986) stated that the rise in women's crime is largely due to younger offenders who do not have the opportunity to commit white-collar crimes, and that the crimes being committed are non-occupational. Statistics still point to non-work-related crimes such as property offenses and drug offenses as the predominant types of crimes committed by women (Bureau of Justice Statistics, 2000).

The marginalization thesis makes the opposite assumption of the opportunity thesis: women commit crimes because they do not have the opportunity to make enough money to support themselves and their children (Simon & Landis, 1991). The proponents of this theory contend that greater access to job opportunities has not led to equality in the workforce or a better economic position for women. Women have largely low-paying jobs and commit petty crimes that might be seen as a rational response to poverty.

Finally, the chivalry thesis contends that the criminal justice system is undergoing a backlash towards women (Messerschmidt, 1986). In effect, as the women's movement has become stronger, the courts are giving women the equality they seek in the form of harsher sentences that are more comparable to those received by men, end-

ing the practice of chivalry. Simon and Landis suggest that there has been little evidence that chivalry ever existed in the court system, and that any favors granted are probably for white, upper-class women who are not a large part of the demographic of women inmates.

Over the last two decades, there has been a great deal of attention focused on social factors related to women's criminality. Research has shown that economic marginalization, substance abuse, sexual and physical abuse, and parenting without adequate financial resources are associated with criminality (Bureau of Justice Statistics, 2000; Chesney-Lind, 1997; Girschick, 1999; Owen, 1998; Simon & Landis, 1991; Sommers, 1995). The majority of women in prison in the United States have reported experiencing one or more types of abuse, and most are underemployed or on welfare, have alcohol or drug problems, are undereducated, and have children under the age of 18. (American Correctional Association, 1990; Bureau of Justice Statistics, 2000; Browne, Millei, & Maguin, 1999; Girschick, 1999; Marcus-Mendoza, Sargent, & Chong Ho, 1994; Owen, 1998; Owen & Bloom, 1995). It seems that the social problems facing women who commit crimes have changed little over the past two centuries.

Feminist Theory and Practice in Prison

Prison programming for women has made some changes over the last two centuries, but is still inadequate. Much of the programming offered to women in prison is still based on gender-based stereotypes (Chesney-Lind, 2003; Marcus-Mendoza & Wright; 2003; Morash, Haarr, & Rucker, 1994; Phillips & Harm, 1998). Although some institutions offer training in more marketable skills, women's prisons still emphasize horticulture, typing, and food preparation, whereas men learn computing, plumbing, and welding. By preparing women inmates to be better at "women's work," prisons still perpetuate gender stereotypes, and women are still at a disadvantage when they enter the job market. In addition to problems with vocational programming for women, programming to address psychological and social issues facing women is also inadequate. Morash, Bynum, and Koons (1998) surveyed departments of corrections in all states and at least one women's prison in each state. Only 242 programs for women, considered by the institution to be innovative, were mentioned. Many of these programs focused on psychological treatment, work programs, parenting programs, aftercare, life skills, and HIV/AIDS. Most were clustered in the same states, and only 16 states had programs cited as highly or considerably innovative. Of these

programs, only 90 fell into the mental-health category and about one-third focused on substance.

In a recent government report, Ritchie (2000) called for gender-specific programming that helps empower women and leads to positive life changes once women are released. However, most prisons do just the opposite. Prisons frequently promote relational disconnection and violation, creating a patriarchal social structure and recreating the harmful relational dynamics often experienced during the inmates' violent past (Covington, 1998; Girschick, 2003; Marcus-Mendoza, Klein-Saffran, & Lutze, 1998).

In contrast, feminist therapies take into account the social and political context, and the unique needs of women. They help women live and grow in a healthy manner. Therefore, programming based on feminist therapy principles would fulfill Ritchie's call for programs that promote positive life changes. According to Brown (1996), feminist therapy is grounded in feminist political philosophy and multicultural feminist scholarship about the psychology of women. Here, therapist and client work together towards strategies for change both within the client's daily personal life and in her interactions with her environment. Ideas about development, diagnosis, boundaries, and relationships in therapy are grounded in feminist scholarship that reflects positive conceptualizations of women. The ethics of practice in Brown's model are consistent with the goals of social change and interpersonal relatedness. Using these theoretical guidelines, Brown's model of feminist therapy helps women resist dominant cultural norms, attend to their own voice, and encourages resistance, personal integrity, self-directedness, and self-esteem.

Another feminist theory, Relational-Cultural Theory (Jordan & Hartling, 2002), postulates that all growth occurs in connection. The goal of growth is not separation and individuation, as suggested in traditional psychological theories of development. Healthy relationships are characterized by mutual empathy and empowerment. Inevitable disconnections are potentially damaging when a woman is unable to voice her feelings in a relationship due to a power differential, or when she encounters indifference, denial, or additional injury in reaction to voices her feeling. Sociocultural disconnections occur when sexism, racism, heterosexism, categorizing, and stereotyping keep women from participating in healthy, growth-promoting relationships. This theory also serves as the foundation of programs that promote positive change.

Although feminist therapy is ideal for incarcerated women, there are many inherent difficulties in doing feminist therapy in correc-

tional settings. One of the basic tenets of feminist therapy is examining and learning to resist harmful social structures. Prison is one of the most oppressive social structures. In prison, resistance is not only discouraged, it is often harshly punished. Women who are incarcerated must conform to prison rules and regulations, no matter how demeaning or irrational the rules may seem. To do otherwise can lead to loss of privileges, time in solitary confinement, and even longer prison stays due to denial of parole or loss of reductions in time for good behavior. Therefore, resistance must occur in passive, internal, or non-public forms. Feminist therapy sessions can be a safe place where all emotions and frustrations can be expressed without fear of reprisal. Although active resistance may be potentially detrimental to an incarcerated woman, therapy can still focus on recognizing and analyzing damaging influences in women's lives and help them plan for the future. When I was employed as a psychologist at a women's prison, therapy often focused on reconceptualizing past traumas and relationships, creating and maintaining healthy relationships with family on the "outside," and thoughtful planning towards a positive, empowered life upon release. Acknowledging that inmates are almost totally powerless in prison, therapy often focused on how to survive prison, about "being sane in insane places."

Another aspect that is key to feminist therapy is egalitarian relationships. However, in prison there is a definite power structure. Inmates are not considered equals or peers by the prison administration. Women are incarcerated against their will, and follow rules in which they have no voice. Even the therapist is considered correctional personnel, which can be difficult for both the therapist and the inmate. For the inmate, it can be hard to trust that the therapist/correctional employee is really fair and unbiased, and is not going to cause harm. Therapists walk a fine line between upholding their duties as a correctional employee— including complying with oppressive rules— and being an advocate and therapist for the inmates. Prison therapists may actively advocate for their clients, more so than they might for non-incarcerated clients. In fact, I felt I had an obligation to be a strong advocate for the women inmates who had little voice, and I was sometimes questioned about "whose side I was on." As I could act in their behalf without the same fear of punishment they faced, I tried to be on both sides. I was the women's therapist and advocate, but I also worked within the system and with my colleagues to bring about needed changes.

Another challenge that faces feminist therapists who work with incarcerated women is the tendency of correctional system to use

programs developed for men and delivered by correctional staff who are not trained therapists and who often have dual roles as correctional officers and counselors (Morash, Haarr, & Rucker, 1994; Marcus-Mendoza, Klein-Saffran, & Lutze, 1998). However, over the past decade scholars have developed innovative, feminist prison programs for women (Harden & Hill, 1998; Sharp, 2003; Zaplin, 1998). These programs utilize feminist principles to address the myriad issues faced by women in prison from a women-centered perspective.

Velasquez (1998) and Marcus-Mendoza & Wright (2003) caution that all programs for incarcerated women, regardless of the focus, must be designed with the unique needs of abuse survivors in mind, as the majority of incarcerated women have experienced one or more types of abuse. They advocate gender-specific, holistic approaches to working with women in prison and contend that failure to take a holistic approach has lead to frustration and failure. Therefore, all aspects of programming for women must address issues in a way that acknowledge women's histories of violence and marginalization. Covington (1998) advocates relational theory and used it to develop guidelines for working with incarcerated women on a wide range of issues including mental and physical health, parenting, decision-making, and spirituality. She strongly advocates a holistic relational approach to working with women in prison. One therapeutic technique effectively used for a variety of issues is art therapy. Art therapy is used to help incarcerated women express feelings within the safe boundaries of their artwork (Merriam, 1998).

Feminist models have also been designed for use with specific groups of women. Henriques and Jones-Brown (1998) developed Self-Taught Empowerment and Pride (STEP), based on relational theory, as a way of helping African-American women transition to the community. Their program takes into account the unique experiences of African-American women. Zaplin and Dougherty (1998) examine programming for mothers in prison, stressing modules on dealing with emotions and stress, promoting self-esteem, and teaching parenting skills. Bradley and Moschella (1998) discuss therapy with prostitutes, arguing that prostitutes, many of whom have a history of sexual abuse, are engaging in a continued exploitation of their bodies that started in childhood. The context of violence is considered a primary risk factor for prostitution, and therefore a key issue to be considered in treatment.

Some researchers, strong advocates for better programming for women, are critical of the feminist viewpoint and question the importance of the social and political context of problems in working with

women in prison. Holtfreter and Morash (2003) conducted research on reducing recidivism. They discount the influence of social factors on criminality. They state, "the feminist literature on women offenders has shown how life experiences and circumstances can influence involvement in criminality, but this is different from showing that there is a tendency for people with such experiences to become offenders. There are many women with a history of childhood sexual abuse, intimate partner violence, poverty, and stresses and strains related to child rearing who do not break the law" (pp. 150-151). In other words, since most women who experience abuse, poverty, and stress do not commit crimes, they minimize the importance of these factors.

Holtfreter and Morash (2003) also differentiate risk factors of recidivism from risk factors for initial incarceration. They cite feminism as a source of confusion in the literature on incarcerated women. They state that "Unfortunately, one of the unintended effects of feminist theorists and activists stressing the importance of meeting gender related needs of women offenders has been the blurring of the differences between needs and risk factors" (p. 151). According to Holtfreter and Morash (2003) addressing criminogenic risk factors (those empirically related to crime) will reduce recidivism and this should be the focus of correctional programming. They agree that needs not related to risk factors should also be addressed, but do not see these needs related to recidivism. By addressing non-criminogenic factors, "women might experience a higher quality of life, a desirable outcome itself, and might have greater incentives to avoid criminality and less stress encouraging them to, for example, use illegal drugs" (p. 153).

Holtfreter's and Morash's (2003) arguments make an artificial distinction between "reducing recidivism" and "avoiding criminality." It is likely that the same social and political issues that influenced women's initial criminality may indeed be problematic for women upon release. In my work with incarcerated women, I found that women became increasingly anxious prior to release about their ability to avoid engaging in such activities as substance abuse and violent relationships. They worried that these behaviors, which they saw as primary factors in their incarceration, would lead them back to prison. Research has shown that the effectiveness of transitional programs, designed to help women reintegrate into society, was based on addressing such issues (Austin, Bloom, & Donahue, 1992).

It is important to note that the measure used to predict recidivism in the study by Holtfreter and Morash (2003) does not includes questions about important contextual social problems that women

face, such as child abuse, and includes only one question about bat-tering as an adult, which is limited to the six months prior to the sur-vey. Therefore, it limits any consideration of the social and political factors influencing criminality to only a six-month time span, dis-counting most of the women's life experiences as relevant to their successful transition from prison. Ignoring these influences and focusing on discreet problems or skills as if they are unrelated to each other and to the larger social structure has been the downfall of women's prisons in the United States for the last two centuries.

Conclusion

Programming for incarcerated women in the United States has been based on stereotypes of women, programming for men, and the notion that each problem faced by women inmates exists in a social vacuum. Feminist therapy offers an alternative viewpoint based on feminist tenets such as resistance, diversity, mutuality, and empower-ment. In feminist therapy, the importance of women's social and political struggles is paramount, and relational connections are val-ued, not pathologized. Concerned and innovative scholars have developed feminist models for providing programming for women in prison. Unfortunately, they have not been widely implemented, and have been discounted by critics. Hopefully, continued research, writ-ing, and advocacy by feminist practitioners and scholars— started by reformers more than a century ago— will soon lead to widespread changes in our correctional system.

REFERENCES

American Correctional Association (1990). The Female Offender: What Does the Future Hold? Arlington, VA: Kirby Lithographic Company, Inc.

Austin, J, Bloom, B., & T. Donahue (1992). Female Offenders in the Com-munity: An Analysis of Innovative Programs and Strategies. Washington, DC: U.S. Government Printing Office.

Bradley, L., & Moschella, L. (1998). "Programs that Work: Working with Pros-titutes." In R. Zaplin (Ed.), Female Offenders: Critical Perspectives and Effective Interventions. Gaithersburg, Maryland: Aspen Publishers, Inc.

Brown, L. S. (1996). Subversive Dialogues: Theory in Feminist Therapy. New York, New York: Basic Books.

Browne, A., B. Miller, B., & Maguin, E. (1999). "Prevalence and Severity of Lifetime Physical and Sexual Victimization Among Incarcerated Women." International Journal of Law and Psychiatry, 22(3-4), 301-322.

Bureau of Justice Statistics (2000). Women Offenders. Washington, DC: U.S. Department of Justice, Office of Justice Programs (NCJ 175688).

Chesney-Lind, M. (1997). The Female Offender: Girls, Women, and Crime. Thousand Oaks, CA: Sage Publications, Inc.

Chesney-Lind, M. (2003). "Reinventing Women's Corrections: Challenges for Contemporary Feminist Criminologists and practitioners." In S. Sharp (Ed.), The Incarcerated Woman: Rehabilitative Programming in Women's Prisons. Upper Saddle River, NJ: Prentice Hall.

Covington, S. (1998). "The Relational Theory of Women's Psychological Development: Implications for the Criminal Justice System." In R. Zaplin (Ed.), Female Offenders: Critical Perspectives and Effective Interventions. Gaithersburg, Maryland: Aspen Publishers, Inc.

Feinman, C. (1980). Women in the Criminal Justice System. New York: Praeger Publishers.

Freedman, E. B. (1981). Their Sisters' Keepers. Ann Arbor: The University of Michigan Press.

Girshick, L. (1999). No Safe Haven. Boston: Northeastern University Press.

Harden, J., & Hill, M. (1998). Breaking the Rules: Women in Prison and Feminist Therapy. Binghamton, NY: The Harrington Park Press.

Henriques, A. W., & Jones-Brown, D. (1998)."Self-taught Empowerment and Pride: A Multimodal/dual Empowerment Approach to Confronting Problems of African American Female Offenders."In R. Zaplin (Ed.), Female Offenders: Critical Perspectives and Effective Interventions. Gaithersburg, Maryland: Aspen Publishers, Inc.

Holtfreter, K., & Morash, M. (2003). "The Needs of Women Offenders: Implications for Correctional Programming." Women & Criminal Justice, 14 (2/3), 137-160.

Jordan, J., & Hartling, L. (2002). "New Developments in Relational-cultural Theory." In M. Ballou and L. Brown (Eds.), Rethinking Mental Health and Disorder: Feminist Perspectives. New York: The Guilford Press.

Lombroso, C. (1920). The Female Offender. New York: Appleton.

Marcus-Mendoza, S., Klein-Saffran, J., and Lutze, F. (1998). "A Feminist Examination of Boot Camp Prison Programs for Women." Women & Therapy, 21 (1),173-185.

Marcus-Mendoza, S. T., Sargent, E., & Chong Ho, Y. (1994). "Changing Perceptions of the Etiology of Crime: The Relationship Between Abuse and Female Criminology." Journal of the Oklahoma Criminal Justice Research Consortium, 1, 13-23.

Marcus-Mendoza, S., and Wright, E. (2003). "Treating the Women Prisoner: The Impact of a History of Violence." In S. Sharp (Ed.), The Incarcerated Woman: Rehabilitative Programming in Women's Prisons. Upper Saddle River, NJ: Prentice Hall.

Merriam, B. (1998). "To Find a Voice: Art Therapy in a Women's Prison." Women & Therapy, 21(1), 157-171.

Messerschmidt, J. W. (1986). Capitalism, Patriarchy, and Crime: Towards a Socialist Feminist Criminology. Totowa, NJ: Rowman & Littlefield.

Morash, M., Bynum, T. S., & Koons, B.A. (1998). "Women Offenders: Programming Needs and Promising Approaches." Research in Brief. Washington, DC: National Institute of Justice (NCJ 171668).

Morash, M., Haarr, R. N., & Rucker, L. (1994). A Comparison of Programming for Women and Men in U.S. Prisons in the 1980s. Crime & Delinquency, 40(2), 197-221.

O'Brien, P. (2001). Making it in the "Free World:" Women in Transition from Prison. Albany, NY: State University of New York Press.

Owen, B. (1998). In the Mix: Struggle and Survival in a Women's Prison. Albany, NY: State University of New York Press.

Owen, B., & Bloom, B. (1995). "Profiling Women Prisoners: Findings from National Surveys and a California Sample." The Prison Journal, 72(2), 165-185.

Phillips, S., & Harm, N. (1998). "Women Prisoners: A Conceptual Framework." In J. Harden and M. Hill (Eds.), Breaking the Rules: Women in Prison and Feminist Therapy. Binghamton, NY: The Harrington Park Press.

Pollack, O. (1950). The Criminality of Women. Philadelphia: University of Pennsylvania Press.

Rafter, N. (1990). Partial Justice: Women, Prisons, and Social Control (2nd Ed.). New Brunswick, NJ: Transaction Publishers.

Ritchie, B. E. (2000). "Exploring the Link between Violence Against Women and Women's Involvement in Illegal Activity." In Research on Women and Girls in the Justice System, Research Forum. Washington, DC: National Institute of Justice (NCJ 180973).

Sharp, S. (2003). The Incarcerated Woman: Rehabilitative Programming in Women's Prisons. Upper Saddle River, NJ: Prentice Hall.

Simon, R. J., and Landis, J. (1991). The Crimes Women Commit, the Punishment They Receive. Lexington, MA: Lexington Books.

Sommers, E. (1995). Voices from Within: Women Who Have Broken the Law. Toronto: University of Toronto Press Incorporated.

Thomas, W. I. (1907). Sex and Society. Boston: Little, Brown.

Thomas, W. I. (1923). The Unadjusted Girl. New York: Harper.

Van Wormer, K., and Bartollas, C. (2000). Women and the Criminal Justice System. Boston: Allyn and Bacon.

Velasquez, A. (1998). "An Integrated Systems Approach to Program Development and Implementation." In R. Zaplin (Ed.), Female Offenders: Critical Perspectives and Effective Interventions. Gaithersburg, Maryland: Aspen Publishers, Inc.

Zaplin, R. (1998). Female Offenders: Critical Perspectives and Effective Interventions. Gaithersburg, Maryland: Aspen Publishers, Inc.

Zaplin, R., and Dougherty, J. (1998). "Programs that Work: Mothers." In R. Zaplin (Ed.), Female Offenders: Critical Perspectives and Effective Interventions. Gaithersburg, Maryland: Aspen Publishers, Inc.

Susan Marcus-Mendoza, PhD, *is an associate professor of human relations and women's studies, and the chair of the Department of Human Relations at the University of Oklahoma. She is also a licensed psychologist. Previously, Dr. Marcus-Mendoza was the chief psychologist at a federal prison camp for women.*

Understanding the Range of Female Criminality:

A Prison-Based Test of Three Traditional Theories

Janice Proctor

Controversy Concerning How Criminology Must Change

Criminological researchers question whether criminology should be substantially revised to provide distinctly different theories of crime for women or whether past theories of criminogenesis can be utilized to understand female criminality. Several criminologists call for a revamping of the field of criminology to incorporate more fully feminist thought and to formulate different theories of crime for women (Leonard, 1995; Messerschmidt, 1993; Naffine & Gale, 1989; Smart 1977). For example, Klein (1995) and Chesney-Lind (1989) advocate a new approach to theorizing women's crime - "one that has feminist roots and a radical orientation . . . that focuses on human needs rather than those of the state, [and that] will require new definitions of criminality, women, the individual and his/her relation to the state" (Klein, 1995, p. 47). However, other criminologists (Smith & Paternoster, 1987) question the need for such a radical restructuring of criminology to account sufficiently for female criminality.

According to Morris (1987, p. 75), one does not need a special feminist theory to explain female criminality: "There is no reason to suppose that explanations for women's crime should be fundamentally different from explanations for men's crime though gender may play a part in any such explanation." Morris (1987, p. 77) suggests that traditional criminological theories need to be "reread and reconsidered in the light of the potential for understanding women's crime."

I share Morris's conviction that a special brand of theorizing is not required to adequately explain female criminality. Therefore, in the research reported and analyzed in this paper, I rely on personal interviews with female inmates to test three traditional theories: Agnew's Extended Strain Theory, Sutherland's Differential Association Theory, and Hirschi's 1969 Social Control Theory. Before elaborating on my research and its results, I will review literature relevant to the field of female criminality and explain the three theories employed in the study.

The Study of Female Criminality: Its Past and Present

Early theories of female criminality usually conceptualized women's criminal behavior as an outcome of their sexuality or of unresolved psychological difficulties. Scarce attention has been paid to how economic, social, and political forces pressure women into committing crimes (Klein, 1995, p. 31). Klein (1995) cites numerous works, including those of Lombroso (1920), Thomas (1923), Freud (1933), Davis (1937), and Otto Pollack (1950), to illustrate that gender-biased explanations of female criminality have been the rule. Women have been neatly categorized no matter which kind of crime they commit: if they are violent, they are "masculine" suffering from chromosomal deficiencies, penis envy, or atavisms. If they conform, they are manipulative, sexually maladjusted and promiscuous. . . . The theme of sexuality is a unifying thread in the various, often contradictory theories (Klein, 1995, pp. 45-46).

A number of scholars (Morris, 1987; Leonard, 1995; Merlo, 1995; Joycelyn Pollack, 1995; Belknap, 1996; Chesney-Lind & Shelden, 1998) review past sociological theories of criminogenesis to determine how well they explain female criminality. An obvious flaw prevalent within such theories is their persistent androcentric bias (Chesney-Lind, 1989). According to Belknap (1996, p. 39), past theories of criminogenesis have failed to account adequately for female offenders since they "were developed to explain male criminality ... [and] fraught with sexist stereotypes often defining female crime in terms of sexuality."

For a long time the study of female criminality was a neglected subject within criminology. As Klein (1995, p. 31) observes, "female criminality has often ended up as a footnote to works on men that purport to be works on criminality in general." However, the 1975 publications of Freda Adler's Sisters in Crime and Rita Simon's Women and Crime brought about a change in the amount of attention paid to female criminal behavior (Belknap, 1996, p. 37; also see Flowers, 1995, pp. 55-59). Adler and Simon developed the "liberation" theory to explain women's criminality—Adler hypothesized that the emancipation of women would increase their violent crime rates, whereas Simon forecast that the liberation of women would decrease their involvement in violent crimes and increase their participation in property crimes. As increased attention to women's criminality developed, discussions among criminologists emerged about how criminology had to be changed to adequately explain female criminality.

While criminological researchers offer varied opinions on revitalizing female criminality, most agree that such an undertaking demands a substantial amount of empirical research. There are encouraging signs that such a revitalized field of criminology is imminent. During the past 25 years, numerous research developments concerning female crime have emerged. Compelling ethnographic research on women and girls engaged in gangs, prostitution, and serving time in prison has appeared (Campbell, 1984; Miller, 2001; Carlen, 1985; Miller, 1986). Researchers are exploring the link between sexual abuse and female criminality (Chesney-Lind, 1989; Chesney Lind & Shelden, 1998; Gilfus, 1992; Widom, 1995; Belknap, 1996). The white-collar crimes of women are being differentiated from those of men (Daly, 1989). Feminist investigators have examined the linkages among race, class, and gender (Simpson, 1991; Simpson, 1995; Chilton & Datesman, 1987; Hill & Crawford, 1990; Chancer, 1998; Bush-Baskette, 1998).

Although such research provided the groundwork for a revitalized field of female criminality, additional research could provide a gender-based view of criminogenesis that stresses how the life trajectories leading into criminality differ for men and women. For example, it is often the victimization of a woman that leads her into criminal behavior. Joycelyn Pollack (1995, p. 19) connects women's victimization to their criminality when she notes that "[w]omen who killed spouses ... had routinely and systematically [been] beaten ... over a number of years [and] have been punished with convictions and prison sentences, even [in instances when] ... the attack came during or immediately after an attack by husbands."

Studies of Incarcerated Females

There are two categories of prior studies about women in prison. The first category examines inmates' responses to imprisonment and relies upon two conceptual models—Sykes's functionalist or deprivation model (1958/1965; also see Sykes & Messinger, 1960) and the importation model (Irwin and Cressey, 1960; Irwin, 1970). The deprivation model interprets inmates' behaviors as arising from the deprivations of imprisonment (Kruttschmitt, Garner, & Miller, 2000, p. 681), while the importation model views inmates' adaptations to imprisonment as emanating from their pre-prison experiences.

The second category of studies examines life histories and social backgrounds of female inmates to understand female criminality (Gilfus, 1987, 1992; Chesney-Lind & Shelden, 1998; Girschick, 1999).

Gilfus (1987, 1992) found that imprisoned women often resort to running away, then prostitution, selling drugs, and using illegal drugs to cope with early sexual and physical abuse. Chesney-Lind and Shelden (1998) contend that female juvenile offenders' survival strategies are being criminalized. Girschick's (1999) discovered that the early lives of female inmates are often chaotic—they experience physical and sexual abuse and come from families in which there is a significant amount of substance abuse and contact with the criminal justice system (viz. 64% of the women of color had incarcerated family members). The study reported in this paper does what Girschick (1999, p. 52) advises: it looks at the context of imprisoned women's lives to understand their criminality.

Theoretical Frameworks Employed in the Study

The three theoretical frameworks employed in this study are: Agnew's Extended Strain Theory/General Strain Theory, Differential Association Theory, and Social Control Theory. My rationale for selecting these three theories is they are some of the most dominant and empirically tested theories in criminology (Agnew, 1995, p. 363). According to Agnew (1995, p. 363), extensive empirical testing of criminogenesis theories has "produced a rough consensus regarding the relative merit of the various crime theories. Learning and control theories dominate the field, followed by strain theory." A discussion of the theoretical frameworks used in the study follows.

Agnew's Extended Strain/GST Theory-Agnew's extended strain or general strain theory (GST)—identifies three sources of strain: "Other individuals may (1) prevent one from achieving positively valued goals, (2) remove or threaten to remove positively valued stimuli that one possesses, or (3) prevent or threaten to present one with noxious or negatively valued stimuli" (Agnew, 1992, p. 187; also see Agnew, 1994). The strain Agnew references "creates pressure for corrective action with delinquency being one possible response" (Agnew, 1995, p. 116; Brezina, 1996). Agnew's essential insight is "that if you treat people badly, they might get mad and engage in delinquency" (Agnew, 1995, pp. 43, 132).

Differential Association Theory—Sutherland (1947) emphasizes preference for crime is learned through social interaction and "a person becomes delinquent because of an excess of definitions favorable to violations of the law over definitions unfavorable to violation of law" (p. 6). Differential Association Theory claims that "definitions presented more frequently, for a longer time of exposure, earlier in life

and from either a more prestigious source or a more intense relationship, receive more weight in the differential association process" (Matsueda, 1988, p. 281; Matsueda, 1982; see Sutherland, 1973, p. 40).

Social Control Theory—Hirschi (1969, p. 16) proposes delinquency occurs when a person's bond to society is weakened or broken. There are four aspects that make up the social bond: 1) attachment (sensitivity to others' opinions); 2) commitment (conformity to conventional rules); 3) involvement in conventional legitimate activities; and 4) belief in the righteousness of obeying society's rules (Hirschi, 1969). Social control theorists argue that involvement in conventional activities provides less time to engage in criminality (Alarid, Burton, Jr., & Cullen, 2000; Agnew, 1985; Johnson, 1979; Rosenbaum, 1987). Sampson and Laub (1993, p. 141; also see Cook, 1975) believe "regardless of delinquent background, [adults] will be inhibited from committing crime to the extent that they have social capital invested in their work and family lives..."

RESEARCH DESIGN

Study and Data

The impetus for this study came from investigating a set of data collected by Dr. Mary Gilfus from women incarcerated at a maximumsecurity facility in Massachusetts. Gilfus (1987) explored the incidence of sexual and physical abuse in the lives of imprisoned women by administering a ten-page questionnaire to small groups of newly sentenced inmates. Although her investigation was not designed to test theories of criminology, the questionnaire she used incorporated measures that could be used to operationalize two existing criminological theories—Agnew's Extended Strain Theory and Hirschi's 1969 Social Control Theory.

I self-consciously decided to use and build upon Gilfus's data. I obtained a new data set from women incarcerated in Kansas to test not only Agnew and Hirschi's theories, but also Sutherland's Differential Association Theory.

Gilfus's Study—Gilfus (1992) administered her questionnaire to volunteer subjects at the MCI-Framingham inmate population during orientation and drug-education meetings held from July 1986—March 1987. In order to utilize Gilfus's data in my study, I acquired an SPSS portable data file from Harvard University's Murray Research Center, which contained information from Gilfus's 96 completed questionnaires. In the fall of 2000 and early 2001, Gilfus's quantitative data were coded into variables representing two tradi-

tional theories of criminogenesis: Extended Strain Theory and Social Control Theory. Sutherland's Differential Association Theory could not be tested with Dr. Gilfus's data since there were no specific questions in her survey that were related to this theory.

The New Study at The Topeka Correctional Facility—To assess whether existing theories of criminogenesis (Agnew's Extended Strain Theory, Differential Association Theory, and Social Control Theory) can account for female criminality, the researchers administered a modified version of Dr. Gilfus's survey to a random sample of inmates at the Topeka Correctional Facility (TCF). Once inmates had signed a consent form approved by the University of Kansas's Advisory Committee on Human Experimentation, they completed a paper-and-pencil questionnaire.

Over a three-day span (August 20–22, 2001), the research team (the author and two psychology graduate students) surveyed inmates in eight group sessions: one minimum-level security survey group, five medium-level security groups, and two maximum-level security groups (see Table 1 below).

Table 1
Breakdown of Participants by Security Level

Security Level	Total Inmates Incarcerated by Level N (%)	Study Participants by Level N (%)	Refusals by Level N (%)
Minimum	275 (53.8)		
Group 1		23 (18.7)	1 (2.4)
Medium	162 (31.7)		
Group 1		10	6
Group 2		21	13
Group 3		16	11
Group 4		11	0
Group 5		26	4
Total		84 (68.3)	34 (27.6)
Maximum 74	(14.5)		
Group 1		14	7
Group 2		2	0
Total		16 (13.0)	7 (16.7)
Grand Total	511 (100)	123 (100)	42 (100)

*35 no-shows

Out of the entire group of 200 women randomly selected to partici-
pate in the study, a total of 120 usable questionnaires were completed.
This constitutes an overall response rate of 60%. There is no reason to
assume that the 40% of inmates who refused to complete the survey
were vastly different from those who completed the survey. The only
observations that could be made about those who refused to com-
plete the survey were that they seemed to be more impatient and
expressed more concern about signing the consent form.

Sample Characteristics

Table 2 compares the Gilfus's sample with the Topeka Correctional
Facility sample in terms of such categories as age, race, marital status,
etc.

Table 2
A Comparison of the Samples

Demographic Variable	Gilfus' Sample (N=96)	Topeka Sample (N=120)
Ethnic Background		
White	63 (65.6%)	55 (45.8%)
African American	18 (18.8%)	31 (25.8%)
American Indian	Not reported	8 (6.7%)
Hispanic	10 (10.4%)	4 (3.3%)
Multi-Racial/Other	5 (5.2%)	15 (12.5%)
Marital Status		
Married	14 (14.6%)	15 (12.5%)
Common Law/Live In	21 (21.9%)	28 (23.3%)
Separated	18 (18.8%)	17 (14.2%)
Divorced	8 (8.3%)	29 (24.2%)
Single	33 (34.4%)	25 (20.8%)
Widowed	2 (2.1%)	5 (4.2%)
Education Level		
College Graduate	2 (2.1%)	5 (4.2%)
Some College	18 (18.8%)	37 (30.8%)
High School Diploma/GED	32 (33.3%)	64 (53.3%)
Some High School	32 (33.3%)	11 (9.2%)
Some Grade School	10 (10.4%)	3 (2.5%)

Offense Classification

Level 1 - Class C Misdemeanor (Assault, Parole Violation)	8 (8.3%)	3 (2.5%)
Level 2 - Class B Non-Person Felony (Prostitution, DUI)	20 (20.8%)	34 (28.3%)
Level 3 (Minor Drug, Stealing)	10 (10.4%)	49 (40.8%)
Level 4 - Non-Person Felony (Aggravated Assault, Burglary)	45 (46.9%)	30 (25.0%)
Level 5 - Person Felony (Major Drug, Homicide)	12 (12.5%)	30 (25.0%
Presence of Physical Health Problem	22 (22.9%)	42 (35.0%)
Presence of Mental Health Problem	20 (20.8%)	38 (31.7%)
Presence of Eating Disorder	29 (30.2%)	26 (21.7%)

Age

Low	17	18
High	48	62
Mean	29.0	36.2
Standard Deviation	6.7	8.5

Dependent Variables

Three dependent variables were measured in this study: the level of criminality, the self-perceived health status of the inmate prior to incarceration, and the self-perceived health status of the inmate while incarcerated. The level of criminality of the inmate was measured by an aggregate criminality score based on the level of her most serious offense based on the Kansas Code, the number of times the inmate tried to run away, her involvement in prostitution, her involvement in stealing, and her involvement in substance abuse.

Independent Variables

The Variable Construct Extended Strain—Agnew (1992) advocates employing a composite index of strain in studies of strain theory. Therefore, a total extended strain score was tabulated for each

respondent, considering the following strains: living with substance abusers; having family members with a history of incarceration; whether or not the inmate was severely punished as a child; the number of people who severely punished the inmate as a child; whether parents engaged in physical violence; whether the inmate was sexually abused; age when sexual abuse started; the number of situations in which someone tried to or succeeded in raping the inmate; whether or not the inmate was involved in relationships where physical violence occurred; and the number of physically violent abusers the inmate has encountered.

The Variable Construct Differential Association—Since tests of Differential Association theory are aimed at determining the exposure an individual has to people who hold favorable estimations of violating the law, the total differential association score for each respondent was tabulated based on time spent with individuals within the inmate's primary group who have done something within the last 12 months for which they could have been arrested (Alarid et al., 2000).

The Variable Construct Social Control—A total social control score was tabulated for respondents based on: marital or partner attachment, since Sampson and Laub (1993) believe such attachments insulate people from antisocial activities; the number of children the inmate has; the type of family environment in which the inmate was raised—the range for this category includes being reared in foster homes to being raised by both parents; whether the inmate was bounced from one situation to another as a child; the number of siblings the inmate lived with; and the inmate's work status, ranging from never having had a job to having always worked or considering herself a full-time mother.

The inmate's social control score also considered her belief in the righteousness of obeying society's rules. New respondents in Kansas were asked to respond (coding: do not agree = 2; agree somewhat = 1; agree fully = 0) to three statements. Statement #1 is "Sometimes you just don't have any choice but to break the law" (Krohn, Lanza-Kaduce, & Akers, 1984). Statement # 2 is "If someone insulted me, I would be likely to hit or slap them (Burton, 1991). Statement #3 is "If breaking the law really doesn't hurt anyone, and you can make a quick buck doing it, then it's really not all that wrong" (Burton, 1991).

The Variable Construct Social Structural Influences—According to Sampson and Laub (1993), social structural influences strongly affect family and school social control mechanisms. Therefore, in

this study negative social structural influences were measured as an independent variable construct. The subject's social structural influence score was calculated by taking into account: her race and ethnic background; age when she had her first child; age when she began to support herself; her family's financial situation; and her education.

The Level of Health Care Received Prior to and During Imprisonment—Each respondent in this study was asked to rate the level of health care services she received prior to and during it (coding: excellent = 0; very good = 1; good = 2; fair = 3; poor = 4).

Hypotheses

I hypothesized that the level of criminality of female inmates in Kansas would be significantly predicted by four construct variables (extended strain, differential association, social control, and social structural influences). I also hypothesized that the dependent variables #2 (the self-perceived health status of the inmate prior to incarceration) and #3 (the self-perceived health status of the inmate after having served part of her sentence) would be predicted directly by three variable constructs.

Analysis of the Data Concerning Female Criminality

Since Liu and Kaplan (1999, p. 200) point out that deviance and many of its correlates tend to depart from a normal statistical distribution, the dependent constructs were checked for normality. Once the dependent constructs were found to be normally distributed, Gilfus's data and my own were analyzed by using regression procedures.

Descriptive Statistics Gilfus's Sample

Table 3 shows the means and standard deviations of the dependent measure of level of criminality and the three independent constructs, as well as the bivariate correlations among these constructs for Gilfus's sample. Both extended strain and social structure are correlated with level of criminality at the .05 level, and social control is correlated with level of criminality at the .01 level. Thus, the inmates with higher levels of strain due to a history of sexual and physical victimization, impoverished socioeconomic backgrounds, or weaker social bonds and supports were more likely to have higher levels of criminality.

Table 3
Means, Standard Deviations, and Correlations

Bivariate Correlations

Construct	Mean	Standard Deviation	Criminality	Extended Strain	Social Control	Social Structure
Criminality (N = 83)	7.0	1.9	—			
Extended Strain[b] (N=71)	8.0	5.5	.25*	—		
Social Control[c] (N = 93)	8.8	3.4	-.33**	-.29*	—	
Social Structure[d] (N = 85)	6.5	3.2	.25*	.27*	-.14	—

*significant at p < .05, ** p < .01
[a] maximum possible = 14, [b] = 39, [c] = 21, [d] = 16

Topeka Sample

The means and standard deviations of the dependent measure of level of criminality and the four independent constructs, as well as the bivariate correlations, are presented in Table 4. Only two of the independent constructs are significantly correlated with level of criminality—extended strain at the .01 level and differential association at the .05 level. Thus, the inmates with higher levels of strain due to a history of sexual and physical victimization were more likely to have high levels of criminality. In addition, inmates with more friends who engaged in unlawful acts, as well as those who reported spending more hours per week with such friends, were more likely to have higher levels of criminality.

Table 4
Means, Standard Deviations, and Correlations

Bivariate Correlations

Construct	Mean	SD	Criminality	Extended Strain	Social Control	Social Structure	Differential Association
Criminality[a] (N = 114)	7.2	1.5	—				
Extended Strain[b] (N=99)	9.3	6.6	.30*	—			
Social Control[c] (N = 114)	16.5	3.0	-.15	-.04	—		
Social Structure[d] (N = 109)	6.1	2.9	-.09	.31**	-.13	—	
Differential Association[e] (N = 100)	4.2	3.0	.22*	.18	-.28**	.05	—

*significant at $p < .05$, ** $p < .01$
[a] maximum possible = 14, [b] = 39, [c] = 27, [d] = 16, [e] = 10

Multiple Regression Results

Gilfus's Sample

Following the bivariate analysis, a series of regression analyses were conducted to examine the relationships between the three predictor constructs (extended strain, social control, and social structure) and level of criminality. Table 5 shows the parameters for the various models. Models were developed adding each highest-correlated independent construct with criminality sequentially. The full model (Model 3) tested initially was not significant, $F(3,52) = 2.6$, MSE = 3.3, $p = .066$, R2 = .128, and none of the constructs contributed significantly to the model predicting the level of criminality. Models were then developed sequentially based on how highly each independent construct was correlated with level of criminality. As seen in Table 5 (Models 2a, 2b, & 3, respectively), when starting with social control, neither extended strain nor social structure, nor a combination thereof, results in a significant improvement to the model. Therefore, within this limited sample the best-fit model of predicting level of criminality is social control (Model 1a). However, the single-pre-

dictor model of extended strain (Model 1b) predicted the level of criminality comparably well.

Table 5
Parameters for Models Tested

Model	R^2	Constructs	Beta	Significance	Semi-Partial Correlations
1a	.094	(Constant)		<.001	
		Social Control	-.306	.022	-.306
1b	.090	(Constant)		<.001	
		Extended Strain	.300	.003	.300
2a	.128	(Constant)		<.001	
		Social Control	-.242	.080	-.229
		Extended Strain	.196	.154	.186
2b	.148	(Constant)		<.001	
		Social Control	-.312	.006	-.308
		Social Structure	.176	.118	.173
3	.128	(Constant)		<.001	
		Social Control	-.242	.084	-.228
		Extended Strain	.195	.178	.177
		Social Structure	.005	.971	.005

Topeka Sample

Following the bivariate analysis, a series of regression analyses were conducted to examine the relationships between the four predictor constructs (extended strain, social control, social structure, and differential association) and level of criminality. Table 6 shows the parameters for the various models.

Table 6
Parameters for Models Tested

Model	R^2	Constructs	Beta	Significance	Semi-Partial Correlations
1	.094	(Constant)		<.001	
		Extended Strain	-.301	.009	-.301
2a	.132	(Constant)		<.001	
		Extended Strain	.300	.003	.300
		Differential Association	.190	.099	.186

2b	**.117**	(Constant)		<.001	
		Extended Strain	.261	.024	.255
		Social Control	-.135	.182	-.135
2c	**.133**	(Constant)		<.001	
		Extended Strain	.387	.001	.357
		Social Control	-.223	.147	-.206
3	**.149**	(Constant)		<.001	
		Extended Strain	.257	.026	.252
		Differential Association	.147	.221	.137
		Social Control	-.136	.249	-.129
4	**.216**	(Constant)		<.001	
		Extended Strain	.412	.002	.352
		Differential Association	.106	.363	.098
		Social Control	-.162	.157	-.152
		Social Structure	-.313	.013	-.272

In order to test my hypothesis that level of criminality found in TCF's female inmates would be predicted by all four constructs, the full model (Model 4) including all four predictor constructs was tested initially. The full model does significantly predict level of criminality, $F(4,69) = 4.7$, MSE = 2.0, p = .002, $R2 = .216$. Therefore, when all independent constructs are incorporated into a full regression equation, the model explains approximately 22% of the variance in criminality. However, only two of the theoretical constructs, extended strain and social structure, contributed significantly to the model, as shown in Table 5.

Therefore, a series of nested model comparisons were conducted to further examine the relationships between the independent constructs and level of criminality. The single-predictor model of extended strain (Model 1) was significant, $F(1,77) = 8.0$, MSE = 2.2, p = .006, $R2 = .094$. Adding differential association to the single-predictor model (Model 2a) did not result in a significant improvement in explaining the variability in level of criminality, $F(1,76) = 3.4$, p = .070, R2change = .039. In the same way, adding social control to the single-predictor model of extended strain (Model 2b) also did not result in a significant improvement in explaining the variability in level of criminality, $F(1,88) = 1.8$, p = .182, R2change = .018. However, adding social structure to the single-predictor model of extended strain (Model 2c) did result in a significant improvement

to the single-predictor model, $F(1,83) = 4.1$, $p = .047$, R2change = .042. Finally, the two-predictor model of extended strain and social structure (Model 2c) was compared to the full four-predictor model (Model 4). The full model was not significantly better than the reduced model, $F(2,69) = 2.1$, $p = .134$, R2change = .047. It is interesting to note that social structure appears to be acting as a suppressor of extended strain, since the semi-partial correlation obtained for extended strain increases once social structure is introduced into the model. In other words, the relationship between extended strain and level of criminality becomes stronger once social structural influences are controlled. It will be beneficial to see if this finding is replicated in future research.

Post-Hoc Analyses of Interest

A closer examination of the individual items that measure the construct extended strain reveals that the number of incest abusers, the number of physically violent relationships as an adult, an early age of sexual abuse, and the number of rape situations were all significantly positively correlated with the dependent measure of level of criminality ($r = .37$ to $.23$). Inmates who had more incest abusers, were sexually abused at an earlier age, had been exposed to a higher number of rape situations, or had more physically violent relationships as adults would be predicted to have higher levels of criminality.

Summary of Major Findings

A series of regression analyses of Gilfus's sample revealed that both extended strain and social control were significantly correlated with level of criminality; however, the best-fit model of level of criminality could only incorporate one of the two. For the Topeka sample, extended strain and differential association were correlated with level of criminality, but the best-fit model included only extended strain and social structure.

Summary and Discussion

Theoretical Implications

Constructs representing two traditional theories of criminogenesis (Agnew's Extended Strain or General Strain Theory and Hirschi's 1969 Control Theory), as well as deleterious social structural influences, were tested on a sample of 96 women interviewed by Dr. Mary

Gilfus in 1986 and 1987 at the Massachusetts Correctional Institution at Framingham. Multiple regression analyses carried out using Gilfus's data showed the construct representing Agnew's Extended Strain Theory, deleterious social structural influences, and the construct representing Hirschi's 1969 Social Control Theory each significantly predicted levels of criminality, but none of the constructs were able to be combined to improve the prediction of the level of criminality.

Constructs representing three traditional theories of criminogenesis (Agnew's Extended Strain or General Strain Theory, Sutherland's Differential Association, and Hirschi's 1969 Social Control Theory), as well as deleterious social structural influences (e.g. low income), were tested on a new sample of 120 female inmates at the Topeka Correctional Facility in August of 2001. As expected, all four predictor constructs mentioned above were able to predict the level of criminality of these women. Together, they accounted for 22% of the variance found in level of criminality. Neither social control nor differential association contributed to the model. Extended strain and deleterious social structural influences together accounted for 13% of the variance in the level of criminality. An unanticipated finding was that the combination of the constructs representing extended strain and deleterious social structural influences (in a regression equation) were the best predictors of the level of criminality of the inmates.

Since the construct representing Agnew's Extended Strain Theory was a significant predictor of level of criminality, even when it was not paired with the construct of deleterious social structural influences, the findings obtained from analyzing data from the Topeka sample are somewhat similar to the findings reported from carrying out regression analyses on Gilfus's data. Thus, the extended strain construct was a significant predictor of level of criminality in both samples, but while deleterious social structural influences added to the prediction of extended strain in the Topeka sample, this was not found in the data from Gilfus's sample. Analyses conducted on both sets of data on imprisoned women suggest that some of the ideas contained in Agnew's Extended Strain Theory may offer insights into female criminality and that further research is warranted into this theory's ability to explain more serious female offending.

One interesting finding, which requires future investigation, was that when the construct of extended strain was joined with the construct deleterious social structural influences to predict level of criminality, the construct deleterious social structural influences

appeared to act as a suppressor. Future research is needed to disentangle how deleterious social structural influences operate in relation to the construct representing Agnew's Extended Strain Theory. Another unexpected finding was that neither the construct representing Sutherland's Differential Association Theory nor the construct representing Hirschi's 1969 Social Control Theory added to the prediction of the level of criminality for the women at the Topeka Correctional Facility.

As other researchers have pointed out (Matsueda, 1988, pp. 284—287; LaGrange & Silverman, 1999, pp. 47—50), it is not an easy task to operationalize complex theories of criminogenesis. Therefore, extending this research might involve reformulating the constructs representing the traditional theories being tested to ensure they adequately represent the ideas and premises of the traditional theories being tested. It may be that some additional items need to be incorporated into the modified constructs representing these traditional theories of criminogenesis in order to enhance their content validity when they are tested in the future on imprisoned women. Extending this research effort also might involve testing other traditional theories of criminogenesis on imprisoned women, such as social learning theories or conflict theories.

Modifying Extended Strain Theory

In analyzing the data from the Topeka sample, I examined the construct of extended strain, which was able to significantly predict the level of criminality of the inmates surveyed. Certain items incorporated within the construct of extended strain merit some discussion. Several factors, which collectively describe a woman's level of sexual and physical victimization, are positively correlated with her level of criminality. The range of correlation of these items with level of criminality is between .23 and .37. There appears to be an association between the sexual and physical victimization of women and their subsequent level of criminality. Extending this research might involve developing a version of extended strain theory, which elaborates on the nexus that exists between sexual and physical victimization and subsequent female criminality. This modified extended strain theory would be used to determine how sexual and physical victimization propels some women into risky behavior and criminal activity. It may be that engaging in criminality helps some women to cope with the sense of powerlessness they experienced as a result of being victimized sexually and physically.

The notion that exposure to sexual victimization, particularly prior to adulthood, predisposes women to becoming engaged in criminality was corroborated in anecdotal comments made by staff at the Topeka Correctional Facility. Staff at the prison observed that many of the inmates at the prison have a history of being sexually assaulted. The prison has developed a therapeutic program for inmates who were sexually abused prior to adulthood. However, the therapeutic program may need to be expanded to incorporate many more of the inmates, as so many of them have histories of being sexually victimized prior to adulthood.

Data from the 120 inmates at the Topeka Correctional Facility revealed that 67.9% of the inmates had been involved in rape situations. While only some of the respondents could remember the age or were willing to report when their sexual abuse began, 43% of the respondents reported they were sexually abused prior to reaching adulthood. These findings are consistent with those of Chesney-Lind and Shelden (1998), Gilfus (1992), Widom (1995), Pollack (1995), and Belknap (1996), who all discovered that there is a strong linkage between the victimization of women and their subsequent criminality. These researchers all stress that the life trajectories leading into criminality differ for men and women. Data analyses in this study disclosed that there was a significant relationship between the strains associated with being sexually and physically abused and subsequent criminal behavior.

Implications for a More Gender-Conscious Criminology

The results of this study revealed that two existing theories of criminogenesis were pertinent to understanding the level of criminality found in imprisoned women. Therefore, a more gender-conscious criminology needs to incorporate the ideas contained within existing theories of criminogenesis, which have been historically utilized to predict male criminality. The findings of this study suggest that such theories require revisions in order to consider the life experiences of disadvantaged women—particularly how their sexual and physical victimization leads to their breaking the law. What appears to be happening within American society is a penalization of economically marginalized women (those who are young, single, and from minority groups) who were simply trying to escape from or cope with their own victimization.

A significant proportion of the respondents from the Topeka Correctional Facility claimed they were imprisoned due to the abuse

and sale of illegal drugs. It is certainly possible that their sexual victimization led them into "criminality." A more gender-conscious criminology needs to look more closely at how our society penalizes and labels female criminals who are using illegal substances as an escape from the painful life experiences of victimization.

Schur (1984, p. 192) provides insight into why women who are abused and simply trying to escape their victimization are criminalized. Schur (p. 238) believes that the "deviance" of women must be considered within society's "broader gender system context," where there is a "close relation between the widespread labeling of women and the failure to adequately stigmatize and punish male offenses against women" (p. 239).

Schur (1984) identifies certain aspects of the present gender system that need to be considered in developing a more gender-conscious criminology. One aspect of the present gender system is that the socialization and social conditions that lead women to choose crime, such as shoplifting and prostitution, are considered to be gender "appropriate" for women (Schur, 1984, pp.192, 220-221). This study provides evidence that the majority of serious female offenders engage in a genre of crimes that are considered to be "feminine" offenses, such as forgery and drug-related crimes. These findings contradict Adler's (1975) prediction that as women become more "liberated" and gain access to education and employment opportunities, the crimes they commit will become more violent and aggressive.

Another aspect of the present gender system that Schur (1984) discusses is the fact that in our society, men are socialized into a broader system of male control. Schur (p. 148) asserts that men are expected to

> act aggressively if they are to "get" sex from women. This outlook is notable for the lack of mutuality it implies. It is upheld in the all-male subculture, within which boasting of sexual exploits remains a staple item of conversation. It is also evident in some of the terminology used by males to describe their sexual activity: "making out," "scoring," and getting women to "put out."

As long as men are socialized to assume an aggressive stance, women will be vulnerable to sexual and physical abuse. As a result, some of these victimized females will resort to criminal activities. Thus, a more gender-sensitive criminology should acknowledge that it is often the persistent subordination and devaluation of women and

"womanhood itself" (Schur, 1984, p. 235) that fosters both male and female criminality.

Applications for Improving Women's Life in Prison

The findings of this study have important implications for effectively managing and helping women in prison. The high level of sexual and physical victimization found in the two samples of imprisoned women may require that prison managers reevaluate how they deal with female inmates. Kruttschnitt, Gartner, and Miller (2000) suggest that the kind of institutional environment personnel create in prisons can either increase or ease the "pains of imprisonment" inmates may encounter in prison. According to these researchers, women tend to fare better in prisons when the prison is operated according to "elements of the maternal, therapeutic model of women's corrections of the past" (Kruttschnitt, Garner, & Miller, 2000, pp. 711-713) and worse in the type of modern-day prisons that stress efficient management and control of inmates.

It seems to me, in view of the pervasive victimization of incarcerated females, that a more nurturing and empowering approach to female inmates may be required to help them overcome their previous victimization and to prevent them from engaging in future criminality. Covington and Bloom (1999) advocate that those working with female offenders should understand that recovery cannot take place in isolation. Thus, correctional personnel working with women must interact with them in an especially supportive way. This means that "nonmutual, nonemphatic, disempowering and unsafe settings" (Covington and Bloom, 1999, p. 16) need to be avoided in order to enhance the recovery of female offenders. Anecdotal information provided to the researchers supports the notion that correctional personnel need to interact with females in a more supportive and empowering way.

Inmates at the Topeka Correctional Facility who were placed in a therapeutic unit to help with long-standing drug and alcohol problems reported that being in a more supportive environment helped them to cope with their interpersonal difficulties and better themselves.

The difference between inmates housed in the therapeutic environment and in other medium-security level units was apparent to the researchers. In the therapeutic unit of the medium-security level inmates were observably more cooperative when approached about participating in the study reported in this paper. It was the researchers' impression that inmates housed in the therapeutic unit,

which was designed to be more supportive and nurturing than other medium-level security units, were more cooperative, approachable, and positive about "doing time" than inmates from more-regimented and less-rehabilitation-oriented units.

Summary and Conclusions

It was my contention that past theories of criminogenesis incorporated elements which could be utilized to account for female offending, especially more serious offending. Therefore, this study tested three well-respected theories of criminogenesis (Agnew's Extended Strain or General Strain Theory, Sutherland's Differential Association Theory, and Hirschi's 1969 Social Control Theory) on two sets of data obtained from two cohorts of female inmates incarcerated fourteen years apart. The results of multiple regression analyses conducted on Gilfus's data suggest a relationship exists between the constructs representing two of the traditional theories of criminogenesis and serious female criminality. The constructs representing Hirschi's 1969 Social Control Theory and Agnew's Extended Strain or General Strain Theory were found to be related significantly to the level of criminality of the subjects surveyed by Gilfus. One might speculate that the construct representing Hirschi's Social Control Theory was only found to be a significant predictor of female criminality for Gilfus's sample since her participants were younger and would have been more apt to be deterred from engaging in criminal behavior by parents. There is some evidence to support this assumption in Gilfus's data since attachment to parents was found to be significantly and negatively correlated with level of criminality.

In testing the Topeka sample, I reformulated the construct representing Agnew's Extended Strain theory so it included items representing the inmates' belief in the righteousness of obeying society's rules. Therefore, I have greater confidence in the results obtained from the Topeka sample. These results indicate that of the three traditional theories of criminogenesis tested, the construct representing Agnew's Extended Strain Theory was the best traditional theory for predicting female criminality. Agnew (1992) believes that participation in crime functions as a way of dealing with negative social relations and their consequent psychological states, such as anger and frustration (Agnew 1995, p. 113). This study suggests strains associated with a particular form of negative social relations—sexual and physical abuse—may influence women to engage in serious criminality and to ultimately establish their criminal careers.

NOTE

This research was supported in part by funds given by the Jeanne Humphrey Block Dissertation Award Program for research at the Henry A. Murray Research Center of the Radcliffe Institute for Advanced Study at Harvard University.

REFERENCES

Adler, F. (1975). Sisters in Crime: The Rise of the New Female Criminal. New York: McGraw-Hill.

Agnew, A. (1985). "Social Control Theory and Delinquency: A Longitudinal Test." Criminology, 23, 47-61.

Agnew, R. (1992). "Foundation for a General Strain Theory of Crime and Delinquency." Criminology, 30, 47-87.

Agnew, R. (1994). "The Techniques of Neutralization and Violence." Criminology, 32, 555-580.

Agnew, R. (1995). "Testing the Leading Crime Theories: An Alternative Strategy Focusing on Motivational Processes." Journal of Research in Crime and Delinquency, 32, 363-398.

Agnew, R., & White, H.R. (1992). "An Empirical Test of General Strain Theory." Criminology, 30, 475-499.

Alarid, L.F. (1997). "Female Inmate Subcultures." In J.W. Marquart and J.R. Sorensen (Eds.), Correctional Contexts: Contemporary and Classical Readings. Los Angeles: Roxbury Publishing Company.

Alarid, L.F., Burton, Jr., V.S., & Cullen, F.T. (2000). "Gender and Crime Among Felony Offenders: Assessing the Generality of Social Control and Differential Association Theories." Journal of Research in Crime and Delinquency, 37, 171-199.

Belknap, J. (1996). The Invisible Women: Gender, Crime and Justice. Belmont, CA: Wadsworth Publishing Inc.

Brezina, T. (1996). "Adapting to Strain: An Examination of Delinquent Coping Responses." Criminology, 34, 39-60.

Burton, Jr., V.S. (1991). "Explaining Adult Criminality: Testing Strain, Differential Association, and Control Theories." PhD dissertation, University of Cincinnati.

Bush-Baskette, S. (1998). "The War on Drugs as a War Against Black Women." In Susan L. Miller (Ed.), Crime Control, and Women: Feminist Implications of Criminal Justice Policy (pp. 113-129). Thousand Oaks, CA: Sage Publications.

Campbell, A. (1984). The Girls in the Gang. New York: Basil Blackwell.

Carlen, P. (1985). Criminal Women. Cambridge: Polity Press.

Chancer, L.S. (1998). "Gender, Class, and Race in Three High-Profile Crimes: The Cases of New Bedford, Central Park, and Bensonhurst." In Susan L. Miller (Ed.), Crime Control, and Women: Feminist Implication

of Criminal Justice Policy (pp. 72-94). Thousand Oaks, CA: Sage Publications.

Chesney-Lind, M. (1989). "Girls' Crime and Woman's Place: Toward a Feminist Model of Female Delinquency." Crime and Delinquency, 34, 150-168.

Chesney-Lind, M., & Shelden, R.G. (1998). Girls, Delinquency, and Juvenile Justice. (2nd Ed.) Belmont, CA: Wadsworth Publishing Inc.

Chilton, R., & Datesman, S.K. (1987). "Gender, Race, and Crime: An Analysis of Urban Arrest Trends, 1960-1980." Gender and Society, (June) 1, 152-171.

Cook, P.J. (1975). "The Correctional Carrot: Better Jobs for Parolees." Policy Analysis, 1, 11-54.

Covington, S., & Bloom, B. (1999). "Gender-Responsive Programming and Evaluation for Women in the Criminal Justice System: A Shift from What Works? To What is the Work?" Unpublished paper presented at the 51st Annual Meeting of the American Society of Criminology, November.

Daly, K. (1989). "Gender and Varieties of White-Collar Crime." Criminology, 27, 769-793.

Davis, K. (1937). "The Sociology of Prostitution." American Sociological Review 2(5), 744-755. (October 1937).

Flowers, R. B. (1995). Female Crime, Criminals and Cellmates: An Exploration of Female Criminality and Delinquency. Jefferson, NC: McFarland & Company Inc.

Freud, S. (1933). New Introductory Lectures on Psychoanalysis. New York: Norton.

Gilfus, M. (1987). "Life Histories of Women in Prison." Paper presented at the Third National Family Violence Research Conference, University of New Hampshire.

Gilfus, M. (1992). "From Victims to Survivors to Offenders: Women's Routes of Entry and Immersion into Street Crime." Women and Criminal Justice, 4(1), 63 89.

Girschick, L.B. (1999). No Safe Haven: Stories of Women in Prison. Boston.

Hill, G.D., & Crawford, E.M. (1990). "Women, Race, and Crime." Criminology, 28, 601-623.

Hirschi, T. (1969). Causes of Delinquency. Berkeley: University of California Press.

Irwin, J. (1970). The Felon. Englewood Cliffs: Prentice Hall.

Irwin, J., & Cressey, D. (1962). "Thieves, Convicts, and the Inmate Culture. Social Problems, 10, 142-155.

Johnson, R. (1979). Juvenile Delinquency and Its Origins: An Integrated Theoretical Approach. New York: Cambridge University Press.

Klein, D. (1995). "Afterword: Twenty Years Ago Today." In B.R. Price & N. J. Sokoloff (Eds.), The Criminal Justice System and Women: Offenders, Victims, and Workers (pp. 47-53) (2nd Ed.). New York: McGraw-Hill, Inc.

Krohn, M., Lanza-Kaduce, L., & Akers, R. (1984). "Community Context and Theories of Deviant Behavior: An Examination of Social Learning and

Social Bonding Theories." The Sociological Quarterly, 25, 353-71.

Kruttschnitt, C., Gartner, R., & Miller, A. (2000). "Doing Her Own Time? Women's Responses to Prison in the Context of the Old and the New Penology." Criminology, 38(3), 681-717.

LaGrange, T.C., & Silverman, R.A. (1999). "Low Self-control and Opportunity: Testing the General Theory of Crime as an Explanation for Gender Differences in Delinquency." Criminology, 37, 41-69.

Leonard, E.B. 1995. "Theoretical Criminology and Gender." In B.R. Price & N. J. Sokoloff (Eds.), The Criminal Justice System and Women: Offenders, Victims, and Workers (pp. 54-70) (2nd Ed.). New York: McGraw-Hill, Inc.

Liu, X., & Kaplan, H.B. (1999). "Explaining the Gender Difference in Adolescent Delinquent Behavior: A Longitudinal Test of Mediating Mechanisms." Criminology, 37(1), 195-215.

Lombroso, C. (1920). The Female Offender. New York: Appleton. Originally published in 1903.

Matsueda, R.L. (1982). "Testing Control Theory and Differential Association: A Causal Modeling Approach." American Sociological Review, 47, 489-504.

Matsueda, R. (1988). "The Current State of Differential Association Theory." Crime and Delinquency, 34, 277-306.

Merlo, A.V. (1995). "Female Criminality in the 1990s." In A.V. Merlo and J.M. Pollack (Eds.), Women, Law, & Social Control (pp.119-134). Needham Heights, MA: Allyn and Bacon.

Messerschmidt, J.W. (1993). Masculinities and Crime: Critique and Reconceptualization of Theory. Lanham, MD: Rowman & Littlefield.

Miller, E.M. (1986). Street Women. Philadelphia: Temple University Press.

Miller, J. (2001). One of the Guys: Girls, Gangs and Gender. New York: Oxford
University Press

Morris, A. (1987). Women, Crime and Criminal Justice. New York: Basil Blackwell Ltd.

Naffine, N., & Gale, F. (1989). "Testing the Nexus Crime, Gender, and Unemployment." British Journal of Criminology, 29, 144-156.

Paternoster, R., & Mazerolle, P. (1994). "General Strain Theory and Delinquency: A Replication and Extension." Journal of Research on Crime and Delinquency, 31, 235-263.

Pollack, J.M. (1995). "Gender, Justice, and Social Control: A Historical Perspective." In A.V. Merlo & J.M. Pollack (Eds.), Women, Law, & Social Control. 3-35. Needham Heights, MA: Allyn and Bacon.

Pollack, O. (1950). The Criminality of Women. Philadelphia: University of Pennsylvania Press.

Rosenbaum, J.L. (1987). "Social Control, Gender and Delinquency: An Analysis of Drug, Property and Violent Offenders." Justice Quarterly, 4, 117-132.

Sampson, R.J., & Laub, J.H. (1993). Crime in the Making. Cambridge, MA: Harvard University Press.

Schur, E.M. (1984). Labeling Women Deviant: Gender, Stigma and Social Control. New York: Random House.

Simon, R. (1975). Women and Crime. Lexington, MA: D. C. Heath.

Simpson, S.S. (1991). "Caste, Class and Violent Crimes: Explaining Differences in Female Offending." Criminology, 29, 605-631.

Simpson, S. (1995). "Doing Gender: Sorting Out the Caste and Crime Conundrum." Criminology, 3(1), 47-81.

Smart, C. (1977). Women, Crime and Criminology: A Feminist Critique. London: Routledge & Kegan Paul.

Smith, D., & Paternoster, R. (1987). "The Gender Gap in Theories of Deviance: Issues and Evidence." Journal of Research in Crime and Delinquency, 24, 140-172.

Sutherland, E.H. (1947). Principles of Criminology (4th Ed.). Philadelphia, PA: Lippincott.

Sykes, G.M. (1958/1965). The Society of Captives. New York: Atheneum.

Sykes, G.M., & Messinger, S.L. (1960). "The Inmate Social System." In R.A. Cloward, D.R. Cressey, G.H. Grosser et al. (Eds.), Theoretical Studies in Social Organization of the Prison (Pamphlet #15). New York: Social Science Research Council.

Thomas, W.I. (1923). The Unadjusted Girl. New York: Harper and Row.

Widom, C.S. (1995). Victims of Childhood Sexual Abuse—Later Criminal Consequences. Research in Brief. Washington: U.S. Government Printing Office, U.S. Department of Justice.

Janice Proctor is an associate professor of Sociology/Criminology at Ohio University. She earned a PhD in Sociology from University of Kansas in 2001. Her areas of interest include theoretical explanations for female criminality, studies of incarcerated women, the health care needs of imprisoned women, and scholarship of teaching and learning.

At the Prison-Community Boundary: The Women's Prison Association of New York City

Mark B. Borg, Jr. and Jennifer McCarroll

In an independent evaluation of the Women's Prison Association (WPA) written for the U.S. Department of Justice, Catherine Conly (1998) notes that:

> Women offenders who return to their communities from prison must often simultaneously comply with conditions of probation or parole, achieve financial stability, access health care, locate housing and commence the process of reuniting with their children and families. Setting priorities and accomplishing goals can seem overwhelming to someone who is confronted with so many tasks at once. Without strong support in the community to help them negotiate the rules and regulations of myriad public agencies, many women offenders quickly spiral back into a life of substance abuse, prostitution, and related crimes (p. 3).

We will use this statement as a starting point for describing how the WPA gives such community support to women who are transitioning from prison into local communities. We will show how the WPA functions as a community-building crime-prevention approach that is consistent with feminist community psychology and meets the criteria for a model program for working with female offenders.

Overview

Since 1980 the number of incarcerated women in state and federal prisons has increased fourfold (Gilliard & Beck, 1998). Much of the increase has been attributed to the national trend in sentencing drug offenders to prison instead of probation or treatment programs (Belknap, 2001; Van Wormer & Bartollas, 2000).[1] During the 1980s, the number of women arrested for drug violations more than tripled—twice the rate of increase for men (Bloom & Chesney-Lind, 2003; Greenfield & Minor-Harper, 1991). Today, the typical incarcerated woman is young, single, non-white, has children, has few job

skills, has little (if any) work experience, and has a significant sub-stance-abuse problem (Conly, 1998; Dittman, 2003).

The Women's Prison Association of New York City (WPA) is a nonprofit organization whose primary task is to create opportunities for change in the lives of women prisoners, ex-prisoners, and their families. It has been serving female offenders since 1844. Recent changes in the criminal justice system have had a direct impact on the WPA's ability to perform its primary task: to help women make the transition from prison back into their communities.[2]

Prevention

It is difficult to establish a direct connection between primary pre-vention and adult criminal behavior (Borg & Garrod, 2003), espe-cially women (Egley, 2002; Howell, 2003; Loeber & Farrington, 1999; Belknap, 2001). By the time most individuals are involved in the criminal justice system, prevention has already entered a secondary or tertiary stage. Community psychologist Martin Bloom (1996) defines primary prevention as a strategy to prevent predictable prob-lems related to criminal behavior, to protect healthy functioning, to promote desired goals in the physical and sociocultural settings of individuals and groups, and to "preclude, delay, or reduce" problem-atic events related to criminal behavior in at risk individuals or groups (p. 2).

The prevention focus of the criminal justice system is generally limited to the areas of recidivism and relapse into criminal behavior, primarily substance abuse. To develop and implement primary pre-vention techniques, the system must develop strategies that target criminogenic elements in communities with high numbers of women offenders, account for the intergenerational transmission of crime and criminal behavior, and purposefully aim at circumstances and antecedent behaviors associated with crime among women (Borg & Garrod, 2003).

Theoretical approaches to female adult criminal behavior pre-vention include those that focus on individuals, on communities, and on the prevention of specific crimes in specific areas. With the excep-tion of the third approach, there are few direct links between pre-vention and adult criminal behavior in the community psychology and primary prevention literature. Furthermore, even though femi-nist scholars such as Joanne Belknap, Roslyn Muraskin, and Meda Chesney-Lind have made important contributions in the area of women offenders, criminology, and the criminal justice system, the

topic of prevention of adult criminal behavior has been almost com-
pletely ignored in the fields of community psychology and primary
prevention (Borg & Garrod, 2003). While public health-based orga-
nizations have implemented some basic crime prevention strategies,
for the most part their approaches have not targeted adults, espe-
cially women (Tonry & Farrington, 1995). The controversial and his-
torically political nature of defining criminals and criminality, of how
our society essentially writes off women criminals, may have con-
tributed to the lack of relevant research and theory regarding pre-
vention of criminal behavior in women (Belknap, 2001; Foucault,
1975; Muraskin, 2003).

The two primary approaches to female crime prevention are
from public health and criminal justice perspectives. However, while
these are the only approaches that have been developed to address
female offending—basically by superimposing a male model upon
female offenders—neither of these two approaches takes into
account factors that are specific to women. The public health
approach views crime (or, more specifically, violence) as emerging
from a complex mix of causal systems that extend beyond an
offender's intentions, motivations, or characteristics. The most com-
mon interventions focus on the prevention of harm before it occurs
(Moore, 1995), but there is little in the way of empirical support for
this strategy (DeLeon-Granados, 1999). In contrast, the criminal jus-
tice approach generally intervenes only after crimes have been iden-
tified or when post-adjudication rehabilitation begins.

Current crime prevention strategies are rooted in: a) a public
health system that only indirectly attempts to prevent adult criminal
behavior by targeting specific age groups (children and adolescents)
and specific behaviors (usually violence); or b) a punitive, arrest-
and indictment-driven criminal justice system. As ex post facto
techniques, neither system addresses the current diversity of crimes,
criminals, and contexts; however, there are alternatives. In DeLeon-
Granados' (1999) words, community projects are often

> pursued with the best of intentions, and people [work] hard to
> build community and respond to crime. But even if such a project is
> given every opportunity to work, there is still a disturbing tension
> underlying it. It is a tension about division between race and class,
> about using community to oil the cogs of a punitive criminal justice
> system and about locking people away rather than forging new
> relations with one another as the most important problem-solving
> strategy (p. 149).

We believe the most promising strategies are those derived from and designed for specific communities. This belief is based on our assertion that an approach that empowers community members to address patterns and perceptions of isolation, inequality, and stagnation creates the best context for crime prevention. If crime is symptomatic of a society that does not adequately address the short- and long-term needs of its members, crime prevention must go beyond symptoms to a perception of crime as a reflection of a culture's mistreatment or neglect of some of its members. New paradigms must reflect the current diversity of crimes, criminals, and victims, as well as the contexts within which the three elements interact.

A community-building approach assumes that crime is one part of a community ecology consisting of economic, political, cultural, moral, symbolic, and spiritual variables (Benard, 1999; DeLeon-Granados, 1999; Kretzmann & McKnight, 1993; Mattessich & Monsey, 2001). According to this model, communities and representatives of the public health and criminal justice systems co-produce those factors that contribute to and reinforce criminal behavior. Community practitioners believe that the most effective solutions are indigenous, time- and place-specific, and the products of collaboration (Borg & Garrod, 2003; Price, Cowen, Lorion, & Ramos-McKay, 1988; Rappaport & Seidman, 2000).

If researchers and practitioners target aspects of community environments that contribute to crime, acknowledge the intergenerational transmission of criminal behavior, and establish interventions that target circumstances and antecedents, we believe it is possible to create effective intervention models for preventing crime among women. The WPA is an excellent example of that potential. In addition, we believe that the success of the WPA is also attributable to their fulfillment of a set of criteria for prisoner programs that incorporates both feminist community psychology thinking and a model program for prisoners. We will offer a justification for this thesis after describing the feminist community theories and model program for prisoners at hand.

Feminist Community Perspectives

The inclusion of a feminist perspective into the field of community psychology has led to a better understanding of the cultural images that have been identified with and incorporated into states of internal oppression (Borg & McCarroll, 2002). A core feature of a feminist community psychology approach to issues involving women in

the criminal justice system is a collaborative perspective based on
solutions rather than problems (Angelique & Culley, 2000; Gutier-
rez, 1991). There is also general agreement that such an approach
must acknowledge a race-gender-class interaction, what Chesney-
Lind (1997, p. 4) refers to as "multiple marginality," when analyzing
the experiences of women in the criminal justice system.

Much of the foundation of community psychology has parallels
with feminist principles (Bond, Hill, Mulvey, & Terenzio, 2000); both
emphasize the need to analyze social problems within social contexts.
Two important challenges are to avoid both "victim blaming" (result-
ing from viewing people out of context) and universalizing (based on
the assumption that social phenomena can be generalized among
many contexts) (Ryan, 1971). A feminist community perspective
addresses the dimensions of interconnection that are central to
understanding women's lives; for instance, gender-, class-, and race-
based power differentials, economic and political forces, and local
community structures and values.

Key concepts found in both the feminist and community psy-
chology literature include: a) integrating contextualized understand-
ings; b) addressing diversity issues; c) speaking from the position of
oppressed groups; d) adopting collaborative approaches; e) adopt-
ing reflexive practices; and f) taking activist orientations (Hill, Bond,
Mulvey, & Terenzio, 2000). Together, they suggest opportunities for
understanding the impacts of community and culture on interven-
tion and consultation.

By using individual and collective experiences to challenge
racial, cultural, and class biases, feminist perspectives have enriched
and expanded our understanding of personal-political ties (Hooks,
1984; Wilkinson & Kitzinger, 1996). Looking at the same connections
in community life reveals unexpected contradictions and paradoxes
among our multiple identities, relationships, and roles. Both femi-
nists and community psychologists seek to conduct their work out-
side of established phallocentric, racial, sexual, and class-based
discourses, and thus reduce their participation in those societal
dynamics (Fine, 1992; Miller & Brunson, 2000; Stanley, 1997).

Model Programs for Prisoners

From a community psychology perspective, a "model" prevention
program requires an acute awareness of the specific circumstances
that women face when dealing with the criminal justice system.
Gilliard and Beck (1998) and Morash and Bynum (1995) evaluated

innovative and promising programs for women offenders. Both research teams found that most of the programs that were considered "innovative": a) concentrated on a particular need (e.g., substance abuse, psychological services, family reunification); and b) took a holistic approach to the problems faced by female offenders, meaning that they addressed a variety of interrelated issues. In commenting on Morash and Bynum's work, Conly (1998) added several attributes that the more innovative programs shared: a) well-trained and dedicated employees and volunteers who can serve as positive role models; b) women-only programming; c) program materials that are focused on skills development and meeting clearly defined needs; d) a willingness to tailor approaches to meet individual needs; e) appropriate treatment controls; f) an emphasis on peer support and the development of peer networks; g) formal recognition of participant achievement; and h) other options for women who fail.[3]

The Consultation

In the fall of 2001, the WPA Program Manager approached our organization, the William Alanson White Institute (WAWI) organizational consultation program, regarding consultative services. In the preceding ten years, WPA had maintained an ongoing consultative relationship with WAWI's organizational program. Both sides view our previous collaborations—mostly providing training for program graduates—as helping both WPA members and consultants expand upon their understanding of the multiple factors that impact women in the criminal justice system.

The WAWI consultation model combines interpersonal psychoanalytic[4] organizational theory and community/organizational action research methodologies, including Pasmore's (2001) "sociotechnical systems" approach. This combination engenders a process whereby consultants and their clients identify and analyze dynamics (including societal) that are unconsciously enacted within an organization. Enactment, as we refer to it, is a way of describing system level (familial, community, societal) dynamics or patterns of interacting as they play out between individuals or groups (Borg & McCarroll, 2002). For instance, in WPA we've noted how patriarchal dynamics associated with the oppression of women—specifically, female prisoners—are enacted in interactions between WPA staff and their clients. Through a collaborative analysis of such dynamics, our goal is to help organization staff to consciously resist the tendency to enact the dynamics they want to avoid. We help organizations incorporate

this awareness into action plans, and assist them in the process of working through the anxieties leading to repetitive enactments.

Our most recent WPA consultation included an analysis of the current staffing structure in light of recent changes in the criminal justice system that were affecting WPA service-delivery efforts—specifically, changes in the ways that laws, especially regarding drug enforcement, have adversely impacted women and their families. Next, we worked with the group's board of directors to address enactments that may have been triggered by these changes. Because of our shared consultative history, we were able to consolidate and build upon previous gains. Looking at the long-term history of our relationship, we were impressed by the WPA's consistent willingness to ask for consultative help in times of major change-a willingness that we view as a positive sign of the organization's overall health, and an example of Bloom's (1996) definition of primary prevention: "coordinated actions seeking to prevent predictable problems, [and] to protect existing states of health and healthy functioning" (p. 2).

Organizational Goals[5]

The WPA mission is to design and offer programs through which women prisoners and ex-prisoners can acquire the necessary life skills for making healthy choices for themselves and their families. A second goal is to increase public awareness of and support for community-based responses to crime. According to the WPA mission statement, the group emphasizes a) self-reliance through the development of independent living skills; b) self-empowerment and peer support; c) client involvement in the community; and d) assistance from dedicated staff, advisers, and volunteers (Conly, 1998, p. 12). On average WPA works with approximately 2,000 women (1,500 in correctional facilities and 500 in communities) and 300 children per year.

The WPA has long recognized that women prisoners and former prisoners require simultaneous assistance on several fronts, including health care, child welfare, public assistance, education, housing, and the local criminal justice system. WPA has consistently developed programs and services that address issues tied to their clients' "multiple marginalities" (Chesney-Lind, 1997). In 1992, it introduced new programs serving women facing specific needs that are often overlooked by the criminal justice system: homelessness, HIV status, substance abuse, and family reunification (Ortiz-Torres, Serrano-Garcia, & Torres-Burgos, 2000; Paradis, 2000).

Through its own resources and referrals to other agencies, WPA provides education, emotional support, and a limited range of ser-

vices to incarcerated clients. To former prisoners, their children, and their families, WPA offers emergency and transitional housing, individualized case management services, skills-building workshops, childcare, counseling, and other forms of support.[6] In 1990, the WPA responded to the sudden five-fold expansion of New York's female offender population by conducting a comprehensive investigation of the needs of women in the state's criminal justice system (Conly, 1998). The four WPA programs that were launched because of this study were:

The Transitional Services Unit, consisting of a) HIV and AIDS services, peer group support, prerelease planning, and housing placement for inmates who are HIV-positive or at-risk for infection; and b) transitional and intensive case management services for HIV-positive women recently released from prison.

The Hopper Home Alternative Incarceration Program, a transitional residence and intensive reporting program for women who would otherwise be imprisoned.

The Sarah Powell Huntington House, a transitional residence for homeless women offenders (including those with AIDS or who are HIV-positive) who wish to reunite with their children.

The Steps to Independence Program, which provides specialized services such as housing and job placement assistance, independent living skills development, parenting training, and aftercare services to homeless women who are enrolled in the other three WPA programs. Depending on their individual circumstances, WPA clients can participate in some or all of these programs for several months or years (Conly, 1998).

An important aspect of the WPA's community-building and anti-recidivism efforts is its formal agreements with 44 community organizations that serve all women and/or criminal justice populations.[7] For the most part, each link to the various community organizations helps with a specific need of female offenders—housing, employment, health care, family support, etc.—while establishing a resource for ongoing client care. Furthermore, the WPA acts as an advocate for the population of women offenders and their families with state and city social service systems by lobbying for policies and programs that serve their clients' interests.

Discussion

According to the various criteria we have outlined thus far, the WPA is one of the best programs of its kind for addressing the needs of women offenders, especially as they face the various struggles of the

reentry process and problems of daily living in a non-incarcerated environment. Taken together, these criteria can be seen as a community building as crime prevention approach. In what follows, we will highlight how the WPA fulfills the community building as crime prevention criteria we have been considering.

The WPA meets the three criteria set out by Borg and Garrod (2003) for stemming future criminal behavior.

The WPA targets aspects of community environments that contribute to crime on multiple fronts. Through its in-house counseling and case management services and through its formal links to over 40 community organizations that target specific needs of women that are reentering society, the WPA is able to ameliorate the impact of social, economic, and political contexts that place daunting limitations on these women's opportunities to succeed and even meet basic needs. For example, through its in-house and community services, the WPA is able to assist former prisoners with substance abuse, family reunification, HIV status, housing, health care, child-care, public assistance, education, and vocational training and placement.

Through services offered through its family re-unification services, the WPA addresses the intergenerational transmission of criminal behavior (i.e., children who are exposed to parental criminal behavior are considered predisposed to engage in criminal behavior themselves) (Howell, 2003). This occurs through counseling services, family education, and working with foster-care agencies. Importantly, the cycle of intergenerational transmission is also abated through former women prisoners successfully working through reentry obstacles and thereby role modeling for their children alternative ways of living that do not involve criminal behavior.

The WPA's in-house counseling and case management services and its formal links to over 40 community organizations also serve as interventions that target not only the wider contexts of criminal behavior, but the specific and personal circumstances and antecedents of each woman's participation in particular criminal events.

The WPA's philosophy and practice of serving female offenders is in line with that of feminist community psychology. Key concepts found in both the feminist and community psychology literature that the WPA incorporates include the following.

The WPA integrates contextualized understandings of the lives of the women they serve by conducting extensive research of potential housing placements and on-site research and evaluation of their home environments. They strive to send former prisoners into healthy neighborhoods, and case managers are available to women

for up to ten years to help strategize and problem-solve around aspects of the home environment and neighborhoods that the women might experience as criminogenic.

WPA addresses diversity issues by tailoring programs and case management to meet the needs of specific individual women with their highly individualized histories and needs. This approach to programming and case management is highly mindful of these women's status as multiply marginalized along race, gender, class, and economic lines.

The WPA speaks from the position of oppressed groups by using the voices of former prisoners who have gone through the program in funding proposals and speaking engagements with the community. More importantly, the WPA continually strives to create a space for the women they serve to develop their own voice and define their own needs rather than the WPA imposing its own values.

The WPA stresses a collaborative approach by requiring its clients to define and refine their own case plans and to assume increasing responsibility for accomplishing their goals. Clients also collaborate with staff to develop new WPA programs, and to serve as public speakers, peer educators, trainers, and WPA staff assistants.

The WPA has adopted reflexive practices by conducting evaluations of its programs on an ongoing basis and making continual revisions based on those evaluations. The primary author of this paper was originally contracted to work with the WPA in order to conduct such an evaluation, and this was one only one of several such evaluations conducted by the William Alanson White Organizational Program over many years.

The WPA takes an activist orientation by advocating for women offenders and their families with state and city social service systems by lobbying for policies and programs that serve their clients' interests. The WPA is also heavily involved in community outreach by arranging speaking engagements in the community to educate the public about the treatment of women in the criminal justice system.

WPA is one of several programs that meet Morash and Bynum's (1995) criteria for "innovative and promising programs for women offenders," and also those of Conly (1998), who added several important characteristics of innovative programs and evaluated the WPA. Criteria that are of specific significance to WPA programs include the following:

Program models that address the needs of women offenders. The WPA's program models are based on research efforts to identify the most common client concerns regarding housing, physical and mental

health, family reunification, and employment. The WPA is adept at using information generated from inside and outside the organization to modify its own programs as well as to educate the public regarding issues of specific concern to women offenders.

Individualized case management, including counseling and service plans. Caseworkers help clients organize and prioritize their service needs, teach clients how to advocate for themselves, and provide clients with support for achieving stated goals. WPA case management emphasizes the use of community-based service providers, and the Association coordinates their efforts in order to avoid redundancy.

Peer support. WPA employees promote the development of healthy relationships through peer support that focuses on self-image and self-esteem problems that are prevalent in the population it serves. This goal is achieved through workshops, support groups, shared work assignments, and recreational activities. Clients are encouraged to utilize these relationships to redefine their sense of self and to create an ongoing base of support as they rebuild their lives.

Strategies for building on client successes. WPA employees help their clients build on their experience and strengths, as opposed to only addressing their deficits, and to recognize small successes (Weick, 1984). Clients are required to define and refine their own case plans and to assume increasing responsibility for accomplishing their goals. They are also encouraged to participate in the development of new WPA programs, and to serve as public speakers, peer educators, trainers, and WPA staff assistants.

Family focus. Helping women to reunite and establish new connections with their children has been shown to motivate them to accomplish other goals (Conly, 1998). Building healthy families also helps prevent children who have been exposed to their parents' substance abuse and criminal activity from becoming involved in those same behaviors (Borg & Garrod, 2003).

Skills development. Each WPA program makes use of skills-building workshops to help women improve their capacities to serve as parents, students, employees, tenants, and friends. Training classes span the broad range of topics described in earlier sections such as physical and mental health promotion, substance abuse prevention, vocational training, parenting, and independent living.

Competent, and well-trained staff. The WPA consistently provides additional training and consultation to its staff employees. Both clinical and organizational consultation services are made available on a regular basis.

Long-term commitment. Clients are eligible to make use of WPA

services over a period of several years, beginning from the date of their initial incarceration. According to Conly (1998) "because it has the capacity to make a long-term commitment, WPA is able to help women offenders address their many concerns regarding sobriety, prior abuse, employment, housing, and health care" (p. 10).

Conclusion

Despite its considerable past accomplishments, funding constraints are forcing the WPA to continually document its efforts and to justify its programs. WPA is therefore developing mechanisms for tracking individual clients and establishing new descriptive and objective scales for measuring client progress—for example, tracking personal growth, efforts to establish independence in their chosen communities, and working to improve their housing, employment, and family situations.

Furthermore, despite its considerable dedication to the women they serve, during the evaluation conducted by Borg in 2001 there were some signs of the WPA's embeddedness in a culture of patriarchal values, traditions, and institutions that bog down the pursuit of its primary task. Some of the legitimately overwhelming circumstances that the staff deal with regularly, such as how to retain optimism and investment in their clients in the face of drug relapse or recidivism, can lead to periodic lapses in the treatment of their clients that reflect problematic patriarchal values. Such lapses include falling back on stereotypes of women prisoners, failure to work collaboratively with clients, and taking more authoritative roles. How to understand and diminish these lapses was the primary goal of the WPA's consult with the primary author of this paper. These lapses do not reflect a failure on the part of the WPA; rather, they reflect the difficulty and pressures created by the societal values and norms in which we live.

Nowhere is this seen more than in the often noted problem of how the women's prison system is a mere duplication of the men's prison system (Belknap, 2001; Chesney-Lind, 1997; Muraskin, 2003). Little forethought has been given to the problems created for women prisoners by submitting them to a penal system that is almost oblivious to the specific needs of women prisoners. Then again, as Van Wormer and Bartollas (2000) comment, this disavowal of the actual needs of women in the shaping of prison life is merely a reflection of how women are treated, mistreated, ignored, and disavowed in the wider society.

NOTES

1. In 1997 the number of female inmates in federal and state prisons increased by 6.2%, slightly greater than the 5.2% increase for males; by the end of that year, 79,624 women were incarcerated (Gilliard & Beck, 1998). From 2001 to 2002, the number of women prisoners increased 1.9%, compared to 1.4% for men (United States Department of Justice, 2003). By mid-2002, there were 113 female prisoners for every 100,000 women in the United States.

2. While writing a chapter on preventing adult criminal behavior for the Encyclopedia of Primary Prevention and Health Promotion (Gullotta & Bloom, 2003), the primary author was serving as a consultant to the WPA. It seemed ironic that his difficulty in finding an adequate model for the prevention of adult criminal behavior in the primary prevention and community psychology literature occurred at the same time that he was working with an organization whose focus was on reducing recidivism, preventing relapses into states of homelessness and substance abuse, and promoting healthful practices among female prisoners, ex-prisoners, and their families.

3. The WPA was one of twenty-three programs evaluated thus far in the United States that meet these standards (Conly, 1998; Morash & Bynum, 1995).

4. Interpersonal psychoanalytic theory—referred to as the "cultural model"—was developed by a group of authors and researchers that included Harry Stack Sullivan (1953), Erich Fromm (1941), Clara Thompson (1964), and Frieda Fromm-Reichmann (1950). Thompson and Fromm-Reichmann independently developed feminist perspectives for psychoanalytic treatment. Their work would later serve as the foundation for challenges to the patriarchal models that had long been used with patients of either gender in analysis.

5. The information in this section comes from interviews with the WPA leadership and board of directors, an extensive review of WPA literature and yearly reports (including funding proposals), interviews with previous WAWI consultants, and Catherine Conly's (1998) independent evaluation that was conducted for the U.S. Department of Justice.

6. Many of the elements considered oppressive toward women that have been observed in the criminal justice system have also been observed in the American foster case system (Martin, 2000; McDonald, Allen, Westerfelt, & Piliavin, 1996).

7. WPA programs and philosophy affirm it's strong belief that assisting women offenders and ex-prisoners requires a broad base of community support. Therefore, in 1990 it formed the Women's Justice Alliance, a coalition of more than 300 public and private agencies and individuals who meet regularly to improve programs and to promote public policy for women offenders in New York City. Within this structure, the WPA continues to provide a wide range of services that match the various needs of their clients at various stages of their reentry into local communities.

The authors would like to thank Jon Lindemann and Dr. Elaine Abrams for their thoughtful comments and suggestions and contributions to both this paper and the WPA project.

REFERENCES

Angelique, H. L., & Culley, M. R. (2000). "Searching for Feminism: An Analysis of Community Psychology Literature Relevant to Women's Concerns." American Journal of Community Psychology, 28(6), 793-814.

Belknap, J. (2001). The Invisible Woman: Gender, Crime, and Justice (2nd Ed.). Belmont, CA: Wadsworth Group.

Benard, B. (1999). "Fostering Resiliency in Communities: An Inside Out Process." In N. Henderson, B. Benard, & N. Sharplight (Eds.), Resiliency in Action. pp. 81-86. San Diego, CA: Resiliency In Action.

Bloom, B., & Chesney-Lind, M. (2003). "Women in Prison: Vengeful Equity." In R. Muraskin (Ed.), It's A Crime: Women and Justice (3rd Ed.) (pp. 175-195). Upper Saddle River, NJ: Prentice Hall.

Bloom, M (1996). Primary Prevention Practices. Thousand Oaks, CA: Sage, 1996.

Bond, M., Hill, J., Mulvey, A., & Terenzio, M. (2000). "Weaving Feminism and Community Psychology." American Journal of Community Psychology, 28(6), 585-597.

Borg, M. B., & Garrod, E. (2003). "Criminal Behavior, Adulthood." In T. Gullotta & M. Bloom (Eds.), Encyclopedia of Primary Prevention and Health Promotion (pp. 266-379). New York: Kluwer/Plenum.

Borg, M, B , & McCarroll, J. (2002). "Feminism in Action." Women, Gender, and Psychoanalysis, 9(2), 6-8.

Chesney-Lind, M. (1997). The Female Offender: Girls, Women and Crime. Thousand Oaks, CA: Sage.

Conly, C. (1998). The Women's Prison Association: Supporting Women Offenders and Their Families. Washington, DC: U.S. Department of Justice (NCJ 172858).

DeLeon-Granados, W. (1999). Travels Through Crime and Place: Community Building as Crime Control. Boston: Northeastern University Press.

Dittman, M. (2003). "A Voice For Women in Prison." Monitor on Psychology, 34(7), 60-62.

Egley, A., Jr. (2002). National Youth Gang Survey Trends from 1996 to 2000. Washington, DC: Office of Juvenile Justice and Delinquency Prevention (OJJDP).

Fine, M. (1992). Disruptive Voices: The Possibilities of Feminist Research. Ann Arbor, MI: University of Michigan.

Foucault, M. (1975). Discipline and Punish: The Birth of the Prison. New York: Vintage.

Fromm, E. (1941). Escape From Freedom. New York: Holt, Rinehart and Winston.

Fromm-Reichmann, F. (1950). Principles of Intensive Psychotherapy.

Chicago: University of Chicago Press.

Gilliard, D. K., & Beck, A. (1998). Prisoners in 1997. Washington, DC: U.S. Department of Justice (NCJ 170014).

Greenfield, L., & Minor-Harper (1991). Women in Prison. Washington, DC: U.S. Department of Justice (NCJ 134732).

Gullotta, T., & Bloom, M. (Eds.) (2003). Encyclopedia of Primary Prevention and Health Promotion. New York: Kluwer/Plenum.

Gutierrez, L. (1991). "Empowering Women of Color: A Feminist Model." In M. Bricker-Jenkins, N. R. Hooyman, & N. Gottlieb (Eds.), Feminist Social Work Practices in Clinical Settings (pp. 271-303). Newbury Park, CA: Sage.

Hill, J., Bond, M. A., Mulvey, A., & Terenzio, M. (2000). "Methodological Issues and Challenges for a Feminist Community Psychology." American Journal of Community Psychology, 28(6), 759-772.

Hooks, B. (1984). From Margin to Center. Boston, MA: South End Press.

Howell, J. C. (2003). Preventing and Reducing Juvenile Delinquency: A Comprehensive Framework. Thousand Oaks, CA: Sage.

Kretzmann, J. P., & McKnight, J. L. (1993). Building Communities From the Inside Out: A Path Toward Finding and Mobilizing Community Assets. Evanston, IL: The Asset-Based Community Development Institute.

Loeber, R., & Farrington, D. P. (Eds.). Serious and Violent Juvenile Offenders: Risk Factors and Successful Interventions. Thousand Oaks, CA: Sage.

Martin, J. A. (2000). Foster Family Care: Theory and Practice. Boston: Allyn & Bacon.

Mattessich, P., & Monsey, B. (2001). Community Building: What Makes it Work. Saint Paul, MN: Amherst H. Wilder Foundation.

McDonald, T., Allen, R., Westerfelt, A., & Piliavin, I (1996). Assessing the Long-term Effects of Foster Care: A Research Synthesis. Washington, DC: Child Welfare League of America.

Miller, J., & Brunson, R. K. (2000). "Gender Dynamics in Youth Gangs: A Comparison of Male and Female Accounts." Justice Quarterly, 17, 419-448.

Moore, M. H. (1995). "Public Health and Criminal Justice Approaches to Prevention." In M. Tonry & D. P. Farrington (Eds.), Building a Safer Society: Strategic Approaches to Crime Prevention. pp. 237-262. Chicago: University of Chicago Press.

Morash, M., & Bynum, T. (1995). Findings from the National Study of Innovative and Promising Programs for Women Offenders. Washington, DC: U.S. Department of Justice (NCJ 171667).

Muraskin, R. (Ed.) (2003). It's a Crime: Women and Justice (3rd Ed.). Upper Saddle River, NJ: Prentice Hall.

Ortiz-Torres, B., Serrano-Garcia, I., & Torres-Burgos, N. (2000). "Subverting Culture: Promoting HIV/AIDS Prevention Among Puerto-Rican and Dominican Women." American Journal of Community Psychology, 28(6), 859-883.

Paradis, E. K. (2000). "Feminist and Community Psychology: Ethics in

Research with Homeless." American Journal of Community Psychology, 28(6), 839-858.

Pasmore, W. (2001). "Action Research in the Workplace: The Socio-technical Perspective." In P. Reason & H. Bradbury (Eds.), Handbook of Action Research (pp. 38-47). Thousand Oaks, CA: Sage.

Price, R. H., Cowen, E. L., Lorion, R. P., & Ramos-McKay, J. (1988). 14 ounces of Prevention: A casebook for practitioners. Washington, DC: American Psychological Association.

Rappaport, J., & Seidman, E. (Eds.) (2000). Handbook of Community Psychology. New York: Kluwer/Plenum.

Ryan, W. (1971). Blaming the Victim. New York: Vintage.

Stanley, L. (1997). Knowing Feminisms. London: Sage.

Sullivan, H. S. (1953). The Interpersonal Theory of Psychiatry. New York: Norton.

Thompson, C. M. (1964). Interpersonal Psychoanalysis. New York: Basic Books.

Tonry, M., & Farrington, D. P. (Eds.) (1995). Building a Safer Society: Strategic Approaches to Crime Prevention. Chicago: University of Chicago Press.

U. S. Department of Justice (2003). "Prison and Jail Inmates at Midyear 2002." Bureau of Justice Statistics, www.ojp.usdoj.gov/bjs.

Van Wormer, K. S., & Bartollas, C. (2000). Women and the Criminal Justice System. Boston: Allyn and Bacon.

Weick, K. (1984). "Small Wins: Redefining the Scale of Social Issues." American Psychologist, 39, 29-48.

Wilkinson, S., & Kitzinger, C. (Eds.) (1996). Representing the Other: A Feminism and Psychology Reader. London: Sage.

Mark B. Borg, Jr., PhD, is a community/clinical psychologist and interpersonal psychoanalyst who is affiliated with the William Alanson White Institute. He is cofounder and principal partner of the Community Consulting Group, which is a community revitalization organization. He lives and practices in New York City.

Jennifer McCarroll, PhD, is a clinical psychologist who works in both private practice and at a community mental health clinic in lower Manhattan. She is in training at the William Alanson White Institute for adult psychoanalytic studies. She was the coeditor of Women and Gender, a biannual publication of Section III, Division 39 of the American Psychological Association during 2001 and 2002.

Sexual Revictimization and Retraumatization of Women in Prison

Danielle Dirks

When women in foreign countries are sexually abused or sexually exploited by government employees, it is a human rights violation (e.g., Fitzgerald, 1992), but when the same thing happens in the United States, it is a "prison sex scandal" (e.g., Meyer, 1992) (excerpt from Baro, 1997).

Understanding of the role of victimization and traumatization in women's lives has recently begun to inform the growing body of knowledge on women's offending (Arnold, 1995; Faith, 1993). Examining the life histories of incarcerated women reveals an extensive and pervasive array of physical, emotional, and sexual abuses (Browne, Miller, & Maguin, 1999; Girshick, 1999; Lake, 1993; Owen & Bloom, 1995; Singer, Bussey, Song, & Lunghofer, 1995). Many of these women have experienced at least one form of sexual victimization in their lifetimes, many of them before the age of 18 (Bloom, Chesney, & Owen, 1994; Heney, 1990). For women with previous histories of abuse, prison life is apt to simulate the abuse dynamics already established in these women's lives, thus perpetuating women's further revictimization and retraumatization while serving time. Women's experiences of revictimization and retraumatization need to be addressed by prison staff, policy, procedure, and programming. A feminist framework may offer a lens by which to view these experiences and offer insight for change.

Arnold (1995) suggests that the interrelated processes that govern women's victimization and criminalization begin with abuse—including physical, sexual, economic, and racial. Through a process of "structural dislocation," institutional forms of oppression such as sexism, racism, and classism aid in the removal of girls and women from primary socializing agents such as families and schools. Facing lives filled with "poverty, illiteracy, substance abuse, mental illness, childhood sexual abuse, and an intricate web of life-threatening physical, psychological, racial, and social problems," many of these women's experiences mark their advent into the criminal justice system (Johnson, 2002, p. 103).

Feminist criminology has moved beyond examining the crimes of women, and has begun to examine the broader links that may explain women's offending. For example, a study by Widom (1989) found that abused girls were more likely than girls without histories of abuse to become criminals or delinquents. Girls who had been sexually abused as children also have an increased risk for adult arrest for prostitution (Widom & Ames, 1994). Other studies have also linked early childhood abuse with later criminal activity (American Correctional Association, 1990; Lake, 1993). Much of the research in this area has focused on the links between childhood abuse, depression, substance abuse, and subsequent criminality (McClellan, Farabee, & Crouch, 1997; Singer et al., 1995; Smith & Thornberry, 1995).

Prevalence and Severity of Women's Histories of Abuse

Given the link between victimization and criminalization, the extant research literature suggests that women in prison have extensive histories of emotional, physical, and sexual abuse. Incarcerated women are estimated to have rates of abuse six to ten times that of women in the general population (Pollock, 2002). Although victimization and traumatization rates vary among samples and research methods, the lives of women in prison have often been characterized by the "prevalence and severity" of physical and sexual abuse throughout their childhoods and adult lives (Browne, Miller, & Maguin, 1999).

Women in both state and federal prisons are more likely to have histories of abuse than men in prison (McClellan et al., 1997; Snell & Morton, 1994). A 1991 study by the Bureau of Justice Statistics (BJS) revealed that nearly half (48%) of women they interviewed had been physically or sexually assaulted prior to their incarceration (Snell & Morton, 1994). Citing that the BJS study (1991) methodology may have suppressed reporting, more recent research has tackled the goal of filling in the gaps of previous literature to elucidate a more comprehensive understanding of the victimization and traumatization experiences of incarcerated women (Browne et al., 1999; Owen & Bloom, 1995).

Owen and Bloom (1995) found that 80% of their sample of women in the California penal system had experienced some form of physical or sexual abuse in their lifetimes. In a study of women in a New York maximum-security facility, Browne, Miller, and Maguin (1999) found that 70% had experienced "severe physical violence" from a caretaker during adolescence and 75% reported experiences

of physical abuse from an intimate partner in adulthood. Nearly 60% of these women reported sexual abuse during childhood or adolescence and 77% reported some form of victimization, including threats of assault involving weapons to physical and sexual attacks by "nonintimates," over their lifetimes. Lake (1993) found that 85% of the 83 women in her sample had experienced at least one form of violent victimization including physical and sexual abuse and assault by parents, siblings, relatives, partners, or strangers. Similar to the rate reported by Browne, Miller, and Maguin, nearly three-quarters of the women in this sample had also been physically or sexually assaulted or robbed by strangers. When including "emotional abuse," Girshick (1999) found that 90% of the women in her prison sample had been abused physically, sexually, or emotionally as adults. Over forty percent (43%) of the women in this sample reported being sexually assaulted.

Singer, Bussey, Song, and Lunghofer (1995) found that 81% of their sample had experienced sexual victimization when combining experiences of child and adult sexual abuse. In this sample, roughly half of the women were serving time for prostitution. Over two-thirds (68%) of the sample experienced one act of forced sexual activity; nearly half (48%) reported experiencing sexual violence before the age of 18. Bloom, Chesney, and Owen (1994) found that 31% of their sample of California women in prison reported childhood sexual abuse and 23% had experienced sexual abuse as adults.

Although women of color are disproportionately overrepresented in the penal system (Johnson, 2002), very little research has focused on how varying intersections of race, class, and sexuality create diverse victimization experiences for women in prison prior to their incarceration. A recent literature review by West (2002) revealed that black women are commonly victims of childhood sexual abuse, intimate partner violence, sexual assault, and sexual harassment and are overrepresented in "severe" categories of childhood sexual abuse. Black women's experiences are often shaped by class distinctions as low-income black women experience elevated rates of sexual assault (Kalichman et al., 1998). Black American women are also significantly less likely to disclose sexual assault and more likely to have repeated assaults than white American women, both of which can have serious effects on recovery from rape trauma (Wyatt, Guthrie, & Notgrass, 1992).

Lesbians may also face elevated rates of physical and verbal abuse in comparison to heterosexual women (Balsam, 2003) and these victimization experiences are sometimes directly related to their sexual

orientation (Balsam, 2003; Pilkington & D'Augelli, 1995). For example, women who identify as lesbian may be at increased risk for verbal and physical abuse in childhood and adolescence, both from their families and their communities as a number of researchers are beginning to find (Pilkington & D'Augelli, 1995; Tjaden, Thoeness, & Allison, 1999). Lesbians may also experience a form of "cultural victimization" characterized by the shame, negative sense of self, and "victim mentality" resulting from living in a heterosexist society (Neisen, 1993, as cited in Balsam, 2003). Undoubtedly, interlocking and intersecting experiences of oppression have impacted the lives of women entering and living in prison as well. Overall, the pervasive existence of victimization has had a significant influence on the lives of all women as both victims and witnesses to this violence (Bloom, Owen, Covington, & Raede., 2003). Prison dynamics may create uniquely harmful experiences for women who already experience cultural victimization in the forms of racism, classism, and heterosexism—among other forms of oppression in their everyday lives.

Vulnerable Women in Vulnerable Positions

Victimization is a "lifelong possibility" for women as childhood abuse experiences often follow women into their adult lives (Girshick, 1999). According to Finkelhor and Browne (1985), four processes shape early traumatization experiences: traumatic sexualization, powerlessness, stigmatization, and betrayal. These early childhood boundary violations can often shape women's later experiences in life in creating a weak sense of self, feelings of guilt or shame, and deprivation, thus shaping women's further alienation and vulnerability (Girshick, 1999; Heney & Kristiansen, 1998). Many women who have been battered, or women who suffer from Battered Woman's Syndrome,1 often experience low self-esteem, a sense of powerlessness or worthlessness, and self-blame (Walker, 1992, 1994). Research has documented the links between previous victimization and subsequent incidents of revictimization; these links represent a constellation of issues regarding women's mental health and well-being (Wyatt et al., 1992).

 Given the prevalence and severity of the experiences of previous sexual victimization and traumatization among incarcerated women, many women in prison suffer from the effects of childhood and adult sexual abuse. If fact, a study by O'Keefe (1998) found that many women in prison score high on measures of Post-Traumatic Stress Disorder (PTSD), a disorder characterized by excessive fear, flash-

backs of trauma, and diminished sense of well-being that affects more women than men. As Girshick (1999) writes, these women are already vulnerable and then placed in further vulnerable positions detrimental to their emotional and physical well-being.

Revictimization and Retraumatization

As Louise (1998) reports, "Unfortunately, the prison system often contributes to the revictimization of these women by perpetuating feelings of powerlessness and vulnerability" (p. 107). Heney and Kristiansen (1998) posit that women in prison are likely to be reexposed to the four "powerful traumatizing processes" of childhood sexual abuse outlined by Finkelhor and Browne (1985) during their incarceration. A legal review by Kupers (2001) outlines the major issues pertaining to women's experiences of revictimization and retraumatization. He acknowledges that women's experiences of sexual harassment and abuse, lack of privacy, and retaliation during incarceration may further increase women's risk for depression, anxiety, PTSD, and decreased overall well being before release from prison. Prison procedures that control every aspect of an imprisoned woman's life may indeed trigger experiences of previous abuses (Heney & Kristiansen, 1998; Lord, 1995; Louise, 1998).

In the Name of Security

Women's traumatic sexualization and powerlessness are recreated by "institutionalized assaults by line staff on prisoner's bodies which are conducted in the name of security" (Faith, 1993, p. 229). These assaults reside in the realm of staff sexual misconduct outlined by Moss (1998) as "sexual behavior directed toward inmates, including sexual abuse, sexual assault, sexual harassment, physical conduct of a sexual nature, sexual obscenity, invasion of privacy and conversations or correspondence of a romantic or intimate nature" and can have devastating effects on women's well-being during incarceration (189). Incarceration also retriggers abuses with grossly unequal power dynamics, invasive searches, restraints, reading of mail, and a lack of privacy (Girshick, 1999).

Prison power dynamics are shaped by the structural distinction between those in power—prison staff and prison administration—and those without power, the prison inmates. As a result, this structural distinction serves as a constant reminder to women in prison that they do not have autonomy over their own bodies or well-being

in prison; this message serves to reinforce women's sense of power-
lessness. Because imprisonment necessitates that these women have
no choice but to comply, these acts also serve to further women's
sense of powerlessness, thus retriggering abuse dynamics found in
childhood and adulthood. Kupers (2001) adds that the absence of a
"safe place" for women in prison occludes women from retreating to
a place of healing, for women in prison, there may be "no safe haven"
from ongoing abuse (Girshick, 1999).

The existence of male correctional officers in women's facilities
may exacerbate power imbalances as women must rely on men for
basic necessities, phone privileges, and visiting privileges (Human
Rights Watch, 1996). Correctional officers' absolute power over giv-
ing warnings, infractions, and punitive measures may provide oppor-
tunities for the development of exploitative relationships that hinge
on "favor-giving" and avoiding punishment (Amnesty International,
1999; Human Rights Watch, 1996). It is important to note that these
patterns of misconduct have also been found among female officers
as well, and that sexually exploitative relationships do not always have
to involve abuse or violence- power often works just as well (Estrich,
1987). The exploited positions of women in prison places them in
the role of "bad girls," thus denying them legitimate victim status
because they are viewed as sexually accessible and likely to consent to
further exploitation and abuse (Baro, 1997; MacKinnon, 1993).

The Reality of Threat

As Zupan (1992) suggests, women in prison are constantly aware of
the threat and possibility for sexual assault in prison. The research lit-
erature focusing on women's imprisonment experiences indicates
that the risk of sexual assault resembles more of a reality for many
women in prison. A report by the Human Rights Watch (1996) orga-
nization revealed that many women in prison suffered from well-
established patterns of sexual degradation, abuse, and assault at the
hands of prison staff and inmates. An investigative report by Amnesty
International (1999) also cited that many of the incarcerated women
they interviewed in the United States reported on a range of abuses
by prison staff including the use of sexually or racially offensive lan-
guage, inappropriate touching of women's breasts or genitals during
searches, inappropriate surveillance while women were unclothed,
and rape.

An anonymous mail survey of men and women incarcerated in
the Midwest indicated that 7.7% of the women reported being pres-

sured or forced to have sexual contact against their will while incarcerated (Struckman-Johnson, Struckman-Johnson, Rucker, Bumby, & Donaldson, 1996). The majority of incidents reported in a follow-up study by the same authors (Alarid, 2000) were perpetrated by other women inmates, contrary to the findings of the Human Rights Watch (1996), Amnesty International (1999), and Baro (1997), who indicate that male staff often use "terror, retaliation, and repeated victimization to coerce and intimidate confined women" (Dumond, 2000, p. 409). In fact, women are more likely than men to be sexually abused by correctional officers (Zupan, 1992). When women are housed at men's facilities, they risk being sexually assaulted by both male officers and male inmates (Amnesty International, 1999; Human Rights Watch, 1996; Stein, 1996). Eigenberg (1994) cautions that the rates of reported sexual assaults in prison may be low estimates, as inmates may feel stigmatized as a result of their experiences and also may fear revealing abuse to researchers or prison authorities for a number of reasons, some including fear of retaliation or fear of further abuse. Research examining women's experiences and rates of sexual abuse and assault in prison are needed, as the majority of the relevant literature focuses on male inmates (Dumond, 1992; Struckman-Johnson et al., 1996).

A Feminist Perspective for Change

As incarceration rates of women continue to surpass those of men, examining the extensive abuse histories of women is an increasingly important topic of research for prison programming and policy. As Lord (1995) suggests, "our questions need to be about women, not about crime or prisons, but about who the women are and how they become who they are" (p. 259). A feminist framework encompasses the context with which women are both victimized and criminalized. Baro (1997) suggests that women's experiences in the criminal justice system have been thematically linked by abandonment. She argues that prison administrations, the legal system, and scholars have abandoned the plight of women's continuing sexual abuse and exploitation within the prison system.

The extant literature does appear to support this notion; there is a notable dearth of prison policy and programming directed toward aiding in women's recovery from traumatization and victimization (Chesney-Lind, 1998; Coll, Miller, Fields, & Mathews, 1998; Covington, 1998; Gray, Mays & Stohr, 1995; McQuaid & Ehrenreich, 1998; Morris & Wilkinson, 1995; Pomeroy & Kiam, 1998). Change needs to

be directed toward creating prison policy and programming that attend to the omnipresent experiences of abuse and intersecting oppressions in the lives of these women. A feminist framework for change and healing has suggested that "empowerment" should be a goal of counseling and programming within the prison. As suggested by Remer (2003), empowerment strategies should encourage people to identify and challenge the conditions of their lives that may serve to devalue and subordinate them—those conditions that effectively deny them equality of opportunity and access to valued life resources.

Feminist therapists examine the broader context of women's experiences and aid people to connect their own experiences and actions to foster, "resistance and personal integrity rather than infantilization, self-directedness rather than conformity, and self-esteem rather than self-doubt" (Marcus-Mendoza, Klein-Saffran, & Lutze, 1998, p. 181). These goals present unique paradoxes in the context of a prison (Hannah-Moffat, 1995, 2000; Heney & Kristiansen, 1998), and many authors have enumerated the dilemmas with feminist ideals "behind bars" and these critiques should be taken into consideration when developing prison programming and policy (Hannah-Moffat, 1995, 2000; Heney & Kristiansen, 1998; Kendall, 1993, 1994). However, the ideals of feminist therapy and a feminist approach to empowerment (as compared to a criminal-justice approach to empowerment) have been endorsed as the most appropriate approach for women's healing from traumatization and victimization while in prison (Kendall, 1993; Scarth & McLean, 1994).

One promising study (Kendall, 1993) indicated that 92% of women interviewed at the Canadian Prison for Women reported that they were ready to deal with the issues they were working on in counseling. The women in this study were also overwhelmingly supportive of the feminist therapy techniques employed by the counselors. Indeed, programming aimed at repairing and recovering from trauma has been cited by women in prison as one of their most important programming needs (Gray et al., 1995). Counseling in prison should be informed by the most up-to-date literature on trauma and recovery and should be accessible to all women who would like to participate. Feminist therapy, as well as other forms of therapy, should not, however, be pushed upon women who may not be ready to deal with painful issues in their lives. Forms of therapy and counseling should not serve to further revictimize or victim-blame.

Other researchers have additionally warned against counselors and prison staff fulfilling confusing and conflicting roles of both "therapist and disciplinarian" (Marcus-Mendoza et al., 1998).

Although training correctional officers to treat women in prison with esteem, empathy, and compassion could result positively, Hannah-Moffat (1995) writes that, "it is difficult to envision the development of meaningful, respectful, and supportive relationships when guards continue to perform strip searches, open women's mail, monitor their relations with others within and outside of the institution, and at times punish the prisoners" (p. 144). By exploring and creating separate roles for therapists and correctional officers, women can learn that "intimidation and intimacy do not have to coexist in all relationships" (Marcus-Mendoza et al., 1998, p. 182).

A feminist framework suggests that all those who work in the prison should value women's diverse experiences and that women should not be treated in a manner that retraumatizes them. Women who have had previous experiences of victimization in their lifetimes are more likely to have repeated experiences of trauma in their lives. Placing vulnerable women in prison among insensitive or predatory officers may have serious implications for the healing process, as one prisoner counselor shared that correctional officers often target women "like a radar" who have histories of sexual abuse (Human Rights Watch, 1996). It may then not be surprising to learn that the legal system has turned a blind eye to both consensual and nonconsensual sexual contact between inmates and prison staff.

Arguing that cases of sexual misconduct that involve "romance" or some level of consensual contact are too difficult to prosecute, those in the legal arena choose to do nothing to aid women who have been exploited or abused by male prison staff (Baro, 1997; Human Rights Watch, 1996). These legal standards also attempt to jeopardize women's victim status by stigmatizing them as "inmates" or "bad girls," thus occluding any opportunity for their experiences to fall under the purview of "real rape" (Estrich, 1987; MacKinnon, 1993). Valuing the lives of all women without dichotomizing "good girls" and "bad girls" (even along racial, class, and sexuality lines) should be one goal of creating change within the prison and legal milieu.

The daunting reporting procedures and threat of retaliation serve to further revictimize women. Those who choose to report abuses should be afforded greater protection in reporting abuses. Women's disclosure should be made confidentially, and retaliation should be taken seriously (Amnesty International, 1999; Human Rights Watch, 1996; Smith, 2001). More-explicit policies and laws that directly prohibit any sexual contact between inmates and staff may also aid in investigations and prosecutions by clearly stating that consensual contact is not possible in the context of a prison (Moss,

1999). Prison administration should also implement extensive train-
ing for employees and inmates on new procedures that ensure the
dignity of women's bodies and rights; invasive and unnecessary
searches should be prohibited to reduce the likelihood of revictim-
ization and retraumatization (Bloom et al., 2003).

As Baro (1997) has suggested, until recently little scholarly
research has been dedicated to exploring the lives of sexually abused
and exploited women within the criminal justice and penal system.
The links between childhood and adult sexual abuse, substance
abuse, mental health issues, and criminality has paved the way for a
number of empirical questions. Research might usefully examine the
efficacy of various prison dynamics and programming. In the slip-
pery politics of "empowerment" and "women-centered" and feminist
prisons, how women have fared as a result of various empowerment
strategies needs also to be explored. Qualitatively examining the life
histories of women is one research methodology that may provide a
richer, more-detailed illustration of the intricate links between vic-
timization and criminalization in women's lives. A thorough exami-
nation of women's intersecting identities and experiences of
oppression also desperately needs to be explored as certain groups of
women—namely, women of color, poor women, and women with
children—are disproportionately incarcerated and victimized.
Finally, outcomes for women as a result of policy or programming
changes also need to be explored in relation to recidivism rates.

Conclusion: From Victims to Survivors

One critique of a feminist perspective on women's imprisonment is
that it still exists within the realm of incarceration and punitive ide-
ology. Hannah-Moffat (1995) calls on feminists to "challenge this
institutional base and consider alternative systems and meanings of
sanctioning" (p. 147). Instead of questioning how we can change the
prison system, she suggests, "we could instead proceed with a ques-
tion about how current structures and relations of power facilitate
the incarceration of an increasingly high number of nonviolent
women" (p. 149). If we understand that women's criminality is inex-
tricably linked to their victimization and traumatization, we also need
to then examine the structural changes that must occur to disrupt
the current cycles of victimization in the lives of girls and women.
Some individuals may question how as a society we could afford such
a structural disruption, but the question still remains, how can we
afford not to make these critical changes?

NOTES

1. Battered Woman's Syndrome is generally recognized as a subcategory of Post-Traumatic Stress Disorder that is characterized by the social, emotional, physical, and psychological symptoms of depression, low self-esteem, and isolation that may often follow the personal experience of a series of violent or harmful acts by an intimate partner. For victims of interpersonal violence such as this, symptoms can resemble those exhibited by persons who have experienced traumatic events, such as sexual assault survivors or prisoners of war.

REFERENCES:

Alarid, L. F. (2000). "Sexual Assault and Coercions Among Incarcerated Women Prisoners: Excerpts from Prison Letters." The Prison Journal, 80, 391-406.

American Correctional Association. (1990). The Female Offender: What Does the Future Hold? Washington, DC: St. Mary's Press.

Amnesty International USA. (1999). Not Part of My Sentence: Violations of the Human Rights of Women in Custody. New York: Amnesty International USA.

Arnold, R. (1995). Processes of Victimization and Criminalization of Black Women." In B. R. Price & N. L. Sokoloff (Eds.), The Criminal Justice System and Women: Offenders, Victims and Workers (pp. 136-146). New York: McGraw-Hill.

Balsam, K. F. (2003). "Traumatic Victimization in the Lives of Lesbian and Bisexual Women: A Contextual Approach." Journal of Lesbian Studies, 7, 1-14.

Baro, A. (1997). "Spheres of Consent: An Analysis of the Sexual Abuse and Sexual Exploitation of Women Incarcerated in the State of Hawaii." Women and Criminal Justice, 8, 61-84.

Bloom, B., Chesney, L. M., & Owen, B. (1994). Women in California Prisons: Hidden Victims of the War on Drugs. San Francisco, CA: Center on Juvenile and Criminal Justice.

Bloom, B., Owen, B., Covington, S. S., & Raeder, M. (2003). Gender Responsive Strategies: Research, Practice, and Guiding Principles for Women Offenders. Retrieved August 11, 2003 from http://www.nicic.org.

Brown, L. (1996). Subversive Dialogues: Theory in Feminist Therapy. New York: Basic Books.

Browne, A., Miller, B., & Maguin, E. (1999). "Prevalence and Severity of Lifetime Physical and Sexual Victimization Among Incarcerated Women." International Journal of Law and Psychology, 2, 301-322.

Chesney-Lind, M. (1998). "The Forgotten Offender." Corrections Today, 60, 66-71.

Coll, C. G., Miller, J. B., Fields, J. P., & Mathews, B. (1998). "The Experiences of Women in Prison: Implications for Services and Prevention." Women & Therapy, 20, 11-28.

Covington, S. S. (1998). "Women in Prison: Approaches in the Treatment of our Most Invisible Population." Women & Therapy, 21, 141-155.

Dumond, R. W. (1992). "The Sexual Assault of Male Inmates in Incarcerated Settings." International Journal of the Sociology of Law, 20, 135-157.

Dumond, R. W. (2000). "Inmate Sexual Assault: The Plague that Still Persists." The Prison Journal, 8, 407-414.

Eigenberg, H. M. (1994). "Male Rape in Prisons: Examining the Relationship Between Correctional Officers' Attitudes Toward Male Rape and their Willingness to Respond to Acts of Rape." In M. C. Braswell, R. H. Montgomery, Jr., & L.X. Lombardo (Eds.), Prison Violence in America (2nd Ed.) (pp. 145-165). Cincinnati, OH: Anderson.

Estrich, S. (1987). Real Rape: How the Legal System Victimizes Women. Cambridge, MA: Harvard University Press.

Faith, K. (1993). Unruly Women: The Politics of Confinement and Resistance. Vancouver: Press Gang Publishers.

Finkelhor, D., and Browne, A. (1985). "The Traumatic Impact of Child Sexual Abuse: A Conceptualization." The American Journal of Orthopsychiatry, 5, 530-541.

Fitzgerald, D. (1992, July 31). "The Secret Torture." New Statesman & Society, 5, 5.

Girshick, L. (1999). No Safe Haven: Stories From Women in Prison. New York: Northeastern University Press.

Gray, T., Mays, L. G., & Stohr, M. K. (1995). "Inmate Needs and Programming in Exclusively Women's Jails." The Prison Journal, 7, 186-202.

Hannah-Moffat, K. (1995). "Feminine Fortresses: Women Centered Prisons?" The Prison Journal, 75, 135-165.

Hannah-Moffat, K. (2000). "Prisons that Empower: Neo-liberal Governance in Canadian Women's Prisons." British Journal of Criminology, 4, 510-531.

Heney, J. (1990). Report on Self-injurious Behavior in the Kingston Prison for Women. Ottawa: Ministry of the Solicitor General, Corrections Branch.

Heney, J., & Kristiansen, C. M. (1998). "An Analysis of the Impact of Prison on Women Survivors of Childhood Sexual Abuse." Women & Therapy, 20, 29-44.

Human Rights Watch Women's Rights Project. (1996). All Too Familiar: Sexual Abuse of Women in U.S. State Prisons. New York: Human Rights Watch.

Johnson, H. D. (2002). Evie Evan's Life History: Her Sociological Sojourn from a Lifetime of Crime to a Life of Dignity. Retrieved June 22, 2003, from www.rcgd.isr.umich.edu/prba/perspectives/springsummer2002/johnson.pdf.

Kalichman, S. C., Williams, E. A., Cherry, C., Belcher, L., & Nachimson, D. (1998). "Sexual Coercion, Domestic Violence, and Condom Use among Low-income African American Women." Journal of Women's Health, 7, 371-378.

Kendall, K. (1993). Program Evaluation of Therapeutic Services at the Prison for Women. Ottawa: Correctional Service of Canada.

Kendall, K. (1994). Creating Real Choices: A Program Evaluation of Thera-

peutic Services at the Prison for Women. Forum on Women in Prison, 6, 1. Retrieved June 22, 2003 from http://www.csc.scc.gc.ca/text/pblct/forum/e06/e061ine_e.shtml.

Kupers, T. (2001). Written Testimony Re: Everson v. Michigan Department of Corrections. Case No. 00-73133, Feb. 16, 2001, U.S. District Court, E. Dist. of Michigan, Honorable Avern Cohn, Judge.

Lake, E. S. (1993). "An Exploration of the Violent Victim Experiences of Female Offenders." Violence and Victims, 8, 41-51.

Lord, E. (1995). "A Prison Superintendent's Perspective on Women in Prison." The Prison Journal, 75, 257-269.

Louise, B. (1998). "The Victimization... and... Revictimization of Female Offenders." Corrections Today, 6, 106-110.

MacKinnon, C. (1993). "Feminism, Marxism, Method and the State: Toward a Feminist Jurisprudence." In P. B. Bart & E. G. Moran (Eds.), Violence Against Women: The Bloody Footprints. Newbury Park, CA: Sage.

Marcus-Mendoza, S. T., Klein-Saffran, J., & Lutze, F. (1998). "A Feminist Examination of Boot Camp Prison Programs for Women." Women & Therapy, 21, 173-185.

McClellan, D. S., Farabee, D., & Crouch, B. M. (1997). "Early Victimization, Drug Use, and Criminality: A Comparison of Male and Female Prisoners." Criminal Justice and Behavior, 24, 455-476.

McQuaid, S., & Ehrenreich, J. H. (1998). "Women in Prison: Approaches to Understanding the Lives of a Forgotten Population." Affilia Journal of Women and Social Work, 13, 233-246.

Meyer, M. (1992, November 9). "Coercing Sex Behind Bars: Hawaii's Prison Scandal." Newsweek, pp. 23-25.

Morris, A., & Wilkinson, C. (1995). "Responding to Female Prisoners' Needs." The Prison Journal, 75, 295-305.

Moss, A. (1999). "Sexual Misconduct among Staff and Inmates." In P. Carlson & J. Garrett (Eds.), Prison and Jail Administration: Practice and Theory. New York, NY: Aspen Publishers.

Neisen, J. H. (1993). "Healing from Cultural Victimization: Recovery from Shame Due to Heterosexism." Journal of Gay & Lesbian Psychotherapy, 2, 49-63.

O'Keefe, M. (1998). "Posttraumatic Stress Disorder among Incarcerated Battered Women who Killed their Abusers and those Incarcerated for Other Offenses." Journal of Traumatic Stress, 11, 71-78.

Owen, B., & Bloom, B.(1995). Profiling the Needs of California's Women Prisoners: A Need's Assessment. Retrieved June 22, 2003 from http://www.nicic.org/pubs/1995/012451.pdf.

Pilkington, N. W., & D'Augelli, A. R. (1995). "Victimization of Lesbian, Gay, and Bisexual Youth in Community Settings." Journal of Community Psychology, 23, 33-56.

Pollock, J. (2002). Women, Prison, and Crime (2nd Ed.). Pacific Grove, CA: Brooks/Cole.

Pomeroy, E. C., & Kiam, R. (1998). "Meeting the Mental Health Needs of

Incarcerated Women." Health & Social Work, 23, 71-75.

Remer, P. (2003). "Empowerment Feminist Therapy." Paper presented at the American Psychological Association Conference, August 7-10, 2003.

Scarth, K., & McLean. (1994). The Psychological Assessment of Women in Prison. Forum on Women in Prison, 6, 1. Retrieved June 22, 2003 from http://www.csc.scc.gc.ca/text/pblct/forum/e06/e061h_e.shtml.

Singer, M. I., Bussey, J., Song, L. Y., & Lunghofer, L. (1995). "The Psychosocial Issues of Women Serving Time in Jail." Social Work, 40, 103-113.

Smith, C., & Thornberry, T. P. (1995). "The Relationship Between Childhood Maltreatment and Adolescent Involvement in Delinquency." Criminology, 33, 451-481.

Smith, C. (2001). "Sexual Abuse Against Women in Prison." Criminal Justice, 16, 30-38.

Snell, T. L., & Morton, D. C. (1994). Women in Prison: Survey of State Prison Inmates, 1991. Washington DC: U. S. Department of Justice.

Stein, B. (1996). "Sexual Abuse; Guards Let Rapists into Women's Cell." The Progressive, 60, 23-24.

Struckman-Johnson, C., Struckman-Johnson, D. L., Rucker, L., Bumby, K., & Donaldson, S. (1996). "Sexual Coercion Reported by Men and Women in Prison." Journal of Sex Research, 33, 67-76.

Tjaden, P., Thoeness, N., & Allison, C. J. (1999). "Comparing Violence over the Life Span in Samples of Same-sex and Opposite-sex Cohabitants." Violence and Victims, 14, 413-425.

Walker, L. (1992). "Battered Women Syndrome and Self-defense." Notre Dame Journal of Law, Ethics, and Public Policy, 6, 321-334.

Walker, L. (1994). "Are Personality Disorders Gender Biased?" In S. A. Kirk & S. D. Einbinder (Eds.), Controversial Issues in Mental Health (pp. 21-29). New York: Allyn & Bacon.

West, C. M. (2002). "Battered, Black, and Blue: An Overview of Violence in the Lives of Black Women." Women & Therapy, 25, 5-27.

Widom, C. S. (1989). "Does Violence Beget Violence? A Critical Examination of the Literature." Psychological Bulletin, 106, 3-28.

Widom, C. S., & Ames, A. (1994). "Criminal Consequences of Childhood Sexual Victimization." Child Abuse & Neglect, 1, 303-318.

Wyatt, G. E., Guthrie, D., & Notgrass, C. M. (1992). "Differential Effects of Women's Child Sexual Abuse and Subsequent Sexual Revictimization." Journal of Consulting and Clinical Psychology, 60, 167-173.

Zupan, L. L. (1992). "Men Guarding Women: An Analysis of the Employment of Male Correctional Officers in Prisons for Women." Journal of Criminal Justice, 20, 297-309.

Danielle Dirks *(ddirks@soc.ufl.edu) is a graduate student researcher at the University of Florida in the Department of Sociology. Her research interests include racial and ethnic relations, gender, and beauty.*

Blurring the Boundaries:

Women's Criminality in the Context of Abuse

Angela M. Moe

A link between women's victimization, generally speaking, and crimi-
nal offending has been substantiated throughout feminist crimino-
logical scholarship. However, more research is needed in order to
better understand the connections between intimate partner victim-
ization and female offending within varying contexts. The purpose
of this study was to examine the ways in which different criminal
offenses within the context of intimate-partner battering may be
understood as an extension of a woman's efforts to survive this vic-
timization. Specifically, I was interested in analyzing how the context
of intimate-partner battering shapes a woman's choices, or lack
thereof, to engage in crime. Stated another way, does intimate-part-
ner victimization create a context for women in which engaging in
illegal activity seems reasonable, or perhaps necessary, in order to
survive and resist victimization? I argue that while there are indeed
various avenues of legitimate help-seeking theoretically available to
battered women (e.g., calling the police, filing for divorce, fleeing to
a shelter), these avenues are sometimes unavailable, inaccessible, or
unhelpful. In this context, committing crimes provides an additional
outlet for surviving violent victimization.

Conceptual Framework

Woman battering is one of the most pervasive social problems today.
It occurs within a central institution in our society, the family or inti-
mate dyad, and involves the patterned manipulation, degradation,
and abuse of a woman by an intimate partner (most commonly a
man) for the purposes of establishing power and control. Battering
accounts for the physical injuries and sexual assaults of approxi-
mately 1.5 million women each year in the United States (Tjaden &
Thoennes, 2000), as well as the deaths of an estimated 1,300 women
annually (U.S. Department of Justice, 2000). These figures illustrate
the way in which even our most intimate of spaces remains infused
with patriarchy and gendered violence.

By supporting idealized hegemonic standards of gender, patriarchy lends a supportive structure for male domination of females in various respects (Rhode, 1989). For instance, men are encouraged to take authoritative roles in dating situations and marriage in ways that ensure women remain respectful of, dependent upon, and submissive to them (McGregor & Hopkins, 1991; Schneider, 2000). Patriarchy also plays a significant role in entrapping battered women in abusive relationships by influencing social expectations about marriage and the role of law in violent domestic situations (Dobash & Dobash, 1988; Schneider, 2000; Stark & Flitcraft, 1991). Marriage has long been considered a sacred and private institution that should not be intruded upon by outside forces like the police or court system (McGregor & Hopkins, 1991). The justice system, particularly the police and courts, have historically marginalized or outright ignored battered women's requests for protection (Buzawa & Austin, 1993; Dobash & Dobash, 1979; Ferraro, 1989; Websdale, 1995; Websdale & Johnson, 1997) and continue to respond to them in inconsistent and often discriminatory ways (Eigenberg, Scarborough, & Kappeler, 1996; Ferraro, 1989, 1993; Ptacek, 1999) in spite of mandatory and presumptive arrest policies, enhanced prosecutorial efforts, and harsher sentences for convicted offenders.

While the Violence Against Women Act [VAWA] has provided much needed funding for police, prosecutors, education and other prevention programs, as well as shelters and victim services (U.S. State Department, 1998), its effectiveness has simultaneously been impeded by welfare reform (Roberts, 1999). The 1996 Personal Responsibility and Work Opportunity Reconciliation Act [PRWORA] substantially eroded welfare benefits for the poor, many of whom are impoverished because of domestic violence (Brandwein, 1999; Ferraro, 2001; Kurz, 1998; Zorza, 1991). While PRWORA provides a stipulation for domestic-violence victims whereby they may be exempted from the time limits placed on recipients for receiving benefits, these exemptions are inconsistently offered to abused women (Kurz, 1998; Roberts, 1999).

Aside from gender and social class, race and ethnicity also affect the ways in which society and the justice system respond to battered women and their abusers. Critical race feminist theorists contend that Black women often face particular forms of social and legal discrimination that cannot be properly accounted for by emphasizing gender over race or vise versa (Collins, 1989; Crenshaw, 1991). Similar concerns have been noted for Latinas (Flores, 1996; Montoya, 1994), Asian American women (Cho, 1997), American Indian

women (Ross, 1998) and First Nation women in Canada (Razack, 1998). Thus, research on woman battering must be approached from multiple perspectives as women of different races, ethnicities, ages, and social classes experience distinct forms of oppression simultaneous to their experiences as survivors of battering.

That being said, institutional and social failures to respond in helpful and empowering ways to battered women, regardless of their intersected identities, have contributed to their entrapment in abusive relationships. Contrary to popular misconceptions, however, most women do eventually leave their abusers, often in spite of the justice and social welfare systems, not because of them (Ferraro, 1997; Jones, 1994). Some continue to seek legal protection from institutions that are indifferent to their needs and circumstances. Some leave their abusers and rely on the good faith of friends, family, and non-profit victim assistance agencies for safety, many of which are unwilling or unable to provide such support. Some women, many of whom have exhausted the previously stated options, engage in some type of illegal activity, either in response to their abuser's threats, as a coping mechanism, or as a survival mechanism after leaving their abusers.

Battered Women as Offenders

The experiences of battered women in illegal activities have garnered increased attention over the last few decades, as scholars have attempted to place women's criminal activity within the context of their lived experiences and circumstances. For example, numerous studies have examined the context in which women commit murder, finding that most do so after being abused by the men they kill (see Browne, 1987; Browne & Williams, 1989; Gauthier & Bankston, 1997). For female juvenile offenders, child physical, sexual, and emotional abuse, as well as neglect, seems to be an almost universal experience. Incest, sexual molestation and severe physical beatings are among the most common reasons delinquent girls report for their initial involvement in criminal activities as they have tried to develop practical survival strategies for their victimization (i.e., running away from home, prostituting on the streets) (Arnold, 1990; Chesney-Lind, 1997; Chesney-Lind & Sheldon, 1998; Lake, 1993; Sargent, Marcus-Mendoza, & Yu, 1993). Similarly, women's non-lethal offenses may encompass strategies for coping with victimization within their intimate relationships (e.g., self-medicating with drugs), as a direct result of battering (e.g., participating in a robbery with one's partner), or as a survival

mechanism upon escaping an abusive environment (e.g., stealing as income for one's family) (Comack, 1996; Ferraro, 1997; Johnson, Li, & Websdale, 1998; Jurik & Winn, 1990).

The process through which victimized women and girls become situated in ways that facilitate their criminalization is often studied through a conceptual framework known as "pathways to crime" (see Arnold, 1990; Chesney-Lind & Rodriquez, 1983; Daly, 1992, 1994; Gilfus, 1992; Owen, 1998; Richie, 1996). "Pathways" literature is primarily concerned with how the boundaries between victimization and offending are blurred for women and girls, particularly with regard to victimization in the home and minor offending. The central goal of pathways research is to examine the events and circumstances throughout the life course that put women and girls at risk for criminal offending (Belknap, 2001).

Gilfus's (1992) analysis of life history interviews of 20 incarcerated women is one of the few examples of pathways research that has concentrated on the links between woman battering and women's non-lethal offending. In this study, 16 (80%) out of the 20 women had been in abusive relationships; some reported being in as many as five battering relationships. They described highly gendered relationships with their abusers, primarily centering on drug use, in which they were expected to secure income for drug purchases, often through prostitution or shoplifting, while their partners acted as pimps or fenced the stolen items. The women described severe battering incidents when their partners thought they were not producing enough income, were taking more than their share of the money or drugs, or wanted to punish them for prostituting.

In a more recent study of incarcerated battered women, Richie (1996) documented the various factors in poor, Black women's lives that result in their social marginalization and facilitate their criminalization. Richie relied on life-history interviews to compare the experiences of 26 battered Black women to five non-battered Black women and six battered White women. She concluded that the battered Black women faced a particular set of circumstances, induced by the injuries, degradation, and trauma caused by battering, and complicated by racism and poverty, which perpetuated their engagement in illegal activities. She used her findings to advance the concept of "gender entrapment," about which she wrote:

> gender entrapment...describe[s] the socially constructed process whereby African American women who are vulnerable to men's violence in their intimate relationships are penalized for behaviors

they engage in even when the behaviors are logical extensions of
their racialized gender identities, their culturally expected gender
roles, and the violence in their intimate relationships. The model
illustrates how gender, race/ethnicity, and violence can intersect to
create a subtle, yet profoundly effective system of organizing
women's behavior into patterns that leave women vulnerable to pri-
vate and public subordination, to violence in their intimate rela-
tionships and, in turn, to participation in illegal activities (p. 4).

It certainly appears as if intimate partner violence plays an important
role in battered women's decisions to engage in illegal activities. As
Gilfus (1992) and Richie (1996) point out, the survival strategies
women select either by choice or necessity to deal with such abuse
seems to facilitate their criminalization, effectively transforming
them from victims to offenders.

Methodology

Qualitative, semi-structured interviews were used to gather data for
this research. This method was chosen for a number of reasons, not
the least of which was a recognition of epistemic privilege, which
holds that members of marginalized groups are better positioned
than members of socially dominant groups to describe the ways in
which the world is organized according to the oppressions they expe-
rience (Collins, 1989; Hartsock, 1987; Smith, 1987). The intent here
was to emphasize battered women's accounts of their criminality over
other, perhaps more commonly accepted explanations offered, for
example, by jail and prison clinicians, criminal justice authorities,
counselors, and even academicians. Hence, the "survivor speech"
(Alcoff & Gray, 1993) included here is aimed at challenging hege-
monic discourses on women's criminality.

I obtained interviews at an emergency shelter for victims of
domestic violence in the Phoenix-metropolitan area of Arizona. The
shelter was medium in size with bed space for women and their chil-
dren for up to three months, contingent upon their successful
requests for extensions and progress through the shelter's treatment
program. During the time of this study, I was employed part-time at
the shelter as a fill-in staff member. After obtaining permission from
the shelter administrators and my university's human subjects review
board, I began introducing the project to residents and interviewing
those who volunteered to participate. I interviewed everyone who
volunteered for the project until my financial resources for providing

stipends to participants were expended. A total of twenty interviews were completed via this method throughout the summer and fall of 2000. However, one woman's interview was excluded from this analysis because she had been battered by her parents rather than by an intimate partner. Hence, her experiences with criminality did not fit within the scope of this article, which focuses on criminality within the context of partner battering.

The interviews occurred at the discretion of the participants within private rooms of the shelter, and lasted an average of 55 minutes. With each woman's permission, the interviews were audiotaped and transcribed. Each woman was given the opportunity to provide her own pseudonym for identification purposes, as well as pseudonyms for other people mentioned during the interview. In cases in which women expressed no preference for particular pseudonyms, alternative names were assigned. Additionally, each participant was given a remuneration of ten dollars cash, and access to her transcript. The transcripts were then coded for emergent and recurring themes and analyzed using a grounded approach (Glaser & Strauss, 1967).

My position at the shelter seemed to facilitate the research process, as many of the women exhibited a great deal of comfort, honesty, and candor throughout the interviews. I asked the women to describe what had brought them to the shelter, the ways in which they had sought help, and responses by social entities to their efforts. During the course of these conversations, I also probed the participants about any illegalities they may have committed throughout their lives and asked them to describe the situations in which those activities were undertaken. All of the questions were open-ended so as to provide the women with opportunities to shape the flow and content of their interviews (Reinharz, 1992). This approach yielded a wealth of information on various aspects of the women's lives, while simultaneously allowing interviewees to stay within their personal boundaries of comfort and safety. So while this method may be criticized because of its lack of reliability and generalizability, it may be credited for producing a richly descriptive set of narratives that would not have been possible through alternative means of data collection (Kvale, 1996).

Profile of Participants

For demographical purposes, I asked the women to describe their identities in terms of race/ethnicity, age, class, and educational attainment. Nine (47%) identified themselves as White, four (21%)

as African American, two (11%) as Latina, two (11%) as American
Indian, and two (11%) as biracial (American Indian/White and
African American/White). Five (26%) women were between the ages
of 18 and 25, ten (53%) were between 26 and 35, and four (21%)
were between 36 and 45. Regarding socioeconomic class, five (26%)
women reported being consistently poor prior to their stay at the
shelter. These women described lives filled with the strain of living in
poverty, which included unemployment, homelessness, and reliance
on public subsidies for cash payouts and food stamps. Ten (53%)
women reported being of lower or working class, and four (21%)
described themselves as middle-class. Regarding education, eight
(42%) had obtained less than a high school education, five (26%)
had either graduated from high school or obtained a G.E.D., and five
(26%) had completed at least some college.

While the women were quite diverse in terms of race, ethnicity,
age, class, and education, they were very similar in terms of mother-
hood and their experiences of abuse. Sixteen (84%) had children,
and all but one of these children were under the age of 18. The
majority of these kids were living at the shelter and four (21%)
women were also pregnant at the time of the interviews. All of the
women had suffered severe and multiple forms of battery. Eighteen
(95%) women stated that they had been physically assaulted, seven
(37%) described instances of sexual assault, 16 (84%) reported emo-
tional or psychological abuse, and 13 (68%) recounted experiences
of financial and/or property abuse. Seven (37%) of the women had
experienced abuse by one partner, six (32%) reported two abusive
partners, three (16%) described three abusive partners, one (5%)
reported having four abusive partners, and two (11%) stated that
they had been abused by five partners.

The women were also quite active in seeking help with their vic-
timization, either during their abusive relationships as they
attempted to prevent further assaults and salvage their relationships,
or during the course of leaving their partners and terminating their
relationships. Indeed, at the time of the interviews all of the women
were separated from their abusers by virtue of residing in the shelter.
Six (50%) had previously moved within the state to escape their abu-
sive partners and four (33%) had moved out-of-state. All had
returned to their abusers for reasons such as having no money; being
threatened, stalked, sabotaged or harassed by their abusers; being
encouraged by their families to reconcile; feeling guilty; being lonely;
and still loving their partners.

Thirteen (68%) had previously sought help or support from

friends and relatives. Their responses varied, with some women receiving a lot of emotional and/or financial assistance, while others felt abandoned. However, the majority felt abandoned. Thirteen women (68%) called the police and cooperated with any subsequent prosecutorial efforts, and eleven (58%) had filed for restraining orders, divorces, or full custody of their children upon separation. In general, such tactics did not seem to protect the women from continued assault or harassment. Prior to their shelter stay at the time of the interviews, fifteen (79%) women had relied on victim-based services such as shelters, hotlines, support groups, and advocacy centers. However, space constraints, rules, and inaccessibility prohibited many women from experiencing consistently positive responses by such agencies. Eleven (58%) women had contacted a social service agency for help, but were largely dissatisfied with the bureaucracy and lack of empathy exhibited within such agencies. Finally, while all of the women had sustained injuries that merited medical attention, only six (32%) sought treatment. Of these, only one woman reported a positive response in terms of support and offers of referral by medical personal, while the five others stated that no one had recognized or questioned them about the cause of their injuries. Those who did not seek medical help either lacked health insurance or money to pay for medical bills, used illicit drugs as self-medication, and subsequently chose not to risk being arrested by going to a doctor, or lacked a means of safe transportation to medical facilities.

It is worth mentioning here that the women's intersected identities seemed to affect their success within legitimate help-seeking avenues. As examples, one woman who had been abused by both male and female partners did not feel that the heterosexual-based services of the shelter addressed her victimization by a lesbian partner. An American Indian woman reported that the only medical facility to recognize the cause of her injuries was the Phoenix Indian Medical Hospital, a resource she only had available to her because of her ethnicity. And a monolingual, Spanish-speaking, Mexican immigrant found it difficult to locate bilingual legal services as she sought an American divorce from her husband.

Findings

Of the 19 battered women interviewed for this research, ten (53%) committed some sort of illegality related to their abuse. Most of these reported offenses were non-violent, petty crimes, the most common being drug- and alcohol-related offenses and low-level fraud and

theft. Some women also reported committing violent offenses, describing instances in which they had attempted to fight back or in some way retaliate against their abusers. It is important to note that with regard to violence, only those women who could have been arrested based on Arizona laws and police practices at the time of this research were included here. There was one woman whose actions, while perhaps violent by definition, were so clearly in the realm of self-defense that it would have been extremely unlikely that she would have been arrested. This woman's "defense wounds" were believed to have saved her life when she struck back against her abuser while he was stabbing her multiple times. Her actions prohibited many of his stabbings from penetrating deeper into her body.

The women described committing crimes for three primary reasons: (1) to cope with abuse by an intimate partner; (2) to keep an abusive relationship in tact and/or appease a batterer; and (3) to survival financially upon leaving the relationship. Thus, criminality seemed to serve as both a survival strategy and as a means of resistance. While the intent of this study was not to suggest that a direct causal link exists between intimate partner victimization and offending (such a link is not statistically testable due to the qualitative nature of the data), there did appear to be a connection between women's intimate partner victimization and their decisions to commit crimes.

Drug- and Alcohol-Related Offenses

Drug- and alcohol-related offenses seemed to be very much related to experiences with intimate partner battering. Consistent with prior research (Richie, 1996; Ross, 1998), women may use drugs and alcohol to numb their feelings, thought patterns, and emotions during and after attacks by their batterers. Their reliance on drugs or alcohol seemed to fluctuate depending on the status of their relationships, increasing or progressing into an addiction with the presence of abusive partners in their lives. Cynthia, a White woman, testified to the benefits of using crystal methamphetamines to mentally escape the abuse she endured throughout her ten-year relationship. Cynthia's abuser was incarcerated intermittently throughout this period and, as she explains, her drug use fluctuated accordingly:

> He was always in and out of jail. The only time I did drugs was when he was around. When he was gone, I worked and took care of the kids.... Sometimes I did it just to escape the pain in my life. By

doing meth you don't feel anything. It just makes you an angry person instead. You don't have to feel all the emotional crying and that crap. [Did he get more abusive with you when he was on meth?] Yes and he was always on it.... The drugs were a tool to help me survive. They had to be there. Sometimes I think if the drugs weren't there I wouldn't have survived because I probably would have just killed myself.... I didn't care about nobody or nothing. I just didn't care. That's how I got through the days. Because if I would've cared then I would've been in so much pain. I don't know at that time if I could have dealt with that. [Q: Did the abuse get worse in time?] Yes. [Q: And then did the drug abuse get worse?] Yes, because you always need more until you're using a lot.

Cynthia also used drugs as an attempt to appease her boyfriend and salvage their relationship. Consistent with prior research with battered female offenders (Richie, 1996), women sometimes believe that going along with their abusers' drug involvement may help them establish a better connection with their partners and avoid further victimization. As is also common (Inciardi, Lockwood, & Pottieger, 1993), Cynthia was initially introduced to crystal methamphetamines by her boyfriend, and became almost immediately addicted to the drug. Her addiction worsened as she used drugs with her boyfriend in hopes of keeping him at home for longer periods of time: "Sometimes I'd do it just to get his attention or keep him at home.... He'd take off and he wouldn't be home for like three or four weeks."

Of course, once addicted to drugs or alcohol, making a decision to leave an abusive partner, particularly if that partner is the supplier of the drugs, is made much more difficult. As Michelle, a 36-year old White woman, described:

> When I got involved with the drug dealer, I kind of said, "Screw my life. I don't care anymore." I felt worthless.... He didn't like force me, he didn't hold a gun to my head and tell me to do anything. He put these people in my life and I was using...I wasn't even in my right mind.... And it's really hard to leave an abuser if you're under the influence of any kind of chemicals because you are just afraid, because you've got this other issue going on.

Certainly domestic violence seemed to fit well within the drug-using milieu, as Ramona, a 29-year old Black woman, attested:

> With my first abusive relationship, that was back in my druggin' days...I thought it was okay that I would get beaten and he'd tell

me, "You make me do this but I love you." I was like "Okay, it's
going to get better. It's going to get better." Then I was dealin' with
addicts also so it was okay. It was just part of what us addicts did or
something...

Another rationale women offered for using drugs and alcohol dur-
ing the context of a battering relationship was to medicate them-
selves after an assault. Women described situations in which they
were not allowed or able to seek medical attention for their injuries.
Some did not have the money or insurance needed to pay for the
proper, legal medication, and subsequently experienced long-term
effects or debilitations due to untreated injuries. These accounts are
quite similar to those cited in Richie's (1996) study as well.

Lee, a 44-year old biracial (Cherokee/White) woman, provided
the clearest example of this. Like Cynthia, she had been introduced
to drugs by a husband, who, along with abusing her, was also well
known on the streets for dealing drugs and committing various acts
of violence:

> Fourteen years ago I was addicted to cocaine. My ex-husband got
> me on it and I was so bad I could hear it being chopped up in the
> next room...It had control of me but I lived that way because of my
> situation there too. I was with a very strong, big dealer and I was
> very much in love. When he got me hooked on it I didn't realize it.

Lee had suffered numerous long-term injuries from this partner's
abuse as well as a subsequent boyfriend's abuse, including nerve and
slight brain damage:

> I self-medicated is what they call it. I used meth but see I would buy
> it and capsule it out. I would take one in the morning and one in
> the afternoon. It was from when I got beaten really badly because I
> ended up with narcolepsy, a form of narcolepsy. It's when the brain
> does not produce your natural speed. They put me on pharmaceu-
> tical speed is what it was but it was too expensive and Medical
> wouldn't cover it because it's a non-life threatening prescription.
> Well, I used that to stay awake. I would take it in the morning so I
> could wake-up. My son would have to actually just wake me until I
> would take it, take a capsule and then I'd go to work. About 12:30 I
> would take another one and that would take me through the day.
> Then by 9:30 we were both in bed. I never partied with anybody. I
> never bought from anybody but my brother. I used it as a medica-
> tion instead of drugs.... I used it for almost ten years.

Thus, similar to the ways in which women used drugs as a mental escape, they also used these substances to relieve pain and recover from injuries. That a woman consciously capsuled out methamphetamines as a way of medicating herself in the absence of proper medical insurance or funds to purchase legal drugs is indicative of the lagging health care system for poor people in Arizona. Given that around the time of this research, nearly 17% of non-elderly Arizona residents were living at or below the poverty line, that approximately 43% were considered low-income, and that about 20% did not have health insurance, the likelihood that many more people self-medicate, either within or outside the context of domestic violence, is great (Henry J. Kaiser Family Foundation, 1998).

Fraud and Theft

The women also admitted to minor acts of fraud or theft as a means of coping with, surviving, and resisting intimate partner abuse. The most common forms of fraud and theft reported were welfare fraud and check fraud; however, a few women also reported stealing credit-card numbers, shoplifting, and burglary as well.

At 28, Tazia, who was White, reported quite a lengthy criminal record. She attributed the start of her criminality to her abusive boyfriend, whom she began dating at age 17 after being legally emancipated from her abusive and neglectful mother and stepfather. Tazia described her circumstances before and after her first incarceration:

> The boyfriend that I was with was real heavy into criminal activity...so I started stealing from the time I was 17 to the time I was like 23. I was stealing to pay my rent, my bills.... At 18 I went to the penitentiary. The boyfriend that I moved in with that taught me how to steal and how to do credit cards and all that, he was working at a restaurant and he had a key to the restaurant and he knew that they kept their deposit money overnight until the morning. He went in and took the money and I guess he bragged to a few friends. When the police came to our apartment, I totally took all the blame for it. He was abusive and he threatened me and told me that he had already been to jail before and if he got caught on this he would be doing a lot of time. I'd never been in trouble with the law before and I'd just get probation or a slap on the hand and I'd be out in no time.... They ended up giving me 18 months in the pen. When I got out I had nothing. I had no clothes, nothing to live on, so I just stole again. I continued to steal to get my money back and then I got my own place...I ended up going to jail again for writing checks

when I was 20. In and out of jail from 18 to 23, constantly...nothing violent or anything like that. It was all theft, shoplifting, checks, possession of stolen items, etcetera.

Most women did not have as extensive or diverse of criminal records for fraud and theft as Tazia. On the other end of the spectrum, Cynthia, cited earlier, simply reported receiving stolen items from her boyfriend who offered them as tokens of reconciliation: "He always stole stuff and he'd bring it to the house and try to give it to me as a present and I'm like, 'I don't want that. It belongs to somebody else.'"

It was more common for women to report only a few instances of one form of fraud or theft, which they committed at very specific times in accordance with abusive relationships. Welfare fraud and check fraud were the most common crimes in these scenarios. Terri, a 38-year old White woman, had traveled through many states fleeing her abusive husband before arriving in the Phoenix area. She admitted that she had probably conspired to commit welfare fraud. She had very little control over money in her household because her husband kept everything from her, only giving her money intermittently to pay for household supplies and food. Because he had a partnership in his own business, Terri believed her husband had adequate resources to provide for their family but never did so. She also believed her husband had been committing some sort of financial fraud through his business that allowed him to report a very low annual income on their last tax return. As far as Terri was concerned, collecting welfare at least helped her somewhat in caring for her six kids:

> [You said you were on food stamps so you guys must not have had much money at all if you were together and you were still eligible for food stamps.] Well, he has money. I know he's hiding it. I think if they started digging, they'd find it pretty easily. He's not that smart. On our taxes, it reflects we made $7000 last year. But he has a friend, a partner, and they play so many games.... I think that we did welfare fraud, in my opinion. I don't feel that I had a knowledge of it. I know he had money but I had to eat. He was down there as head of household so I don't know. I don't know why we got the food stamps. We got $598 a month.

Lydia, a 27-year old Latina, also acknowledged that she had probably committed welfare fraud. An abusive boyfriend, who fathered Lydia's youngest child, was wanted by the Federal Bureau of Investigation for bank robbery and other felonies. Lydia had changed her and her son's names and social-security numbers because of the danger this

man posed. However, she was not able to do the same with her two older sons because they had been fathered by her ex-husband. Thus, when she applied for and received public assistance, she did so just for herself and her youngest son, believing that she did not have to document her older children. When her oldest son became ill, and Lydia applied for Medicaid to cover his medical expenses, the state linked her to her older sons and found out that she had lied on the welfare application:

> I'm going to have to talk to the Department of Human Services about welfare fraud. I did it unintentionally. It was because of the name change and because I didn't know I still had to put my older two on there. I was trying to keep the names separate. My [oldest] son ended up sick. He had an asthma attack and his dad was out of town so I took him to the hospital. It linked our names right there. I had tried to apply for Medicaid to pay for the hospital so we got linked right there.

Faith, a young 22-year old White woman, had spent six months in jail for writing fraudulent checks while pregnant. She had become pregnant by a boyfriend who raped her and was becoming increasingly physically abusive:

> I told him to get off me and he refused. At first I consented to having sex with him but...I told him to get off me. This is a big, huge football player. There's no way.... I found out I was pregnant and I had no money to my name and wanted to get out of the situation I was in and wanted to get out of state. The only thing I could do to survive, put food in my stomach and clothes on my back, was to write bad checks. I took the consequences for it. [About how much money did you write checks for?] I've already paid $3000. I still owe another $3000. [How long were you writing bad checks?] Two months maybe, if that.

Faith also admitted to lying on her welfare application about the father of her child because she did not want the ex-boyfriend to find her or threaten to take her son away from her. As she stated:

> I just didn't tell them the truth about who his father is because I don't want anybody looking him up, telling him that Nathaniel is his.... I'm not going to let that happen. He told me...if I got pregnant he would take the child from me. I will not let him near my child.

In these scenarios, women committed welfare or check fraud (or went along with their partner's fraudulent activities) because of economic necessity. They did what they felt they needed to do in order to provide for their families.

Theft did not seem to be as common a crime for women as welfare and check fraud in terms of surviving and coping with abuse. This may have been because collecting extra welfare checks, falsifying welfare applications, and writing bad checks were easier and more convenient activities than actually stealing items from businesses or individuals. Indeed, women often do commit crimes that correlate directly to their daily routines and activities (English, 1993). These routines and activities are subsequently influenced by societal gender norms, which shape the capabilities and freedom women have to commit illegalities (Steffensmeier & Broidy, 2001). However, for one woman in particular, stealing a single item was imperative to her effort to flee her abuser.

Lee, whose self-medicating use of drugs was described earlier, decided to flee California with her four-year old son after she realized her son had also become aware and frightened of his father's abuse. In the excerpt below, Lee describes the urgency with which she prepared to leave the man whom she described as "the bad of the bad":

> I stayed in the state for four years after John was born because that was John's dad. No matter what we had, that was still John's dad. He treated John like a king until one day John said, "Mommy, we need to go because daddy isn't daddy anymore. He is going to hurt us. He scares me." I was packed, loaded, had changed four tires on my truck, stole a fuel pump, and was out of town within 45 minutes.

In sum, the women seemed to commit petty acts of fraud and theft, primarily to obtain the funds needed to survive during an abusive relationship or to leave one. Their actions did not appear to include a great amount of forethought or planning beyond the immediate concern for survival. However, their decisions were deliberate; engaging in illegalities was seen as a necessary choice among dire options. Mothers seemed particularly willing to commit these types of crimes when their children's welfare was at stake. They used the money generated from fraud and theft to house, feed, and care for their children during or after an abusive relationship.

Violence

Few women reported violent crimes, a finding that supports prior research, which has found that female offenders are more likely to commit nonviolent, petty, or property crimes than violent crimes (Greenfeld & Snell, 1999; Warren & Rosenbaum, 1986). The few women who reported committing acts of violence did so either as retaliation for abuse by their partners or as a means of defending themselves during assaults. Ramona, cited earlier, explains her violence:

> He put my face into a medicine cabinet after beatin' me. Even now when I get happy and laugh a lot...you can feel the indents from his fists. I never reported it. I never went to the doctor. Pretty much healed on my own but I guess it didn't because it's still there...I've been letting it go all this time.... After he beat me like this he fell asleep. I was still angered and raged after he went to sleep. I got the cast iron skillet and he was sleeping on the couch. I started beating him in his head. He had already been in a car accident and his head hadn't healed up all the way. I reopened that scar. I left him for dead.

In Ramona's mind, the aggressiveness and hostility with which she beat her boyfriend was well deserved after the injuries she had endured. The fact that she waited until her abuser had passed out was also common. Many women described instances in which they became quite attuned to their abusers' psychological state before and during an assault. They were able to predict an upcoming assault based on the way their partners acted preceding such incidents. They also became adept at gauging how serious an assault would be depending on the nature of the argument that preceded it and whether their partners were intoxicated. During some assaults, they believed they could defend themselves successfully. As Patsy, a 26-year old Sioux woman, reported, "I never used to hit him but after a while I was fighting back." However, during other assaults, the women believed any sort of retaliatory action would have made the situation worse. Michelle, cited earlier, described a particular incident:

> Normally I would have fought back but I...at the time that he was abusive that day, he was trying to quit drinking and the doctor put him on Librium and then he went a whole week overmedicating on Librium and then drank alcohol on the seventh day and he was out of his mind...he scared me. He was totally out of control.

Whether or not women chose to retaliate against their abusers, one

prominent theme was clear from their descriptions—their abusers were the instigators of the assaults and inflicted the majority of injuries. As Melissa, a 25-year old biracial (Black/White) woman, attested:

> I fought back. There's been times I fought back. [You fought back or you started the fights?] No, I fought back. I don't start fistfights but I've started arguments before, but I know that he can over-power me so I'm not going to be stupid enough to hit first. You hit me first, I'll hit you back. That's just...there's a reaction.

For some of the women, retaliatory violence was precipitated by what they viewed as a lack of response by law enforcement to their own victimization. As Cynthia, cited earlier, described:

> I called the police all the time at first...20 or 30 times, and then I just said, "Forget it. They're not helping me." I've had like 15 restraining orders against him. [And he's never been arrested?] Never.

Cynthia went on to describe the extent to which she felt isolated because of the lack of attention her abuse garnered by law enforcement. However, when she took matters into her own hands and retaliated against her boyfriend, she was arrested:

> I was arrested one time for throwing butter knives and he told them he wanted me arrested for assault. [They never charged you for anything?] No. They just told me not to throw butter knives.

Regardless of her not being prosecuted for this action, to Cynthia, being arrested for retaliating against a person who had previously abused her on numerous occasions was illustrative of the sexism still present within law enforcement: "I think the state is very hard on women and they don't want to help them get out of situations."

After already having dealt with abusive partners, some women developed a self-protective attitude and viewed retaliatory violence as a means of showing any subsequent partners that they were not going to tolerate further victimization. Lee, previously cited, described her encounter with her last boyfriend, which ended their relationship:

> I had a boyfriend for about three years and he started getting abu-sive. He was very mentally abusive but only after the first six months. The last six months it was like, "You need to move!" He

finally got physically abusive and I almost killed him. I grabbed a
gun and almost shot him. That's when I moved him out. I loaded
the boxes and rented him an apartment and I moved him.

Discussion and Conclusion

Based on the narratives of the women interviewed for this study, bat-
tering seems to be an important situational factor precipitating crim-
inality for women with particular types of experiences. In the context
of experiencing multiple forms of victimization caused by their inti-
mate partners and attempting to make use of legitimate help-seeking
outlets, over half of the women described some sort of criminality
that seemed linked to their victimization. In many of the narratives,
intimate partner abuse was offered as a primary, if not sole, reason
for their decisions to commit crimes. These crimes fell within three
areas: drugs, fraud/theft, and violence. From their descriptions of
these offenses, it seemed clear that such acts were taken to (1) cope
with their victimization during the course of a violent relationship;
(2) keep the relationship together or appease their partners; or (3)
survive financially or emotionally after the termination of a violent
relationship. These connections, even if tentative, must increased
attention. With the majority of female inmates in American jails and
prisons reporting intimate partner victimization (American Correc-
tional Association, 1990; Greenfeld & Snell, 1999), it seems that
"something" is going on which can no longer be ignored. Yet only a
handful of studies have explicitly investigated the link between bat-
tering and non-lethal offending.

While over half of the women in this study described some sort of
criminal offense related to their victimization, a next step in under-
standing how criminality fits within their help-seeking opportunities
would be to examine the differences between this set of women and
those who did not report criminality. Stated differently, how were the
women who reported crimes in this research different than those
who did not? While such a comparison was not the focus of this
inquiry, extending this research into a comparison of offending and
non-offending battered women may yield important findings in
terms of who and who is not being served by legitimate help-seeking
outlets (e.g., police, courts, victim services, social services).

Certainly not all battered women seek help from all available out-
lets. Moreover, some of the agencies we rely on to respond to domes-
tic violence may not be available to women in particular
circumstances. For example, prior criminal records, outstanding war-

rants, and illegal immigration statuses may prevent some women from calling the police, filing orders of protection, or even going to an emergency room for fear of being arrested. Not having the financial resources to utilize the legal system in obtaining divorces or filing for child custody may also prevent women from accessing the protection they need. Furthermore, practicing addicts, felony offenders, and women with serious mental illness are often seen as unsuitable for victim-based services. Additionally, speaking a non-English language may prohibit communication with legal authorities, victim service providers, and social service agents. The list of possible exclusions seems infinite.

Indeed, examining the impact of intersectionality on the women's circumstances is vital to understanding their criminality. Race and ethnicity seemed to affect the women's situations and choices to commit crimes. As noted earlier, women identified ways in which their race, ethnicity, nationality, and sexual orientation affected the ways they experienced legitimate help-seeking. However, few incorporated such discussions into their descriptions of criminality. Based on these findings, it seems that the intertwined and culminating effects of diversity may work against women who are trying to use legitimate help-seeking opportunities in their struggles to survive abuse. Their subsequent success or failure may play a role in their decisions to commit crimes as a survival strategy, even if not explicitly recognized through their descriptions of these illegalities.

Of course, the overarching influence of patriarchy must remain central to any analysis of woman battering and female offending. Along with racism and poverty, Richie (1996) looks to gender as a primary tenet in understanding abused women's criminality. As she suggests, women are essentially entrapped by their gender when they are battered by male partners. Ross (1998) further contends that the abuse itself exemplifies patriarchy and serves to deflect women's strength and desire to resist and survive social marginalization. Within this context, women face a double-edged sword as they are expected to seek assistance from the very institutions that condone their victimization (Ross, 1998). Consistent with Richie's (1996) research, many of the women in this study made what appeared to be quite rational decisions to engage in illegalities in order to survive the patriarchal gauntlet.

Certainly the level of recognition and action currently put forth with regard to woman-battering has not seemed to have greatly affected the circumstances of those who are excluded from legitimate help-seeking avenues. Thus, related to the need of addressing

violence in the home is the necessity to question the criminalization of some women's survival strategies. The women who committed crimes in the context of abuse perceived few, if any, alternative options. They were victims of heinous assaults they did not deserve. They became "criminals" for becoming active agents in their lives. They made decisions based on the limited set of options they perceived to be available at a given time, options we as a society placed before them. Breaking a (man-made) law was subsequently deemed necessary for survival.

REFERENCES

Alcoff, L., & Gray, L. (1993). "Survivor Discourse: Transgression or Recuperation?" Signs, 18, 260-290.

American Correctional Association (1990). The Female Offender: What Does the Future Hold? Laurel, MD: Author.

Arnold, R. (1990). "Processes of Victimization and Criminalization of Black Women." Social Justice, 17, 153-166.

Belknap, J. (2001). The Invisible Woman: Gender, Crime and Justice (2nd Ed.). Belmont, CA: Wadsworth.

Brandwein, R. A. (1999). Battered Women, Children, and Welfare Reform: The Ties that Bind. Thousand Oaks, CA: Sage.

Browne, A. (1987). When Battered Women Kill. New York: Free Press.

Browne, A., & Williams, K. R. (1989). "Exploring the Effect of Resource Availability and the Likelihood of Female-perpetrated Homicides." Law and Society Review, 23, 75-94.

Buzawa, E. S., & Austin, T. (1993). "Determining Police Responses to Domestic Violence Victims." American Behavioral Scientist, 36, 610-623.

Chesney-Lind, M. (1997). The Female Offender: Girls, Women, and Crime. Thousand Oaks, CA: Sage.

Chesney-Lind, M., & Rodriquez, N. (1983). "Women Under Lock and Key: A View from the Inside." The Prison Journal, 63, 47-65.

Chesney-Lind, M., & Sheldon, R. G. (1998). Girls, Delinquency, and Juvenile Justice (2nd Ed.). Pacific Grove, CA: Brooks/Cole.

Cho, S. K. (1997). "Converging Stereotypes in Racialized Sexual Harassment: Where the Model Minority Meets Suzie Wong." In A. K. Wing (Ed.), Critical Race Feminism: A Reader (pp. 203-220). New York: New York University Press.

Collins, P. H. (1989). "The Social Construction of Black Feminist Thought." Signs, 14, 745-773.

Comack, E. (1996). Women in Trouble: Connecting Women's Law Violations to their Histories of Abuse. Halifax, Canada: Fernwood.

Crenshaw, K. (1991). "Demarginalizing the Intersection of Race and Sex: A Black Feminist Critique of Antidiscrimination Doctrine, Feminist Theory, and Antiracist Politics." In K. Bartlett & R. Kennedy (Eds.), Feminist Legal

Theory: Readings in Law and Gender (pp. 57-80). Boulder, CO: Westview Press.

Daly, K. (1992). "Women's Pathways to Felony Court: Feminist Theories of Lawbreaking and Problems of Representation." Review of Law and Women's Studies, 2, 11-52.

Daly, K. (1994). Gender, Crime and Punishment. New Haven, CT: Yale University Press.

Dobash, R. E., & Dobash, R. (1979). Violence Against Wives. New York: Free Press.

Dobash, R. E., & Dobash, R. P. (1988). "Research as Social Action: The Struggle for Battered Women." In K. Yllo & M. Bograd (Eds.), Feminist Perspectives on Wife Abuse (pp. 51-74). Newbury Park, CA: Sage.

Eigenberg, H. M., Scarborough, K. E., & Kappeler, V. E. (1996). "Contributory Factors Affecting Arrest in Domestic and Non-domestic Assaults." American Journal of Police, 15, 27-54.

English, K. (1993). "Self-reported Crime Rates of Women Prisoners." Journal of Quantitative Criminology, 9, 357-382.

Ferraro, K. J. (1989). "Policing Woman Battering." Social Problems, 36, 61-74.

Ferraro, K. J. (1993). "Cops, Courts, and Battering." In E. Moran, P. Bart, & P. Miller (Eds.), Women and Male Violence (pp. 165-176). Newbury Park, CA: Sage.

Ferraro, K. J. (1997). "Battered Women: Strategies for Survival." In A. Carderelli (Ed.), Violence Among Intimate Partners: Patterns, Causes and Effects (pp. 124-140). New York: Macmillan.

Ferraro, K. J. (2001). "Woman Battering: More Than a Family Problem." In L. Goodstein & C. Renzetti (Eds.), Women, Crime and Criminal Justice: Original Feminist Readings. pp. 135-153. Los Angeles: Roxbury.

Flores, L. A. (1996). "Creating Discursive Space Through a Rhetoric of Difference: Chicana Feminists Craft a Homeland." Quarterly Journal of Speech, 82(2), 142-156.

Gauthier, D. K., and Bankston, W. B. (1997). "Gender Equality and the Sex Ratio of Intimate Killing." Criminology, 35, 577-600.

Gilfus, M. E. (1992). "From Victims to Survivors to Offenders: Women's Routes of Entry and Immersion into Street Crime." Women and Criminal Justice, 4(1), 63-89.

Glaser, B., & Strauss, A. L. (1967). The Discovery of Grounded Theory: Strategies for Qualitative Research. Chicago: Aldine.

Greenfeld, L. A., & Snell, T. L. (1999). Bureau of Justice Statistics Special Report: Women Offenders (NCJ 175688). Washington, D.C.: U.S. Department of Justice.

Hartsock, N. (1987). "The Feminist Standpoint: Developing a Ground for a Specifically Feminist Historical Materialism." In S. Harding (Ed.), Feminism and Methodology (pp. 157-180). Milton Keynes, Great Britain: Open University Press.

Henry J. Kaiser Family Foundation. (1998). Arizona at a Glace. State Health Facts.

http://www.kff.org/docs/state/states/az.html (17 Apr. 2001).

Inciardi, J., Lockwood, D., & Pottieger, A. E. (1993). Women and Crack-Cocaine. New York: Macmillan.

Johnson, B., Li, D., & Websdale, N. (1998). "Florida Mortality Review Project: Executive Summary. " In American Bar Association [ABA], Legal Interventions in Family Violence (pp. 40-41). Washington, D.C.: U.S. Department of Justice.

Jones, A. (1994). Next Time She'll be Dead: Battering and How to Stop It. Boston: Beacon Press.

Jurik, N. C., & Winn, R. (1990). "Gender and Homicide: A Comparison of Men and Women Who Kill." Violence and Victims, 5, 227-242.

Kurz, D. (1998). "Women, Welfare, and Domestic Violence." Social Justice, 25(1), 105-122.

Kvale, S. (1996). InterViews: An Introduction to Qualitative Research Interviewing. Thousand Oaks, CA: Sage.

Lake, E. S. (1993). "An Exploration of the Violent Victim Experiences of Female Offenders." Violence and Victims, 8(1), 41-51.

McGregor, H., & Hopkins, A. (1991). Working for Change: The Movement Against Domestic Violence. North Sydney, Australia: Allen & Unwin.

Montoya, M. (1994). "Mascaras, trenzas y grenas: Un/masking the Self while Un/braiding Latina Stories and Legal Discourse." Chicano-Latino Law Review, 15, 1-27.

Owen, B. (1998). In the Mix: Struggle and Survival in a Women's Prison. New York: State University of New York Press.

Ptacek, J. (1999) Battered Women in the Courtroom: The Power of Judicial Responses. Boston: Northeastern University Press.

Razack, S. (1998). "What is to be Gained by Looking White People in the Eye? Culture, Race, and Gender in Cases of Sexual Violence." In K. Daly & L. Maher (Eds.), Criminology at the Crossroads: Feminist Readings in Crime and Justice (pp. 225-245). New York: Oxford University Press.

Reinharz, S. (1992). Feminist Methods in Social Research. New York: Oxford University Press.

Rhode, D. L. (1989). Justice and Gender: Sex Discrimination and the Law. Cambridge, MA: Harvard University Press.

Richie, B. E. (1996). Compelled to Crime: The Gender Entrapment of Battered Black Women. New York: Routledge.

Roberts, D. (1999). "Welfare's Ban on Poor Motherhood." In G. Mink (Ed.), Whose Welfare? (pp. 152-167). Ithaca, NY: Cornell University Press.

Ross, L. (1998). Inventing the Savage: The Social Construction of Native American Criminality. Austin, TX: University of Texas Press.

Sargent, E., Marcus-Mendoza, S., & Yu, C. H. (1993). "Abuse and the Woman Prisoner: A Forgotten Population." In B.R. Fletcher, L.D. Shaver, & D.G. Moon (Eds.), Women Prisoners: A Forgotten Population (pp. 55-64). Westport, CT: Praeger.

Schneider, E. M. (2000). Battered Women and Feminist Lawmaking. New Haven, CT: Yale University Press.

Smith, D. (1987). The Everyday World as Problematic: A Feminist Sociology. Toronto, Canada: University of Toronto Press.

Stark, E., & Flitcraft, A. H. (1991). "Spouse Abuse." In M. L. Rosenberg & M. A. Fenlet (Eds.), Violence in America: A Public Health Approach (pp. 123-157). New York: Oxford University Press.

Steffensmeier, D., & Broidy, L. (2001). "Explaining Female Offending." In C. Renzetti & L. Goodstein (Eds.), Women, Crime, and Criminal Justice: Original Feminist Readings (pp. 111-132). Los Angeles: Roxbury.

Tjaden P., & Thoennes, N. (2000). Extent, Nature, and Consequences of Intimate Partner Violence: Findings from the National Violence Against Women Survey. Washington, DC: U.S. Department of Justice (NCJ 181867).

U.S. Department of Justice, Bureau of Justice Statistics. (2000). Homicide Trends in the U.S.: Trends by Gender. http://www.ojp.udoj.gov/bjs/homicide/gender.htm (5 Dec. 2000).

U.S. State Department. (1998). Violence Against Women. www.state/www/globalwomen/fs_ 980310_women_violence.html (5 Dec. 2000).

Warren, M. Q., & Rosenbaum, J. L. (1986). "Criminal Careers of Female Offenders." Criminal Justice and Behavior, 13, 393-418.

Websdale, N. (1995). "Rural Woman Abuse: The Voices of Kentucky Women." Violence Against Women, 1, 309-388.

Websdale, N., & Johnson, B. (1997). "The Policing of Domestic Violence in Rural and Urban Areas: The Voices of Battered Women." Policing and Society, 6, 297-317.

Zorza, J. (1991). "Woman Battering: A Major Cause of Homelessness." Clearinghouse Review, 25, 421.

NOTE

An earlier draft of this article was presented at the 2002 meetings of the American Society of Criminology, Chicago, IL, and is based on a chapter of the author's dissertation, which was completed under the direction of Drs. Kathleen Ferraro, Marjorie Zatz, and Madelaine Adelman. The author would like to thank all of the women who participated in this study, as well as the staff and administrators of the shelter in which these interviews were conducted.

Angela M. Moe is an Assistant Professor of Sociology at Western Michigan University, 1903 W. Michigan Avenue, Kalamazoo, MI, 49008-5257; Phone (269) 387-5275; Fax (269) 387-2882; E-mail: angie.moe@wmich.edu. She earned a PhD in Justice Studies, Law and the Social Sciences from Arizona State University in 2001. Her areas of interest include victimization, particularly violence against women; the criminalization of victimized women; and women in carceral settings. Her work has appeared in the journals Violence Against Women, Women and Criminal Justice, *and* The Journal of Contemporary Ethnography.

Domestic Violence at the Crossroads

Violence Against Poor Women and Women of Color

Natalie J. Sokoloff

Mainstream feminist theory argues that socially structured and culturally approved gender inequality is causative in understanding domestic violence.[1] This approach was far superior to the earlier individual psychological arguments that pathologized battered women's experiences and blamed them for their own abuse. Too, it was an advance over the family systems approach, which ultimately pathologized either the individual (man or woman) or both partners.

But the intersectional or multicultural domestic violence approach challenges gender inequality as the primary factor explaining domestic violence: gender inequality is neither the most important nor the only factor that is needed to understand domestic violence in the lives of marginalized women. Gender inequality is only part of their marginalized and oppressed status. In fact, argues Bograd (1999), gender inequality is modified by its interesection with other systems of power and inequality that affect the lives of battered women. And one's experience as a battered woman is realized only in relation to other social locations or intersectionalities in society of race, ethnicity, class, sexual orientation, and immigrant and disability status. As Bograd states: "Intersectionalities color the meaning and nature of domestic violence, how it is experienced by self and responded to by others; how personal and social consequences are reproduced, and how and whether escape and safety can be obtained" (p. 276).[2]

In the multicultural domestic-violence literature, two sometimes conflicting objectives emerge: giving voice to battered women from diverse social locations and cultural backgrounds while still focusing on the structural inequalities (i.e., race, gender, class) that constrain and shape the lives of battered women, albeit in different ways. The first has been described as the "race/class/gender" perspective, whose focus is on multiple, interlocking oppressions of individuals and difference; the second has been described as the "structural"

perspective, requiring analysis and criticism of existing systems of power, privilege, and access to resources (see Andersen & Collins, 2001; Mann & Grimes, 2001). My work honors both of these perspectives and demands both "difference" (including culture) and "structural inequality"—as well as culture—to understand the diverse experiences of battered women typically on the margins of U.S. society.

How a Multicultural or Intersectional Analysis Can Help to Understand Marginalized Women's Experiences of Domestic Violence Without Further Disempowering Them

For years we have heard that domestic violence cuts across all classes, races, and ethnic groups. To be sure, there is truth in this statement. Yet multicultural scholars challenge this uncritical view by arguing that poor women of color are the "most likely to be in both dangerous intimate relationships and dangerous social positions" (Richie, 2000, p. 1136). Beth Richie argues that the anti-domestic violence movement's avoidance of a race and class analysis of violence against women "seriously compromises the transgressive and transformative potential of the antiviolence movement's potential [to] radically critique various forms of social domination" (p. 1135). The failure to address the multiple oppressions of poor women of color jeopardizes the validity and legitimacy of the anti-domestic-violence movement.

One dilemma is the problem of how to report race and class differences in domestic violence prevalence rates. This literature indicates that there is tremendous diversity among women regarding the prevalence, nature, and impact of domestic violence—even within ethnic, racial, religious, socioeconomic groups, and sexual orientations (Hampton, Carillo, & Kim, 1998; West, 2004). Several studies indicate that Black women are severely abused (West, 2004) and murdered at significantly higher rates (Hampton et al., 1998; Websdale, 1997; West, 2004) than their representation in the population.

By itself, this information may serve little purpose but to reinforce negative stereotypes about African Americans. One solution to this problem of representation is to contextualize these findings within a structural framework—one that looks at socially organized systems of social inequality. An emerging body of work offers support, in large part, for an economic or structural explanation for differential prevalence rates. Many studies on intimate partner violence, which control for socioeconomic factors find that racial/ethnic differences in domestic violence rates largely disappear (Hampton et al., 1998; Rennison and Planty, 2003). This finding suggests that at

least one major underlying reason for the greater level of domestic violence among African Americans is not attributable to racial and cultural factors but to the high and extreme levels of poverty in black communities. Moreover, it is becoming increasingly clear that not only is abuse more likely to be found among impoverished African Americans, but they are also more likely to be young, unemployed urban residents (Hampton et al., 1998; West, 2004). Thus age, employment status, residence, poverty, social embeddedness, and isolation combine to explain higher rates of abuse within black communities—not race or culture per se.

This being said, it is also important to understand the profound racism that exists in U.S. society, including the effects of racially segregated communities. Thus, for example, the degree of poverty is more intense in the black community. Whereas 75% of poor blacks live in communities with other poor blacks, and all their attendant disadvantages,only 25% of poor whites live in poor white communities. Instead, poor whites are more likely to live in communities with working-class and middle-class white residents, which provides an immeasurable degree of resources available to that community (see Rusk, 1995). So comparing poverty in poor black and white neighborhoods is simply not "comparable." This must be taken into account in working toward lowering levels of domestic violence in black and white communities.

How a Multicultural/Intersectional Analysis Challenges Stereotypes of Marginalized Communities and Their Cultures

All too often, white America is quick to allocate blame to non-white cultures (especially black and immigrant) for domestic violence. According to Shamita Das Dasgupta (1998), "American mainstream society still likes to believe that woman abuse is limited to minority ethnic communities, lower socio-economic stratification, and individuals with dark skin colors" (pp. 212-213). This leads to stereotyping of battered women from "other" cultures. But it also fails to look at the strengths of other cultures and how they provide protective factors for battered women. Moreover, this approach fails to understand the impact of U.S. imperialism and the oppression of the state both within and outside the U.S. and their relationship to domestic violence in different communities. As Almeida and Lockard (2004) suggest, the impact of this public violence of imperialism, classism, and racism on battering in the private sphere of the home and intimate relationships "has, unfortunately, received little research." In fact, a

research agenda and analysis to understand state violence against
people of color and its implication on violence against women of
color is suggested in a joint statement (2004) by Incite! Women of
Color Against Violence (a transnational organization of feminists of
color who organize around the intersections of interpersonal and
state violence) and Critical Resistance (which organizes against the
prison-industrial complex). They came together in order to develop
a document that could help bring together the anti-prison and antiv-
iolence movements in closer collaboration.

With regard to stereotyping, Uma Narayan (1997) describes how
in the U.S., when women in India or Pakistan die "by fire" in dowry
deaths (a man or his family kills the woman because they are dissatis-
fied with her dowry to the paternal family line with whom she often
lives), many people in the United States call this barbaric, horren-
dous, and due to the "backwardness" of the South Asian culture.
However, when women in the U.S. are killed by guns (at the same
rate as dowry deaths in India), this is rarely, if ever, said to be due to
the culture; rather it is usually blamed on the individual man's unsta-
ble personality at best and patriarchy at worst. But American culture
is not said to be "backward" or to blame for her death.

With regard to a culture's protective factors, for example, Kan-
tor, Jasinski, and Aldarondo (1994) have found that Mexican men
born in Mexico but living in the U.S. are less likely to be violent
against their wives than U.S.-born Mexican-American men; and the
longer the men are in the U.S., the more violent they are toward
their wives. Thus, contrary to the myth that Latino/a culture is more
patriarchal—and thus supposedly more dangerous for its women—
the intact nature of the Mexican experience, not diluted as much by
U.S. influence, seems to act as a protective factor against battering.
Likewise, Murray (1998) reports that in some Cheyenne tribes,
where women have legal rights to property and children, the practice
of polygamy may have protected women from abuse. Thus, if the hus-
band were abusing one wife, the other wives would neither sleep with
him nor provide sexual services until he stopped abusing her.

One last example I would like to share is the particular belief in
U.S. society for battered women from marginalized communities to
look to "outside" help : if they only left their batterer, they would be
safe. The criticism to this approach is in reference to issues of racism,
homophobia, and xenophobia (fear of foreigners). First, most
women do leave their batterers; it takes on average seven attempts
before she is ultimately able to be free from him or her; and that the
most violent and dangerous time for a woman in a battering relation-

ship is just before or at the point of leaving (see Browne, 2003). Leaving does not necessarily mean safety.

One of the major issues for battered women from marginalized communities is that outside help is feared because there is so much individual and institutional discrimination against her from "outsiders"—police, courts, doctors, domestic-violence agencies, etc.—in mainstream communities. So while it may be true that she will face violence in her family or community, it is just as true that if she goes outside her community, she will face another set of hostilities. For example, women who come from other countries who have dark skin may have never experienced racism in their home countries. But in the U.S., where racism is common and profound, a battered woman of color may be treated badly (e.g., discriminated against or violated) by the system, not due to her personal situation but because she is perceived within a racist framework. This is seen most profoundly in immigrant and non-English-speaking communities, but is also prevalent wherever poor, marginalized populations are involved (Dasgupta, 1998; DeKeseredy et al., 2003; Narayan, 1997; Websdale, 2004).

Typically, black and Latina women often do not want to call the police because they want the battering to stop, not to have their partners arrested and incarcerated. The discrimination in the criminal justice system in the U.S. is deep and profound: as many as one-third of all young African-American men are in prison, jail, on probation, or on parole in the U.S. (Sokoloff, 2003). In some cities, like Baltimore and Washington D.C., it is over half! Black women who are battered often do not feel the police and the criminal justice system will solve their problems; rather, they may just intensify them. In short, the advice to either "leave" the situation or to "call the police" may actually harm rather than help certain groups of battered women.

Culturally Competent and Community Based Alternatives

Many new alternatives which will ultimately help all women are being proposed for dealing with domestic violence in marginalized communities. I would like to end by mentioning just one such alternative: that of the Cultural Context Model (CCM), an approach fostered by Rhea Almeida and her colleagues (1999, 2004). This approach requires abusers to take responsibility for their violence and supports the empowerment of victims and children by providing a wide range of services to the entire family. The CCM rejects the commonly held belief that domestic violence is the product of "other" cultural tradi-

tions by identifying domestic violence as a universal pattern of domination and control. At the same time, this therapeutic model acknowledges the powerful impact that social, cultural, and structural forces can have on families. It links gender ideology and subordination in individual couples with experiences of racial subordination and colonization in marginalized communities, thereby linking the struggle for gender equality with the struggles for racial and economic justice—without requiring the women to choose between cultural identity or group membership and their safety and autonomy.

Given the racism, classism, sexism, and homophobia inherent in (i.e., structured into) the criminal justice system, the CCM offers battered women an alternative approach. A unique aspect of the program includes men's and women's "culture circles" where participants can discuss the ways in which structural factors may help shape peoples' choices with regard to domestic violence. Participants are also assigned a sponsor, who provides ongoing support with a focus on accountability for batterers and empowerment for victim-survivors. While this model places full responsibility for violence on abusers, it also recognizes the impact of a number of social forces, including both structure and culture, upon families. As the authors suggest, "this system of intervention offers a range of new options: the possibility of returning to their now nonviolent partners, the possibility of children rebuilding relationships with their abusive parent, the possibility of having a civil and safe divorce, and lastly, the possibility of maintaining safety through community rather than criminal justice intervention" (Almeida and Lockard, 2003, p. 25). Several programs in the Latino/a community share similar features to the Cultural Context Model (Garza, 2001).

Finally, it is important to state that even culturally competent services are inadequate alone: they cannot prevent or stop domestic violence. Domestic violence is part of the larger systems of violence (e.g., imperialism, racism, colonialism, patriarchy, etc.) and as such domestic violence must be attacked at its root causes: the socially structured systems of inequality—of race, class, gender, sexual orientation, immigrant status, and the like. We need structural solutions to structural problems, all the while respecting and understanding specific contributions of individual cultures. But most importantly, we must look to understanding the intersectionality of these structural and cultural institutions as we struggle against domestic violence in all communities.

REFERENCES

Almeida, R., & Dolan-Delvecchio, K. (1999). "Addressing Culture in Batters Intervention: The Asian Indian Community as an Illustrative Example." Violence Against Women, 5(6), 654-683.

Almeida, R., & Lockard, J. (2004). "The Cultural Context Model". In N.J. Sokoloff (Ed.), Domestic Violence: At the Intersections of Race, Class, and Gender in the U.S. NY: Rutgers University Press (forthcoming).

Andersen, M., & Collins, P.H. (2001). "Introduction." In M. Andersen & P. H. Collins (Eds.), Race, Class & Gender: An Anthology (4th Ed.) (pp. 1-9). Belmont, CA: Wadsworth.

Bograd, M. (1999). "Strengthening Domestic Violence Theories: Intersections of Race, Class, Sexual Orientation, and Gender." Journal of Marital & Family Therapy, 25(3), 275-289.

Browne, A. (2003). "Fear and the Perception of Alternatives: Asking "Why Battered Women Don't Leave" Is the Wrong Question." In B. Raffel Price & N.J. Sokoloff (Eds.), The Criminal Justice System and Women: Offenders, Prisoners, Victims, and Workers (3rd Ed.) (pp. 343-359). New York: McGraw-Hill.

Dasgupta, S.A. (1998). "Women's Realities: Defining Violence Against Women by Immigration, Race and Class." In R. Kennedy Bergen (Ed.), Issues in Intimate Violence (pp. 209-219). Thousand Oaks, CA: Sage.

DeKeseredy, W., et al. (2003). Under Siege: Poverty and Crime in a Public Housing Community. Lanham, MD: Lexington.

Garza, M. (2001). Latinas Create own Domestic Violence Strategies. WomensENews. Available at www.womensenews.org/article.cfm/dyn/aid/544. (May 10).

Hampton, R., Carillo, R.,& Kim, J. (1998). "Violence in Communities of Color." In R. Carrillo & J. Tello (Eds.), Family Violence and Men of Color: Healing the Wounded Male Spirit (pp. 1-30). New York: Springer.

Incite-Critical Resistance Statement. (2004). "Gender Violence and the Prison Industrial Complex: Interpersonal and State Violence against Women of Color." In N.J. Sokoloff (Ed.), Domestic Violence: At the Intersections of Race, Class, and Gender in the U.S. New York: Rutgers University Press (forthcoming).

Kantor, G. K., Jasinski, J., & Aldarondo, E. (1994). Sociocultural Status and Incidence of Marital Violence in Hispanic Families. Violence and Victims, 9(3), 207-222.

Mann, S.A., & Grimes, M. (2001). "Common and Contested Ground: Marxism and Race, Gender & Class Analysis." Race, Gender & Class, 8(2), 3-22.

Murray, V. (1998). "A Comparative Survey of the Historic Civil, Common, and American Indian Tribal Law Responses to Domestic Violence." Oklahoma City University Law Review, 23, 433-457.

Narayan, U. (1997). "Death by Culture." In Dislocating Cultures (pp. 81-117). New York: Routledge.

Rennison, C., & Planty, M. (2003). "Non-Lethal Intimate Partner Violence: Examining Race, Gender and Income Patterns." Violence and Victims, 18(4), 433-443.

Richie, B. (2000). "A Black Feminist Reflection on the Antiviolence Movement." Signs: Journal of Women in Culture and Society, 25(4), 1133-1137.

Ristock, J. (2001). No More Secrets: Violence in Lesbian Relationships. New York: Routledge.

Rusk, D. (1995). Baltimore Unbound: Creating a Greater Baltimore Region for the 21st Century: A Strategy Report. Baltimore: Johns Hopkins University.

Sokoloff, N. J. (2004). "Impact of the Prison Industrial Complex on African American Women." SOULS: A Critical Journal of Black Politics, Culture, and Society, (forthcoming).

Websdale, N. (1997). Understanding Domestic Homicide. Boston: Northeastern University.

Websdale, N. (2004). Nashville: Domestic Violence and Incarcerated Women in Poor Black Neighborhoods. Policing the Poor: From Slave Plantation to Public Housing. Boston: Northeastern University (forthcoming).

West, C. 2004. "The 'Political Gag Order' Has Been Lifted: Violence in Ethnically Diverse Families." In N. J. Sokoloff (Ed.), Domestic Violence: At the Intersections of Race, Class, and Gender in the U.S. New York: Rutgers University Press (forthcoming).

Wilt, S., et al. 1994. Female Homicide Victims in New York City 1990-1994. NYC Dept. of Health, Injury Prevention Program.

NOTES

For more information on this topic, see the extensive bibliography by Natalie J. Sokoloff, Multicultural Domestic Violence Bibliography at: www.lib.jjay.cuny.edu/research/DomesticViolence/. Her book, Domestic Violence: A Reader on the Intersections of Race, Class, and Gender in the U.S., will be published by Rutgers University Press in late 2004.

I would like to thank Ida Dupont for her many contributions to my thinking on this topic and Provost Basil Wilson and Jacob Marini for their constant support throughout the time of this project.

1. Domestic violence is a term that includes physical, sexual, and psychological violence—typically, but not exclusively, by men against women in an intimate relationship.

2. Of course lesbian battering automatically challenges the notion of gender inequality as primary in explaining domestic violence at its very core (see Ristock, 2001, for an understanding of the complexity of all situations of battering, including lesbian battering).

Natalie J. Sokoloff *is the author of* A Multicultural Bibliography on Domestic Violence, *which is available at: www.lib.jjay.cuny.edu/research/DomesticViolence/. She is also the editor of* Domestic Violence: A Reader at the Intersections of Race, Class, and Gender; *the book also covers the intersectionalities of immigrant status and sexual orientation (to be published by Routledge, summer 2004). Her article on "Domestic Violence at the Intersections of Race, Class, and Gender: Challenges and Contributions to Understanding Violence against Marginalized Women in Diverse Communities," will be published by* Violence Against Women *in 2004. Natalie Sokoloff, Professor of Sociology, teaches about Women, Crime, and Justice; Imprisonment and Empowerment; and Domestic Violence at John Jay College of Criminal Justice-CUNY, where she has worked for more than 30 years. She is also on the doctoral faculties in Sociology, Criminology, and Women's Studies at The Graduate School, City University of New York. Professor Sokoloff holds a BA from the University of Michigan, an MA from Brown University (N.I.M.H. scholar), and a PhD from The City University of New York, Graduate School. She is the author of* Between Money and Love: The Dialectics of Women's Home and Market Work *(Praeger, 1980; translated into Japanese, 1987);* The Hidden Aspects of Women's Home and Market Work *(Praeger, 1987);* Black Women and White Women in the Professions: Occupational Segregation by Race and Gender, 1960-1980 *(Routledge, 1992);* The Criminal Justice System and Women, 3rd Ed. *(McGraw-Hill, 2003);* Women, Crime, and Justice: A Bibliography Using a Race/Class/Gender Perspective *(Institute for Teaching and Research on Women, Towson University, 1994, 1997);* Prisoner Empowerment Programs in New York State: A Directory *(CUNY Dispute Resolution Consortium of John Jay College, 1998);* Prisoner Empowerment Programs in Maryland: A Directory *(Institute for Teaching and Research on Women). In addition, Professor Sokoloff, who has published dozens of articles, has most recently published two articles on women and crime: "Myth and Reality of Violent Female Offenders in New York City" in Andrew Karmen's* Crime and Justice in New York City *(2001) and "The Impact of the Prison Industrial Complex on African American Women" in* Souls: A Critical Journal of Black Politics, Culture, and Society *(2004).*

Battered Women Add Their Voices to the Debate about the Merits of Mandatory Arrest

Paula C. Barata and Frank Schneider

Laws prohibiting domestic violence have been in place in Canada and the United States for decades; however, for much of that time the laws have not been enforced (Hemmons, 1981; Oppenlander, 1982). In an effort to improve the enforcement of domestic-violence laws, police response to domestic violence shifted drastically in the 1980s, with many jurisdictions changing their policies to mandatory arrest (Gelles, 1993). Under "mandatory arrest," officers who attend a domestic dispute call must arrest the batterer if there is probable cause to believe that an assault has occurred regardless of whether or not the victim/survivor wants the individual arrested. The goal is to make batterers accountable for their violence. However, there is considerable controversy in the academic literature about whether mandatory arrest is helpful or harmful to victims/survivors (e.g., Berk, 1993; Pate & Hamilton, 1992; Sherman, 1992; Stark, 1993).

The main purpose of this research was to examine the controversy over the advantages and disadvantages of mandatory arrest from the perspectives of victims/survivors. A second purpose was to contribute to the existing evidence on the degree to which victims/survivors support the notion of mandatory arrest. The participants were women at a shelter for abused women. Thus in this study, the words "victim/survivor" refers to a woman. Likewise the word "batterer" implies a man.

Pros and Cons of Mandatory Arrest

The debate on the advantages and disadvantages of mandatory arrest has centered largely on three questions: (1) Does mandatory arrest increase or decrease future violence to the victim/survivor? (2) Does mandatory arrest empower or disempower the victim/survivor? (3) Should domestic violence be dealt with by the law in the same manner as other violent crimes?

Increase or decrease in violence. An argument advanced in support of mandatory arrest is that violence is decreased due to a deterrent

effect on the batterer. That is, batterers learn to contain their vio-
lence to avoid the punishing aspects of future arrest. Sherman and
Berk (1984) investigated the deterrent effects of mandatory arrest
for cases of domestic violence and concluded that arrest does serve
as a deterrent. However, subsequent replications of the Sherman and
Berk study yielded contradictory conclusions (e.g., Garner, Gagan, &
Maxwell, 1995; Gelles, 1993; Schmidt & Sherman, 1993). Some
researchers even reported an increase in future violence for some
victims/survivors, namely those who were unmarried (Sherman,
Smith, Schmidt, & Rogan, 1992) or whose batterers were unem-
ployed (Pate & Hamilton, 1992). This evidence led to the argument
that mandatory arrest does not work as a deterrent in all cases and
may actually exacerbate violence against some victims/survivors.

 Empowerment or disempowerment. It is possible that mandatory
arrest may disempower the victim/survivor because it removes the
woman's decision-making power and gives it to an already powerful
judicial system that historically has not been particularly understand-
ing of battered women's issues (Buzawa & Buzawa, 1996). There are
many reasons why the victim/survivor may not want the batterer
arrested (e.g., fear of retaliation, financial suffering, trauma to chil-
dren, and stigma). Indeed, a system that assumes the victim/survivor
does not know what is best for her family and her own well-being can
be perceived as patronizing. Moreover, some authors have been con-
cerned with the increased possibility of dual arrest under mandatory
arrest policies (Miller, 2001; Saunders, 1995). Arresting the
victim/survivor, of course, is an extreme act of disempowerment.

 On the other hand, victim/survivor empowerment also has been
used as an argument for the implementation of mandatory arrest
laws (Stark, 1993). According to this view, the victim/survivor is
empowered by having her complaint taken seriously (i.e., she per-
ceives the police as being on her side). Stark (1993) believes that
mandatory arrest empowers women by reducing police discretion
and thus the expression of police bias against arresting. Stark main-
tains that such increased empowerment is particularly true of minor-
ity women who are more likely to use police services to halt abuse
and who are especially powerless as a result of institutional discrimi-
nation.

 Domestic violence as violent crime or family matter. Straus
(1993) argues that family violence is different from stranger assault
and in many cases should to be treated differently. Straus believes
that the police should handle only the very dangerous domestic situ-
ations (approximately 10% of the cases) and that the remaining

cases should be dealt with outside of the criminal justice system, per-
haps through private counselling. Similarly, Schmidt and Sherman
(1993) suggest that mandatory-arrest laws should be replaced with
structured police discretion that would include taking the
victim's/survivor's decision into account and the possibility of, for
example, referring the victim/survivor to a shelter or taking the sus-
pect to an alcohol-detoxification center.

On the other hand, others maintain that repeal of mandatory
arrest laws would be a huge step backwards for the movement against
domestic violence because it would once again normalize this kind of
violence as less than criminal (Pagelow, 1992; Stark, 1993). Accord-
ing to this position, criminalizing domestic violence sends a strong
social message that this kind of behaviour is unacceptable and will
not be tolerated.

Victims'/Survivors' Opinions

The mandatory-arrest debate has generated much-needed attention
to the problems of policing domestic violence. However, the question
of whether or not mandatory arrest is beneficial for victims/survivors
of domestic violence remains equivocal. As reviewed, the empirical
evidence regarding the violence issue has yielded contradictory find-
ings and conclusions. The other two issues—arrest empowers or dis-
empowers victims/survivors and domestic violence should be dealt
with inside/outside the criminal justice system—have largely been
unexamined through research and are primarily speculative. A very
important source of information that has not yet been fully explored
is the victims/survivors themselves. How do victims/survivors view
mandatory arrest? Do victims/survivors support the implementation
of mandatory arrest, and what do they perceive as the advantages and
disadvantages of the policy. Do victims/survivors, in fact, feel physi-
cally endangered or safer with such laws? Do they feel empowered or
disempowered?

Until very recently the voices of victims/survivors of domestic
violence were noticeably quiet (Bowman, 1992; Coulter & Chez,
1997; Erez & Belknap, 1998). Fortunately, there has been a surge of
research in the last few years that has examined victims'/survivors'
views of the criminal justice system; however, only two studies by
Smith (2000, 2001) have considered victims'/survivors' support for
mandatory arrest. Both studies indicated that the majority of vic-
tims/survivors support mandatory arrest laws and report a greater
benefit for others than for themselves. However, neither of the stud-

ies delved into the aforementioned issues that have been emphasized in the academic debate about mandatory arrest: that is, the policy's effect on levels of violence, on empowerment, and on whether or not it demonstrates that domestic violence is being treated as a violent crime. The major contribution of the current study is that it goes beyond the question of whether or not victims/survivors support mandatory arrest to an examination of their views on these issues. This study is also unique in the use of open-ended items as well as close-ended items.

Objectives of the Study

The main objective of this study is to add victims'/survivors' perspectives to the academic debate about the advantages and disadvantages of a mandatory arrest policy. Specifically it seeks to describe victims'/survivors' views about, and degree of support for, the policy. Victims/survivors of domestic violence were asked their views about the effect of mandatory arrest on subsequent levels of batterer aggression toward victims/survivors, on victim/survivor empowerment, and on whether domestic violence should be treated in the same manner as other violent crimes. In addition, victims'/survivors' support for mandatory arrest was measured both in terms of their own particular cases and in terms of domestic violence cases in general. Based on the results of Smith's (2000, 2001) studies, it was expected that victims/survivors would support the policy more strongly for domestic violence cases in general than for their own particular cases.

Method

Participants

The participants were 39 women in residence at an emergency shelter for women who had experienced violence in their intimate relationships. The staff at this particular shelter encourages criminal justice intervention; however, the shelter does serve women who prefer not to use the criminal justice system for recourse. The participants' mean age was 32.90 years (SD = 10.56), and their self-reported racial backgrounds were Caucasian (n = 26, 67%), African-Canadian (n = 3, 7.7%), First Nations (n = 2, 5.1%), Latin American (n = 2, 5.2%), biracial (n = 2, 5.1%), other (n = 2, 5.1%), and omitted (n = 2, 5.1%). The highest educational level achieved was community college or university degree (n = 6, 15.4%), some college or university

(n = 8, 20.5%), high school (n = 13, 33.3%), some high school (n = 10, 25.6%), and some elementary school (n = 2, 5.1%). Most of the women were either married to the man who had abused them (n = 17, 43.6%) or living with him (n = 12, 30.8%), and several were separated or divorced (n = 5, 12.8%) or exclusively dating or engaged (n = 4, 10.3%). The mean length of the relationship with the abusive partner was 9.1 years (SD = 9.88). Approximately a quarter of the women (25.6%) were employed outside the home, and monthly incomes were extremely varied (median monthly income = $1,050; range 0 - $3,600).

Measures

Participants completed a questionnaire designed to correspond with the concerns and issues expressed in the literature on mandatory arrest and included both open-ended and close-ended items.

Open-ended questions. The questionnaire began by defining mandatory arrest as a policy for domestic violence disputes in which officers must arrest the alleged perpetrator if there is reason to believe that an assault has occurred. It further stated that the batterer likely would be taken to the police station and questioned, but not necessarily charged with a crime or prosecuted. The definition was followed by three items that asked participants to consider the policy in terms of their most recent abusive relationship. The first item asked participants to list the advantages of the policy, and the second asked them to list the disadvantages. The third item asked them to decide whether or not they liked the policy for their particular cases and to explain their answers.

Close-ended items. There were 23 close-ended items that were rated on a five-point Likert scale that ranged from 1 = strongly disagree to 5 = strongly agree. Six items dealt with support for the policy and resulted in two variables. The first variable contained three items stated in terms of the participants' own situations (e.g., "I would support the use of a mandatory arrest policy in my particular case"). The second variable contained three items stated in such a way as to denote victims/survivors of domestic violence in general (e.g., "I would support the use of a mandatory arrest policy for most cases of domestic violence"). The remaining 14 variables fell into three categories: views about the effect on violence; views about the effect on empowerment; and views about judicial actions. Table 1 lists the variables in these categories.

Procedure

Counselors at the shelter asked all new residents a day or two after they had arrived if they would like to participate in a study about domestic violence and the criminal justice system. When a woman agreed to participate, the researcher (first author) met with her in a private room. After the participant read and signed the informed consent letter, the researcher read the mandatory arrest definition to her and asked if the she had any questions about the policy. Participants filled out the questionnaire and a demographics form on their own; however, efforts were made to clarify any items that participants did not understand. Upon completion, the researcher explained the study in detail and explained the criminal justice policies that were in place at the time in their community.

Results

Open-Ended Items

Each of the three open-ended questions was examined separately. Content analyses resulted in 13 categories of perceived advantages of a mandatory arrest policy, 10 categories of perceived disadvantages, and 12 categories reflecting why participants would or would not like the policy. To establish interrater reliability, a second rater classified the statements of 20 participants. The percentage agreement was 89%, 86%, and 81% for advantages, disadvantages, and reasons for liking or disliking the policy, respectively.

With respect to the advantages of mandatory arrest, 38 of the 39 participants (97%) listed at least one categorizable advantage. A reduction of violence (or increased safety) was the advantage most frequently mentioned by participants. Overall, 74% (n = 29) of the participants listed a reduction of violence as an advantage of a mandatory arrest policy. However, some participants specified whether violence would be reduced in the short term or in the long term. 33% (n = 13) of all the women indicated that violence would be reduced that day or night, 21% (n = 8) indicated that violence would be reduced in the future, and 33% (n = 13) mentioned a time-unspecified reduction of violence. Another commonly cited advantage (21%; n = 8), which is connected to a reduction in short-term violence, is that the policy would give the batterer an opportunity to cool down. A large minority (26%; n = 10) also indicated that the policy would give the victim/survivor an opportunity to leave the house safely.

It should be noted that two women (5%) mentioned an advantage related to empowerment. They indicated that the police would have to take the victim/survivor seriously with respect to dealing with domestic violence as a crime. Three women (8%) indicated that the batterer should be arrested because the abuse is a crime, and three women (8%) indicated that it would give the batterer the message that the assault is wrong and will be punished. Five other topics were mentioned: starts a paper record of the abuse (13%; n = 5); woman cannot stop the police from arresting (10%; n = 4); children are protected (5%; n = 2); some action is finally taken, which could but an end to the abuse (5%; n = 2); and abuser may get help (3%; n = 1).

Twenty-nine participants (74%) listed at least one disadvantage of mandatory arrest. By far the most common disadvantage mentioned was an increase in violence or anger when he comes back (56%; n = 22). No other disadvantage was cited with appreciable frequency. No one directly mentioned feelings of disempowerment, but two women (5%) did mention the possibility that the victim/survivor could be arrested. No one indicated that domestic violence should be dealt with outside the law, although one woman (3%) wrote that it would violate her privacy. Other disadvantages mentioned were: negative emotional experience for the victim (10%; n = 4); no prosecution or conviction after arrest (8%; n = 3); it would be bad for their partner (5%; n = 2); the arrested individual might be innocent (3%; n = 1); loss of financial support (3%; n = 1); batterer might assault the police (3%; n = 1); and the victim may be afraid to call the police (3%; n = 1).

The third open-ended question asked participants if they would like a mandatory arrest policy in their particular cases, and why they did or did not like the policy. A large majority of women (74%; n = 29) responded affirmatively, one was undecided, and 23% (n = 9) responded in the negative.

The most common reason for liking the policy in one's own case was an expected decrease in violence (or increase in safety) either that night, in the future, or at an unspecified time. Overall, 41% (n =12) of the women who liked the policy mentioned some decrease in violence. The next most common explanation for liking the policy, mentioned by 21% (n = 6) of the participants, was that it would send a message to the batterer that assault is wrong. In addition, two women (7%) said they liked the policy because the abuser should be arrested because his actions are criminal. No one mentioned an increase in empowerment as a reason for liking the policy, although 14% (n = 4) said that the liked the policy because the victim cannot

stop the police from arresting, suggesting that it is not disempowering. Other reasons for liking the policy were: victim has time to leave safely (17%; n = 5); situation is defused that day or night and the batterer can cool down (7%; n = 2); and it starts a paper record of the abuse (3%; n = 1).

The most common explanation for disliking the policy in one's own case, given by five of the nine women who disliked the policy (56%), was that it was not necessary to involve the police at the time. There also was mention of an increase in violence (33%; n = 3) and a fear of calling the police in the future (22%; n = 2).

Overall the open-ended questions revealed that the majority of women supported mandatory arrest, and most were able to list at least one advantage and one disadvantage of the policy. The possible effect of the policy on the batterer's future violence was a very salient issue for many of the participants in listing advantages, disadvantages, and explaining why they liked or disliked the policy in their own cases. Although a small number of women mentioned empowerment or disempowerment, this topic did not stand out in the open-ended responses. Several women cited the importance of dealing with domestic violence as a crime as an explanation for liking the policy.

Close-Ended Items

The participants' degree of support for mandatory arrest was also determined by their responses to six close-ended items. Three items asked women to consider their own situations, and three asked them to consider the situation of most cases of domestic violence. The total scale of 6 items resulted in a coefficient alpha of .91. Item intercorrelations revealed coefficients that were substantially higher within each three-item subgroup (r = .74 -.85) than across subgroups (r = .40 - .59). Thus, the participants' responses were reduced to two variables: support for mandatory arrest for the participants' particular cases (alpha = .94) and support for mandatory arrest for domestic violence cases in general (alpha = .94).

With respect to support for mandatory arrest, the absolute levels of the means (shown in the top section of Table 1) indicate that participants liked the policy both for their own particular cases (M = 4.08) and for domestic violence in general (M = 4.53). However, a one-sample t-test indicated that participants liked the policy more for domestic violence cases in general than for their own particular cases, t(37) = -2.60, p = .01. This is further illustrated by the fact that 90% supported the policy in general, whereas only 72% supported

the policy for their particular cases.

Views about the effects of a mandatory arrest policy on future violence were measured using three items from the questionnaire (second section, Table 1). The absolute values of the means indicate that victims/survivors perceived the policy as increasing violence towards the victim/survivor in general and especially when the victim/survivor was blamed for the batterers' arrest. Participants did not show consistent agreement about whether violence would be decreased in the long run. A t-test indicated that victims/survivors were more likely to believe that violence would increase due to blame than they were to believe that violence would decrease in the long run, t(38) = 3.36, p = .002.

Views about the effects on empowerment (third section, Table 1) were measured using 10 items from the questionnaire. Items that were conceptually related and significantly correlated at the .01 level were reduced to one variable. This resulted in four single-item variables: reduces burden of responsibility; reduces victim/survivor influence on the decision to arrest; reduces police bias; and without the policy the victim/survivor had influence on the decision to arrest. Three variables involved a combination of two items: police will take the abuse seriously (r = .57, alpha = .72); empowers the victim/survivor (r = .52, alpha = .68); and disempowers the victim/survivor (r = .65, alpha = .79). The items that directly measured empowerment and disempowerment used language such as "increased power" and "increased control."

Participants agreed most that the policy would make the police take the abuse seriously (M = 4.37); 85% agreed with this notion, whereas only 8% disagreed. Next, women most agreed that the policy would reduce the burden of responsibility for the victim/survivor (M = 4.13). In addition, participants were significantly more likely to agree that the policy would be empowering (M = 3.84) than they were to agree that the policy would be disempowering (M = 2.41), t(36) = -4.86, p = .001). It is noteworthy that participants agreed least with the idea that mandatory arrest would be disempowering.

Views about judicial involvement (fourth section, Table 1) were measured using four items from the questionnaire. Most participants thought that the abuse should be treated as a violent crime (M = 4.08). 74% of the women agreed with this notion, whereas only 15% disagreed. The item in this section that was least supported by the women was that they wanted to stop the police from arresting their partners (M = 1.82). This item was supported by only 15% of the women, whereas 72% disagreed.

Discussion

Support For Mandatory Arrest

The large majority of participants in this investigation supported a mandatory arrest policy. However, women were significantly more likely to support the policy in general than in their particular cases. This finding is consistent with the results of Smith's (2000, 2001) studies, which indicated that victims/survivors of domestic violence were more likely to see the benefits of mandatory arrest for other victims/survivors than for themselves. Perhaps victims/survivors predominately embrace the mandatory-arrest principle, but when it comes to their personal cases their enthusiasm is mitigated by the particular realities of their situation. Whether or not they support the policy may be influenced, for example, by feelings of love for their partner, the perceived threat of continued abuse, or worries about financial hardship.

That women consider policies differently for themselves than for other victims/survivors was also found by Coulter and Chez (1997) with respect to mandatory reporting and is becoming increasingly robust (present study; Smith, 2000, 2001). Such a finding has methodological implications for research on domestic violence. Researchers must be clear in their survey design if their focus is on participants' views about their own circumstances, violence in general, or both.

Views About the Effect of Mandatory Arrest on Violence

The debate on mandatory arrest has centered largely on three questions, which deal with (1) future violence; (2) empowerment; and (3) the appropriateness of dealing with domestic violence in the same way as other violent crimes. With respect to past research on the effects of mandatory arrest on violence, the open-ended responses of the participants in this study echo the inconclusiveness of the literature. Many women described a reduction of violence as an advantage of the policy, but at the same time described an increase in violence as a disadvantage of the policy. However, considering the pattern of results may help to explain this somewhat puzzling finding. Violence may decrease initially because the situation is defused, and the batterer is removed from the home; 13 participants mention this kind of a decrease (e.g., "I'm safe for the time that he is in jail"). Violence may then increase when the abuser returns because the he may be angry and seek revenge for being arrested.

Almost all of the women who mentioned an increase in violence as a disadvantage included the notion of increased anger or a need for revenge (e.g., "This will make him angrier, and then he'll want more revenge"). Finally, violence may decrease again in the long term because of a fear of being arrested in the future. Eight participants mentioned that violence will be reduced in the future, and of these women six specifically noted a deterrent effect (e.g., "If they know about this policy, then the batterer would think twice about hitting and maybe not hit at all"). However, the perceived decrease in long-term violence was not strongly evident in the close-ended responses. Only 38.5% agreed that the policy would result in decreased violence in the long run. It is noteworthy that the close-ended results showed that well over half of the participants did agree that the mandatory-arrest policy increases violence in general, and because the victim/survivor is blamed.

Overall, the participants' responses indicated that the effects of mandatory arrest on violence are complex and that it may not be especially fruitful to evaluate the policy using only a criterion that simply reflects whether violence increases or decreases. Research on the effects of mandatory arrest needs to consider not only whether violence occurs after arrest, but when it occurs and under what circumstances. For example, is the violence retaliatory? If violence is retaliatory, other policies and procedures can be implemented in conjunction with mandatory arrest in order to minimize retaliatory violence and increase deterrence. One way to reduce the opportunity for retaliatory violence might involve telling the victim/survivor when her partner will be released. Also, increasing the severity of the consequences to the batterer for retaliatory violence may increase the deterrent effect.

Views About the Effect on Empowerment

Most of the participants in this study did not believe that mandatory arrest was disempowering. Feelings of disempowerment were not mentioned in the open-ended questions, and the close-ended responses revealed that only a small proportion of women agreed with items reflecting disempowerment.

There are two reasons why participants may not have felt that mandatory arrest would be disempowering. First, the results suggest that input into the arrest decision is simply a responsibility that many victims/survivors do not want to have: that is victims/survivors may perceive involvement in an arrest decision as a burden. The partici-

pants generally agreed that the policy took the burden of responsi-
bility off them and disagreed that they wanted to stop the police from
arresting their partner. In fact, four women in the open-ended
responses volunteered that lack of victim/survivor input is an advan-
tage. Second, victims/survivors may not believe that they have influ-
ence over the decision to arrest even without a mandatory arrest
policy in place. This is partially supported by the close-ended data
that indicated that without a mandatory-arrest policy, most partici-
pants did not feel that they had influence over whether or not the
police would arrest their partners.

It has also been argued that mandatory arrest empowers because
the victim/survivor sees that her complaint is taken seriously and
because it reduces police bias towards not arresting in domestic dis-
putes (Stark, 1993). The vast majority of women in this study agreed
that mandatory arrest would make the police take the abuse more
seriously (and two women mentioned this as an advantage of the pol-
icy in the open-ended responses). Also, over half of the women
agreed that mandatory arrest would result in a reduction of police
bias (although this is not mentioned in the open-ended responses).
The results of the close-ended variable that directly examined empow-
erment showed that over half of the women agreed that mandatory
arrest was empowering and only a small percentage believed that it
was not empowering. Overall, the results of this study indicate that the
majority of participants did not perceive mandatory arrest as disem-
powering. Rather, they perceived it as empowering, especially if
empowerment is defined as being taken seriously by the police.

Views About Treating Violence as a Violent Crime/Family Matter

The majority (74.4%) of women in this study indicated that domestic
violence should be treated as a crime, not as a family problem. Six
participants who liked the policy for their particular cases explained
that it sends a message to the batterer or to society that assault is
wrong and will be punished Although the absolute number may not
appear large, this argument is the second-most-common explanation
for liking the policy (the first is a decrease in violence). No one men-
tioned that this kind of abuse should be dealt with outside of the law.

Limitations of the Present Study

In interpreting the results it is important to consider that the women
in this study had all sought help from a shelter. Women who have not

sought assistance through a shelter may feel very differently about mandatory arrest. The sample also was relatively small, but given that the support for the policy was similar to studies that have used a larger number of participants (Smith 2000, 2001), greater confidence can be placed in the participants' responses to the items that addressed other issues.

The women in this study were given a definition of mandatory arrest, but they were not informed about what other policies might also be in place. In future research, it will be important to ask women what their views are on combinations of policies to get a more realistic picture of victims' support for the various policies. Nevertheless, victims' support for mandatory arrest indicates that police officers play an important role in defusing the immediate danger, the value of which is emphasized by the participants' responses.

Empowerment is a complex term, and the limited number of items dealing with empowerment in this study is unlikely to have exhausted the full meaning of the concept. Nevertheless, empowerment is an especially important area of study because victims/survivors may feel particularly disempowered as a result of an abusive relationship. Future research should focus on what victims/survivors specifically perceive as empowering and how judicial policies can increase their sense of empowerment.

Conclusion

All three of the main issues arising from the literature on mandatory arrest (i.e., violence, empowerment, judicial involvement) were addressed to varying degrees in participants' open-ended responses. This evidence is encouraging because it indicates that the debates that have taken place in the literature are reflective of victims'/survivors' concerns. However, past research may have emphasized some issues—for example, the effect of mandatory arrest on violence—to the relative neglect of other factors that may also be important to understanding victims'/survivors' decisions to support or not support mandatory arrest. Violence was indeed a salient concern of many victims/survivors in this study; however, it was not the major concern for many in their decisions to support or not support the policy. Accordingly, it would be misguided to use an increase or decrease in violence as the only measure of the success or failure of the policy.

Similar to other studies, the majority of the women in this investigation felt quite positive about mandatory arrest. This is fortunate

because mandatory arrest and other similar policies (i.e., mandatory charging) are already in place in Canada and in most American states (See Hirschel and Buzawa [2002] for a breakdown by state). More importantly, the participants shed light on some of the reasons why mandatory arrest may be supported by a majority of victims/survivors. Understanding what influences victims'/survivors' support for policies that affect them is essential in deciding what practices will be most beneficial to them.

REFERENCES

Berk, R. A. (1993). "What the Scientific Evidence Shows: On the Average, We Can Do No Better than Arrest." In R.J. Gelles & D. R. Loseke (Eds.), Current Controversies on Family Violence (pp.323-336). Newbury Park, CA: Sage.

Bowman, C. G. (1992). "The Arrest Experiments: A Feminist Critique." The Journal of Criminal Law and Criminology, 83, 201-208.

Buzawa, E.S., & Buzawa, C.G. (1996). Domestic Violence: The Criminal Justice Response. Thousand Oaks, CA: Sage.

Coulter, M. L., & Chez, R. A. (1997). "Domestic Violence Victims Support Mandatory Reporting: For Others." Journal of Family Violence, 12, 349-950.

Erez, E., & Belknap, J. (1998). "In Their Own Words: Battered Women's Assessment of the Criminal Processing System's Responses." Violence and Victims, 11, 251-268.

Garner, J., Gagan, F., & Maxwell, C. (1995). "Published Findings from the Spouse Assault Replication Program: A Critical Review." Journal of Quantitative Criminology, 11, 3-28.

Gelles, J. (1993). "Constraints Against Family Violence." American Behavioral Scientist, 36, 575-586.

Hemmons, W. M. (1981). "The Need for Domestic Violence Laws with Adequate Legal and Social Support Services." Journal of Divorce, 4, 49-61.

Hirschel, D., & Buzawa, E. (2002). "Understanding the Context of Dual Arrest with Directions for Future Research." Violence Against Women, 8(12), 1449-1473.

Miller, S. L. (2001). "The Paradox of Women Arrested for Domestic Violence: Criminal Justice Professionals and Service Providers Respond." Violence Against Women, 7(12), 1339-1376.

Oppenlander, N. (1982). "Coping or Copping Out. Police Service Delivery in Domestic Disputes." Criminology, 20, 449-465.

Pagelow, M. D. (1992). "Adult Victims of Domestic Violence." Journal of Interpersonal Violence, 7, 87-120.

Pate, A.M., & Hamilton, E.E. (1992). "Formal and Informal Deterrents to Domestic Violence: The Dade County Spouse Assault Experiment." American Sociological Review, 57, 691-697.

Saunders, D. G. (1995). "The Tendency to Arrest Victims of Domestic Violence. A Preliminary Analysis of Officer Characteristics." Journal of Interpersonal Violence, 10, 147-158.

Schmidt, J. D., & Sherman, L. W. (1993). "Does Arrest Deter Domestic Violence?" American Behavioral Scientist, 36, 601-609.

Sherman, L. W., & Berk, R.A. (1984). "The Specific Deterrent Effects of Arrest for Domestic Assault." American Sociological Review, 49, 261-272.

Smith, A. (2000). "It's My Decision, Isn't it? A Research Note on Battered Women's Perceptions of Mandatory Intervention Laws." Violence Against Women, 6, 1384-1402.

Smith, A. (2001). "Domestic Violence Laws: The Voices of Battered Women." Violence and Victim, 16, 91-111.

Stark, E. (1993). "Mandatory Arrest of Batterers. A Reply to its Critics." American Behavioral Scientist, 36, 651-680.

Straus, M.A. (1993). "Identifying Offenders in Criminal Justice Research on Domestic Assault." American Behavioral Scientist, 36, 587-600.

Table 1.

Descriptive Statistics on Quantitative Variables

	Participants' responses						Mean	SD
	Disagree		Neither		Agree			
	n	%	n	%	n	%		
Support for mandatory arrest								
Victim's own case	6	15.4	4	10.3	28	71.8	4.08	1.25
Cases in general	1	2.6	3	7.7	35	89.7	4.53	.85
Views about the effect on violence								
Increases violence due to blame	4	10.3	5	12.8	30	76.9	4.08	1.13
Increases violence in general	9	23.1	7	17.9	23	60.0	3.82	1.18
Decreases long term violence	14	35.9	10	25.6	15	38.5	2.97	1.53
Views about the effect on empowerment								
Police will take the abuse seriously	3	7.7	2	5.1	33	84.6	4.37	.92
Reduces burden of responsibility	7	17.9	1	2.6	30	76.9	4.13	1.34
Empowers victim/survivor	5	12.8	11	28.2	22	56.4	3.84	1.04
Reduces victim/survivor influence	8	20.5	8	20.5	22	56.4	3.71	1.41
Reduces police bias against arrest	11	28.2	7	17.9	20	51.3	3.50	1.43
Without policy victim/survivor not have influence	18	46.2	8	20.5	12	30.8	2.76	1.57
Disempowers victim/survivor	24	61.5	6	15.4	7	17.9	2.41	1.30

Views about judicial involvement

Deal with abuse as a violent crime, not as a family problem	6	15.4	4	10.3	29	74.4	4.08	1.42
Arrest has positive effect on victim/survivor	9	23.1	8	20.5	22	56.4	3.62	1.50
Wants influence in decision to arrest	13	33.3	9	23.1	17	43.6	3.13	1.56
Wants to stop the police from arrest	28	71.8	5	12.8	6	15.4	1.82	1.67

Mean scores could range from 1 = strongly disagree to 5 = strongly agree. Scores between 1 and 2.5 were labeled "disagree", scores between 2.6 and 3.5 were labeled "neither," and scores between 3.6 and 5 were labeled "agree." Items in each of the four sections are listed in tho order in which they worc mosl slrongly endorsed.

Paula Barata, PhD, recently graduated from the Applied Social Psychology program at the University of Windsor, Ontario, Canada, Her research interests include law and psychology and women's health. Her dissertation delved into survivors' use and experiences of the criminal justice system. She is currently doing a postdoctoral placement at the University Health Network in the Women's Health Program. Her projects deal with domestic violence in the Portuguese community of Toronto, and with housing discrimination against battered women.

Frank W. Schneider received his MA in counseling psychology from Ohio University and his PhD in Social Psychology from the University of Florida. He is currently a Professor of Psychology and Coordinator of the Applied Social Psychology Program at the University of Windsor. His research generally focuses on policing-related issues, and he has published on such topics as officer recruitment and selection, performance appraisal, organization effectiveness, program evaluation, job satisfaction, and community policing.

Unintended Consequences of Constructing Criminal Justice as a Dominant Paradigm in Understanding and Intervening in Intimate Partner Violence

Elizabeth P. Cramer

One in three women in the United States will experience physical or sexual abuse by an intimate partner during the course of her lifetime (Family Violence Prevention Fund, 1999). Women who are not directly victimized by their partners may be indirectly affected by intimate partner violence (IPV) when their parents, children, coworkers, or friends are being abused. Feminists pushed the issue of IPV into the national spotlight by framing it as a social problem requiring intervention rather than a private trouble to be handled by the family.

When communities agreed that IPV was indeed a public issue, not just a family (private) matter, formal systems were established to respond to IPV. Shelters for battered women emerged in the mid 1970s (Schechter, 1982). Feminists pushed for the police and the courts to treat IPV as a crime rather than a family feud. Thus, mandatory arrest ordinances were passed in communities across the country and courts adopted aggressive prosecution methods, including "no drop" policies and subpoenaing victims as witnesses in trials regardless of whether they wanted to testify (Mederos & Perilla, 2003). Batterer intervention programs (BIPs) developed with a variety of clinical perspectives for "treating" batterers and the courts began to refer persons convicted of domestic assault to BIPs, sometimes in lieu of jail time (Mederos, 1999). In addition to formulating a criminal justice response to IPV, clinical models for understanding and serving victims/survivors[1] emerged, including Lenore Walker's battered woman syndrome (Walker, 1984) and survivor therapy model (Walker & Holland, 1994). The medical/public health field began publishing books and journal articles about IPV as a major cause of injury to women and a public health crisis (Campbell & Humpheys, 1984; Rounsaville & Weisman, 1978). Instruments such as the Abuse Assessment Screen were developed for medical professionals to assess IPV (McFarlane, Greenberg, Weltge, & Watson,

1995; McFarlane, Parker, Soeken, & Bullock, 1992).

While the development and enhancement of these systems indicated a more serious and formal response to IPV, concerns emerged about a lack of coordination among the various responders and ineffective or potentially damaging responses to victims. These problematic responses included high rates of "dual" arrests (when both the victim and offender are arrested) and ineffective monitoring of domestic assault offenders while they were on probation (Pence, 1999). Therefore, communities developed councils and task forces to enact a coordinated community response to IPV; these collaborations are often referred to as coordinated community response initiatives (CCRIs). CCRIs often include representatives from law enforcement and the court system (e.g., magistrates, prosecutors, judges, and staff from victim witness agencies), programs serving battered women, BIPs, public schools, youth-service agencies, community mental health, housing and development, substance-abuse treatment programs, private practice, social services/child protective services, hospitals/clinics, public health departments, and universities. In some communities, concerned citizens and battered/formerly battered women also sit on the coordinating councils. CCRIs have differing goals depending on locality; however, typical aims are to advocate for mandatory arrest policies and/or monitor existing arrest policies, institute aggressive prosecution methods focused on the safety of the victim/survivor, monitor court sentencing and community corrections for the offender, establish and/or monitor BIPs (some communities have state standards/certification for BIPs), and collaborate with battered women's advocates (Mederos & Perilla, 2003).

In a relatively short time, a private family matter turned into a significant societal problem that required the creation and maintenance of a number of new systems and the modification of policies and practices of some existing systems. While there are different theories about why IPV occurs and the best interventions to prevent and respond to it, one of the dominant theories emanates from the criminal justice arena: IPV should be viewed as a crime and thus should be treated as such. In this paper, I will provide an overview of the concepts paradigm, theory, models, and techniques. I will describe the dominant paradigms for interpreting and intervening in IPV. Lastly, I will focus on how the use of the criminal justice system as a dominant paradigm has achieved some early goals of the battered women's movement, but at the same time has produced unintended consequences that could be viewed as disempowering, and in some cases harming, survivors.

Paradigm, Theory, Models, and Techniques

Theories of human behavior, as well as clinical practice theories, derive from assumptions about human nature and the interaction between persons and their environments. A frame of reference for viewing the world is referred to as a paradigm, which includes a set of concepts and assumptions for understanding the social world (Bailey, 1982). For example, the assumptions underlying crisis theory might be something like: crisis is normative; certain events over the life course can predict times of crisis; there are typical cognitive, emotional, and behavioral changes one experiences when in crisis mode; and a time of crisis provides a person with an opportunity for change and growth. The theories that emanate from this paradigm include crisis theory and post traumatic stress theory. Theories can be defined as "a group of related hypotheses, concepts, and constructs, based on facts and observations, that attempts to explain a particular phenomenon" (Barker, 1991, p. 236). Theories intend to describe why a social phenomenon occurs; theories guide research studies (and research sometimes attempts to verify theories) and treatment interventions (Rubin, 1983). From theories, various models for intervention have been derived (Barker, 1991). In the case of crisis theory, brief treatment methods and crisis intervention models have been developed. These models provide a set of knowledge and skills for practitioners to use, including specific techniques (such as desensitization) to use when working from that model.

In the area of IPV, there have been a number of paradigms developed to attempt to explain why IPV occurs—why some persons engage in violent behavior toward their partners and why some survivors get into, stay in, and get out of abusive relationships. Three such paradigms that have dominated the field of IPV have been feminist, clinical, and criminal justice. Each of these paradigms will be described, along with the theories, models and techniques associated with them.

The Feminist Paradigm

The feminist paradigm, coming from the early activists who sensitized the nation about battered women, emphasizes the role of gender socialization and patriarchy (male power and privilege) in understanding IPV (Dobash & Dobash, 1979; Schecter, 1982). Historically, patriarchal traditions encouraging a subservient relationship of women to men were supported by church doctrine and the vestiges of English common law that were transported into American

law (Dobash & Dobash, 1979). Feminists argue that batterers use IPV as a way to obtain and maintain power and control over their partners (the power and control theory). Physical abuse is but one of the methods that batterers use to gain power and control; other methods to control include emotional abuse, isolation, intimidation, economic abuse, threats, using children, and using male privilege (Pence & Paymar, 1985). The specific techniques batterers use might be name-calling (emotional abuse), disabling a vehicle to keep a woman from leaving the home (isolation), and taking a child from school and leaving town with the child so as the woman will not know the whereabouts of her child (using children). Other assumptions of the feminist paradigm of IPV include: battering behavior is intentional, not a result of impulse-control problems; battering is not caused by one's lack of ability to manage one's emotions (anger, frustration, insecurity, etc.); and batterers typically engage in minimization and denial of their abusive behaviors and frequently blame their partners for their decision to use violence (Shepard, 1991).

Practice models emanating from the feminist paradigm have emphasized victim/survivor empowerment (Busch & Valentine, 2000, Dietz, 2000), batterer accountability (Edleson & Tolman, 1992), attention to the cultural and socioeconomic background of victims (Sharma, 2001; White, 1985), and the systems' responsibility for providing safety and justice for battered women (Daniels, 1997; Davis, Hagen, & Early, 1994). An example of a specific technique in the victim/survivor empowerment model is offering support groups for battered women to reduce the affects of isolation and to provide information about battering and resources in the community.

The Clinical Paradigm

The clinical paradigm focuses on the psychopathology of the batterer and the abused woman. Diagnostic categories that may be applied to cases of IPV include antisocial personality disorder, borderline personality disorder, narcissistic personality disorder, impulse control problems, and low self-esteem, for the batterer (Chornesky, 2000; Zosky, 1999); and for the battered woman, affective disorder, dissociative identity disorder, anxiety, panic disorder, suicidal ideation, dependent personality disorder, borderline personality disorder, depression, adjustment disorder, masochism, and post traumatic stress disorder (Berg, 2002; Bograd, 1982; Jones, Hughes, & Unterstaller, 2001; Lundy & Grossman, 2001).

The relationship between the batterer and battered woman may

be viewed within a family systems perspective where each person is thought to contribute to the dynamic of violence, known as circular causality (O'Leary & Murphy, 1992). The contribution of each person to the violence may be analyzed according to child-parent factors when each partner was growing up. For example, attachment to parents and its effect on adult attachment styles may be seen in partners with anxious attachments to each other due to having parents who did not provide adequate nurturing and security. In adult relationships, anxiously attached males develop coercive methods to keep their partners, while anxiously attached females fear abandonment and become dependent on their partners. This illustrates the application of object-relations and attachment theories to IPV (Chornesky, 2000; Zosky, 1999).

When using object relations theory in IPV cases, the practitioner may use such techniques as assisting abusive men in examining their issues related to separation and individuation. For example, abusive males in a domestic violence group were instructed to "examine what needs they had, who they typically sought to fulfill their needs, and how this affected their boundaries with significant people in their lives" (Zosky, 1999, p. 66); while the abused women in the parallel women's group were encouraged to recognize their mates' "primitive defenses such as splitting and projective identification" and to refrain from taking on the "split off disavowed negative projections" of their mates (p. 67).

The Criminal Justice Paradigm

The criminal justice paradigm emerged from the push of battered women's advocates to provide protection for victims and consequences to abusers for their abusive behavior (Schechter, 1982). This enabled a shift from viewing IPV as a private family trouble to a crime—a crime that required police intervention, civil and criminal remedies for victims in the courts, and "punishments" for the batterers. The theories of the criminal justice paradigm have been contradictory when it comes to IPV, particularly prior to mandatory arrest. Not uncommon when responding to "domestic disturbance" calls was the proverbial "walk around the block" that the officer conducted with the alleged offender to "cool him off" (Martin, 1976). While this type of intervention would be unusual in cases of assault by a stranger, or perhaps in muggings or robberies, because IPV was still often viewed as a family matter, arrest was not the preferred response. When arrests were made, victims of IPV were often reluc-

tant to testify in court against their partners; more IPV victims desired to drop charges than victims of nonintimate violent offenses (Ferraro, 1993). Battered women were labeled as "uncooperative" or "reluctant" witnesses.

Communities began to implement a coordinated criminal justice response to IPV, including mandatory arrest; restraining orders (also known as protective orders, which are typically identified as emergency, temporary, or permanent); aggressive prosecution (sometimes referred to as "no drop" policies that would proceed with prosecution regardless of the victim's desires or her refusal to testify); monitoring of court orders; court-ordered treatment for batterers; and training of law enforcement, judges, and court personnel on the dynamics of domestic assault and services available to victims and offenders (Bureau of Justice Assistance, 1993; Cahn, 1992). In more recent years, the criminal justice system has been involved in distributing emergency pagers or cell phones programmed to dial 911 to victims. The primary goal of the coordinated criminal justice model is to obtain convictions of offenders (McHardy, 1992). The criminal justice method has dominated communities' responses to IPV. The majority of members of CCRIs are involved in the criminal justice system in some way, and, as noted above, many CCRIs focus primarily on the criminal justice response to IPV (Mederos & Perilla, 2003).

The establishment of the Violence Against Women Office as a result of the passage of the 1994 Violence Against Women Act (VAWA), which is situated in the National Institute of Justice, Office of Justice Programs, further reinforces the dominance of the criminal justice paradigm in shaping our understanding of and responses to IPV (Brooks, 1997). Funding from the Violence Against Women Act funnels largely through CCRIs (Mederos & Perilla, 2003).

Unintended Consequences of the Criminal Justice Paradigm

Certainly treating IPV as a crime has protected many women from further injury, and, in some cases, death. This is commendable; however, there have been undesirable outcomes in constructing the criminal justice framework as primary in our analysis of and intervention in IPV situations. I will describe four areas of unintended consequences: (a) underutilization of the criminal justice system, particularly by women of color and immigrants; (b) criticism of BIPs as being overly confrontational and lacking cultural sensitivity; (c) the lack of focus on primary prevention efforts and outreach; and (d) victim/survivor disempowerment.

Underutilization of the Criminal Justice System

Three-quarters of the victims of IPV do not report the assault to the police (Tjaden & Thoeness, 2000). Therefore, a considerable number of abused women are not being served through the criminal justice system; they are seeking alternate solutions. The reluctance to involve law enforcement is especially prevalent among women of color with partners of color due to the concern that their partners will be treated unfairly by the criminal justice system and their awareness of the disproportionate numbers of incarcerated men (and women, for same-sex couples) of color (Bent-Goodley, 2001; Kanuha, 1990; Richie, 1996). Immigrant and undocumented women may hesitate to involve law enforcement because of a fear of deportation (theirs and/or the abuser's) (Raj & Silverman, 2002). Survivors may want the battering to discontinue, but not want to feel responsible for their partners getting arrested or being jailed. Aggressive prosecution may be undesirable by survivors who intended to stop the violence at the time it was happening (by calling the police, and perhaps hoping for an arrest to temporarily stop the assault); however, they may not wish to press charges or for their partner to be convicted of an assault. Survivors may initially support the requirement that their partners attend a BIP; however, they may come to realize that their partner has not made the hoped-for changes while in the BIP. In fact, one-fifth of the women with partners in a BIP reported that the BIP appeared to make their mates more angry and that their partners learned new controlling strategies while in the program (Gregory & Erez, 2002).

Criticisms of BIPs

Rates of "success" for abusers participating in BIPs vary widely depending on program philosophy (e.g., anger management, "Duluth" style programs based on power and control model), program format (e.g., programs lasting several months versus weekend rehabilitation), measures used (e.g., instruments to measure physical abuse, instruments to measure other nonphysical forms of abuse), what is being measured (e.g., presence or absence of physical assault, presence or absence of other controlling tactics, reduction of angry responses), and the type of follow-up employed (e.g., none, regular reports from victims, reports from batterers, re-arrest records) (Gregory & Erez, 2002; Tolman & Edleson, 1995). Some BIPs have been criticized for a confrontational style—a style that is similar to the hierarchical relationships in other areas of batterers' lives and is one

from which they are being told to refrain in their own homes. Mederos and Perilla (2003, p. 4) suggest that "this confrontational style increases the risk that abusers will adopt a defensive or falsely compliant stand during sessions, and then maintain a defensive or hostile attitude when they return home."

Batterers mandated to BIPS are likely to be poor and under- or unemployed. Thus, fees for service may deter these men from following through with a program (Mederos & Perilla, 2003). While there are some BIPS that attend to unique cultural, ethnic, and class issues, BIPs in general have been criticized for a "one size fits all" model that ignores or focuses little attention on how issues of race, culture, ethnicity, and class intersect with battering (Mederos & Perilla, 2003). The criminal justice system's reliance on BIPs for a "treatment" alternative to incarceration becomes problematic when considering the lack of uniform definitions for what "success" means in batterer treatment. Batterer intervention programs vary considerably in the degree of involvement of abused partners in the program – from programs that do not contact the partners at all to programs that provide services (such as a victims' group) to the abused partners. Additionally, BIPs may or may not hold the abusers accountable for additional violence committed while the abusers are in the program. A domestic violence program in Virginia provides an example (Virginians Against Domestic Violence, 2002, p. 10):

> Lisa's husband was on probation through Community Corrections because of an incident that occurred last summer. He held her at knifepoint in a grocery store parking lot and was charged with abduction. He was sentenced to six months of suspended jail time as long as he remains on "good behavior." His counselor requested that he remain on probation due to his lack of participation in a court-ordered Batterer Intervention Program, even though technically he completed the program. Around the same time, when Lisa was in the early stages of her pregnancy, her husband became physically violent, bruising her back with a steel toe boot and holding his father's gun to her head. She did not report this to law enforcement. She did tell the Batterer Intervention Service Provider and the probation officer, but they didn't formally intervene because Lisa was unwilling to report the incidents to law enforcement.

Lack of Primary Prevention and Outreach

The criminal justice response largely is one of intervention after an assault has occurred rather than primary prevention and outreach to

influence community norms and practice regarding use of violence. Law enforcement, prosecutors, magistrates, judges, victim-witness providers, BIPS, all primarily focus their work and resources after the crime has been committed. Some CCRIs have become involved in primary prevention efforts, in part due to the increase in funding for prevention planning (Centers for Disease Control and Prevention, 2003; Chapel, 2003). While it could be argued that it is very important to intervene with men engaged in abusive behavior, it could also be argued that a greater number of men are at risk for becoming involved with battering and need to be provided with messages condemning violence and offering alternative means to handle relationships. Many more men who are engaged in abusive behavior are not involved in the criminal justice system in any way: thus the majority of batterers are not receiving interventions through the criminal justice system (and perhaps not through any other system either). A significant amount of resources and efforts to address IPV, however, are funneled through the criminal justice system.

Victim Disempowerment

One definition of empowerment is to "develop within individuals, families, groups, or communities the ability to gain power" (Parsons, Gutiérrez, & Cox, 1998: 4). Parsons et al. note that power occurs on three levels: personal, interpersonal, and environmental. They list the components of empowerment as follows: (a) the ability to act on one's own behalf, to have control over one's life, to have a sense of self worth; (b) the opportunity to realize that one is not alone, that one shares an experience with others. This helps people to realize that some of their perceptions are indeed valid and legitimate, thus reducing self-blame; (c) giving people the knowledge and skills to think critically about the internal and external contributors to their problems: their own attitudes, beliefs, and values that influence problems as well as macro-level structures that impact their lives; and (d) moving into action to effect change. People assume responsibility for their actions and have a sense that they can impact their own lives. They act with others to reach their goals and create societal change.

When a battered woman experiences an assault and she contacts the police, she often is hoping that the violence will stop temporarily. She could be afraid of more serious injury or afraid for her life. When the police officers arrive, she may vehemently protest the arrest of her partner, because again, her goal may have been to stop the violence, not to have the abuser arrested. The moment of the

choice being taken out of her hands is victim disempowerment. She
no longer feels in control of her own life. Then, if she lives in a com-
munity with "no drop" prosecution, she may be directed to appear in
court and forced, even if unwillingly, to testify against her partner.
Here again, she may feel that she does not have control over her own
life. On the contrary, women who want to use the criminal justice sys-
tem to consequence the actions of their abusive partners may be dis-
appointed and disillusioned if, for example, they do appear in court,
testify about the assault, yet their partners receive a deferred sen-
tence or a minimal fine. I am reminded of working with a woman
several years ago who testified in court about a serious assault where
her partner repeatedly banged her head on the floor. He received a
misdemeanor conviction and a $50 fine. She said she would never go
through the court process again for such an outcome. In these exam-
ples, the women's intentions and behaviors did not result in
expected outcomes. Their decisions over their lives were in the
hands of others.

The professionals who have control over these women's lives are
certainly well-intended. When I worked at a battered women's pro-
gram in Michigan, one of the magistrates said that he could see the
"invisible hands of the abuser around the woman's throat" when left
up to her whether she would testify against the abuser. When the
prosecutor took it out of her hands, she could say to the abuser that
she had no choice, even if she vehemently protested testifying against
him or even lied on the stand. This magistrate's intention was to take
the pressure off the victim and let the court take the heat from the
abuser. While some may view this as "protecting" the victim, others
see it as paternalism. Survivors have an uncanny ability to... survive.
They manage to persevere in the most brutal of circumstances and
many are able to leave abusive relationships without formal agency
help. Yet, when entering the criminal justice arena, they need to have
someone else take over (for their own good).

Victim disempowerment also occurs when victims get labeled
"good/cooperative" victims versus "bad/reluctant/hostile" victims. A
"good" victim calls the police when an assault occurs; makes a coher-
ent statement to the responding officers (and has visible signs of
injury); is cooperative with the prosecutor and victim-witness; testi-
fies beautifully on the stand; is happy when the abuser is sentenced;
gets a protective order and reports violations of it to the court; and
leaves the abusive relationship. A "bad" victim may or may not call
the police (if she does, she doesn't want the abuser arrested); denies
the assault occurred once police arrive; does not show up on her

ation of music, and the importance of the black church, as a method for raising awareness about and preventing domestic violence in the African-American community. Others are offering for consideration the use of restorative justice principles with IPV offenders rather than the traditional criminal justice approach (Hudson, 2002).

Lewis, Dobash, Dobash, and Cavanagh (2000) suggest that abused women are active agents in using the criminal and civil legal system as a "strategy to resist violence and secure protection" (p. 200). The reasons women seek assistance from the legal system may be for protection, for prevention (deterrence), or for rehabilitation for their abusive partners. Yet the criminal justice response is not always aligned with the motivations for why abused women contact the legal system in the first place. For example, an abused woman who calls the police hoping to deter future violence may be disappointed if the police do not take action. As a participant in the Lewis et al. (2000) study said: "I suppose it would make him worse if he's getting off with it all the time, he'll get worse and worse because he knows he's going to get off with it" (p. 189).

One study (Buzawa, Austin, Bannon, & Jackson, 1992) that included interviews with domestic violence victims found that victim satisfaction with police response was correlated with whether the officer complied with the victim's preference on arrest. If, for example, the victim/survivor wanted the officer to refrain from arresting the abuser, but instead to talk with him, make the violence stop at that moment, or get the abuser to leave the residence, and the officer did one of these, then the victim was satisfied. This included cases of serious injury to the victim. Another study found that women who had been through a domestic-violence-related court case felt more satisfied when they perceived themselves as having control over the court system and the outcome of the case (Fleury, 2002). Mills (1996) echoes the call for putting control in the hands of battered women and discusses several options for interventions that empower abused women, including combining court systems with social work or therapeutic methods; creating courts that hear only child, spouse, and elder abuse cases; implementing all-female-run police stations with investigators who work in conjunction with social workers; and designing domestic violence commissions. Mills (1996) notes that the commissions could:

> advance domestic violence policy by empowering the battered woman herself to design a course of action she felt would eradicate violence from her life. A flexible remedy menu and time line that

court date (and might be arrested for not doing so) or, if she does, she protests having to testify; denies the assault took place while on the stand; asks the court to refrain from convicting and sentencing her partner; and is unhappy if the court convicts and sentences her partner. A bad victim does not admit an attachment to her abuser, yet research has shown that emotional attachment plays a significant role in abused women's decisions to return to an abusive relationship (Griffing, Ragin, Sage, Madry, Bingham, & Primm, 2002).

Alternative Models to the Criminal Justice Approach

There are advantages to treating IPV as a crime. Many women's lives have been spared because of the intervention of the criminal justice system. This crime, however, is unlike many other crimes for which we as a society seek punishment. This is a crime that takes place within an intimate relationship, between two people who profess love to each other, who may have children together, and who might have made commitments to each other. So many times the women with whom I worked said they had difficulty leaving the abuser because they loved him—plain and simple. It is rare that one loves the person who mugged you at the ATM or the person who cut your screen in your window and vandalized your home and stole your money and jewelry. Love complicates the efficiency of the criminal justice system. The courts haven't figured out how to handle this love factor. He beat you—leave him

How can criminal justice professionals believe that they are doing their jobs while at the same time survivors feel empowered? There are no easy solutions. Mederos and Perilla (2003) describe several initiatives in Boston, Atlanta, and Texas that:

- Reach out, through preventative community education and early intervention activities, to abusers, to men who are risk of becoming abusers, and to men who can act as educators for their peers.
- Engage men in ways that reflect a deep knowledge of their cultural backgrounds, life challenges, and positive aspects of their traditions of manhood.
- Engage a wide range of community agencies in educating and reaching out to men about ending intimate partner violence. (p. 4)

Oliver (2000) suggests the use of black popular culture, which he includes the intergenerational effects of racist practices, the appreci-

respected the uncertainty generated by conflicting loyalties could
be just what the battered woman needs to finally face, incremen-
tally and at her own pace, what she may have otherwise tolerated
for fear that the legal system, with its essentialist and blunt criminal
instruments, would do for her what she was not yet ready or willing
to do for herself. (p. 266)

Perhaps survivors should be able to choose from several alternatives
when they seek support. They should be given realistic information
about options (legal and otherwise) from which they could choose: a
menu of informed choices, if you will. Ideally, providers would
respect survivors' choices and survivors wouldn't be labeled as good
or bad because of their decisions. As with other social policies, some-
times the best intentions fail to translate into desirable outcomes. It is
time to reevaluate our reliance on the criminal justice response to
address the issue of IPV. By institutionalizing the criminal justice
response as a dominant paradigm in understanding and intervening
in IPV, we have unintentionally recreated a controlling relationship
with abused women. The self-determination of battered women
needs to be at the center of any paradigm in our analysis of and inter-
vention in IPV.

NOTES

1. I will use both the terms victims and survivors to refer to persons who
 have been or are currently being abused. The criminal justice system
 tends to use the term "victim," while battered-women's advocates usually
 prefer "survivor."
2. Agency representatives may also identify as battered/formerly battered.
 An unintended consequence of having a "slot" for battered/formerly
 battered women on councils is that it reinforces an assumption that the
 professionals are separate from the victims/survivors rather than some
 of us (professionals) are them (battered/formerly battered).

REFERENCES

Bailey, K.D. (1982). Methods of Social Research. New York: Free Press.
Barker, R.L. (1991). The Social Work Dictionary (2nd Ed.). Washington, DC:
 National Association of Social Workers.
Bent-Goodley, T.B. (2001). "Eradicating Domestic Violence in the African
 American Community: A Literature Review and Action Agenda." Trauma,
 Violence, & Abuse, 2(4), 316-330.
Berg, S.H. (2002). "The PTSD Diagnosis: Is it Good for Women?" AFFILIA,
 17(1), 55-68.
Bograd, M. (1982). "Battered Women, Cultural Myths and Clinical Interven-

tions: A Feminist Analysis." Women & Therapy, 1(3), 69-77.

Brooks, R. (1997). "Feminists Negotiate the Legislative Branch: The Violence Against Women Act." In C.R. Daniels (Ed), Feminists Negotiate the State: The Politics of Domestic Violence (pp. 65-81). Lanham, MD: University Press of America.

Bureau of Justice Assistance (1993, October). Family Violence: Interventions for the Justice System. Program Brief. Washington, DC: Author.

Busch, N.B., & Valentine, D. (2000). "Empowerment Practice: A Focus on Battered Women." AFFILIA, 15(1), 82-95.

Buzawa, E.S., Austin, T.L., Bannon, J., & Jackson, J. (1992). "Role of Victim Preference in Determining Police Response to Victims of Domestic Violence." In E.S. Buzawa & E. Buzawa (Eds.), Domestic Violence: The Changing Criminal Justice Response (pp. 255-269). Westport, CT: Auburn House.

Cahn, N.R. (1992). "Innovative Approaches to the Prosecution of Domestic Violence Crimes." In E.S. Buzawa & C.G. Buzawa (Eds.), Domestic Violence: The Changing Criminal Justice Response. pp. 161-180. Westport, CT: Auburn House.

Campbell, J.C., & Humphreys, J. (1984). Nursing Care of Victims of Family Violence. Reston, VA: Reston Publishing Co.

Centers for Disease Control and Prevention. (2003). Domestic Violence Prevention Enhancement and Leadership Through Alliances (DELTA) Project. [Virginians Against Domestic Violence DELTA Sub-Grant Application]. Williamsburg, VA: Virginians Against Domestic Violence.

Chapel, T.J. (2003, April 22). "Using the CDC Evaluation Framework to Think Strategically about VAW." Presentation for the Planning Workshop for the Prevention of Violence Against Women. Richmond, VA: Center for Injury & Violence Prevention, Department of Public Health.

Chornesky, A. (2000). "The Dynamics of Battering Revisited." AFFILIA, 15(4), 480-501.

Daniels, C.R. (1997). Feminists Negotiate the State: The Politics of Domestic Violence. Lanham, MD: University Press of America.

Davis, L.V., Hagen, J.L., & Early, T.J. (1994). "Social Services for Battered Women: Are They Adequate, Accessible, and Appropriate?" Social Work, 39(6), 695-704.

Dietz, C.A. (2000). "Responding to Oppression and Abuse: A Feminist Challenge to Clinical Social Work." AFFILIA, 15(3), 369-389.

Dobash, R.E., & Dobash, R. (1979). Violence Against Women. New York: Free Press.

Edleson, J.L., & Tolman, R.M. (1992). Intervention for Men Who Batter: An Ecological Approach. Newbury Park, CA: SAGE Publications, Inc.

Family Violence Prevention Fund. (1999). Domestic Violence is a Serious, Widespread Social Problem in America: The Facts. San Francisco, CA: Author.

Ferraro, K.J. (1993). "Cops, Courts, and Woman Battering." In P.B. Bart & E.G. Moran (Eds.), Violence Against Women: The Bloody Footprints (pp.

165-176). Newbury Park, CA: SAGE Publications, Inc.

Fleury, R.E. (2002). " Missing Voices: Patterns of Battered Women's Satisfaction with the Criminal Legal System." Violence Against Women, 8(2), 181-205.

Gregory, C., & Erez, E. (2002). "The Effects of Batterer Intervention Programs: The Battered Women's Perspectives." Violence Against Women, 8(2), 206-232.

Griffing, S., Ragin, D.F., Sage, R.E., Madry, L., Bingham, L.W., & Primm, B.J. (2002). "Domestic Violence Survivors' Self-identified Reasons for Returning to Abusive Relationships." Journal of Interpersonal Violence, 17(3), 306-319.

Hudson, B. (2002). "Restorative Justice and Gendered Violence: Diversion or Effective Justice?" British Journal of Criminology, 42(3), 616-634.

Jones, L., Hughes, M., & Unterstaller, U. (2001). "Post-traumatic Stress Disorder (PTSD) in Victims of Domestic Violence: A Review of the Research" Trauma, Violence, & Abuse, 2(2), 99-119.

Kanuha, V. (1990). "Compounding the Triple Jeopardy: Battering in Lesbian of Color Relationships." Women & Therapy, 9(1/2), 169-184.

Lewis, R., Dobash, R.P., Dobash, R.E., & Cavanagh, K. (2000). "Protection, Prevention, Rehabilitation or Justice? Women's Use of the Law to Challenge Domestic Violence." International Review of Victimology, 7, 179-205.

Lundy, M., & Grossman, S. (2001). "Clinical Research and Practice with Battered Women: What We Know, What We Need to Know." Trauma, Violence, & Abuse, 2(2), 120-141.

McFarlane, J., Greenberg, L., Weltge, A., & Watson, M. (1995). "Identification of Abuse in Emergency Departments: Effectiveness of a Two-question Screening Tool." Journal of Emergency Medicine, 21(5), 391-394.

McFarlane, J., Parker, B., Soeken, K., & Bullock, L. (1992). "Assessing for Abuse During Pregnancy: Severity and Frequency of Injuries and Associated Entry into Prenatal Care." Journal of the American Medical Association, 267, 3176-3178.

McHardy, L.W. (1992). Family Violence: State-of-the-art Court Programs. Reno, NV: National Council of Juvenile and Family Court Judges.

Martin, D. (1976). Battered Wives. San Francisco, CA: Glide.

Mederos, F. (1999). "Batterer Intervention Programs: Past and Future Prospects." In E. Pence & M. Shepard (Eds.), Coordinating Community Responses: Lessons from Duluth and Beyond (pp. 127-150). Newbury Park, CA: Sage Publications. Mederos, F., & Perilla, J. (2003). Community Connections: Men, Gender, and Violence. Retrieved May 26, 2003 from http://www.endabuse.org/bpi.

Mills, L. (1996). "Empowering Battered Women Transnationally: The Case for Postmodern Interventions." Social Work, 41(3), 261-268.

O'Leary, K.D., & Murphy, C. (1992). "Clinical Issues in the Assessment of Spouse Abuse." In R.T. Ammerman & M. Hersen (Eds), Assessment of Family Violence: A Clinical and Legal Sourcebook (pp. 26-46). New York: John Wiley & Sons, Inc.

Oliver, W. (2000). "Preventing Domestic Violence in the African American Community: The Rationale for Popular Culture Interventions." Violence Against Women, 6(5), 533-549.

Parsons, R.J., Gutiérrez, L.M., & Cox, E.O. (1998). "A Model for Empowerment Practice." In L.M. Gutiérrez, R.J. Parsons, & E.O. Cox (Eds.), Empowerment in Social Work Practice: A Sourcebook (pp. 3-23). Pacific Grove, CA: Brooks/Cole Publishing Co.

Pence, E. (1999). "An Introduction: Developing a Coordinating Community Response." In E. Pence & M. Shepard (Eds.), Coordinating Community Responses: Lessons from Duluth and Beyond (pp. 3-23). Newbury Park, CA: Sage Publications.

Pence, E., & Paymar, M. (1985). Power and Control: Tactics of Men who Batter. Duluth, MN: Domestic Abuse Intervention Project.

Raj, A., & Silverman, J. (2002). "Violence Against Immigrant Women: The Roles of Culture, Context, and Legal Immigrant Status on Intimate Partner Violence." Violence Against Women, 8(3), 367-398.

Richie, B. (1996). Compelled to Crime: The Gender Entrapment of Black Battered Women. New York: Routledge.

Rounsaville, B., & Weisman, M. (1978). "Battered Women: A Medical Problem Requiring Detection." International Journal of Psychiatry in Medicine, 8, 191-202.

Rubin, H.J. (1983). Applied Social Research. London: Charles E. Merrill.

Schechter, S. (1982). Women and Violence: The Visions and Struggles of the Battered Women's Movement. Boston: South End Press.

Sharma, A. (2001). "Healing the Wounds of Domestic Abuse: Improving the Effectiveness of Feminist Therapeutic Interventions with Immigrant and Racially Visible Women Who Have Been Abused." Violence Against Women, 7(12), 1405-1428.

Shepard, M. (1991). "Feminist Practice Principles for Social Work Intervention in Wife Abuse." AFFILIA, 6(2), 87-93.

Tolman, R.M., & Edleson, J.L. (1995). " Intervention for Men who Batter: A Review of Research." In S.R. Stith & M.A. Straus (Eds.), Understanding Partner Violence:Prevalence, Causes, Consequences and Solutions (pp. 262-273). Minneapolis, MN: National Council on Family Relations.

Tjaden, P., & Thoeness, N. (2000, July). Extent, Nature and Consequences of Intimate Partner Violence: Findings from the National Violence Against Women Survey. Washington, DC: U.S. Department of Justice, Office of Justice Programs.

Virginians Against Domestic Violence. (2002, Fall/Winter). In Our Vision [newsletter].Williamsburg, VA.

Walker, L.E. (1984). The Battered Woman Syndrome. New York: Springer Publishing.

Walker, L.E. (Writer), & Holland, J. (Producer/Director) (1994). The Abused Woman: A Survivor Therapy Approach [Videotape and manual]. New York: Newbridge Communications Inc.

White, E.C. (1985). Chain, Chain, Change: For Black Women Dealing with

Physical and Emotional Abuse. Seattle: The Seal Press.

Zosky, D.L. (1999). "The Application of Object Relations Theory to Domestic Violence." Clinical Social Work Journal, 27(1), 55-69.

Elizabeth P. Cramer, PhD, L.C.S.W., A.C.S.W., *is an Associate Professor in the School of Social Work at Virginia Commonwealth University, Richmond, VA. Her primary practice and scholarship areas are domestic violence, lesbian and gay issues, and group work. Dr. Cramer has published a number of journal articles, book chapters, and a curriculum module on CD-ROM on such areas as abuse experiences and service needs of women with disabilities, variables predicting convictions and acquittals in domestic assault cases, and the relationship of sentencing options to recidivism rates in domestic violence. Dr. Cramer has also presented on these topics at national, regional, and local conferences. Dr. Cramer is on the editorial board of the Journal of Lesbian Studies and has served as a peer reviewer for the journals Criminal Justice and Behavior, Journal of Gay and Lesbian Medical Association, Journal of Social Work Education's Special Section on Domestic Violence, and for the publication Integrating Domestic Violence Content in the Social Work Curriculum. She has also served on a grant review panel for the Department of Justice Violence Against Women office. Dr. Cramer is a member of the Advisory Committee of Virginians Against Domestic Violence, an advisory committee member for Violence and Women with Disabilities (a grant-funded project in Virginia), a member of the Chesterfield County Domestic Violence Task Force, and a volunteer trainer with the YWCA Women's Advocacy Program. She's been involved in the domestic violence field for over 20 years.*

Lesbianism and the Death Penalty: A "Hard Core" Case

Ruthann Robson

Bernina Mata was sentenced to death in Illinois in 1999 for being a lesbian—or, as the prosecutor labeled her, a "hard core lesbian."

Such a declaration strains credibility. 1999? Illinois? Sentenced to death? Is this really a claim of a direct causal link?

In my previous scholarship investigating lesbians and the criminal justice system, I interrogated the prosecutorial use of lesbianism in trials and sentencing and often, not surprisingly, discovered bias against lesbians (Robson, p. 1998). Nevertheless, I concluded that I could not sustain any claim of legal causation and argued that positing lesbianism (and other identities) "as the cause of prosecution and conviction is facile," and it was more important to consider statistical overrepresentation and the tropes which prosecutors use to dehumanize the lesbian defendant (ibid., p. 46-47). Analyzing the transcripts of two lesbians who were then on death row—Aileen Wuronos, who has since been executed, and Ana Cardona, who has since had her sentenced reversed—I thought that "the-lesbian-as-man-hater is never explicitly articulated but virtually floats from the transcript pages" (ibid., p. 36).

Yet when I read the transcript in the case of Bernina Mata, I confronted a trial and sentencing hearing in which the-lesbian-as-man-hater was no mere floatational trope. Instead, it was the prosecution's theory of guilt of first-degree murder and the prosecution's justification for the death sentence. Given the facts of the case—a stabbing relating to a sexual encounter and involving a third party—it seemed to me that the only real reason the jury could have convicted Ms. Mata of first-degree murder and sentenced her to death was the prosecutorial (mis)use of her lesbianism.

I became aware of the case of Bernina Mata through a former student and now practicing attorney, Joey Mogul, of The People's Law office in Chicago, Illinois. Ms. Mogul was representing Ms. Mata in a clemency hearing, as part of the individual clemency hearings ordered for every death-row inmate by then-Governor George Ryan. After reading the transcripts, I agreed to become an "expert" on the bias in Bernina Mata's trial and sentencing hearing.

The next section of this piece contains the affidavit submitted on Bernina Mata's behalf. After the affidavit, section three illuminates the process of writing the affidavit and some of the issues it raised. Finally, the last section considers the outcome of the hearing and Ms. Mata's present situation.

Affidavit

PARDON DOCKET NO. 23679
BEFORE THE ILLINOIS PRISONER REVIEW BOARD
FALL TERM, 2002
ADVISING THE HONORABLE GEORGE RYAN
IN THE MATTER OF BERNINA MATA

AFFIDAVIT

1. My name is Ruthann Robson. I am a Professor of Law at the City University of New York School of Law and a member of the Florida Bar. My legal training and experience consists of a J.D. degree, a LL.M. degree, a clerkship with the Honorable William J. Castagna, United States District Court for the Middle District of Florida, a clerkship with the Honorable Peter T. Fay, United States Court of Appeals Judge for the Eleventh Circuit, and a practice with Florida Rural Legal Services. I have been teaching at the City University of New York School of Law since 1990 in the areas of constitutional law, including equality and the first amendment, sexuality and the law, and family law.

2. The bulk of my scholarship has been in the area of lesbian legal theory. This work appears in several books I have authored including Lesbian (Out)Law and Sappho Goes to Law School (Columbia University Press, 1998), in over fifty articles in law reviews, anthologies, and encyclopedias, and has been cited in excess of three hundred instances in various law reviews and anthologies in the United States and abroad. Additionally, I have spoken about lesbian legal issues at a multitude of law schools, universities, academic conferences, and other venues in the United States, Canada, Great Britain, Australia, and New Zealand. I have been cited and quoted by numerous periodicals as an expert on lesbian legal issues.

3. I am familiar with death penalty jurisprudence and doctrine. I have co-authored articles which appeared in The California Law Review and The Florida State Law Review on specific constitutional

aspects of the imposition of the death penalty. During my clerk-
ships, I worked on numerous habeas corpus cases involving capital
punishment and criminal issues.

4. Given the confluence of these interests, my previous research has
included a consideration of the possibility of bias in the imposition
of the death penalty against lesbians and other sexual minorities. I
have also more generally investigated prejudice against sexual
minorities in various aspects of the criminal justice system, includ-
ing sexual minorities accused of crimes and sexual minorities as vic-
tims of crimes.

5. The materials I have read regarding the imposition of the death
penalty against Bernina Mata, including portions of the trial tran
script and the arguments of counsel, convince me that Ms. Mata was
sentenced to death based in large part because of the prosecutorial
portrayal of Ms. Mata as a lesbian.

My opinion is specifically directed to the prosecutor's incessant
characterization of Ms. Mata as a lesbian, and I offer no opinion
about whether Ms. Mata should, in fact, be accurately described as a
lesbian rather than as a bisexual, given the other evidence of her
sexual relationships with men, possibly including the victim.

6. Bias against lesbians and other sexual minorities is well docu-
mented. For example, The American Enterprise Institute (AEI) for
Public Policy Research reports that in 1973, when the National
Opinion Research Center at the University of Chicago first polled
people about sexual relations between persons of the same sex,
73% characterized such an event as "always wrong." According to
AEI's own polls in the years 1996, 1998, and 2000, the percentage of
persons judging sexual relations between persons of the same sex as
"always wrong" was reported at 60%, 58%, and 59% respectively.

Members of juries are composed from this population of those
who disapprove of homosexuality. Thus, it is not surprising that a
disproportionate number of potential jurors admit to being biased
against lesbian and gay defendants in the criminal context. As
reported in The Chicago Sun-Times in 1998, the year prior to Ms.
Mata's trial, potential jurors were "more than three times as likely to
think they could not be fair or impartial toward a gay or lesbian
defendant as toward a defendant from other minority groups, such
as blacks, Hispanics, or Asian Americans" (p. 37). This finding,
based on the Juror Outlook Survey, conducted by the National Law
Journal and Decision Quest, a national trial consulting and legal
communications company, is especially striking given that "more

than 40 percent of those polled and more than 70 percent of blacks polled believe that minorities are treated less fairly than others" in the criminal justice system, meaning that sexual minorities are treated even less fairly (ibid.).

Given the statistics supporting jury bias, it is not be surprising that one of the very few empirical studies to address the specific issue of discrimination against lesbians in the criminal justice system concludes that lesbians are more likely to be convicted that heterosexual women (Leger, 1987).

7. The most frequent negative stereotypes of lesbians in popular culture fantasize lesbians as violent and man-hating. As a 1991 Report from GLAAD, the Gay and Lesbian Alliance Against Defamation, found, the depiction of lesbians on television and movies is "almost uniformly negative," citing as an example that "out of a total of the four lesbians appearing on series television last season, two were portrayed as murderers, and one as a murder victim in which the other lesbians are under suspicion for the murder" (Rhue, 1991, p.3). The Report concludes that in summary, "lesbian images in film and television depict us as man-hating, society-destroying, sex-driven or sexless creatures who have no hearts, homes, families, values, or reasons to live" (ibid., 4).

8. In my opinion, the prosecutor in the case against Ms. Mata capitalized on this prejudice against lesbians and the negative stereotypes of lesbians as man-hating murderers to convince the jury that Ms. Mata's acted in a cold, calculated, and premeditated manner, the only permissible and possible aggravating factor which the jury found in this case (a factor which the Illinois Governor's Commission has recommended be abolished). It is also my opinion that the prosecution's reliance on Ms. Mata's lesbianism served as a de facto impermissible aggravating factor in the imposition of the death penalty.

9. Specifically, the prosecutor's introduction of books from Ms. Mata's house, with titles such as *Call Me Lesbian* and *Best Lesbian Reading* (Trial Record (hereinafter R) 3036-3039), demonstrates the impermissible use of negative stereotypes to influence the jury members. In the prosecutor's own words, the prosecutor introduced the books to "show that she has a motive to commit this crime in that she is a hard core lesbian" (R2135), and argued that "these books have been the most direct route to show that she is a lesbian and is motivated to commit this crime." (R2140). This evidence should have been excluded as irrelevant.

As I have previously theorized, there are instances in which a defendant's sexual relationships and identity are relevant to the circumstances of the crime, and in such instances, the prosecution should introduce this evidence in the most factual and least biased manner as possible. However, in Ms. Mata's trial, her sexual identity is absolutely irrelevant to the crime. The only possible "relevance" of Ms. Mata's sexual identity as a lesbian depends upon an acceptance of the stereotype of all lesbians as man-hating murderers.

10. In my opinion, the introduction of books with titles such as *Call Me Lesbian*, as well as the frequent references to Ms. Mata's lesbianism, operated to impermissibly prejudice the jury in two distinct ways. First, the arguments regarding Ms. Mata's lesbianism constitute the basis for the sole aggravating factor found by the jury: that the murder was committed in a cold, calculated, and premeditated manner. The prosecution repeatedly emphasized Ms. Mata's lesbianism in its argument at trial (R4947-948; R4952-954; R4959). It was the prosecutor's explicit theory argued to the jury that Ms. Mata, because "she is a lesbian," was "infuriated" by a man's sexual advance in a bar, and therefore decided to murder him, first luring him to her home under the pretense that he was "going to get lucky" (R2132-2133). Absent the negative stereotypes of lesbians as man-haters, there is little credible evidence to support a finding that the male victim was killed pursuant to a cold, calculated, and premeditated plan. Indeed, the evidence concerning the victim's death by stabbing occurred in Ms. Mata's bedroom under circumstances which indicate a sexual relationship, whether consensual or not, between Ms. Mata and the male victim, with the involvement of another party. Such a scenario more typically reflects a second-degree murder charge or conviction, not a first-degree murder charge or conviction. The imposition of capital punishment in such a situation is an anomaly, explicable by of the prosecutorial pandering to prejudice against lesbians.

11. Secondly, the prosecutorial arguments regarding Ms. Mata's lesbianism comprise an impermissible de facto aggravating circumstance that the jury then improperly considered in its death sentence. Based upon the negative stereotypes of lesbians as persons having "little reason to live," the jury was prompted to determine that Ms. Mata deserved to die because, as the prosecutor phrased it, she was not "a normal heterosexual person." The dehumanizing of a criminal defendant as a person not worthy of living may be an accepted strategy of prosecutors seeking the death penalty; however, the use of Ms. Mata's lesbianism to dehumanize

her demonstrates a level of bias and prejudice that should not be tolerated.

12. There is an evolving norm regarding the introduction evidence regarding a defendant's sexuality during criminal trials, including cases involving the imposition of the death sentence, which prohibits the use of sexual materials to inflame and prejudice the jury. For example, the Arizona Supreme Court in State v. Grannis, 900 P.2d 1 (Az. 1995), reversed the conviction and death sentences of two defendants because of the admission at trial of certain photographs of male homosexual pornography found in one of the defendant's closets. The court found that the photographs were only marginally relevant and that the photographs may have "repulsed many of the jurors" so that the their "verdict may well have been improperly influenced by their revulsion and not entirely based upon a belief that the state proved the elements of the crime." (ibid., p. 6.)

Although the trial judge in Ms. Mata's case determined that "looking at the photos of the books," there "does not appear to be anything that's shocking value to them" or "pornographic or sexually explicit," in seeking to introduce the books into evidence, the prosecutor confusingly stated that "these aren't picture books. These are books about lesbianism, books with one woman visually depicted performing lesbian acts upon another woman. It's not like this is books [sic] about living a lesbian life and such?" And, as in the Grannis trial from Arizona, the prosecutor in Ms. Mata's trial sought to prove the defendant's sexual orientation by the most repulsive means possible. Indeed, the prosecutor proclaimed on behalf of the state that "We don't have to accept any form of stipulation,"as to Ms. Mata's sexuality. Instead, the prosecutor sought to introduce and reintroduce and reintroduce evidence of Ms. Mata's lesbianism for the purpose of inflaming and prejudicing the jury.

13. Additionally, there is an evolving norm regarding the level of bias and prejudice against lesbians, gay men, and other sexual minorities that will be tolerated by members of society. For the Illinois Prisoner Review Board to refuse to commute Ms. Mata's death sentence despite the prosecutor's prejudicial use of Ms. Mata's lesbianism as the motive for her crime and support for the aggravating circumstance(s) meriting the death sentence is to continue to perpetrate an injustice not only against Ms. Mata, but against the lesbian and gay communities of Illinois and this nation. Indeed, a non-commutation in Ms. Mata's case announces to members of the

lesbian and gay community that our sexual orientation constitutes a motive for us to murder and a rationale for us to be sentenced to death according to the State of Illinois. It tells us that our relationships, sexual or otherwise, with those of our own gender are tantamount to our desire and willingness to "lure" members of the opposite sex to their death. It tells us that the books on our shelves—or perhaps even the books that we have authored—are admissible and proper evidence of our propensity to murder and our unfitness for life.

14. Based on the foregoing, it is my opinion that the death sentence imposed on Ms. Bernina Mata was largely, if not exclusively, based upon the prosecutorial characterization of her as a lesbian. Given such bias and prejudice, I support the Illinois Prisoner Review Board's commutation of the death sentence imposed on Bernina Mata.

Ruthann Robson
Professor of Law
City University of New York (CUNY) School of Law
65-21 Main Street Flushing, NY 11367 USA

SWORN TO AND SUBSCRIBED BEFORE ME
this ___ day of October, 2002

Confronting the Politics of Identity

In this section, I will examine some of the issues raised in the composition of the affidavit. In my analysis of the transcripts and contemplation of writing the affidavit, two issues in particular plagued me, both revolving around Ms. Mata's identity as a lesbian. The first problem I had was that Ms. Mata seemed to me to be more accurately labeled as bisexual. According to the transcripts, she lived with the co-defendant, her male roommate with whom she seemed to be having a sexual relationship. Moreover, she met the male victim at a bar and brought him to her house.

Describing her identity as bisexual would stress the heterosexual dimensions of the encounter which led to the victim's death. Whether the explanation for the killing was sexual jealousy between the two men or whether the explanation was that the male victim became sexually aggressive and the male roommate acted in her

defense, the facts would sustain a second-degree murder charge committed in the "heat of passion," but not a premeditated first-degree murder charge of which she had been convicted and which led to the death sentence. In sum, I thought that referring to Ms. Mata as "bisexual" throughout the affidavit would undercut the prosecutor's arguments on both the facts and the law.

Yet the use of the term "bisexual" was deemed confusing and objectionable by several persons who reviewed the affidavit. While I was initially reluctant to abandon the term, I decided to eschew use of the label while raising the issue but rendering no conclusion. I did not want to be guilty of the same act of which I was accusing the prosecutor—viewing a situation and declaring the sexual orientation of Ms. Mata to suit my own purposes.

The second issue relating to Ms. Mata's identity which caused me incredible consternation was the manner in which the prosecutor proved her lesbianism—through the titles of books on her bookshelves. *Call Me Lesbian*, introduced into evidence at Ms. Mata's trial, is a book of lesbian theory by Julia Penelope which I have on my own shelves, in addition to many other books about lesbian issues. As an avid reader and collector of books, as an author of books, and as a law professor who teaches a course on the First Amendment, I found this highly unsettling. I knew that there was nothing inherently unlawful about introducing books or other written texts in a criminal trial to prove particular facts, especially to prove intent (often incorrectly referred to as "motive") on the part of the defendant. Nevertheless, I spent countless fruitless hours researching this point and trying to develop a legal argument.

What I wanted to ask the members of the Prisoner Review Board was whether they would want to be judged by the book titles on their shelves. After all, I assumed that given their positions, it might be likely that their shelves would hold books on serial murderers, child molesters, and psychiatric disturbances. However, to pose a rhetorical question to the decision-maker is as dangerous as one of the first lessons one learns as a trial attorney: do not ask a hostile witness a question on cross-examination to which one does not already know the answer. In this case, it might be that the members of the panel would be nonreaders without books or they could be perfectly willing to be judged by the books—or The Book—on their shelves.

I thus decided to insert myself into the affidavit, although this could be an equally treacherous ploy. As an attorney, one is an advocate and one's position is clear, but one's credentials and opinions are not proffered. On the contrary, as an expert one is asked to offer

an opinion, which is based on an examination of the facts, but also on one's credentials, background, and training. The first few paragraphs of the affidavit seek to establish my qualifications as an expert and this type of information is typical in an expert affidavit or opinion at trial. Equally important, however, the expert should be impartial. In many trials, the opposing counsel seeks to discredit the expert and her opinion by seeking to elicit facts which demonstrate the expert's bias. A common strategy would be questioning the expert regarding her remuneration. Unpaid experts, however, can be vulnerable to an even more devastating method of impugning our objectivity: that we have a political stake in our conclusions.

Clearly, however, I did have a political stake. Rather than attempt to obscure it, I decided to deploy it in a rather personalized manner by trying to construct a relationship between the members of the board and myself. A non-commutation, I argued, was not solely about Ms. Mata, but was a judgment that every lesbian, including a lesbian law professor who possessed or who had authored books about lesbian life, was a man-hater with a propensity to murder men and deserved the death penalty. In this regard, I thought that one of the books I have written, *Lesbian (Out)Law*, was particularly relevant, but I ultimately decided that its use detracted from the point by making it overly specific (Robson, 1992).

This argument also seeks to remind the Prisoner Review Board of the political stakes involved in their determination of Ms. Mata's fate. By using the word "our" and invoking "the lesbian and gay community," I hoped to single out Ms. Mata's case for special scrutiny in the midst of the already highly charged atmosphere in which the Prisoner Review Board's hearings were taking place. Moreover, this reference was meant to reinforce other material in Ms. Mata's file urging her commutation, including several advertisements and letters from various lesbian, gay, bisexual, and transgender groups which were obtained and organized by the Chicago-based group Queer-to-the-Left and a letter signed by LGBT law professors whom I had marshaled.

Moreover, even apart from advocacy, I believe it is an important political stance of solidarity for those of us who are workers in the legal system not to distance ourselves from those of us who are "objects" of the legal system. Too often I have heard LGBT activists deny any relationship with LGBT persons who have been convicted of crimes. Certainly, it can seem more palatable to identify with the victim of a crime than with the perpetrator, even assuming the person deemed the perpetrator is always guilty. Yet the "evolving norm"

of nondiscrimination that I declared to be true in the affidavit—
somewhat brashly, I admit—must encompass criminal defendants,
prisoners, and others in the criminal justice and civil justice systems.

Commutation Without Resolution

On January 11, 2003, 48 hours before his term as the Governor of
Illinois expired, Governor George Ryan commuted the sentences of
the 163 men and 4 women who were occupants of the state's death
row.

Governor Ryan issued the blanket clemency because he con-
cluded the system was fundamentally flawed and unfair: "haunted by
the demon of error: error in determining guilt and error in deter-
mining who among the guilty deserves to die" (Wilgoren, 2003, p.1).

Thus, Bernina Mata is no longer on death row.

Justice, however, remains incomplete. Ms. Mata's appeal to the
state's highest court, pending for over a year at the time Governor
Ryan issued the clemency, still has not been decided. Even more
problematic is the conundrum in which Ms. Mata finds herself.
Should any of Ms. Mata's appeals be successful and a new trial
ordered, the state could again seek the death penalty.

Moreover, without a judicial opinion that the prosecutorial use
of lesbianism to prove intent or "motive" is impermissible, Ms.
Mata—and all lesbians—remain in danger of having our sexuality
used as the real basis for conviction and sentencing.

REFERENCES

(2002). AEI Studies in Public Opinion, Attitudes About Homosexuality.

Leger, R. (1987). "Lesbianism Among Women Prisoners." Criminal Justice
and Behavior, 14(4), 448.

Lester, W. (October 24, 1998). "Jurors Say They Follow Beliefs, not Instruc-
tions." Chicago Sun-Times, 37.

Rhue, S. (1991). Images of Lesbians in Television and Motion Pictures.
http://www.glaad.org/media/archive_detail.php?id=307&.

Robson, R. (1992). Lesbian (Out)Law. Ithaca: Firebrand Books.

——. 1998. "Convictions: Lesbians and Criminal Justice," in Sappho Goes to
Law School: Fragments in Lesbian Legal Theory (pp. 29-s41). New York:
Columbia University Press.

State v. Granis, 900 P.2d 1 (Az. 1995).

Wilgoren, J. (January 12, 2003). "Citing Issues of Fairness, Governor Clears
Out Death Row in Illinois." The New York Times, 1.

Ruthann Robson *is a Professor of Law at the City University of New York where she teaches primarily in the areas of constitutional law and law and sexuality. She is the author of many articles in law reviews and other scholarly publications concerning the development of a lesbian legal theory. Additionally, she is the author of the novel* A/K/A *(St. Martin's Press 1998) among other creative works.* *For assistance with the preparation of the affidavit or with this article, gratitude is extended to Joey Mogul, Jeffrey Kirchmeier, S.E. Valentine, and Katerina Semyonova.*

Medea of Suburbia:
Andrea Yates, Maternal Infanticide, and the Insanity Defense

Rebecca Hyman

On May 12, 2003, in the town of Tyler, Texas, Deanna LaJune Laney called the police to inform them that she had just stoned her three children to death. Laney's husband slept through the children's murder, emerging from the house in his nightclothes at 12:52 p.m. to find the police in his yard. In their reports, the police stated that when they arrived they found Joshua and Luke dead in the front yard, and Aaron lying critically wounded in his crib. A fervent Christian with no known history of criminal activity or mental illness, Laney explained to the police that she "had to do it" because God told her to kill her children. When she was interviewed in her prison cell later that day she was described by Sheriff J. B. Smith as "incoherent . . . sometimes [she] lays in a fetal position, sometimes walks around her cell singing gospel music. Sometimes she seems to realize what she's done and says 'Oh, no!'" (Cohen, 2003).

Laney's crime, sensational in its own right, gained further notoriety by its uncanny similarity to that of Andrea Yates, another devout Christian from the suburbs of Houston, Texas, who in June of 2001 drowned her five children in the family bathtub. Both Laney and Yates were left alone without supplemental help to care for and home-school their children, and both invoked divine injunction to explain their crimes. Because Yates's life and trial received such extraordinary publicity, a local judge immediately issued a gag order on those involved in the Laney case (2003, Accused Mom). In their initial speculation about the trial, however, lawyers and other commentators predicted that the prosecution, like that in the Yates case, would seek the death penalty (Cohen, 2003).

Cases of maternal infanticide are gripping because they seem to violate an inherent natural law, calling into question the essentialist notion that women are endowed with a nurturing maternal instinct. Incidents of maternal infanticide garner more press than paternal infanticide and evoke greater outrage from the public. Manuel Gamiz, Jr. (2002) of the Los Angeles Times, for example, compared

the press coverage devoted to the Yates case to that surrounding the case of Adair Garcia, a Pico Rivera man who intentionally killed five of his children by lighting a barbecue in his house and poisoning them with carbon monoxide. Though in the first four weeks of the Yates trial "more than 1,150 articles" were published about her case, only 77 articles were written about Garcia (p. 3). Gamiz argued that the radical disparity in coverage was evidence of a gender bias in the reporting of infanticide—there was something more shocking and forbidden about maternal violence than paternal infanticide. In the case of Yates, men and women uniformly called for her death on radio talk shows and public Internet forums despite the evidence that she was suffering from mental illness. Others, particularly feminists, called for leniency, seeing Yates's life as emblematic of the contradictions between maternal ideology and the daily practice of motherhood, and her crime a consequence of postpartum psychosis (Cohen, 2002; Williams, 2001).

In this essay I consider the public reception of Yates's acts to examine why maternal infanticide generates such heated debates among the public, particularly those who are feminists or religious conservatives. I demonstrate that infanticide is thought by some to be comprehensible only when viewed in relation to popular conceptions of maternal responsibility, whereas others see the act as purely a crime, a form of murder. In doing so, I explore the ways in which the law, because it is predicated on a universal subject, is unable to account for someone like Yates, a woman suffering from a gender-specific mental disorder. The particular form in which Yates' disorder made itself manifest, moreover, indicates the extent to which a clinical entity cannot be extracted from the larger culture within which it is embedded. Yates' belief that she was possessed and an evil mother stemmed from the disjunction between her life and the cultural construction of idealized maternity, a schema of interpretation that finds little room in a court of law. The prosecution's arguments at Yates's trial were accordingly viewed by feminists as exercises in willful blindness to the particular needs of isolated mothers in the postpartum period.

Yet as much as it is useful to examine the Yates trial through the lens of feminist theory, it is equally important to recognize that many of the debates that seem unique to the Yates trial have plagued the insanity defense since its inception. The Yates case is thus at once an expression of contemporary debates about motherhood and a reiteration of the historical conflict between law and medicine. As such, it is a particularly useful lens through which to examine the relation-

ship between popular culture and the gendered subject before the
law.

The Crime

On the morning of June 20, 2001, Andrea Yates fed her children
their morning cereal and sent her husband Rusty off to his job at
NASA in Houston (Roche, 2002; Begley, 2002; 2002, Transcript). She
then filled her bathtub within three inches of the top and methodi-
cally drowned each of her five children. The youngest, Mary, a six-
month-old infant, sat on the floor screaming while in turn Yates
called Paul, 3, Luke, 2, and John, 5, into the bathroom. When each
child died, Yates put his corpse on the bed and covered it with a
sheet. After having drowned the three younger boys, Yates held Mary
under the water and then chased her eldest boy Noah, who was seven
(Gesalman, 2002). Noah was running through the house to escape
her, but she caught him and they struggled as he fought for his life.
Noah came up for air a number of times, Yates recalled, but then said
"I'm sorry" and drowned. Dripping with water, Yates walked out of
the bathroom and called 911, telling the operator that she had killed
her children (2002, Transcript). She then called Rusty, saying only
"it's time" and asked him to come home (Roche, 2002). When
Andrea was questioned about the murders, she told the police that
she was possessed by Satan. She had killed her children, she
explained, because she was a bad mother and they were not behaving
properly. The children's deaths would assure their safety, for they
would be spared her influence and instead go to heaven. More
importantly, her death would ensure the death of Satan, who would
be killed when she was given the death penalty. When she was
brought to jail, Yates asked that her head be shaved so that others
could see that Satan had engraved his emblem, 666, on her skull
(2002, Evil Inside).

Feminist and Conservative Responses to Yates

The Yates case became an overnight sensation because Yates's per-
sonal history was at once woefully inadequate to account for her
crime and yet strangely illuminating: her life could in some ways per-
fectly explain her ultimate actions. As a myriad of articles attempted
to link her expressed motive to her particular circumstances, inci-
dents from her life were hailed for their explanatory power. Yates
clearly suffered from an acute mental illness and paranoid delusions.

She had been diagnosed with postpartum depression; she had been hospitalized; she had attempted suicide (Roche, 2002; Begley, 2002). She was intensely religious; she was isolated; she was left alone to care for five children under the age of eight. The details of Yates's life and her crime were repeated like an incantation by feminists and religious conservatives, each group appropriating her story to warn against what they saw as the unacknowledged political context of her act (Williams, 2001; Quindlen, 2001; Gandy, 2001; Caldwell, 2002; Kaus, 2001; McElroy, 2001; May, 2001).

Liberal feminists, particularly members of the National Organization for Women, argued that Yates's crime should serve as a catalyst for others to remedy the inexcusable lack of research on postpartum depression and psychosis (Varner, 2002). Kim Gandy, President of NOW, (2001, September 6) argued that the case drew attention not only to the plight of suburban housewives, but further to the fragile state of the U.S. healthcare system, which had allowed Yates to be discharged in a clearly psychotic state:

> If we, as a society, allow Yates's case to be treated as a freak crime, stand by while the state of Texas executes her, and then move on to the next sensationalized story, we will have failed in our responsibility to address the larger issues. The overheated dialogue and the repeated characterization of Andrea Yates as "a monster" and "evil" interfere with the kind of clearheaded dialogue we must have in order to prevent the infliction of such misery on another family.

To seek the death penalty for someone as sick as Yates, as State Prosecutor Joe Owmby and District Attorney Chuck Rosenthal did, was proof that Texas was unable to appropriately judge the relationship between mental illness and criminal responsibility.

Members of NOW joined the ACLU, Murder Victims' Families for Reconciliation, and other anti-death-penalty organizations to contest the prosecution's call for Yates's execution, holding rallies demanding that she receive the medical care she so desperately needed. Katie Couric aired the number for Yates's defense fund on the Today Show and Time profiled the case, devoting a special issue to Yates and postpartum depression (Roche, 2002). Because some held that she suffered from both postpartum psychosis and schizophrenia, Newsweek published a feature comparing Yates's disease to that of John Forbes Nash, Jr., the schizophrenic mathematician who was the subject of the film "A Beautiful Mind" (Begley, 2002).

In addition to seeing Yates as the victim of an increasingly

bureaucratized healthcare system, feminists saw Yates's act as illustrative of maternal frustration. Though her crime was certainly extreme, the publicity surrounding the case, some hoped, would disrupt the myth of the eternally giving mother. Though all mothers experienced a conflict between maternal ideology and the daily failures of motherhood, particularly under strain were those like Yates who, in giving up a career to become a full-time mother, had exchanged an independent existence for the contingent identity of motherhood. By interpreting Yates as an emblematic isolated mother, they hoped to rend the veil of maternal ideology, causing others to recognize the extent to which impossible cultural standards could cause women to believe themselves unfit for the role (Quindlen, 2001; Williams, 2001). Yates lived in a conventionally conservative household—her husband did not help her care for their children, did not hire others to aid her with her household duties, and expected her to continue home-schooling the children even when she was diagnosed with clinical depression. Already stretched to what popular author Suzy Spencer (2002) called the "breaking point," Yates also cared for her father, who was suffering from Alzheimer's Disease.

Despite her conforming to the patriarchal standards of female behavior, Yates lived in a state of frantic self-doubt. Her feelings of inadequacy were exacerbated by the teachings of the family's spiritual guide, the radical preacher Michael Woroniecki, whom Rusty had met when he was a student at Auburn University (Hunt, 2002; Pollitt, 2002). In his newsletter, *The Perilous Times*, Woroniecki wrote that mothers were responsible for the spiritual life of their children, and that children who had not been saved by age thirteen or fourteen were most certainly damned. Both Andrea and Rusty Yates corresponded with Woroneicki about their family, and as Andrea's depression worsened, she became convinced she was an "evil" mother (Saunders, 2002).

After the birth of her fourth child, Luke, in 1999, Yates became withdrawn and silent, staring vacantly at the television, pacing, and obsessively scratching her head until she became bald in places. In June of the same year, she took an overdose of Trazodone and was hospitalized. She was discharged in late June, but at the end of July Rusty found her in the bathroom holding a knife to her throat. Yates was then re-hospitalized and placed on the anti-psychotic medication Haldol. In August, her psychiatrist, Eileen Starbranch, warned Rusty and Andrea that further pregnancies could worsen her depression. By February, however, the couple felt that Andrea had recovered

from her illness and she became pregnant again, giving birth to Mary, their fifth child, in November of 2000. Unbeknownst to Rusty, however, Andrea had been suffering from violent hallucinations since the birth of Noah. At first she merely saw a knife flashing, dripping with blood, but as the months wore on she saw both the knife and a person being stabbed—she refused to tell her psychiatrists who was being killed. The strange behaviors that others had taken as merely side effects of depression and strong medications, she explained, were instead her attempts to prevent herself from acting on her violent visions (Roche, 2002).

That no one was sufficiently concerned about Yates's mental health to prevent her from having more children was staggering. That Rusty seemed not to find her extraordinary home responsibilities a potential cause for further mental strain indicated the extent to which he was incapable of comprehending the demands of motherhood. Writing on the case in retrospect, columnist Anna Quindlen (2001) saw Yates as a vivid example of the problems endemic to motherhood. Her plight was like that of other mothers, each of whom who was overworked, guilt-ridden, filled with doubt, and incapable of living up to the standards of behavior they set for themselves. Quindlen felt an outpouring of sympathy for Yates, emotions she found shared by other mothers with whom she discussed the case. For many women, the depression and frustration experienced by Andrea Yates were only too understandable, emotions they had shared. Marie Osmond's "I had lost all joy and hope," the essay in which Osmond recounts her own battle with postpartum depression, appearing in Newsweek in July of 2001, was one of many articles devoted to postpartum depression and maternal guilt that appeared in conjunction with reporting on the Yates case. Some believed Yates's story dramatized the particular difficulties faced by women who are bereft of emotional and material support, who are ejected from a health care system that does not adequately understand postpartum disorders, and who have had to choose between having a career and having a family (Long, 2002; Szegedy-Maszak, 2002). Quindlen wrote that "every mother" with whom she spoke about Andrea Yates "has the same reaction. She's appalled; she's aghast. And then she gets this look. And the look says that on some forbidden level she understands" (2001, p.64). Feminists, then, saw Yates as both emblematic and exceptional—she was both an Everymom and an extremely ill woman, incapable of perceiving reality through the scrim of postpartum psychosis.

Contesting this view were those who evacuated Yates's crime of

any political significance, arguing that her insanity defense was a
ploy, a means to excuse her violent nature. Yates was guilty of murder.
The purpose of the law, they argued, is to reestablish the harmony of
the family unit, a microcosm of the larger social order, regardless of
the relationship between the actor who harms and the family itself.
Conservatives lambasted those feminists who championed Yates's
depression as on a continuum with that of other housewives, arguing
that her mental illness was not an adequate excuse for her violating
her children's rights. Mike LaSalle (2002) of the *Men's News Daily*
exulted that the Yates case would serve as a corrective to the view that
women, because of their maternal instinct, are essentially nurturing
and nonviolent. Christopher Caldwell, (2002) Senior Editor of the
Weekly Standard, argued that "feminists cast Yates' behavior as an
understandable (if extreme) reaction to the oppression of normal
bourgeois family life. They wound up undermining her insanity
defense, even as they thought they were promoting it" (p. 14). Yates
was a violent criminal and even though she was ill she should be exe-
cuted. Jay Nordlinger, (2002) Managing Editor of the *National
Review,* wrote that "the parents of the murdered children were both
concerned with saving the murderer's skin . . . no one is crying out
for retribution on behalf of those kids. Give her the chair."

Comparing Yates to Melissa Drexler, the "Prom Mom" who com-
mitted infanticide and was then granted parole after three years for
good behavior, the *National Review Online's* Deroy Murdock (2002)
argued that Drexler's release was "the latest and most revolting exam-
ple of the ho-hum attitude too many Americans hold toward baby-
killing. Mothers (and some fathers) who murder their own newborns
and young children often can expect light punishment accompanied
by a chorus of experts, activists and authorities eager to excuse their
crimes." By implicitly invoking the debate between feminists and con-
servatives over abortion, Murdock emphasizes that fetal and infant
life are equivalent, and that infanticide should be censured as murder,
rather than given a separate, more lenient sentence, as it is in coun-
tries like Great Britain (Meyer & Oberman, 2001).

Particularly incensed by the feminist arguments about Yates were
conservative women, who ridiculed the idea that Yates was in any
sense a representative mother. Shannon May, (2001) a contributor to
Rightgrrl, wrote that Quindlen:

> insinuates that any mother could have been driven to murder her
> children under similar circumstances, and that what's needed here
> is a way to raise awareness of the shocking struggles faced by

oppressed mothers everywhere . . . Poor unfortunate Mrs. Yates had
five of the little beasts clamoring for [a full stomach, a clean diaper,
and love] at once. Oh the horror! Any jury would certainly see that
she was overcome by the pressure and was inexorably compelled to
murder her children.

Amy Holmes of *USA Today* saw Quindlen as a "liberal feminist" writer
who had turned Yates into "a casualty in the psychological war of
modern motherhood" (Kaus, 2001).

The very rapidity with which Yates's history was used by conserv-
atives to attack second-wave feminism is striking. Portrayed as naïve,
selfish, and singularly out of touch with the realities of contemporary
women's lives, "NOW feminism" is represented as a kind of thera-
peutic discourse, evacuated of any political salience, that allows frus-
trated women to escape the responsibilities they have chosen by
posing as passive victims of their oppressive husbands. At the same
time, however, the seriousness and intensity with which the feminist
position is critiqued by conservatives, especially conservative women,
attests to the power it still retains in popular discourse. Quindlen had
articulated a great unspoken, raising the specter of women's anger
and potential for violence, two qualities that are given no place in the
pantheon of maternal attributes. The fact that a number of mothers
empathized with Yates and yet others rose up to contest the compari-
son between Yates and Everymom demonstrates the extent to which
her case expresses the current fetishistic disavowal of maternity as
anything but an experience of fulfillment and joy. The silencing of
women who express frustration with motherhood then reaffirms the
public rhetoric that "other women" are happy mothers and it is only
the exceptional woman who is dissatisfied with her role.

The moniker "rightgrrl," moreover, is an interesting reconfigu-
ration of feminist discourse, self-consciously invoking the "riotgrrls,"
young women who started feminist punk bands and independent
zines in the 1980s. These women created a new form of feminist
expression, using camp and parody as well as rage to represent what
has come to be known as "third wave" feminism. The journal *Right-
grrl* thus inverts riotgrrl politics even as it uses their attitude of defi-
ance and parody to promote a conservative agenda, calling feminists
to task for portraying the discourse of the right as a bastion of white
male privilege. May (2001) thus appropriates the power and inde-
pendence of speech that is associated with feminism, but rejects the
politics that enabled her to write and publish as a conservative
woman.

By demonstrating that women should have the right to speak from any point along the political spectrum, journals like *Rightgrrl* represent feminism as univocal and reactionary. What is more significant about articles like that of May, however, is that they appeared at the moment when second-wave feminist analyses were under attack not only from without, but also from within. The liberal feminist critique of the housewife that was launched in the late 1960s and early 1970s, best expressed by Betty Friedan's *The Feminine Mystique*, came under particular scrutiny when Daniel Horowitz's (1998) contentious biography of Friedan criticized her for posing as a naïve suburban housewife, unwittingly delineating the "problem that has no name" when instead she was an active member of the left and worked as a union organizer before writing the book. Wendy McElroy, (2001) a columnist for the Fox News website, published a piece in *Ideas on Liberty* linking the current feminist response to the Yates case to Friedan's work. McElroy is confident that Friedan masked her allegiance to the left in order to gain readers who would "never have identified with the real Friedan: a left-wing labor journalist; a member of Marxist discussion groups; author of the union pamphlet 'UE Fights for Women Workers' which critiqued wage discrimination based on sex; a rent striker; and a career woman with a good mother-substitute—a housekeeper-nurse." McElroy presents Friedan as not only duplicitous but also a sellout, a left-wing woman who hired other women to do the real work of motherhood while she worked outside the home.

What McElroy does not address is the fact that Friedan's book resonated with a number of readers. Regardless of whether these women would have read a book by an avowed leftist, the fact is that they did read the text and were moved by its contents. Though Friedan did not experience at first hand that which she described, clearly others did. Despite the criticism of Friedan's choice to deny her history when writing the book, she did galvanize a group of predominantly middle-class women and contributed, along with the legacy of the Civil Rights Movement, to a feminist agenda seeking social change. The fact that second-wave feminism is represented in the popular media as a movement of white middle-class women with a single agenda, rather than the disparate movement it actually was, has made it easy for current political commentators, both liberal and conservative, to characterize contemporary feminism as monolithic, concerned only with achieving financial success for white women working in corporations.

Following this line of reasoning, NOW feminists who champion

Yates are viewed as arguing that Yates's depression is a really conse-
quence of the fact that she elected to stay at home rather than con-
tinue working as a nurse. Yates, then, becomes the disavowed
remainder of second-wave feminist discourse, left behind by those
women who rushed into the working world and castigated for elect-
ing to stay home when others were breaking their bonds. As much as
McElroy's critique depends on the belief that Friedan neglected her
responsibilities to her children in order to pursue fame as a writer—
a choice that McElroy, too, may be making—so too does the carica-
ture of second-wave feminism depend upon the idea that any woman
who stays at home is a dupe of patriarchy, selling out her own poten-
tial for a life of vacuous service to others. The situation becomes still
more complicated when third wave feminists argue that second-wave
feminists wanted them to "do it all," to become superwomen, main-
taining both a home and a career to the point of becoming physically
and emotionally exhausted. In this line of reasoning, it seems that
that it is feminism, rather than the larger social order, that causes
women to feel that they are constantly found wanting in all areas of
their lives. Given the radically bifurcated arguments about contem-
porary motherhood, it should be no surprise to find so many moth-
ers feeling frustrated and guilty about the choices they make in
balancing work and family life. The fact that the decision to stay at
home or work is presented discursively as a "choice" each individual
woman is empowered to make, moreover, masks not only the very
real and difficult economic and social contexts within which women
operate, but also the fact that very few modern families conform to
the nuclear model upon which the Yates family was structured.

Yates and the Insanity Defense

It would seem then, that feminists and conservatives callously
exploited Yates's history to advance their political agendas, losing
sight of her individuality in a bid to make her a stand-in for a particu-
lar platform. Yet as Yates gained notoriety for her crime and her trial
began, the debates about contemporary politics gave way to those of
the law: how was Yates's insanity plea to be interpreted? Was she suf-
fering from a gender-specific disorder, postpartum psychosis, which
has yet to achieve legitimacy in the American Psychological Associa-
tion's Diagnostic and Statistical Manual? Should the law have sepa-
rate standards for women and men? Would such a conception of the
law reinforce Victorian notions of the sexual and intellectual differ-
ences between men and women, effectively infantilizing woman dur-

ing their "confinement"? Was Yates reaching for insanity because it
was her only possible plea, given that she had admitted to the crime
when she called the police? Even if one countenanced the feminist
arguments that the stresses of motherhood had, in part, exacerbated
her depression and implicitly caused a psychotic break, how was one
to adjudicate between contemporary politics and the category of
murder, the timeless standard of the law?

These problems and questions were crucial to the prosecution,
defense, and the jury, each of which sought to exploit the relation-
ship between contemporary morality and the law. In doing so, how-
ever, the defense and prosecution came into conflict with the
inherently conservative function of the law itself. Though the catalyst
for a criminal act may be something specific to the present, the act is
at once inserted into a preexisting set of categories that strip it of its
particular context and make it instead a manifestation of a timeless
"crime." Murder is especially suitable to this logic because it charac-
terizes the state of nature, the war of all against all. In this sense mur-
der has no history, for it is always the primal crime, the act upon
which the social order is founded. Citizens trade their capacity to kill
one another for the benefits of a social order regulated by the law.
When a jury is collected it is to act as a reiteration of the first public
sphere, confirming the integrity of the social order by maintaining its
boundaries and expelling those who threaten its cohesion.

The law is predicated on the fiction that by the force of its will a
jury can rid itself of bias, setting aside its individual differences in the
name of a collective good. That this objectivity is always already a fic-
tion is demonstrated by the lengthy process of jury selection. In
order to render a convincing verdict once the trial is in progress,
however, the law and the jury must be taken as iterations of a timeless
category (law, jury) rather than particular, local manifestations of the
public mind. The jury, in other words, is not representative in the
political sense, but instead must be evacuated of its historical speci-
ficity in order to execute a universal justice. To agree to be a juror is
to acquiesce to substituting a collective identity, that of the jury, for
one's specific history.

It was precisely the mandate to take the law as an expression of
universal justice rather than of contemporary morality that the pros-
ecution took as its imperative in preparing its case against Yates.
Rather than see her illness and its manifestation as a call to murder
her children as in part a consequence of her personal history and the
culture within which she was embedded, the prosecution argued that
her actions could only be understood as murder. The defense con-

tested this position, maintaining that Yates was insane and if, following John Locke's definition, insanity is right reasoning from wrong premises, then her actions should be evaluated by the extent to which her founding premise explained her behavior. Yates's conviction that she was possessed by Satan and was an instrument of his wrath seemed clear evidence that she had a deranged mind, and her actions clearly followed from her belief that she was inhabited by evil. When it came time to go to trial, neither the prosecution nor the defense contested the fact that Yates was suffering from mental illness. Under Texas law, however, a person can only be found not guilty by reason of insanity when it is established with "clear and convincing evidence" that they are unable to distinguish between right and wrong (Legal Information Institute, 2002).

The prosecution argued that Yates knew that her behavior was wrong and used a two-pronged argument to prove its case. First, they maintained, Yates referred to her crime as a sin, attributing her motives to Satan and expecting to receive the death penalty for committing infanticide. Second, Andrea was guilty of premeditation. As early as two years before she committed the crime, she had thoughts of killing her children. She had successfully prevented herself from drowning them two months before her crime, proving that she recognized that her actions were wrong and that though she was ill, she was capable of restraining herself. Kaylynn Williford, a prosecutor, told the jury that on June 20th Andrea had acted out of free will and with intent: "She made the choice to fill the tub. She made the choice to kill those five children. She knew it was wrong" (qtd. in Stein, 2002, p. 8).

Park Dietz, the expert witness for the prosecution, testified that Yates's speech and actions during and after the crime were further evidence that she understood that her behavior was wrong. If one granted Yates her premise that she had murdered her children so that they would be saved from her negative influence, Dietz argued, she would have been happy that they had died. She would have told her children to rejoice because they were going to heaven, and she would have shared the good news with others. Instead, she believed God would judge her because she had committed a sin. She covered the bodies, Dietz explained, because she felt guilty for killing her children (2002, Doctor: Yates Suffered Mental Illness). Dr. Melissa Ferguson, the jail psychiatrist who spoke with Yates just after the crime, testified that Yates had said "I am guilty" and that she "deserve[d] to be punished" (2002, Defense Witness: Yates Weighed Methods).

The defense countered that Yates should be found not guilty by reason of insanity because she was mentally ill and therefore could not be held accountable for her actions. The expert witness Dr. Philip Resnick argued that although she recognized that her act was illegal, she believed that it was "the right decision to keep her children from eternal damnation" (2002, Doctor: Yates Driven By Delusions). Dr. George Ringholz, a Baylor neuropsychologist, concurred with the defense's position that Yates was incapable of evaluating her actions because she was "acutely psychotic" and "did not know the actions she took on that day were wrong" (2002, Psychologist). The defense showed the jury home videos of Yates with her children just after the birth of Mary and at a child's birthday party, where she had baked a cake in the shape of a hot air balloon. Yates was a devoted mother who loved her children, they argued. Her actions were purely the consequence of her mental illness and her erroneous belief that she was a pernicious influence on her children.

The prosecution prevailed and Yates was found guilty. Significantly, however, the jury refused to grant the prosecution's request that Yates be executed for her crime. Instead of following the logic of their verdict, they sentenced her to life in prison, a decision that was taken by many as a sign of mercy, a recognition that Yates was mentally ill. Others, however, took the disjunction between the verdict and the sentence as an expression of the jury's frustration with the law itself, an act that legal scholars call "jury nullification." If the jury truly believed that Yates was guilty of murder they should have sentenced her to death. If they thought her mental illness rendered her incapable of being held criminally responsible, they should have found her not guilty by reason of insanity. Instead, they sent a mixed message. As one juror explained, there was "no doubt" that Yates was "mentally ill," yet at the time of her act, her confession had "proved to her that Yates was thinking pretty clearly and didn't sound psychotic" (Teachy, 2002).

Even Park Dietz, whose testimony was in many ways responsible for the jury's verdict, stated publicly after the trial that he personally opposed the law he had so zealously upheld in court. Dietz explained that he always worked for the prosecution because "prosecutors . . . seek truth and justice . . . The defense has a different set of duties. Their duty is to help their client, and often there are pieces of evidence that are not in their client's interest to have disclosed or produced" (Toufexis, 2002, p. F5). Dietz maintained that as a prosecutor, he was paid to uphold the Texas law and, according to its terms, Yates was guilty: "It was obvious where public opinion lay, it

was obvious she was mentally ill, it was obvious where the professional
organizations would like the case to go, but it would be wrong to dis-
tort the law, to stretch the truth and try to engineer the outcome"
(ibid.). Like the jury, Dietz seemed to want to bend the law even as
he upheld its mandates. Why would Dietz publicly criticize the law if
he did not intend his critique to serve as a catalyst for change? Why
did the jurors send a two-part message to the Texas court if not to sig-
nal their difficulty reconciling their belief that Yates was mentally ill
with their desire to punish her for committing a heinous crime?

Both Dietz and the jury sought to uphold the law as a timeless
vector of unbiased justice and at the same time implicitly argued that
the law should be an instrument capable of reflecting the public will.
In his book Commonplace Justice, Georgetown University psychol-
ogy professor Norman Finkel (1995) argues that jurors should be
allowed to judge not only the facts of a case but also the law itself, cit-
ing the arguments of John Adams and Thomas Jefferson to support
his case (p.30). Others, however, contend that if a jury were given
free reign to interpret the law as well as the facts of a case, they would
undermine the law, which would suddenly reflect local biases rather
than operate in the same fashion across a number of jurisdictions. By
all accounts, the jury in the Yates case should have called for her exe-
cution, for they had just found her guilty of two counts of premedi-
tated murder. By choosing to imprison her instead, the jury became
a political body, adjudicating between their definition of morality, a
matter of opinion, and the objective logic of the law. The fact that the
verdict was read by some as a manifestation of mercy and by others as
a sign that the law is flawed, unable to account for one who is men-
tally ill yet still commits crimes, demonstrates the extent to which the
law, said to be immune to the vagaries of popular opinion, is never an
unbiased vector of an abstract justice.

The law is always doubled, at once the expression of contempo-
rary politics and at the same time an iteration of the universal. The
insanity defense is a particularly rich site through which to investi-
gate the doubled nature of the law, therefore, because that which
constitutes insanity itself is particularly mutable and reflects popular
conceptions of mental illness. The insanity defense is more likely to
change over time because it is dependent upon medicine to define
insanity, and the scientific understanding of insanity itself is con-
stantly shifting. The American Psychological Association and the
American Medical Association, in fact, no longer accept "insanity" as
a medical term, arguing that the word is too broad to have any scien-
tific value. Instead, "insanity" is a legal term and is restricted to the

insanity defense (Facts About the Insanity Defense). Nevertheless, the behaviors and expressions that the law will term "insane" depend upon the evaluations of doctors and psychiatrists. The insanity defense is thus the point at which the discourses of law and medicine converge, but the imperatives of each profession put the two disciplines in conflict with one another. In order to maintain its authority, the law must represent itself as timeless. The authority of medicine, however, is augmented and bolstered by the extent to which it advances to reflect new scientific discoveries. The law is expected to reflect changes in the medical understanding of insanity but, as the register of unchanging social codes, the law is inherently conservative—it must resist change in order to maintain the fictive stability of the social order. The law must fix and limit the bounds of insanity even as medicine seeks to expand or refine them.

The conflict between law and medicine is further exacerbated by the fact that juries will supplement the testimony of expert witnesses with their own notions of insanity, usually expecting a defendant to present them with mania and incomprehensible speech. Because postpartum depression and psychosis are limited in duration, those women suffering from the disorders are usually "sane," or at least stabilized, by the time they stand trial. Because postpartum psychosis is characterized by highly volatile behavior and thinking, moreover, a woman could make a call and appear lucid after killing her children, as Yates did, yet still suffer from psychosis (Meyer & Spinelli, 2003, p. 176). Those who have written about postpartum psychosis and the insanity defense have shown that juries have a radically inconsistent response to women suffering from the disorder, in part because the defendants do appear lucid, as one juror in the Yates case remarked in defending the verdict. As the lawyer Judith Macfarlane (2003) has commented, "the most pervasive characteristic of postpartum disorders, their changeability, renders it extremely difficult to convince a jury that a woman was insane at the time she caused the death of her infant when at trial she appeared to be totally 'normal'" (p. 164). Because the disorder is not adequately understood by either lawyers or doctors, women suffering from postpartum depression or psychosis have been given wildly inconsistent sentences: "about half the women who raise postpartum psychosis as a defense are found not guilty by reason of insanity, one-fourth receive light sentences, and one-fourth receive long sentences" (Meyer and Spinelli, 2003, p. 174).

The fact that there is not a definitive treatment for, or understanding of, postpartum disorders has contributed to the skepticism with which they are received by jurors. In this sense, postpartum dis-

orders are not only viewed with suspicion in their own right, but are further open to criticism when they are placed in the context of an insanity defense. Insanity law, already open to interpretation, seems further compromised when it is expected to account for differences in gender and criminal intent.

Justice and the Gendered Subject

Yates's verdict and sentence comment as much on the concept of insanity itself as they do about her particular case. To call for Yates to be found not guilty by reason of insanity is not only to sanction the psychological entity postpartum psychosis, but also to argue that Yates is a kind of Everymom, and that her history and its result—infanticide—is a manifestation of the public's disengagement with a mother's needs. To find her not guilty by reason of insanity grants attention to her illness and makes a public commitment to addressing the root cause of the violence—the problems of motherhood, postpartum disorders, and emotional isolation. To vote as a jury for an insanity defense is thus not to sanction Yates's insanity per se, Rather, it is to acknowledge what insanity stands for, is articulated in relation to the "insanity" of leaving a woman at home with no support. A vote against insanity is therefore not only a vote for Yates's capacity to conceive a criminal intention. It is also a vote against the idea that maternal ideology invokes an ideal of womanhood that is virtually unattainable in practice and may lead a woman to become clinically depressed.

Yates's case is exceptional because her plight seems inextricably linked to her womanhood and to a fundamentalist patriarchal definition of the female role. Yates's husband clearly felt that it was his wife's responsibility to care for their children, to maintain the home, to care for her father, and to school the children in Christian beliefs. In the sense that these responsibilities were thought the social and perhaps biological province of womanhood, Yates's crime cannot be adequately understood outside an analytic of gender difference. Furthermore, the fact that her hallucinations occurred after she gave birth to her fifth child make her crime susceptible to biologistic arguments about women and crime. The fact that the jury nullified their verdict demonstrates the extent to which they sought to valorize the work she had performed as a woman before she committed her crime—to in effect extract her maternity from her criminality. In doing so, they not only rewarded her for her past devotion as a mother, but also created an artificial division between motherhood

and criminality, making Andrea Yates both a murderer and a mother suffering from a disease. In sparing Yates's life, therefore, the jury also spares the public from confronting the specter of the vicious mother who intends to kill her children to rid herself of responsibility or to punish her husband for his transgressions, whether they be those of sexual infidelity or parental neglect. By finding Andrea Yates both guilty and not guilty, the jury reflects not only the split imperative of the law, but further, the way in which gender saturates the "neutral" categories of criminality and intent. To preserve Yates's femininity, fidelity, and commitment to motherhood—to retrieve the maternal, that is, from the arena of crime—the jury renders her criminality as that which is outside of her womanhood, leaving her both a woman of virtue and a felon under the law.

REFERENCES

(2003, May 12). Accused Mom on Suicide Watch. CBS News.Com. Retrieved May 14, 2003, from http://www.cbsnews.com/stories/2003/05/12/national

Begley, S. (2002, March 11). "The Schizophrenic Mind." Newsweek, 44-s57.

Brusca, A. (1990). "Postpartum Psychosis: A Way Out For Murderous Moms?" Hofstra Law Review, 18, 1133-s1177.

Caldwell, C. (2002, March 25). "Insanity on Trial: Andrea Yates Was Insane, and Everybody Knew It." Weekly Standard, 14.

Cohen, A. (2003, May 12). Applying Yates to Laney. CBS News.Com. Retrieved May 14, 2003, from http://www.cbsnews.com/stories/2003/05/12/news/ opinion/courtwatch

Cohen, R. (2002, February 21). "Why Kill Andrea Yates?" The Washington Post, Opinion, A21.

(2002, May 20). Defense Witness: Yates Weighed Methods of Killing Five Children. CourtTV.Com Retrieved May 20, 2002 from http:// www.courttv.com/trials/yates/022502-pm_ap.html

(2002, May 20). Doctor: Yates Driven By Delusions. CourtTV.Com. Retrieved May 20, 2002 from http://www.courttv.com/trials/yates/030702-b_ap.html

(2002, May 20). Doctor: Yates Suffered Mental Illness. CourtTV.Com. Retrieved May 20, 2002 from http://www.courttv.com/trials/yates/030802-illness._ap.html

(2002, January 21). The Evil Inside: Andrea Yates Believed She Was Possessed. ABCNews.Com. Retrieved May 21, 2002 from wysiwyg://zoffsitebottom.6/ http://...20122Yates_family_revelations.html

Facts About the Insanity Defense. American Psychiatric Association Public Information. Retrieved May 25, 2002 from http://www.psych.org/public_info/insanity.cfm

Finkel, N. J. (1995). Commonsense Justice: Jurors' Notions of the Law. Cambridge: Harvard University Press.

Gamiz, M. Jr. (2002, April 15). "2 Tragic Cases Show Marked Contrasts." Los Angeles Times, Monday Home Edition, 3.

Gandy, K. (2001, September 6). Tragedy Focuses Attention on Postpartum Psychosis: Statement of NOW President Kim Gandy. Retrieved May 21, 2002 from http://www.now.org./press/04-01/09-06.html

Gesalman, A.B. (2002, March 4). "A Dark State of Mind." Newsweek, 32.

Horowitz, D. (1998). Betty Friedan and the Making of "The Feminine Mystique": The American Left, the Cold War, and Modern Feminism. Amherst, MA: University of Massachusetts Press.

Hunt, C. (2002, March 21). Exclusive Look at Controversial Preacher Followed by Yates. ABC13 KTRK-TV Houston. Retrieved May 19, 2002 from http://www.abclocal.go.com.ktrk.news/32102 news_50pmyatespreacher.html

Kaus, M. (2001, July 2). Apocalypse Mom: The Horror of Anna Quindlen. Kausfiles.Com 2. Retrieved May 21, 2002 from http://www.kausfiles.com /archive/index.07.02.01.html

LaSalle, M. (2002). "The Yates Trial: No Antidote to the Archetype." Men's News Daily. Retrieved May 22, 2002 from http://www.mensnewsdaily.com.

Legal Information Institute. Texas Law. Section 17. Insanity Defense. Cornell University. Retrieved May 27, 2002 from http://www4.law.cornell.edu/ uscode/18/17.html

Long, K.R. (2002, April 7). "A Mother's Heartache; The Façade Can Crack—For All of Us." Plain Dealer Reporter, Sunday Magazine, 3.

Macfarlane, J (2003). Infanticide: Psychosocial and Legal Perspectives on Mothers Who Kill. Washington, D.C.: American Psychiatric Publishing, Inc.

May, S. (2001, July 10). "What Have We Done to Motherhood?" Rightgrrl. Retrieved May 21, 2002 from http://www.rightgrrl.com/2001/yates.shtml

McElroy, W. (2001 November). Politicizing the Housewife. Retrieved June 5, 2002 from http://www.fee.org/vnews.php?nid=323)

Meyer, C.L., and Oberman, M. (2001). Mothers Who Kill Their Children: Understanding the Acts of Moms from Susan Smith to the "Prom Mom." New York: New York University Press.

Meyer, C.L., and Spinelli, M.G. (2003). Medical and Legal Dilemmas of Postpartum Psychiatric Disorders. Infanticide: Psychosocial and Legal Perspectives on Mothers Who Kill. Washington, D.C.: American Psychiatric Publishing, Inc.

Murdock, D. (2001, December 10). "Wrist-Slapping Baby Killers." National Review Online. Retrieved June 6, 2002 from http://www.nationalreview .com/murdock/murdock121001.html

Nordlinger, J. (2002, March 25). Impromptus: The World's Most Important Columnist, the Question of Blackmail, Andrea Yates, & National Review. Retrieved June 2 , 2002 from http://www.nationalreview.com/impromptus/impromptus032502.asp

Pollitt, K. (2002, April 1). "God Changes Everything." The Nation. Retrieved

May 19, 2002 from http://www.thenation.com/doc.mhtml?I=20020401s=
pollitt

(2002, May 20). Psychologist: Yates Was Insane. CourtTV.Com. Retrieved
May 20, 2002 from http://www.courttv.com/trials/yates/022702_ap.html

Quindlen, A. (2001, February 7). "Playing God on No Sleep." Newsweek, 64.

Roche, T. (2002, January 20). "The Yates Odyssey." Time.Com. Retrieved
June 5, 2002, from http://www.time.com/time/nation/article/0,8599,
195267,00.html

Saunders, D. (2002, March 15). "Preacher's Sway Apparent: Texas Mother
Was Follower of Nomadic Extremist." The Detroit News. Retrieved May
19, 2002, from http://www.detnews.com/2002/nation/0203/15/a04-
44137.htm

Spencer, S. (2002). Breaking Point. New York: St. Martin's Press.

Stein, L. (2002, March 25). "Top of the Week: Life Sentence; Pearl Indict-
ment; Return to Sender; Terrorist Blues; Judgment Day." US News and
World Report, 8.

Szegedy-Maszak, M. (2002, March 18). "Mothers and Murder." U.S. News
and World Report, 23.

Teachy, L. (2002, March 18). "Jurors Say They Believed Yates Knew Right
from Wrong." Houston Chronicle.Com. Retrieved May 19, 2002 from
http://www.chron.com/cs/CDA/printstory.hts/special/drownings/
1299679

Toufexis, A. (2002, April 23). "A Conversation with Park Dietz; A Psychia-
trist's-Eye View of Murder and Insanity." The New York Times, F5.

(2002, February 21). Transcript of Andrea Yates' Confession. Hous-
tonChronicle.Com. Retrieved May 19, 2002 from http://www.chron
.com/cs/CDA/printstory.hts/special/drownings

Varner, L.K. (2002, April 16). "The Thousand Stories of Postpartum Depres-
sion." Seattle Times, Opinion, B4.

Williams, P.J. (2001, July 16). "Beyond the Village Pale." The Nation.
Retrieved May 19, 2002 from http://www.thenation.com/doc.mhtmli=
20010716&s =williams

Rebecca Hyman *is Director of the Women's and Gender Studies Program
and an Assistant Professor of English at Oglethorpe University. She recently
completed a year as a fellow at Oregon State University's Center for the
Humanities, researching and writing her manuscript* Anatomies of the
Mind: Manufacturing an American Unconscious. *In addition to her work
on pre-Freudian subjectivity, Hyman is interested in the relationship among
feminist praxis, embodiment, and poststructuralist theory.*

Policing Race and Gender: An Analysis of "Prime Suspect 2"

Gray Cavender and Nancy C. Jurik

As a cultural production, the crime genre spans short stories and novels, film, radio, and television, and is a predominant genre across these media (Mandel, 1984; Rafter, 2000). Despite some notable exceptions (e.g., Agatha Christie earlier on, and Sara Paretsky more recently), for the most part, crime has been a male-oriented genre (Reddy, 2003). Literary critic Kathleen Klein (1995, p. 200), in a word-play on the title of a P.D. James novel, notes that the genre is so male-identified, often so deeply misogynistic, that the task of discovering "Whodunit" may be "an unsuitable job for a feminist."

Crime has been a white-oriented genre as well. Literary figures like Chester Himes in the 1950s and Walter Mosley more recently are notable exceptions to the "whiteness" of the crime genre (Bailey, 1991; Reddy, 2003). In many films and novels, people of color are depicted as the Other, esoteric figures who symbolize the shadowy, menacing opposite of whites (Gray, 1995, pp. 16-17). People of color are portrayed in stereotypic, caricatured roles (Hobson, 2002).

A recent exception to these rules-of-thumb is "Prime Suspect", a series of seven made-for-television films about London policewoman Jane Tennison. Critics hail the fictional Tennison as one of television's most popular policewomen, and praise the series for its accurate and trenchant portrayal of women professionals. In addition to its sensitivity to gender issues like women working in traditionally men's jobs, "Prime Suspect" addresses other social issues, such as racism in policing (Abercrombie, 1996, pp. 72-73). Deborah Jermyn (2003) credits the series with beginning the "forensics realism" trend which is a common feature of CSI and other successful television crime dramas.

Other critics see "Prime Suspect" as a failed attempt to transcend stereotypes common to this genre. Notwithstanding socially relevant plots, in the end the series returns to the narrative convention of a detective solving a crime (Tomc, 1995). Moreover, there is a tendency to paint Tennison with a marked postfeminist hue: she increasingly becomes isolated and bitter (Thornham, 1992). Some critics argue that the series fares badly in its treatment of race. According to

Dianne Brooks, "Prime Suspect 2"'s portraits of black women and black men reinforce racial stereotypes (1994, p.102).

In this paper, we consider the second film in the Prime Suspect oeuvre, "Prime Suspect 2" (1993). We consider the film's treatment of race and gender. We analyze the film's depiction of police-community relations in an Afro-Caribbean neighborhood, and its depiction of individual-level racism which it condemns, and institutional-level racism, about which it is more ambivalent. We attend to Tennison's characterization in terms of gender, including the portrayal of a woman police detective, and postfeminist elements in the film's narrative structure.

We assess the subversive implications of "Prime Suspect 2." We draw upon Patricia Hill Collins (1990), Dorothy Smith (1996, 1999), and Iris Marion Young (1994) to develop the concept of "progressive moral fiction." This concept refers to fictional works that illuminate the impact of structural oppression in everyday lives and offers visions and hope for collective challenges to these oppressions. Works of progressive moral fiction include elements that (1) draw on insights from the experiences of those who are socially marginalized and oppressed, (2) locate the experiences within their larger social context, (3) reveal fissures in the predominant ruling apparatus, and (4) offer vision or hope for collective empowerment and challenges to unjust social arrangements and organizations.

Our concept is informed by the analyses of Dorie Klein (1992) and Maureen Reddy (2003), who describe a new feminist crime fiction consistent with our concept of progressive moral fiction in that it subverts the conventions of the genre and advances notions of social justice. We also are influenced by novelist and critic John Gardner (1982) and his advocacy for moral fiction. For Gardner, fiction is moral when it "presents valid models for imitation," when it deals in "eternal verities," and when it offers a "vision of the possible which can inspire and incite human beings toward virtue" (1982, p. 18). We offer progressive moral fiction as an ideal type and seek to examine its presence and absence in ostensibly progressive or subversive dramatic material.

We recognize that progressive works may entail contradictory moments with characters who are flawed and whose actions may at times reinforce status quo social arrangements. In her critique of dichotomous (either/or) thinking, Collins (1990) argues that there are no pure victims or pure oppressors; there is a bit of both oppressor and victim in us all. Good dramatic fiction—in the novel, in film, or on television—should reflect some of the world's complexity, but

also should engender a struggle for justice (Boler & Allen, 2002). We consider the degree to which these works offer glimpses of the need for change and the potential for social justice.

Television, Gender, and Race

Policing is in a crisis. Revelations of sexist and racist practices by the police, e.g., racial profiling, are commonplace (Brown & Heiden-sohn, 2000). In response, some police organizations have opted for an additive solution: they hire more women and more racial ethnic minorities. However, the ideological assumptions that underlie sexist and racist occupational practices are embedded and reinforced in the larger culture (Hunt, 1990, p. 9). These cultural beliefs are circu-lated through the mass media.

The media generally and television in particular bombard us with images that influence our definitions of who we are, what is real, and what matters (Press, 1991; Dow, 1996; also see Boler & Allen, 2002). This is not surprising because, in its narrative construction, television is one of our principal storytellers (Kozloff, 1987). Like other tellers of tales, e.g., folklore or urban legends, television deals in myths that sym-bolize society's important issues (Degh, 1994; Abercrombie, 1996).

But television is a conservative medium. Profit is its mantra, and to be profitable programs must lure and hold large audiences. For television's narratives to work and to generate high ratings, programs must resonate with dominant cultural constructions (Lotz, 2001).

Television represents a kind of archeological record. As society changes, as new cultural constructions emerge, television must change if its programs are to hold the audience. It is for this reason that feminist scholars study social history through an analysis of tele-vision programs. In the 1970s, for example, when the women's move-ment began to change U.S. society, television responded with programmatic changes in which women characters left the home and sometimes the family and entered the workplace (Dow, 1996).

Scholars who study women in society and television's depiction of women refer to the contemporary situation as "postfeminism." The working assumption of postfeminism is that women got what they wanted—independence and the possibility of a career—but at a cost: an absence of love (usually heterosexual love) and family (Rosenfelt & Stacey, 1987; Modelski, 1991; Dow, 1996). Lotz (2001) tries to rehabilitate the term "postfeminism" to analyze how televi-sion depicts gender power relations and the situations faced by women since the second-wave feminist movement (2001, pp. 115-

118). In accord with Lotz's approach, we use "postfeminism" as a composite term to mean a continued commitment to the inclusion of women in the public sphere (especially the workplace) without a clear political agenda or even an awareness of gendered power differences.

Postfeminism as a cultural construct is played out on television in both drama and news. "Murphy Brown" (1980s) is an icon for the postfeminist position in that she enjoys career success, but is alone and unlikable. She is competitive with, not connected to, other women (Dow, 1996). The women on "Sex and the City" are in a similar bind: they are successful, independent women, but the costs are high. Deborah Jermyn's (2001) analysis of news coverage of the murder of Jill Dando, a British television celebrity, offers a similar reading: Dando enjoyed fame and wealth, but was "incomplete" because she lacked love and marriage.

As with gender, television circulates images of race. Indeed, television is a medium wherein the struggle over and meaning of race and identity are inscribed upon our consciousness (Gray, 1995). For years, people of color were either absent from television or were relegated to negative, stereotypic roles. However, in the late 1980s and continuing into the early 1990s, people of color increasingly appeared on television and in positive roles (Gray, 1995). Recently, the situation has deteriorated. Here we adapt a reference originally employed by Tuchman (1978) with respect to women, and note that television is "symbolically annihilating" people of color. They have appeared with less frequency on U.S. television (see Keveney, 2001). Most continuing series employ only a few characters who are people of color, and these are subsidiary roles which leave little room for character development. A similar situation exists in film (Hobson, 2002).

Moreover, negative racial stereotypes persist on the news and in dramatic programming. Local news disproportionately covers violent crime committed by criminals who are persons of color (Gilliam & Iyengar, 2000). The news depicts suspects who are persons of color as more threatening than white suspects (Chiricos & Eschholz, 2002). Similarly, both primetime crime drama and reality television programs present crime in a manner that heightens fears by whites when they view persons of color (Mastro & Robinson, 2000; Eschholz, Chiricos & Gertz, 2003). Such depictions produce public support for punitive crime policies at a time when Americans of color increasingly are subjects of the criminal justice system (Oliver & Armstrong, 1998; Gilliam & Iyengar, 2000). These depictions also square with the conventions of the traditionally white-oriented crime genre (Reddy, 2003, p. 10).

Jane Tennison and "Prime Suspect"

"Prime Suspect" is not the first depiction of a woman crime fighter on television. Two series in the 1970s, "Charlie's Angels" and "Police Woman", offered as lead characters women who detected crime and captured criminals. However, both programs featured glamorous actresses who often were rescued by their male superiors. In the 1980s, "Cagney and Lacey" depicted two strong, independent women cops. Despite critical acclaim, there was constant pressure from network executives to convert "Cagney and Lacey" into a more subordinated women's program. The network's efforts to glamorize "Cagney and Lacey" or to cancel the program are well-documented (D'Acci, 1994).

"Prime Suspect" is perhaps the best recent production in the crime genre starring a woman. Helen Mirren plays Jane Tennison, a Detective Chief Inspector (DCI) of the London Metropolitan Police. The films aired on PBS between 1992 and 1997, usually on the Mystery series. The films won numerous awards in England and the U.S., including an Emmy for the best U.S. television miniseries (Feinsilber, 1995).

In an earlier article (Cavender & Jurik, 1998), we analyze the first film in the series. "Prime Suspect" (1992) sets the tone for the series. Tennison holds the rank of Detective Chief Inspector—she can direct a team of detectives in a criminal investigation—but receives only station-house duties. Our analysis tracks Tennison's demand for a case and her experiences as she directs a team of detectives (primarily men) in the search for a serial killer. She succeeds, but, along the way endures sabotage, insubordination, and the constant sexualization of her behavior. Tennison stays with it, and, through brains, hard work, and occasionally "special women's insights," (Cavender & Jurik, p. 24) solves the case and earns the respect of her detectives.

"Prime Suspect" sets the tone for the series in other ways. For example, the crimes are serious, but Tennison relentlessly, obsessively pursues her prime suspect. She is revealed to be a serious careerist. Tennison's ambiguities are a refreshing change of pace: juxtaposed against the easy self-confidence of a male genre hero, her flaws make Tennison an interesting character. In an interview, Helen Mirren recounts her delight in playing a character whose obsessive personality is related to her success. Mirren reports a large, positive response from professional women (Rennert, 1995).

"Prime Suspect" as an Analytic Site

Two notable features make the series an important site for analysis.

First, the films are relevant for an analysis of the crime genre, especially a feminist crime genre. Criminologist Dorie Klein (1992) and literary scholar Maureen Reddy (2003) suggest that a feminist crime genre has emerged that challenges conventional authority and definitions of justice. It features strong, independent women, and women-centered plots (Klein, 1992; Reddy, 2003). Although these comments refer to the novel, as we noted earlier, historically the crime genre has successfully crossed media. To a degree, "Prime Suspect" exemplifies Klein's and Reddy's observations: conventional authority is challenged and the narrative is woman-centered. As a caveat, Jermyn (2003) notes that women protagonists may not be progressive or challenge genre conventions.

Second, "Prime Suspect" is a police procedural, a subgenre of the crime genre which details the inner workings of the police organization. The standard plot device—detectives solve crimes—drives them, but contemporary procedurals address social issues and the personal lives of the police detectives, what television analyst Lynne Joyrich (1996) refers to as "a police family." "Prime Suspect" is unusual because police procedurals are resistant to feminist revision (see Reddy, 2003, p. 177). However, a woman-centered procedural offers unique possibilities. For example, the audience is privy to backstage scenes set in the friendly confines of a superintendent's office wherein, amid taken-for-granted camaraderie and good whiskey, the male hierarchy worries over DCI Tennison.

Moreover, because they deal with the police organization, procedurals allow us to investigate television's portrayal of work routines. Kanter's (1977) insights about tokenism and the heightened visibility of women are especially relevant. Men of color and women working in traditionally white, male occupations like policing are subjected to close scrutiny. As "outsiders," they pose a perceived threat to established work routines and hierarchies (Martin & Jurik, 1996). As a competent woman, Tennison challenges the masculine identity of superiors and subordinates, and, in so doing, renders transparent the male dominance of the police organization. This television drama corresponds to the real world in terms of women and work.

The "Prime Suspect" series represents a point of intersection for an analysis of the crime genre, gender, and television. "Prime Suspect 2" continues the focus, but now takes up race. Indeed, issues of gender and race, and more, the intersection of these issues, are at the core of "Prime Suspect 2."

While the salience of race and gender reinforce the notion of a socially relevant feminist crime genre, "Prime Suspect 2" is as

ambiguous as its predecessor. The film offers two potential readings: a feminist positive or a postfeminist negative. The feminist positive offers hope that through collective organization and struggle, women and other oppressed groups can produce institutional change, at least in a fictional world. This reading squares with our notion of a progressive moral fiction. In contrast, a postfeminist negative suggests that feminism has caused a strong woman character stress and isolation. "Prime Suspect 2" exemplifies these concerns. After a brief methodological note, we turn to this film.

Methods

Our analysis comes from a detailed qualitative analysis of "Prime Suspect 2." We viewed the film three times. First, we watched the film and, afterwards, noted research themes and questions. During the second viewing, we took extensive notes about plot and characters. During the third viewing, we recorded quotes and visual motifs, and replayed scenes as necessary for the elaboration of our analysis.

Our paper is divided into two sections. Section one deals with race at two levels: the individual and the institution. Section two deals with gender: the gendered detective and a postfeminist detective. We begin the analysis with a synopsis of "Prime Suspect 2."

Synopsis

"Prime Suspect 2" opens with two interrelated scenes: DCI Jane Tennison interrogates a black man, a suspect in a rape case; elsewhere, a white policeman tells a black kid, "Shut your mouth." As the opening credits roll, these two scenes, intercut in juxtaposition, are more fully developed.

The rape suspect is Detective Sergeant (DS) Bob Oswalde, and the interrogation is a training sequence at a police conference. That night, Tennison and Oswalde make love in her hotel room. Tennison's nemesis, DCI David Thorndike, sees DS Oswalde leave her room. The other scene involves what will become a murder investigation. The body of a young woman, dead for several years, is discovered under a flat in a section of London that is home to an Afro-Caribbean population. At the hotel, Tennison's tryst is interrupted by a telephone call: she will head the murder investigation.

"Prime Suspect 2" is a police procedural. As the film unfolds, a series of scenes depict the details of an investigation: door-to-door canvassing of the neighborhood where the body was discovered;

Tennison's appearance at a tense community meeting; a coroner's report that establishes the date of death; a review of missing-person reports from the time period; the production of a forensic bust to aid victim identification; and computer checks of credit agencies to discover a suspect's whereabouts.

Two parallel investigations are at the heart of the film's narrative. In the first, Tennison learns that the flat where the victim was discovered was once owned by the Allen family, who rented it to a man called David Harvey and lived next door in another flat they owned. Harvey becomes Tennison's prime suspect. The second investigation involves Tennison's conference lover, DS Bob Oswalde, who is assigned to Tennison's team over her objection. He identifies the victim (Joanne) through missing-person reports. Oswalde suspects the Allens' son, Tony, who reacts emotionally when he sees the forensic bust.

Tennison and Oswalde relentlessly pursue their prime suspects. Tennison's motivation is that her suspect, Harvey, is deathly ill. He admits to the murder in a deathbed confession. Oswalde hounds Tony Allen at home, at work, and then takes him into custody. After an intense interrogation, Allen hangs himself in his cell. DCI Thorndike is assigned to investigate Allen's suicide.

Despite a confession, Tennison worries about flaws in Harvey's admission. At his flat, she discovers pornographic photographs of Tony Allen, his sister, Sarah, and Joanne, the murder victim. Harvey's nephew, Jason Reynolds, is a photographer, and in one of the photos is wearing a belt that bound Joanne's wrists. Jason goes missing, but Tennison traces him, sets up a stakeout, and Oswalde captures him.

DCI Thorndike exonerates the police of wrongdoing in Tony Allen's suicide. Tennison's superior, Detective Chief Superintendent (DCS) Bob Kernan, is promoted to the rank of Chief Superintendent. Tennison wanted Kernan's command, but her nemesis, Thorndike, gets the position. Bitter, Tennison requests a transfer.

Race

Race matters in "Prime Suspect 2." The film begins with a darkened screen and Helen Mirren's voiceover: DCI Tennison interrogates a rape suspect. Then, Bob Oswalde's face fills the television screen. The camera focuses in extreme close-up on Oswalde, a black man. From that opening scene, race is an ever-present aspect of character and narrative development in "Prime Suspect 2." In this section, we address individual-level and institutional racism.

A back story highlights the importance of race. The police fear that the murder victim is Simone Cameron, a missing woman. Simone's brother, in prison for stabbing a white man, was convicted upon questionable evidence, and there is ill will between neighborhood residents and the police.

Individual-level Racism

"Prime Suspect 2" directly tackles the issue of racism in policing. It portrays individual-level racism in the character of Detective Frank Burkin. Burkin's racism surfaces in the opening sequence when he tells a black kid, "Shut your mouth." The kid is a part of a hostile crowd standing behind a police barricade outside of the flat where the body was discovered. Burkin wades into the crowd, apparently trying to keep them behind the barricade. His behavior soon gets him into trouble. Tennison, who is aware of the animosity toward the police, orders a door-to-door canvassing of the neighborhood, but warns the detectives, "Easy does it," and urges them to act like graduates of a charm school. At the first door in the canvass, Burkin arrests and manhandles a black teenager for smoking marijuana. This is the sort of situation that Tennison wanted to avoid. When she dresses Burkin down, he comments about policing in that community, "They hate us. And I ain't so keen on them." Tennison threatens to fire him.

Burkin survives, but his racist behaviors persist. When Oswalde is assigned to the team, Burkin looks askance and says, "Now we have to work with them." Tennison assigns Oswalde to menial tasks, which pleases Burkin. He tells another detective, "I'm glad to see the boss is keeping our colored friend in his place."

The narrative in "Prime Suspect 2" is critical of Burkin's racism; it demonstrates that racism impedes police work. Some black reggae musicians have concert tapes that might contain an important clue. Burkin and another white detective must get the tapes, but Burkin interacts badly with the musicians, who refuse to share the tapes. The other detective interacts positively, and the musicians loan him the tapes, which contain key information.

The "Prime Suspect 2" narrative condemns racism at the individual level, and portrays it as a belief system that is foreign to Tennison. Of course, Tennison never questions her own position of white privilege. Moreover, as is often the case in the crime genre, by focusing on the individual level, racism is portrayed as a matter of personal prejudice unrelated to existing power relations (see Reddy, 2003, p. 166). The film also depicts racism at the institutional level.

Institutional Racism

"Prime Suspect 2" offers a critical view of policing and race, and deals with notions of race and identity. There are, however, some troubling ambiguities in the film's depiction of institutional racism. Although it exposes instances of institutional racism in the police organization, it offers little hope for individual or collective challenges to the problem.

A sense of institutional-level racism emerges in the first scene. Bob Oswalde's responses to Tennison's faux interrogation are steeped in racial stereotypes: the myth of the black male rapist who says "white women like it rough" (see Hunt, 1999). The session is a training seminar, but it is interesting that Oswalde, a sergeant, reproduces the stereotype of the black rapist. Later, when Tennison teases him about his "white women like it rough" comment, Oswalde says, "Hey, that wasn't me. I don't think that way." Issues of race and identity emerge throughout the film. With Oswalde still in her hotel room, Tennison, via a telephone call, is assigned to the murder case. As she prepares to leave to commence the investigation, Oswalde, insulted by her abrupt departure, accuses Tennison of treating him like "a black stud." She denies the allegation, but asks him to be discreet.

As Tennison leaves the hotel, she encounters DCI Thorndike, who warns her not to trust "our Afro-Caribbean friends." It is unclear whether he refers to Oswalde or to the neighborhood where the body was discovered. It is clear that for Thorndike and for the officers at the crime scene, that neighborhood is problematic. The back story—a possible wrongful conviction of a black man—both heightens the tension and demonstrates institutional racism. The situation is so politically sensitive that Tennison's boss, DCS Mike Kernan, is at the crime scene. As the residents shout insults at the police, Kernan, trying to control the situation, yells at the crowd, "Go home." The symbolic power of the phrase is manifest as he repeats, "You people should just go home."

At times, "Prime Suspect 2" deals with the intersection of individual-level and institutional racism. Det. Frank Burkin's decision to arrest the marijuana-smoking teen is one such point. His actions are both a command and a career problem for DCS Kernan, who is under consideration for a promotion. Kernan fears that removing Burkin from the case could be an embarrassment, but allowing him to remain could cause further incidents.

The Prime Suspect series is interesting because of its complex characters. Tennison is perhaps the most complicated of all. She

rejects individual-level racism. Not only does she threaten to fire
Burkin, when another detective muses that the victim means "one less
of them on the street," she asks if color matters after someone has
been murdered. Even as she condemns racism at the individual level,
however, Tennison reproduces it at the institutional level. This is espe-
cially the case when her career is involved. When she learns that
Oswalde has been assigned to her team, Tennison confronts Kernan.

> Tennison: "What do you mean co-opting someone onto my team
> without telling me?"
> Kernan: "...a black face is a useful addition, an antidote to the
> [Frank] Burkins of the world."
> Tennison: "It smacks of tokenism...it's political maneuvering."
> Kernan: "I've heard he's a good officer."
> Tennison: "Yes, yes, I'm sure he is. I just don't want him on my
> team."

Kernan admits that, while Oswalde is a good cop, his assignment rep-
resents the addition of a black face. In terms of the policing litera-
ture, this is an additive solution to the lack of officers of color and the
difficulty of policing minority populations (Brown & Heidensohn,
2000). Tennison acknowledges and then dismisses Oswalde's abili-
ties. Her concern is not frivolous. As the academic literature (Martin
& Jurik, 1996) demonstrates, and as we saw in "Prime Suspect," Ten-
nison's behavior (like that of real policewomen), is scrutinized and
sexualized. The liaison with Oswalde will damage her career. Tenni
son's characterization of Oswalde's assignment as "tokenism" paral-
lels criticisms of her made by male superiors in "Prime Suspect."

Oswalde remains on the team and Tennison assigns him to the
sort of menial tasks that initially characterized her duties in "Prime
Suspect." When a subordinate intervenes in Oswalde's behalf, Tenni-
son cuts him off. She refuses to acknowledge her position of white
privilege, or how it plays out given her authority over Oswalde. Even
when Oswalde offers a creative idea, Tennison assigns Burkin, the
racist cop, to follow it up. Despite his menial tasks, Oswalde identifies
the murder victim and begins to suspect Tony Allen. In a noteworthy
scene, Oswalde drops by Tennison's apartment and reports what he
has learned. As he recounts his discoveries, Tennison listens, amused.

> Tennison: "What are you trying to prove? It's as if you're trying to
> take some test all the time."

Oswalde: "Well, you're no different...I watched you on the course. You know they're all lined-up wanting to see you fall flat on your face. So, you want to be the best...come out on top. Well, I'm the same as you."

Oswalde recognizes that institutional racism is an ever-present threat, much as sexism threatens Tennison's career. Perhaps his thoughts only draw a parallel between race and gender, but they nonetheless recognize that their problems are institutional rather than mere personal prejudice.

Oswalde is an obsessive officer, and, once he suspects Tony Allen, he harasses him at home and at work. In a powerful scene, Oswalde interrogates the psychologically fragile young man at the police station. Tony Allen, an Afro-Caribbean man, asks, "What kind of brother are you to say things like that to me?" Oswalde answers, "I'm not your brother. I am a police officer." Oswalde's loyalty to his police identity aptly demonstrates the limitations of the "additive" solution to police and race issues without any structural change. Interestingly in this scene, Burkin pulls Oswalde from the interrogation room. He knows that Oswalde lacks the evidence to support his suspicions and that Allen is becoming unstable. A jailor suggests that they call a doctor for him, but Oswalde refuses, "He's alright. Let him stew for a bit." A few moments later, Allen hangs himself.

DCI David Thorndike investigates Allen's death. Burkin and the jailor lie to protect Oswalde and the police. All suffer reprimands, but the organization is exonerated. Even Burkin's racism is trumped by his loyalty to the police. The scene suggests that police share an identity that transcends race (see Reddy, 2003, p. 118).

Oswalde is devastated by Allen's suicide. He again visits Tennison and confides that he bullied Allen and is responsible for his death. In this scene, Oswalde confronts his competing identities. He tells Tennison that he may be a coconut as others say: brown on the outside, white on the inside.

Toward the end of the film, institutionalized racism combines with organizational politics. Under Tennison's leadership, Oswalde captures the murderer. Kernan is promoted, but Thorndike, not Tennison, is promoted to replace him. She is passed over for the promotion because of her tryst with Oswalde. Of course, this has gender implications as well. We now turn to that aspect of the film.

Gender

Tennison: The Woman Detective

The detective/cop is the central figure of the crime genre (Klein, 1992). A part of the pleasure of the genre is to follow the exploits of the hero, who should be a unique and interesting person. This is a challenge when the hero is a woman in a male-identified genre, but an opportunity as well to subvert genre conventions and create a more progressive drama or fiction (Klein, 1992; Reddy, 2003). A powerful personality, rich in an ambiguity, and a woman, Jane Tennison is an interesting character.

Gender is an organizing feature in "Prime Suspect 2", much as it was in the first film. Early on, there is a sense that Tennison is more accepted in the organization. her authority is taken-for granted, not negotiated, and her standing in the police force is exemplified in the assignment to head a politically sensitive investigation.

Even so, because she is a woman Tennison's behavior is closely scrutinized, and she is aware of this scrutiny. When Oswalde is assigned to her team, she knows that a casual affair is not viewed the same for her as for a man. Tennison thinks Oswalde requested the assignment and fears that the discovery of their tryst could hurt her career. When she tries to remove Oswalde and fails, anger and fear cause her to assign him to tasks that are beneath his rank and ability. It is as if, by denigrating him professionally, she can make him invisible and protect her career. Later, when Oswalde draws parallels between his racial and her gendered vulnerability, Tennison balks at an alliance. She recognizes her vulnerability, but is the consummate professional and the consumed careerist.

These facets of Tennison's personality are depicted in a series of scenes with DCS Kernan. Tennison meets with Kernan after Frank Burkin has arrested and roughed-up a black youth. She suggests removing Burkin from the case, but Kernan responds that he is up for promotion to Chief Superintendent and cannot "wash his dirty laundry in public." Without missing a beat, Tennison, who knew nothing of the promotion, responds, "I hope you'll be recommending me for your post." In a second scene, Kernan, nervous before his promotion interview, asks Tennison, "How do I look?" "Like a Chief Superintendent," she answers, straightening his tie. In a third scene, Tennison's obsession with the case is so distracting that she forgets to ask Kernan about his interview.

Other scenes depict Tennison, the smart detective. The whereabouts of David Harvey—a former tenant in the flat where the body

was discovered—are unknown. Tennison learns that Harvey paid rent erratically, reasons that perhaps he had financial troubles, runs a credit check, and discovers his address. Later, she elicits a confession from Harvey, a Catholic, who is dying. Tennison holds his hand and tells him that she, too, is a Catholic, and that confession will make him feel better. He confesses and dies. But Tennison doubts Harvey's confession. Ever the thorough detective, she re-interviews a witness who had provided an alibi for Harvey; despite Harvey's confession, the witness remains firm in the alibi. In a reversion to genre convention, Tennison illegally enters Harvey's house and finds evidence (photos) that implicates his nephew, Jason Reynolds.

Tennison reveals her sympathetic side when Oswalde, distraught over Allen's suicide, visits her. She comforts Oswalde and offers to let him stay the night. He declines but, at her front door, she kisses him. Jason Reynolds, the killer, photographs the kiss, and mails the film to tabloids, which print it. Tennison's affair with Oswalde already is known (probably due to DCI Thorndike), so she is in trouble with the organization. Even so, Tennison uses the photos to bond with Sarah Allen, herself a "victim" of Jason Reynolds's photography. She tells Sarah, "we can't let Jason make us into victims." Sarah recounts Joanne's murder. Whether Tennison's bond is real (woman-to-woman) or strategic (like her Catholicism with the dying Harvey), we cannot know.

Tennison is a careerist and a good detective. She also is a woman, which impedes her success in the police organization. While "Prime Suspect 2" depicts her as a strong woman, aspects of her character are decidedly postfeminist.

A Postfeminist Detective?

In postfeminism, women enjoy the benefits of the feminist agenda—independence and career opportunities—but with no political commitment to feminism. Postfeminist narratives typically portray the cost of success as a loss of heterosexual love and family. DCI Jane Tennison embodies many of these postfeminist characteristics.

In "Prime Suspect" Tennison directs an investigation, and, despite impediments, brilliantly succeeds. At film's end, as she basks in the admiration of the detectives, her lover has left and she is alienated from her family. In a sense this is nothing new: the loner detective is a genre convention. However, as Reddy (1988, p. 69) notes, unlike their male counterparts, women detectives in feminist crime fiction are usually connected to "chosen families" (i.e, friends and lovers). Contem-

porary procedurals devote more attention to detectives' personal lives and to their "police families" (Reddy, 1988; Joyrich, 1996, pp. 48-s49). This genre convention has postfeminist implications with a woman like Tennison who only has a "police family," and even here she is on shaky ground. In the first two films, she often asks detectives at the end of the work day if they would "fancy a drink." They decline; they must get home to their families. Tennison is alone.

Seen in this light, Tennison's relationship with Oswalde is frustrating. He might be someone with whom she could have a relationship. She seems comfortable with him in the afterglow of conference sex. However, when assigned to head the investigation, she immediately dresses and prepares to leave. The work is everything. When Oswalde is angered by her abrupt departure, Tennison coldly notes that she is not the love of his life. At other junctures, it seems that she and Oswalde could share an alliance, if not a relationship. Like her, he is a smart, aggressive cop. He tries to bond with her, noting the police organization's response to his race and her gender. Tennison refuses to connect with Oswalde, choosing instead to remain isolated. Her treatment of Oswalde—assigning him to menial tasks and accusing him of wanting special favors— rejects any commitment to feminism's agenda, and more, mimics the organization's treatment of her. Tennison cannot see this. All that she sees is her prime suspect and DCS Kernan's job.

"Prime Suspect 2"'s final scenes are brutally postfeminist. The mise-en-scene when Tennison learns that she has been passed over for Kernan's job is revealing. She faces Thorndike, who sits behind what is now his desk; his hands are clasped at his chest in a gesture of authority. Tennison says, "You'll have my formal request for a transfer first thing in the morning." Perhaps she expects some positive response; after all, she has successfully concluded a sensitive case. At first, Thorndike does not respond. Finally, simply, he says, "Very well." Tennison slumps but says nothing, then turns and leaves. Thorndike sighs. Tennison's path from the building takes her past the squad room, where the detectives enjoy a beer—Thorndike's reward for their success. No one sees her leave; no one says goodbye. In the final shot, as the closing credits roll, the camera focuses on the front of the police station. Tennison exits the building and then the frame. Alone.

Conclusion

The detective drives the crime genre. Certainly, the force of Tennison's character, powerfully acted by Helen Mirren, is an important

element in the popularity of the Prime Suspect series. Its popularity also is due to the issues that comprise the stories: sexism, racism, and other social concerns. Such socially relevant subject matter is a hallmark of the emerging feminist crime genre (Klein, 1992; Reddy, 2003).

Even so, our analysis of "Prime Suspect 2" must conclude with some positives, some negatives, and a host of ambiguities. The film tackles the matter of race, for example, how the police police black communities, and their view of the police. The film critiques the individual-level racism of Frank Burkin and others, and demonstrates the inadequacy of an additive police response to issues of race. Bob Oswalde, a sympathetic character, struggles with his identity but succumbs to an excess of policing (and careerist) zeal and drives a young man to suicide.

The film addresses institutional racism. In scenes that resonate with news headlines about police and minority populations, the film portrays the police upper echelon as a white hierarchy that views a black community as a population that cannot be trusted. Powerful, back stage scenes depict that hierarchy as it faults Tennison for her lapse of judgement—an affair with Oswalde, a black man—and bypasses her for promotion.

At the same time, "Prime Suspect 2" offers little hope that its characters can or will challenge the sexist and racist organizational hierarchy of policing. Because they enjoy the chase, because they are sure of their judgements, because they are such careerists, because they identify with and want to impress the upper echelon and want promotions to that echelon, Tennison and Oswalde identify with people they can never please, much less be: privileged white men in the hierarchy of power. They are victims of the organization and reinforce its institutionally racist policies.

"Prime Suspect 2" reinforces the feminist statement of the first film. Tennison's behavior (like that of other working women) is sexualized and scrutinized for errors. A man might have a casual affair at a conference, but Tennison's affair with a subordinate who is a man of color costs her a promotion. The film offers a compelling depiction of what Rennert (1995, p. 18) calls the "crappy sacrifices a woman makes for her career." Tennison may be more accepted as a detective, but she remains an outsider.

Along side its feminist stance, the series includes a postfeminist sensibility. This began to emerge in "Prime Suspect" when Tennison's success as a detective came at the expense of her personal life. At least she had her "police family." At the end of "Prime Suspect 2,"

she has lost even that, and her postfeminist characterization is starker. Tennison is so driven by her obsession with work and career that, at the peak of her success, she is isolated from everyone.

In terms of a progressive moral fiction, we reluctantly give "Prime Suspect 2" mixed reviews, reviews that tilt toward the negative. The film offers views of marginalized people—the Afro-Caribbean community, the Allen family, DS Bob Oswalde, even Tennison—and locates their marginalization within the larger social context. Following Lotz's (2001) efforts at the rehabilitation of "postfeminism" as a means for developing new analytic tools, "Prime Suspect 2" describes relations of power—Oswalde to Tennison, both to the police hierarchy—and depicts fictional situations that represent important issues to women and people of color. The narrative confirms Collins's (1990) observation that people are both oppressors and victims: Tennison, a marginalized woman, treats Oswalde badly; Oswalde, a marginalized man, causes Allen's suicide. Yet, whatever fissures in the ruling apparatus are revealed are quickly and thoroughly sealed over in a manner that minimizes hopes for change. The rigidity of the police organization, together with the strong desires of Tennison and Oswalde to succeed, causes these characters to miss opportunities that might promote social change. Ultimately, their actions perpetuate the organizational status quo.

We wish that, after learning that Thorndike, the organization man, had received "her" promotion, Tennison had left to join Oswalde and other marginalized officers in a debriefing session. The film then might offer hope of a better future, a more collective challenge to the institutional order.

Instead, "Prime Suspect 2" has a less-than-happy ending. The killer is caught, but an innocent young man is dead. And Tennison and Oswalde, who solved the case, reap no rewards. The good guys, who are not always so good, do not win; the hierarchy wins. Tennison and Oswalde are like characters in a noir novel: seemingly active agents with chances for success, but really pawns in a much larger game that, try as they might, they will loose.

It may be, as some critics suggest, that "Prime Suspect" is limited by the institutional strictures of television, or by the conventions of the crime genre (Brooks, 1994; Thornham, 1992), especially the police procedural, which is resistant to feminist revision (Reddy, 2003). Perhaps Jermyn (2003) is correct that "Prime Suspect" is simply a crime narrative, not a feminist crime narrative.

But, television is our society's storyteller; it takes our cultural assumptions and ideologies and weaves them into mythic tales that

guide and inform us. We would hope that these would be moral and uplifting tales that mobilize us to do better, especially given the film's popularity among women viewers. "Prime Suspect 2" is like the child's fable about the dog and the bone and the reflecting pool. The dog has a bone, but, seeing its reflection in the pool, grabs at it and looses the bone. In this postfeminist retelling of that old fable, Tennison succeeds, but wants it all and, in the process, loses everything. "Prime Suspect 2" shows an isolated, friendless career woman going off, alone, in defeat. This ending is both disturbing and cynical, affects which are intensified by the film's realism. Moreover, the ending establishes themes and trends in the films that follow.

REFERENCES

Abercrombie, N. (1996). Television and Society. Cambridge: Polity Press.

Bailey, F. (1991). Out of the Woodpile: Black Characters in Crime and Detective Fiction. New York: Greenwood Press.

Boler, M., & Allen, K. (2002). "Whose Naming Whom: Using Independent Video to Teach About the Politics of Representation." Women's Studies Quarterly, 30, 255-270.

Brooks, D. (1994). "Television and Legal Identity in Prime Suspect." In A. Sarat (Ed.), Studies in Law, Politics and Society, Vol. 14 (pp. 89-104). Greenwich, CT: JAI Press.

Brown, J., & Heidensohn, F. (2000). Gender and Policing: Comparative Perspectives. New York: St. Martin's Press.

Cavender, G., & Jurik, N.C. (1998). "Jane Tennison and the Feminist Police Procedural." Violence Against Women, 4, 10-29.

Chiricos, T., & Eschholz, S. (2002). "The Racial and Ethnic Typification of Crime and the Criminal Typification of Race and Ethnicity in Local Television News." Journal of Research in Crime and Delinquency, 39, 400-420.

Collins, P.H. (1990). Black Feminist Thought. New York: Routledge.

D'Acci, J. (1994). Defining Women: Television and the Case of Cagney & Lacey. Chapel Hill: The University of North Carolina Press.

Degh, L. (1994). American Folklore and the Mass Media. Bloomington: Indiana University Press.

Dow, B. (1996). Prime-time Feminism. Philadelphia: University of Pennsylvania Press.

Eschholz, S., Chiricos, T., & Gertz, M. (2003). "Television and Fear of Crime: Program Types, Audience Traits and the Mediating Effect of Perceived Neighborhood Racial Composition." Social Problems, 50, 395–415.

Feinsilber, P. (1995). "Three New Prime Suspects." In A. Rennert (Ed.), Helen Mirren: Prime Suspect (pp. 80-87). San Francisco: KQED Books.

Gardner, J. (1982). On Moral Fiction. New York: Basic Books.

Gilliam, F., & Iyengar, S. (2000). "Prime Suspects: The Influence of Local Television on the Viewing Public." American Journal of Political Science,

44, 560-573.

Gray, H. (1995). Watching Race: Television and the Struggle for Blackness. Minneapolis: University of Minnesota Press.

Hobson, J. (2002). "Viewing in the Dark: Toward a Black Feminist Approach to Film." Women's Studies Quarterly, 30, 45–59.

Hunt, D. (1999). O.J. Simpson Facts & Fictions: News Rituals in the Construction of Reality. Cambridge: Cambridge University Press.

Hunt, J. (1990). "The Logic of Sexism Among Police." Women & Criminal Justice, 1, 3-30.

Jermyn, D. (2003). "Women With a Mission: Lynda LaPlante, DCI Jane Tennison and the Reconfiguration of TV Crime Drama." International Journal of Cultural Studies, 6, 47-64.

Jermyn, D. (2001). "Death of the Girl Next Door: Celebrity, Femininity, and Tragedy in the Murder of Jill Dando." Feminist Media Studies, 1, 342-359.

Joyrich, L. (1996). Re viewing Reception: Television, Gender, and Postmodern Culture. Bloomington: Indiana University Press.

Kanter, R.M. (1977). Men and Women of the Corporation. NY: Basic Books.

Keveney, B. (2001). "Few Latinos Featured As Leads On TV." The Arizona Republic, September 17, E8.

Klein, D. (1992). "Reading the New Feminist Mystery: The Female Detective, Crime and Violence." Women & Criminal Justice, 4, 37-62.

Klein, K. (1995). The Woman Detective: Gender & Crime (2nd Ed.). Urbana: University of Illinois Press.

Kozloff, S.R. (1987). "Narrative Theory in Television." In R. Allen (Ed.), Channels of Discourse (pp. 42-73). Chapel Hill: The University of North Carolina Press.

Lotz, A. (2001). "Postfeminist Television Criticism: Rehabilitating Critical Terms and Identifying Postfeminist Attributes." Feminist Media Studies, 1, 105-121.

Mandel, E. (1984). Delightful Murder: A Social History of the Crime Story. Minneapolis: University of Minnesota Press.

Martin, S., & Jurik, N.C. (1996). Doing Justice, Doing Gender: Women in Law and Criminal Justice Occupations. Thousand Oaks: Sage.

Mastro, D., & Robinson, A. (2000). "Cops and Crooks: Images of Minorities on Primetime Television." Journal of Criminal Justice, 28, 385-396.

Modelski, T. (1991). Feminism Without Women: Culture and Criticism in a "Postfeminist" Age. NY: Routledge.

Oliver, M.B., & Armstrong, G.B. (1998). "The Color of Crime: Perceptions of Caucasians' and African-Americans' Involvement in Crime." In M. Fishman & G. Cavender (Eds.), Entertaining Crime: Television Reality Programs (pp. 19-35). New York: Aldine de Gruyter.

Press, A. (1991). Women Watching Television: Gender, Class, and Generation in the American Television Experience. Philadelphia: University of Pennsylvania Press.

Rafter, N. (2000). Shots in the Mirror: Crime Films and Society. New York: Oxford University Press.

Reddy, M. (1988). Sisters in Crime: Feminism and the Crime Novel. New York: Continuum.

Reddy, M. (2003). Traces, Codes, and Clues: Reading Race in Crime Fiction. New Brunswick, NJ: Rutgers University Press.

Rennert, A. (1995). "Introduction." In Amy Rennert (Ed.), Helen Mirren: Prime Suspect (pp. 12-13). San Francisco: KQED Books.

Rosenfelt, D., & Stacey, J. (1990). "Second Thoughts on the Second Wave." In K. Hansen & I. Philipson (Eds.), Women, Class, and the Feminist Imagination: A Socialist-Feminist Reader (pp. 549-567). Philadelphia: Temple University Press.

Smith, D. (1999). "From Women's Standpoint to a Sociology for People." In J. Abu-Laghouat (Ed.), Sociology for the Twenty-First Century: Continuities and Cutting Edges (pp. 65-82). Chicago: University of Chicago Press.

Smith, D. (1996). "Telling the Truth after Postmodernism." Symbolic Interaction, 19, 171-202.

Thornham, S. (1992). "Feminist Interventions: Prime Suspect." Critical Survey, 6, 226-233.

Tomc, S. (1995). "Questioning Women: The Feminist Mystery After Feminism." In Greenwood Irons (Ed.), Feminism in Women's Detective Fiction (pp. 46-63). Toronto: University of Toronto Press.

Tuchman, G. (1978). "The Symbolic Annihilation of Women By the Mass Media." In G. Tuchman, A. K. Daniels, & J. Benet (Eds.), Hearth and Home: Images of Women in the Mass Media (pp. 1-38). New York: Oxford University Press.

Young, I. M. (1994). "Punishment, Treatment, Empowerment: Three Approaches to Policy for Pregnant Addicts." Feminist Studies, 20, 33-55.

Gray Cavender *is a Professor of Justice and Social Inquiry at Arizona State University. He teaches courses on Media, Law & Society, and Punishment. His primary research interest is in the media, and includes topics ranging from reality television to how the media depict crime. With Mark Fishman, he edited Entertaining Crime: Television Reality Programs (Aldine de Gruyter, 1998).*

Nancy C. Jurik *is a Professor of Justice and Social Inquiry at Arizona State University. She teaches courses on "Women and Work" and "Economic Justice." Her publications focus on gender, work organizations, and economic development programs. She has published a book entitled Doing Justice, Doing Gender: Women in Law and Criminal Justice Occupations (Sage, 1996), and numerous articles on gender and work issues. She recently completed a book on U.S. microenterprise development programs entitled Bootstrap Dreams — U.S. Microenterprise Development in an Era of Welfare Reform (Cornell University Press, forthcoming). She was the 2002-2003 President of the Society for the Study of Social Problems.*

Women and Crime: Essay and Syllabus

Nancy Lewis-Horne

The "Women and Crime" course taught at State University of New York, College at Potsdam is an elective course for sociology, criminal justice and women's studies students offered through the Sociology Department. The course is designed to support and further the study of American society by focusing on the social conditions that shape women's experiences engaging with the criminal justice system. The level of student skepticism encountered and the impact of the course on individual students makes this course challenging to teach.

The course examines three inter-related areas of study: women as offenders, women as victims, and the social construction of masculinities[1] leading to violence against women. The course content is selected and presented to achieve three broad goals:

1. introduce the criminal justice system as a powerful social institution that intervenes in the lives of women as victims, offenders and in women's relationships with the men in their lives.
2. recognize that criminal justice system interventions are guided by relations of power (gender, race/ethnicity, and social class) reproduced through myths and stereotypes and pervasive throughout American society.
3. reveal social change through the expanding definition of women's deviant behavior and the increasing reliance on formalized mechanisms of social control (criminal justice response-law enforcement, court involvement, and correctional follow up) to regulate women's productive and reproductive labor and social relationships.

These goals support my personal and professional pursuit of women's equality through ending male violence against women.

Patriarchy is the unifying concept tying together the three areas of study. Patriarchy is defined as male control of women's sexuality and labor through control of the important institutions of power in society (family, government, law, military, religion, economy). Consequently, men are in a position to define law and use the criminal justice system to control women's reproductive and productive choices and relationships. Male power is the product of socially defined cul-

tural and historical circumstances that placed women in the privacy of the home, and absent from public life. The recurring theme of social control of women's productive and reproductive capacity is applied to an analysis of society's definition of crime, women's opportunity for criminal behavior, and criminal justice response policies to women as victims and offenders.

The lens of feminist analysis identifies gendered hierarchies as defining all social relationships. However, in addition to hierarchies of gender, hierarchies of race and social class are introduced as a necessary focus of inquiry to achieve a fuller understanding of the relationship between women and the criminal justice system. Consequently, to understand the position of women in society, women and their intersection on various social hierarchies must be the focus of inquiry.

Focusing on the relationship between women and the criminal justice system highlights gender difference in society. A discussion of gender difference is somewhat confusing given that the criminal justice systems approach to gender is not clear. Feminist legal scholars believe the law, and by extension the criminal justice system, is androcentric in that the law operates in the image of men, such as through the test of "a reasonable man." As women moved out of the home into the public domain, the law was extended to apply to women too. However, the underlying premise of male interest and the male model never changed. Consequently, reliance on the gender neutrality of law obscures the context of women's offending behavior and victimization. Ignoring gender difference tailors criminal justice interventions to actually reproduce gender hierarchies that leave untouched patriarchy operating in the home and public life.

The following discussion will summarize the perspective and arguments I employ to introduce undergraduate students to the role of the criminal justice system as a powerful institution of social control in the lives of women. As identified above, the consistent theme of patriarchy structuring women's productive and reproductive choices and potential is evident throughout the study of women's relationship to the criminal justice system. In addition, topics and research are presented demonstrating the ability of the criminal justice system to reproduce the many myths and stereotypes about gender, race, and social class prevalent throughout society, serving to maintain the status quo.

In addition, the discussion introduces the theme of gender difference demonstrating that masculinity and femininity are differentially valued and that women and men perform different roles in society. A focus on gender difference identifies gendered contexts to

the offending pattern of women and women's victimization. Consequently, gender difference and social hierarchies structure criminal justice system interventions in the lives of women as offenders, victims, and their relationships with the men in their lives.

I have taught this course four times in the past four years with varying levels of success. Although the course content (as described below) has remained mostly consistent, I found adjusting pedagogy to an experientially based approach has improved the course immensely. This past semester students were more willing to apply feminist theory and understood the concepts and themes organizing the course. However, this approach may not work for every instructor as it raises issues faculty do not often cope with.

The paper finishes with a brief discussion of important considerations faculty may wish to consider in the planning and administration of a "Women and Crime" course. Course content, theoretical perspective and student interest raise many issues that serve to differentiate this course from other sociology and criminology courses. Consequently, a few of the risks associated with teaching this course are identified.

Women as Offenders

Women's involvement in crime is analyzed according to the argument "women's crimes mirror women's lives." Definitions of crime and criminal justice response policies are socially determined to encourage women's conformity and punish deviance from socially approved roles of reproduction and production. Lecture topics are selected to identify the goal of the criminal justice system as the social control of women's reproductive and productive roles, including lectures discussing the criminalization of women's reproductive roles and their sexuality. For instance, lecture content examines prostitution, poor minority pregnant women's use of drugs and alcohol, female youth involvement in the juvenile justice system, and the lack of regard and priority for incarcerated women's maternal roles.

The interaction of production and reproduction along with women's intersection in other hierarchies (race/ethnicity, social class, age) place women in various positions of power and powerlessness. As a result, gender hierarchies intersecting with other social hierarchies provide varying opportunities for involvement in crime and different types and degrees of criminality. For instance, research demonstrates that women giving birth in public medical facilities are much more likely to have their blood and the blood of their new born baby tested for the presence of drugs. According to Logan

Women's Studies Quarterly 2004: 3 & 4

(1999, p. 115), this occurs even though women in both facilities use similar amounts of drugs and alcohol (although drug of choice is different). This example illustrates that poor women and women of color (who are proportionately at a greater risk of being poor) are more likely to have their reproductive labor regulated by criminal justice intervention.

A second example making a connection between the social control of women and intersections on other social hierarchies includes a lecture examining the relationship between young women and the juvenile justice system. Chesney-Lind (1997) reveals the entanglement of young women in the justice system and their incarceration is based not on their criminal behavior and their risk to society, but on their involvement in status offenses. Young women who fail to follow the rules of a probation order, such as by staying out late, not attending school, or by engaging in socially risky behavior such as drinking underage, being associated with males known to the police, find themselves incarcerated at a much higher rate than do their male peers. Consequently, young women are incarcerated to maintain "sexual and moral boundaries" defined by society and reinforced by the patriarchal family, as opposed to being incarcerated for criminal offenses.

The importance of gender difference is evident to students through an examination of the profile of female crime. Understanding gender differences in the context of the values and roles of women and men in society is the essential first step in understanding the significance of gender difference reproduced by social institutions, such as through the criminalization of women's reproductive choices and labors (as explained above). Women's roles in society as consumers driven by social values associated with these roles place women in stores for many hours making many purchases in an environment in which temptation for theft is high because products are "in your face," available, and financially unattainable. In addition, criminal justice response policies have changed to criminalize first-time shoplifters. Not surprisingly then, the profile of women's offending pattern reveals that minor property crime such as shoplifting and minor theft is frequently part of the pattern.[2] The public discourse especially evident in media presentations about "mutual battering" and the battered husband demonstrate the dangers of pursuing the fallacy of gender neutrality. DeKeseredy and Schwartz's[3] analysis of the conflict tactics scale (1998. p. 2) alerts us to focus not on quantifying the violence in intimate relationships, but instead, to understand the context in which violence was used. Examining domestic violence through analysis of gender difference makes evi-

dent the contextual difference in the means, method, and motive for male and female use of violence in intimate relationships. Obscuring gender difference in the context of domestic violence by adopting gender neutral language, such as "mutual battering" will have a negative impact on women by expanding the definition of deviant women to include the criminalization of women who use violence in self-defense. Consequently, more women will be defined as criminal and subject to formalized social control in the shape of arrest, prosecution, and supervision (incarceration or community corrections).

The reading assignment for the women as offenders section of the course is Elisabeth Beattie and Mary Angela Shaughnessy, *Sisters in Pain: Battered Women Fight Back* (2000). Beattie and Shaughnessy's book chronicles the life stories of women who killed their intimate male partners in response to the years of violent sexual and physical assaults they endured at the hands of the men in their lives. In addition to sexual and physical violence, the life stories chronicle the emotional abuse that serves to lock the women into abusive relationships. The Sisters in Pain were paroled by the Governor of Kentucky following a review of their cases.

The case studies presented in the book do an excellent job of supporting lecture content that identifies myths and stereotypes that serve to maintain wife abuse. For instance, myths about domestic violence include, "why don't they just leave?" The "Sisters" all tried numerous times to leave but the men pulled them back in, i.e., the men wouldn't let them leave. As well, myths about zero tolerance and mandatory arrest policies suggest that police not only respond to all calls from battered women for assistance, but that police intervention will in and of itself end the violence.

An examination of the criminal justice systems response to women as offenders demonstrates the power of the criminal justice system to intervene in women's reproductive and productive choices and labors. Increasingly, women's reproductive lives are being regulated through the expanding definition of deviant behavior. The criminalization of pregnant women who use certain drugs, young women who are outside the control of their family, women who use violence to protect themselves from further abuse, and women who survive through the sex trade all risk being labeled deviant and subject to sanction via the criminal justice system. However, it is clear that women do not share the scrutiny of the criminal justice system equally. The intersection of gender with other social hierarchies place some women at greater risk of criminal justice intrusion than others.

The language of gender neutrality clouds the true picture of

gender difference. Understanding the profile of women as offenders and the crimes they commit provides an opportunity to intervene to change the social environment that leads to the deviant label. Obscuring gender difference focusing on gender neutrality results in continued social control of women's reproductive lives and ineffective interventions (such as through correctional programming).

Women as Victims

The main argument linking the various topic areas examining violence against women is that violence against women in society is maintained through ineffective intervention policies pursued by social institutions. Patriarchy, or the control of women's reproductive and productive potential in the home and public life, is the central organizing concept suggesting the use of violence by some men is purposeful behavior used to achieve social control. Violence against women is introduced in its broadest definition through radical feminists' continuum of violence beginning with the two extremes of everyday occurrences of behavior women are encouraged to accept, to the ultimate of killing of women because they are women (referred to as femicide). Lectures, discussions, assignments, and assigned readings related to sexual assault on the college campus and femicide further help to illustrate that violence against women is tolerated in American society as it defines and reflects patriarchal power in the home and public space. The assigned readings for both this section (women as victims) and the previous reading *Sisters in Pain* demonstrate the lack of effectiveness of the government through welfare departments, police, education, the military, and family to intervene to assist battered women. The recurring theme of gender difference is a crucial element in understanding violence against women. Just as gender-neutral language promoted the idea of symmetry in intimate violence and expanded the definition of women as equally as violent as men, the language and myths promoting gender neutrality and suggesting gender equality is used to limit criminal justice interventions to protect women from violence. Myths heightened by the language of gender neutrality suggest women could simply leave their homes and relationships in order to protect themselves and children, or that women could protect themselves from sexual violence by adjusting their behavior and wardrobe.

There are interesting parallels between gender difference in the means, method and motive of domestic battering as revealed by DeKeseredy and Schwartz and that of the killing of an intimate partner. Lec-

ture, discussion, and a group assignment examining femicide (the killing of a female partner because she is a woman) highlights the qualitative gender differences in the means, method and motive of killing an intimate partner. For instance Gartner, Dawson, and Crawford (1998) found men, more often than women, hunt down and kill estranged spouses, kill their partner and then commit suicide, kill in response to infidelity, engage in familicidal massacres (killing additional family members), and kill as the culmination of a lengthy violent relationship. Intimate femicide, especially as it involves the sexualized torture of a female partner previous to killing or the killing of her children, is the ultimate measure of sexual and reproductive control.

Students are encouraged to recognize the interconnectedness of social institutions, including the language of gender neutrality used by other social institutions. For instance, the media often present coverage of intimate homicide in a context that is void of the gendered characteristics of the event. Gender-neutral language is suggestive of mutual fault (e.g., using terms such as domestic violence), a temporary lapse of rationality, an isolated act of anger. Explaining the high number of women killed in North America by their abusive husbands as an isolated act of irrationality, or suggesting that some how the dead victim is partly responsible through her participation in ongoing "domestic violence" ensures that the criminal justice system can continue ignoring gender difference and reproducing male power and control in the home and society.

The main reading assignment for the violence against women section of the course is *Saving Bernice: Battered Women, Welfare and Poverty* by Jody Raphael, (2000). *Saving Bernice* is a case study of an African American woman who successfully moves from welfare to work and in the process leaves behind the father of her children who has repeatedly abused her. Although this is a case study of Bernice's life, Raphael applies available research examining the links between welfare, poverty, and violence against women to argue that there is a relationship between women who collect welfare and higher levels of domestic violence at the hands of the men in their lives.

Raphael's book supports lecture content, feminist theory, and the synthesizing argument through its illustration that wife battering is the outcome of male power and control in the home. One of the strengths of Raphael's book is the link it draws between male control and women's reproductive labor. Raphael argues that poor women on welfare have less ability to use birth control because abusive men believe pregnancy and dependent children make women less attractive to other men and employers. As Bernice's story makes evident

welfare to work programs will not be successful for battered women on welfare because women's financial independence from welfare will also mean their financial independence from their men, and this an abusive man cannot tolerate.

A web link to a paper presented by Angela Davis (http://www.casac.ca/issues/angelad.htm) provides analysis of the intersections of gender and race in the experience of African-American women who are abused by their male partners. As this paper makes evident the historical legacy of repression accomplished by social institutions and maintained today by the over representation of African-American men in the "criminal justice juggernaut"[4] puts African-American women victimized by wife abuse in a bind. A decision to protect themselves by bringing in the police will invoke a system of social control that will intervene not just to protect her, but to lock him into the "criminal justice juggernaut," a system that continues to be unfair to African-American men. Calling the police will reinforce the negative stereotype of angry and aggressive black men in the wider community also. In addition, as research by Maxwell, Garner, and Fagan (2001), demonstrate it is not clear that police intervention will deter episodes of violence as police intervention is not always successful in that regard. Consequently the intersection of gender with other social hierarchies presents some groups of women with fewer choices to use social institutions to protect themselves.

Presentation of feminist theory, methods, and research examining women as victims of male violence argued that, violence against women in society is maintained through ineffective intervention policies pursued by social institutions. The criminal justice system failed to protect Bernice, the "Sisters in Pain," and all the women killed by their intimate male partners even though their abuse was known to the police. As a social institution the criminal justice system and the law reflect the myths and stereotypes prevalent throughout society that maintain violence against women. Violence against women is seen as purposeful behavior that limits women's participation in society.

The purpose of violent behavior used by some men is to control their female partner's reproductive and productive potential and labors. However, ignoring the gendered use of violence maintains violence against women. As Raphael's study of women on welfare finds, not all women share equally the risk of violence in their lives. Women dependent on welfare face a higher risk of violence from their intimate partners. Current government policies such as welfare-to-work and saturation policing may exasperate poor women and

African-American women's risk by increasing the costs of asking for state intervention to end violence in their relationships.

Pedagogy

I enjoy teaching "Women and Crime". However, it has not been an easy course to deliver. The first time I offered the course I was shocked by student resistance. After three more interpretations and recreations, I have arrived at a course that I am happy with. I have achieved my goals (set out in the introduction) and have not had to handcuff students to their chairs and feed them feminist theory intravenously against their will. In fact, student evaluations of the course from spring semester 2003 were excellent. Course improvement had less to do with content and more to do with delivery.

I discovered this course works best coming from an experientially based approach. To that end, the readings assigned provide a balance between case-study methodologies and academic research. As well, students need many opportunities to reflect on the course content. This is achieved through five written assignments, allowing students to combine and reflect on the actual experiences of the women in the case studies as applied to the academic research. In addition, group discussion questions encourage student participation and discussion during lecture.

As effective as the experientially based approach is, it may be very disturbing for some students as it can raise personal and family experiences of victimization. These experiences are not the content of public discussions about having your wallet stolen, but instead are experiences of violence that are not permissible to speak about. Consequently for students who experience violence in their relationships, this course is most often the first public forum in which they hear that theirs is not a unique experience. As well, it is my experience that these students have not had the opportunity for personal growth or informed reflection that counseling can achieve. Consequently there are risks inherent in pursuing an experientially based approach given the course content.

The first risk involves students self-disclosing their personal and family experiences of violence. Self-revelation is best handled in the privacy of my office when I have sufficient time and control to ensure the students needs are handled effectively. Ten to fifteen percent of students from the class come to see me during office hours to confide their experiences and ask for advice and referrals.[5] An example of student issues I have dealt with include:

- current stalking and death threats by a former intimate partner
- sexual and physical harassment by another student during the current semester
- historical experiences of incest
- child abuse concurrently with abuse of mother
- homicide of a student's mother by mother's boyfriend
- homicide of a student's father by her mother and mother is now serving a life sentence (mother fits the case studies of the "sisters in pain")

Although it is not my goal to act as a social worker, I have a responsibility to ensure that the students who reveal these experiences receive appropriate interventions. The importance of appropriate intervention by the instructor is intensified when the student reveals experiences of current and ongoing violence in their relationships. To that end, my first priority is to ensure the student and other family members are safe. The next step is to refer the student to counseling services at the college. With the student's permission, I call counseling services and make the referral.[6]

The second risk is an outcome of the first in that this course can take more of the instructor's time then the delivery and administration of more traditional courses. In addition to the extra time used to meet with students from the class with personal issues of violence to discuss, I find that students seek me out after class to continue a class discussion or ask me about an issue raised in class. For example, students want to know:

- how to intervene with friends and acquaintances that reveal they have been sexually assaulted
- measures the college and Greek societies can take to prevent sexual assaults
- what to say to their brother who calls from police lockup because he was arrested for hitting his wife
- whether some women do beat men

I have learned to schedule the "Women and Crime" class at the end of the day to avoid the stress associated with arriving late at my next responsibilities.

I am increasingly satisfied with the experiential approach to the "Women and Crime" course. My goal to have students understand the criminal justice system as a powerful institution of social control that reproduces male power and control was met. In their written assignments students adopted the argument "women's crimes mirror

women's lives" to explain how society's definition of deviance and its response is directly related to social control of our gendered roles and values in society. As students discarded the myth of gender neutrality, they identified the threat to women of the widening definition of women's deviant behavior and a criminal justice system ever-ready to intervene to regulate women's reproductive and productive labor. An analysis of women's intersection on various social hierarchies demonstrated that some women face higher levels of criminal justice intervention as offenders and lower levels of state intervention as victims of violence. These women face a higher risk of having their reproductive and productive labor controlled by abusive men in the home or patriarchal power granting gender, racial, social class and age privilege in public institutions.

While this course expands students awareness of the social conditions that shape women's experiences in American society by offering a fundamentally different perspective, it comes with certain risks as described above. It is my belief that the students who revealed personal and familial experiences of violence (and those who didn't) benefitted from this course by gaining a better understanding of the role of violence in controlling their lives. However, on balance the risks of this approach are manageable considering the very important goal to end violence against women and achieve gender equality.

APPENDIX 1 COURSE OUTLINE
WOMEN AND CRIME: SOCI 376

Course Description:

The relationship between gender and crime provides insight into the broader picture of the role of social institutions in structuring and maintaining gender difference and hierarchies of inequalities based on gender, class, and race/ethnicity. The purpose of this course is to examine the important role of gender in both criminality and social responses to crime in society. Accordingly, specific emphasis will be given to feminist explanations of the relationship between women and the criminal justice system as offenders and victims. As well, recent theoretical development and research examining masculinities will focus our attention on the relationship between men and criminality.

Three areas will be explored:
1. *Criminal Justice System Response to Women as Victims.*
Areas and debates explored: exploration of the continuum of vio-

lence women are exposed to (both in the United States and internationally)
multiple marginalities—the intersection of gender, class, and race in understanding women's victimization and opportunities for change
police response policies to wife abuse, including zero-tolerance domestic violence courts measuring violence against women—is the issue male violence in society, or mutual battering (use of the conflict tactics scale).

2. *Women as Criminal Offenders.*
Areas and debates explored:
Casting a wide net—the criminal justice system as a powerful form of social control of women. Understanding the criminalization of women's survival strategies.
Self-help homicide—criminal justice response to women who kill their abusers
the new violent female?
a profile of women as offenders
pregnant women addicts
triple jeopardy, or multiple marginalities, female, visible minority and an offender
criminal justice system response to mothers as offenders—treatment/custodial needs vs. reproductive and maternal roles

3. *Masculinities and crime.*
Areas and debates explored:
social construction of masculinity
de-bunking radical feminism
masculinities, violence, and culture
the construction of sexual predators
masculinities, class and violence

Required Texts:

Beattie, L. Elisabeth & Shaughnessy, Mary Angela, Sisters in Pain: Battered Women Fight Back. Lexington: University press of Kentucky, 2000
Raphael, Jody, Saving Bernice: Battered Women, Welfare and Poverty. Boston: Northeastern University, 2000.
Messerschmidt, James, Nine Lives: Adolescent Masculinities, the Body, and Violence. Westview Press, 2000

Reserve Readings:

DeKeseredy, Walter, & Schwartz, Martin, "Measuring the Extent of Woman Abuse in Intimate Heterosexual Relationships: A Critique of the Conflict Tactics Scales" (2/01/98) from Applied Research Forum National Electronic Network on Violence Against Women.

Martin, Patricia Yancey, & Hummer, Robert, "Fraternities and Rape on Campus," Gender and Society. vol. 3, no. 4, pp. 457-473, 1989.

Web Readings:

Fisher, Bonnie, Cullen, Francis, & Turner, Michael, "The Sexual Victimization of College Women." National Institute of Justice, Bureau of Justice Statistics and Department of Justice, December 2000.

Schedule:

Topic Area Reading Assignment Jan. 22

Introduction to the course, requirements, and outline Raphael, Jody, Saving Bernice: Battered Women, Welfare and Poverty. Boston: Northeastern University, 2000.

(book assignment due Monday Feb. 10, 2003)

Jan. 27 class cancelled

Jan. 29 Feminist Criminology, theories, and perspectives used to understand gender and crime

Feb. 3 Women as Victims of Crime: Introduction

Feb. 5, 10 Battering of women in intimate relationships

Feb. 12 Minority women and Domestic Violence

Feb. 17 Class Cancelled

Feb. 19, 24 Femicide

Feb. 26 Sexual Assault Fisher, Bonnie, Cullen, Francis, and Turner, Michael, The Sexual Victimization of College Women. National Institute of Justice, Bureau of Justice Statistics and Department of Justice, December 2000. Take Home Examination #1: Focusing on Women as Victims of Crimes of Violence. Due March 5, 2003 37682 Introduction to Women as Offenders and the criminal justice system response

Beattie, L. Elisabeth, & Shaughnessy, Mary Angela, Sisters in Pain: Battered Women Fight Back. Lexington: University press of Kentucky, 2000 (Book assignment due March 17, 2003)

March 5, 10 Women Who Kill-self help homicide? Battered Women Defence

March 12, 17 Trends in Female Crime: The new violent female criminal?

March 19: Last day to withdraw Mutual Battering? on reserve: DeKeseredy, Walter, & Schwartz, Martin, "Measuring the Extent of Woman Abuse in Intimate Heterosexual Relationships: A Critique of the Conflict Tactics Scales" (2/01/98) from Applied Research Forum National Electronic Network on Violence Against Women. Triple Jeopardy: Women of Color and the CJS

March 26, 31 Pregnant drug abusers Take Home Examination #2: Focusing on Women as Offenders. Due April 14, 2003

April 2, 14 Masculinities and Crime: Messerschmidt and structured action theory

Messerschmidt, Nine Lives. Book assignment due April 16, 2003

April 7, 9 no classes, spring recess

April 21, 23 Other research related to masculinity and crime: Male Peer Support Model Yancey Martin & Hummer, "Fraternities and Rape".

April 28, 30, May 5 Examining the nine lives Tying together all of the strands to understand gender and crime Take Home Examination #3: Focusing on crime as a resource in the construction of masculinity. Due May 9, 2003

NOTES

1. Due to space restrictions I do not discuss this area of study in the current paper. See outline in appendix for further information.
2. According to the Bureau of Justice Statistics (10/3/2000) females are overrepresented in larceny/shoplifting arrests as they accounted for 35% of all those arrested for larceny in 1998, but are only 22% of all arrest categories.
3. The assigned reading for this lecture is Walter DeKeseredy & Martin Schwartz, "Measuring the Extent of Woman Abuse in Intimate Heterosexual Relationships: A Critique of the Conflict Tactics Scales" (2/01/98) from "Applied Research Forum National Electronic Network on Violence Against Women."

4. Term used by Neil Websdale (2001) referring to the growing web of corrections, aftercare, and law enforcement apparatus that regulates the everyday lives of the poor and particularly poor African Americans.
5. A few students reveal their experiences of personal or family violence in their written assignments. The men in the class are more likely to do this before venturing into my office.
6. Other referral agencies included the Elizabeth Fry society, Interval House, and the local police department.

REFERENCES
Beattie, L.E., & Shaughnessy, M.A. (2000). Sisters in Pain: Battered Women Fight Back. Lexington: University Press of Kentucky.

Chesney-Lind, M. (1997). The Female Offender: Girls, Women and Crime. Thousand Oaks: Sage.

Davis, A. (2000). "The Color of Violence Against Women," Originally published in ColorLines Magazine. Fall 2000. (http://www.casac.ca/issues/angelad.htm)

DeKeseredy, W., and Schwartz, M. (2/01/98). "Measuring the Extent of Woman Abuse in Intimate Heterosexual Relationships: A Critique of the Conflict Tactics Scales." Applied Research Forum National Electronic Network on Violence Against Women.

Gartner, R., Dawson, M., & Crawford, M. (1998). "Woman Killing: Intimate Femicide in Ontario". Resources for Feminist Research, 26, 151-173.

Greenfeld, L., & Snell, T. (2000). Women Offenders. Washington, DC.:U.S. Department of Justice, Office of Justice Programs.

Logan, E. (1999). "The Wrong Race, Committing Crime, Doing Drugs, and Maladjusted For Motherhood: The Nation's Fury Over "Crack Babies."" Social Justice, 26(1), 115.

Maxwell, C., Garner, J., & Fagan, J. (2001). "The Effects of Arrest on Intimate Partner Violence: New Evidence From the Spouse Assault Replication Program." Washington, D.C.: U.S. Department of Justice, Office of Justice Programs, National Institute of Justice.

Messerschmidt, J. (2000). Nine Lives: Adolescent Masculinities, the Body, and Violence. Westview Press.

Raphael, J. (2000). Saving Bernice: Battered Women, Welfare and Poverty. Boston: Northeastern University Press.

Websdale, N. (2001). Policing the Poor: From Slave Plantation to Public Housing. Boston: Northeastern University Press.

Yancey Martin, P. & Hummer, R. (1989)."Fraternities and Rape on Campus." Gender and Society, 3(4), 457-473.

Nancy Lewis-Horne is an Assistant Professor of Sociology at the State University of New York, Potsdam College. Her interest in violence against women developed from earlier employment as a Crisis Intervention counselor with the Calgary Police Service.

Educating Students About the War on Drugs: Criminal and Civil Consequences of a Felony Drug Conviction

Marylee Reynolds

American society is a patriarchal one, where the needs, issues, and concerns of women are largely ignored. It should not be surprising then, that when legislators enact crime control policies, especially drug policies, the social and economic impact of such policies on women are rarely considered. While women who violated drug laws were once confined to punishment by the criminal justice system, increasingly, legislative policies concerning welfare reform and other social policy areas are combining to penalize women with drug felony convictions (Hirsch, 1999; Allard, 2002; Hirsch, 2002; Mauer & Chesney-Lind, 2002; Travis, 2002; Petersilia, 2003). Although these forms of punishment are "civil" rather than criminal in nature (Travis, 2002), they are just as punitive because they increase the likelihood of family dissolution since they deny women welfare benefits, food stamps, higher education, employment, and housing, impeding their ability to successfully transition from prison into their communities. As a result, the social safety net for poor people in this country has been deteriorating (Allard, 2002; Travis, 2002).

A feminist examination of criminal (direct) as well as "civil" (collateral) punishments for a drug felony conviction exposes how laws, policies, and regulations enacted by the federal government affect women's lives, and places women's experiences at the center of its analysis. Specifically, this article examines how legislative policies penalize women convicted of drug felonies, particularly poor women of color, and suggests assignments, discussion questions, and resources educators can use to convey this material to their students. Those who teach in women's studies, political science, and criminal justice departments will find this article useful. The course that I teach this subject matter in is titled "The Criminal Justice System and Women" and is an elective in both Women's Studies and Criminal Justice.

In communicating this material to students, there are four important areas to consider: (1) policies that have increased women's imprisonment (see Chesney-Lind, 2002, 2003); (2) the use of statistics to demonstrate trends in women's imprisonment; (3) the criminal (direct) and civil (collateral) consequences of a felony drug conviction; and (4) the need for reform to reduce the harm of a prison sentence and to foster, not hinder, community reintegration. For each of these areas I have provided succinct material that can be developed more fully by the instructor, or be used as a starting point for a classroom lecture and/or discussion. Additionally, I have included a list of essential terms and concepts, assignments and research projects that incorporate Internet exercises, and discussion questions. After addressing each of these four areas separately, I then provide a list of readings that can be assigned to the students, or used by the instructor to enhance their own knowledge.

Unless students are criminal justice majors, they will know little about the War on Drugs (the Government's initiative to combat drug abuse) and imprisoned women. Therefore, the best method for conveying large amounts of information to students is the traditional lecture format combined with classroom discussion, and student assignments and/or research projects that can be completed individually or in small groups. Students should be prepared to discuss their research findings with the class.

The use of films about women prisoners or about drug policy in the United States will enhance classroom lectures, and is a valuable teaching method for visual learners. A field trip to a woman's prison is also suggested as an important teaching strategy. When teaching the course "The Criminal Justice System and Women," I arrange a visit to the women's prison in my home state, and the feedback from students is always positive. The students get to speak with the women, and hear their personal stories. What is most important is that the students come to empathize with the imprisoned women, realizing that the women are not so different from themselves.

Policies that Increase Women's Imprisonment

The United States is the leader of the incarcerated world, and now has the shameful distinction of incarcerating more of its citizens than Russia (Shane, 2003). The chief catalyst behind America's imprisonment binge is the War on Drugs and this war has primarily been waged against women—particularly women of color. The drug war, launched in the mid-1980s, was accompanied by a number of puni-

tive crime-control policies implemented at both the national and state levels. These reforms include state and federal sentencing guidelines, mandatory minimum sentences, three-strikes legislation, truth-in-sentencing laws, and the atrophy of parole.

Bolstered by the Anti-Drug-Abuse Act of 1986, federal sentencing guidelines became effective on November 1, 1987, and required federal judges to sentence individuals based on mandatory minimum sentences, eliminating most judicial discretion (Chesney-Lind, 2003; Petersilia, 2003). In essence, this meant that not only would more women be incarcerated, but that they would be incarcerated for longer periods. Most states also have mandatory minimum sentences for drug offenses, and are a critical factor in women's rising incarceration rates in these states (Mauer, Potler, and Wolf, 1999; Chesney-Lind, 2003; Petersilia, 2003). In short, due chiefly to the War on Drugs, arrests and convictions of women for newly defined drug felonies has skyrocketed, and has played a significant part in their escalating rates of confinement (Bush-Baskette, 1998; Mauer et al., 1999; Chesney-Lind, 2003; Petersilia, 2003).

In addition to mandatory minimum sentences and federal sentencing guidelines, increases in women's imprisonment can also be explained by the changing focus of probation and parole supervision, from treatment and rehabilitation to surveillance and control. As a result, more women are being sent to prison for technical (non-criminal) violations of probation and parole (Chesney-Lind, 2003; Petersilia, 2003). Technical violations are generally violations of the conditions of probation and parole and might include failing to report as directed, absconding, testing positive for drugs, or not attending work, school, or a substance-abuse treatment program.

A. Essential Terms and Concepts

Federal Sentencing Guidelines, Mandatory minimum sentences, Parole, Probation, Technical violation, Three-strikes legislation, Truth-in-sentencing laws, War on Drugs

B. Assignments and Research Projects

1. Investigate the crack epidemic of the 1980s. Find newspaper and news magazine articles that examined this epidemic. How did the media stereotype poor women of color that sold or possessed crack cocaine? What racial stereotypes surfaced in the media about crack-addicted pregnant women? Examine how this epidemic

sparked the War on Drugs in low-income, urban neighborhoods. Share your findings with the class.

2. Provide a social and demographic portrait of drug-abusing women (see especially Hirsch, 1999; Allard, 2002). Research how women are introduced to drugs, why they continue to use drugs, and why they sell them. Consider how poverty and abuse contribute to women's drug use. Examine the role of women in drug sales. Be prepared to discuss your research in class.

3. Use the Internet to investigate the impact of the War on Drugs on the incarceration of women. You may want to search drug policy organizations such as the Drug Policy Alliance (http://www.drugpolicy.org), prison advocacy groups such as Prison Activists (http://prisonactivist.org), and human rights groups such as Amnesty International (http://www.amnestyusa.org) or Human Rights Watch (http://hrw.org).

4. Complete an Internet search using the search terms "international drug policies." One possible site is "Drug War Facts—International Facts, Policies and Trends: Data from Various Nations," (http://www.drugwarfacts.org/internat.htm). You might also want to try the site for European Drug Policies: European Monitoring Center on Drugs and Drug Addiction (http://www.emcdda.org). Compare and contrast the drug policies of the United States and other western industrialized nations. Share your findings with the class.

C. Discussion Questions

1. Discuss the factors that have contributed to the rising number of women prisoners.

2. Classroom Debate: "Drug use is a criminal justice problem that requires punishment," or "Drug addiction is a disease that should be treated".

3. The War on Drugs targeted street-level drugs—crack, cocaine, and heroin. Moreover, crack was one of the least-used of all the illicit drugs in the United States, and more whites used illicit drugs than blacks. Still, the War on Drugs targeted the sale and possession of crack cocaine by blacks. Additionally, the penalties for individuals involved with crack-related offenses are much harsher than for individuals that are involved with powdered cocaine offenses. Discuss how the politics of race, class, and gender guided the direction of the War on Drugs toward poor communities of color and their residents.

The Use of Statistics to Demonstrate Trends in Women's Imprisonment

Statistics are used to document the increasing rates of women's imprisonment; to demonstrate that convictions for drug felonies has been the main catalyst behind this increase, and to show that women of color represent a disproportionate share of women sentenced to prison for a drug offense. These statistics also provide a social and demographic profile of incarcerated women, and can be used to compare the profile of incarcerated women with that of incarcerated men. These differences are significant due to the gender-specific needs of imprisoned women (see Koons et al., 1997; Acoca, 1998; Allard, 2002; Hirsch, 2002). National statistics, as well as statistics from the Departments of Corrections of individual states, can be used for these purposes.

The most important source of summary information on the incarcerated population is produced by the Bureau of Justice Statistics in the United States Department of Justice (http://www.ojp.usdoj.gov/ bjs). Instructors should obtain the special report on Women Offenders produced by the Bureau of Justice Statistics (Greenfeld & Snell, 1999) that is included in the reading list at the end of this article (see also assignment number one below). Of course, data from independent researchers can also be used to show trends in women's imprisonment (see for example, Bush-Baskette, 1998; Mauer et al., 1999).

Women in prison share many of the same characteristics as their male counterparts; they are generally young, single, poor, persons of color, with substance-abuse problems, limited education, vocational skills, and job experience. Nevertheless, they also differ from their male counterparts in significant ways. Women primarily commit nonviolent drug and property offenses, are mothers, and have histories of trauma and abuse. Additionally, adult women confined in state and federal prisons generally have more emotional, psychological, medical, and substance-abuse problems than their male counterparts. And today, an increasing percentage of imprisoned women are pregnant at admittance and/or HIV-positive (see Acoca, 1998; Hirsch, 1999; Allard, 2002). Given the problematic personal histories of imprisoned women, the lack of available treatment programs and services within the prison environment is detrimental to the women's well being.

A. Essential Terms and Concepts

Abuse, Gender-specific needs of imprisoned women, Trauma

B. Assignments and Research Projects

1. Have students visit the website of the Bureau of Justice Statistics and review the report on women offenders (http://www.ojp. usdoj.gov/bjs/pub/pdf/wo.pdf). Ask them to create a social and demographic profile of women behind bars, and to compare this profile with a profile of incarcerated men.

2. Ask students to go to the website of Human Rights Watch and access their report on "Punishment and Prejudice: Racial Disparities in the War on Drugs" (http://www.hrw.org/reports/2000/usa/ Rcedrg00-05.htm). Have them read the sections of the report on "Racially Disproportionate Drug Arrests," and "Women, Race, Drugs, and Imprisonment," and report what they learn to the class.

3. Classroom Debate. "Should pregnant women be incarcerated"?

4. Read the following article:

Acoca, Leslie. 1998. "Defusing the time bomb: Understanding and meeting the growing health care needs of incarcerated women in America." Crime and Delinquency 44, 49-69.

Given the mental and physical health needs of women, do you think their needs can be adequately met in the prison environment? Be prepared to discuss your opinion in class.

C. Discussion Questions

1. Discuss trends in women's imprisonment from the mid 1980s to the present. How do these changes compare to changes in the male incarceration rate?

2. Given the needs of women prisoners, discuss whether you think their needs can be adequately met in the prison environment.

3. Discuss the social impact of the War on Drugs on communities of color?

The Criminal and Civil Consequences of a Felony Drug Conviction

In addition to a prison sentence as punishment for a drug felony conviction, poor women of color will have to endure the ancillary or collateral consequences of their imprisonment—the civil consequences that stem from having a criminal record (see Hirsch, 1999; Allard, 2002; Hirsch, 2002; Mauer & Chesney-Lind, 2002; Travis, 2002; Petersilia, 2003). Jeremy Travis (2002) has termed these collateral consequences "invisible punishments," "the laws and regulations that serve to diminish the rights and privileges of those convicted of

crimes" (p. 16). The ancillary or collateral consequences of impris-
onment punish not only individuals but their children, families, and
communities as well, and have a tendency to punish ex-offenders
long after their sentences are completed.

Some consequences of imprisonment take effect immediately—
such as increased social control, the separation of mothers from their
children, inadequate prison programs and services, and the expo-
sure to prison violence. However, the majority of ancillary conse-
quences result from the legal barriers women face as they attempt to
reintegrate into their communities, including the loss of civil rights,
and the denial of welfare benefits, food stamps, housing, student
loans, and employment (see Hirsch, 1999; Allard, 2002; Richie, 2002;
Rubinstein & Mumakal, 2002; Petersilia, 2003).

As stated above, there are several areas where women's lives are
affected by little-known legislative policies that target convicted drug
felons, including the termination of parental rights, and the denial of
housing, welfare benefits, food stamps, higher education, and
employment. Time constraints will determine how many of these top-
ics can be covered during the course of a semester. A brief explana-
tion of some of the legislative policies that target convicted drug
felons are listed below. Instructors wanting to learn more about any of
these policies are referred to the reading list at the end of this article.

Teachers should stress to students that most prisoners are
released (93%) and will return to their communities (Petersilia,
2003). Hence, government policies that deny ex-offenders certain
rights and privileges are illogical because they impede the prisoner
reentry process. It should also be stressed that because poor women
of color are disproportionately overrepresented among welfare
recipients and among those incarcerated for drug felonies; the Drug
Felony Provision of the Welfare Reform Act has had a disproportion-
ate impact upon them (see Allard, 2002). In fact, education and
housing policies, that target convicted drug felons, are equally dis-
criminatory against poor women of color. The women who need
these services the most (poor, single women with children) are the
least likely to receive them.

A. Essential Terms and Concepts

Collateral consequences of imprisonment, Invisible punish-
ments, Recidivism, Reintegration

Housing Opportunity Program Extension Act of 1996 and the
Quality Housing and Work Responsibility Act of 1998: These Acts

"strengthened the ability of public housing authorities to exclude individuals with drug backgrounds by specifically targeting individuals convicted of drug-related offenses" (Rubinstein & Mumakal 2002).

The Adoption and Safe Families Act of 1997: This Act hastens the termination of parental rights for children who have been in foster care for 15 of the most recent 22 months and bans particular individuals who have criminal convictions for specific offenses (including drug offenses) from becoming foster or adoptive parents.

The Personal Responsibility and Work Opportunity Reconciliation Act of 1996 (the Welfare Reform Act of 1996) and The Felony Drug Provision of the Welfare Reform Act of 1996: Section 115 of this welfare reform act places a lifetime ban on Temporary Assistance to Needy Families (TANF) and food stamp benefits for convicted drug felons

The United States Department of Housing and Urban Development—"one strike and you're out" initiative (1996): This policy allows public housing agencies or Section 8 landlords to evict a tenant or any guest or "other person under the tenant's control" who is involved in "drug-related criminal activity" on or off public housing premises

Higher Education Act (as amended in 1998): This policy states that a student who has been convicted of any offense under state or federal law involving the possession or sale of a controlled dangerous substance is not eligible to receive any grant, loan, or work assistance.

Employment: In several states, a woman's felony conviction subjects her to a lifetime ban from public employment (e.g., working for the county, state, or federal government). Most states prohibit ex-offenders with felony convictions from obtaining licenses or certification in professions traditionally held by women, including child care, nursing, education, social work, dental hygiene, health care, and cutting hair.

B. Assignments and Research Projects

1. Two direct consequences of a prison sentence for inmate mothers include separation from their children and inadequate prison programs and services, including parenting, child visitation, mental health, and substance-abuse-treatment programs. Select one of these areas to research, and report at least five things you learned to the class.

2. Women convicted of drug felonies will be prohibited from col-

lecting welfare benefits and food stamps due to the Felony Drug Provision of the Welfare Reform Act of 1996. Some states have opted out of the welfare ban completely or have modified its enforcement. Find out if your state enforces the ban completely, or partially, by calling or visiting the website of the Department of Health and Human Services. If your state partially enforces the ban, what are the requirements for ex-offenders in order to collect benefits? Report your findings to the class.

3. Read any nonfiction account of your choice on imprisoned women. Write a short paper (no more than five typed double-spaced pages) on the women described in the book. Comment on their social and demographic characteristics as well as their commitment offenses. How do the women described in the book compare to what you have learned in class about imprisoned women?

Book Suggestions:

ACE (AIDS Counseling and Education) Program. 1998. Breaking the Walls of Silence: AIDS and Women in a New York State Maximum-Security Prison. Woodstock, NY: The Overlook Press.

Enos, Sandra. 2001. Mothering from the Inside: Parenting in a Women's Prison. Albany, NY: State University of New York Press.

Lamb, Wally. 2003. Couldn't Keep it to Myself: Wally Lamb and the Women of York Correctional Institution. NY: HarperCollins Publishers.

O'Brien, Patricia. 2001. Making it in the "Free World": Women in Transition from Prison. Albany, NY: State University of New York Press.

C. Discussion Questions

1. Discuss the negative effects of incarceration on mothers, and on their children.

2. Given that the average prison sentence is now 29 months, how will the Adoption and Safe Families Act of 1997 harm women's chances of reuniting with their children?

3. Discuss the negative effects of the felony drug provision on women and on their families. How is this provision biased against poor women of color?

4. How will housing policies impede the transition of women from prison into their communities?

5. How will the Higher Education Act, as amended in 1998, restrict the ability of low-income women to attend college?

6. You can commit rape, aggravated assault, or robbery and still be eligible for welfare benefits and food stamps but if you possess or sell a small quantity of drugs you are prohibited from ever collecting welfare benefits and food stamps. Is it unjust that only convicted drug felons are subjected to the lifetime welfare ban, and not violent offenders?

7. A prison sentence is a direct consequence of a drug felony conviction. Should an ex-offender be subjected to the collateral consequences of a drug felony conviction as well? How might the collateral consequences of a drug felony conviction increase recidivism?

Reforms to Reduce the Harm of a Prison Sentence and to Foster Community Reintegration

Drug policies, as well as other policies that target felony drug offenders have exacted a heavy toll on the well being of women of color, their children, and their communities. Immediate intervention can help to reverse some of these negative effects. Legislators need to re-examine existing sentencing policies that send nonviolent drug offenders to prison for lengthy periods of time. However, until our sentencing policies are changed, reforms need to be implemented that will reduce the harm of a prison sentence and that will foster, not hinder, community reintegration among ex-offenders.

A greater portion of America's Gross National Product now goes to corrections than to education and welfare, and many states are now spending more on prisons than schools (King, 1999). We have created a vast "prison-industrial complex," "which is made up of special political and economic interests that encourage increasing spending on imprisonment, regardless of need" (Petersilia, 2003, p. 237). Women's pathways to criminality are primarily due to their past and/or present trauma and victimization, their poverty status, and their drug addiction. Money should be spent on combating these problems, not on building more prisons for women.

A. Essential Terms and Concepts

Prison-industrial complex, Recidivism, Reforms, Reintegration

B. Assignments and Research Projects

1. The recent literature provides evidence that some treatment programs can work to reduce recidivism, and in the long-run are

more cost-effective than punishment. Read the following article:

Koons, Barbara A., John D. Burrow, Merry Morash, & Tim Bynum. 1997. "Expert and offender perceptions of program elements linked to successful outcomes for incarcerated women," Crime and Delinquency, 43, pp. 512-532.

According to the article, what types of programs for imprisoned women are most successful in reducing recidivism? Report your findings to the class.

2. Develop a policy for reducing the harm of a prison sentence and for fostering community reintegration. Your policy can address all or some of the following areas: treatment programs, educational and vocational programs, parenting programs, barriers that impede reentry for convicted drug offenders, policies that currently lead to the dissolution of families, violence against women and girls, and drug addiction.

C. Discussion Questions

1. Classroom Debate: "Money should be spent on treatment, not punishment."

2. What groups do you think would have a vested interest in prison expansion? Explain why.

3. Why do our tough-on-crime policies fall disproportionately on poor women of color?

Concluding Remarks

Women of color are a disempowered group, and our get-tough-on-crime policies fall disproportionately upon them. Women of color have been victimized by their increasing rates of incarceration as well as by the collateral consequences of their imprisonment. The collateral consequences of a criminal record, and more specifically of a felony drug conviction, are not well known by the public. Perhaps legislators are so cavalier about the harmful effects of these punishments on the powerless because they do not fall upon their own children, families, and communities. It is important to educate students on the negative effects of crime control and social welfare policies that target our most vulnerable citizens. All too often ordinary citizens, including our students, buy into the political rhetoric espoused by politicians and the media about the "dangerous criminal classes," that is, about poor people of color who reside in urban areas. Teaching students about the War on Drugs will help to eradicate the myths

and misconceptions students have about the poor, drug addiction, drug policies, and imprisoned women. Additionally, focusing on the social and economic consequences of a felony drug conviction on the lives of women brings attention to matters that are too often left out of public policy debates.

For students who are interested in learning more about the War on Drugs and are concerned about America's drug policies there are several organizations they can contact or join. The majority of these organizations can be easily accessed through the Internet by using the search terms "drug policy organizations." Following are three such organizations:

> Students for Sensible Drug Policy
> 1623 Connecticut Avenue, NW, 3rd floor,
> Washington, DC 20009
> Phone: 202.293.4414

> Drug Policy Alliance
> 925 15th Street NW, 2nd floor
> Washington, DC 20005
> Phone: 202.216.0035

> DrugSense
> 1425 Culver Drive
> #328
> Irvine, CA 92604-0326
> Phone: 800.266.5759

Reading List

Acoca, Leslie. (1998). "Defusing the Time Bomb: Understanding and Meeting the Growing Health Care Needs of Incarcerated Women in America." Crime and Delinquency 44, 49-69.

Allard, Patricia. (2002). "Life Sentences: Denying Welfare Benefits to Women Convicted of Drug Offenses." Washington, DC: The Sentencing Project.

Bush-Baskette, Stephanie R. (1998). "The War on Drugs as a War Against Black Women." In Susan L. Miller (Ed.), Crime control and women: Feminist implications of criminal justice policy, pp. 113-129. Thousand Oaks, CA: Sage Publications.

Chesney-Lind, Meda. (2002). "Imprisoning Women: The Unintended Victims of Mass Imprisonment." In Marc Mauer & Meda

Chesney-Lind (Eds.), Invisible Punishment: The collateral consequences of mass imprisonment, pp. 79-94. . New York: The New Press.

Chesney-Lind, Meda. (2003). "Reinventing Women's Corrections: Challenges for Contemporary Feminist Criminologists and Practitioners." In Susan F. Sharp (Ed.), The Incarcerated Woman: Rehabilitative programming in women's prisons, pp. 3-14. Englewood Cliffs, NJ: Prentice-Hall.

Greenfeld, Lawrence A., & Tracy L. Snell. (1999). Women Offenders. (special report) Washington, DC: Bureau of Justice Statistics.

Hirsch, Amy E. (1999). "Some Days are Harder than Hard: Welfare Reform and Women with Drug Convictions in Pennsylvania." Washington, DC: Center for Law and Social Policy.

_____. (2002). "Every Door Closed: Barriers Facing Parents with Criminal Records" (Executive Summary). Washington, DC: Center for Law and Public Policy.

Koons, Barbara A., Burrow, John D., Morash, Merry, & Bynum, Tim. (1997). "Expert and Offender Perceptions of Program Elements Linked to Successful Outcomes for Incarcerated Women." Crime and Delinquency, 43, 512-532.

Mauer, Marc, Potler, Cathy, & Wolf, Richard. (1999). Gender and Justice: Women, Drugs, and Sentencing Policy. Washington, DC: The Sentencing Project.

Petersilia, Joan. (2003). When Prisoners Come Home: Parole and Prisoner Reentry. New York: Oxford University Press.

Richie, Beth. (2002). "The Social Impact of Mass Incarceration on Women." In Marc Mauer & Meda Chesney-Lind (Eds.), Invisible Punishment: The collateral consequences of mass imprisonment, pp. 136-149. New York: The New Press.

Rubinstein, Gwen, & Mumakal, Deborah. (2002). "Welfare and Housing—Denial of Benefits to Drug Offenders." In Marc Mauer & Meda Chesney-Lind (Eds.), Invisible Punishment: The collateral consequences of mass imprisonment, pp. 37-49. New York: The New Press.

Travis, Jeremy. 2002. "Invisible Punishment: An Instrument of Social Exclusion." In Marc Mauer & Meda Chesney-Lind (Eds.), Invisible punishment: The collateral consequences of mass imprisonment, pp. 15-36. New York: The New Press.

REFERENCES

ACE (AIDS Counseling and Education) Program. (1998). Breaking the Walls of Silence: AIDS and Women in a New York State Maximum-security

Prison. Woodstock, NY: The Overlook Press.

Acoca, L. (1998). "Defusing the Time Bomb: Understanding and Meeting the Growing Health Care Needs of Incarcerated Women in America." Crime and Delinquency, 44, 49-69.

Allard, P. (2002). "Life Sentences: Denying Welfare Benefits to Women Convicted of Drug Offenses." Washington, DC: The Sentencing Project.

Bush-Baskette, S.R. (1998). "The War on Drugs as a War Against Black Women." In S.L. Miller (Ed.), Crime Control and Women: Feminist Implications of Criminal Justice Policy. Thousand Oaks, CA: Sage Publications.

Chesney-Lind, M. (2002). "Imprisoning Women: The Unintended Victims of Mass Imprisonment." In M. Mauer & M. Chesney-Lind (Eds.), Invisible Punishment: The Collateral Consequences of Mass Imprisonment. pp. 79-94. New York: The New Press.

_____. (2003). "Reinventing Women's Corrections: Challenges for Contemporary Feminist Criminologists and Practitioners," In S.F. Sharp (Ed.), The Incarcerated Woman: Rehabilitative Programming in Women's Prisons. pp. 3-14. Englewood Cliffs, NJ: Prentice-Hall.

Enos, S. (2001). Mothering From the Inside: Parenting in a Woman's Prison. NY: State University of New York Press.

Hirsch, A.E. (1999). "Some Days are Harder than Hard: Welfare Reform and Women with Drug Convictions in Pennsylvania." Washington, DC: Center for Law and Social Policy.

Hirsch, A.E.. (2002). "Every Door Closed: Barriers Facing Parents with Criminal Records" (Executive Summary) Washington, DC: Center for Law and Public Policy.

King, R. (1999). "It's Time to Open the Doors of Our Prisons." Newsweek, p. 19.

Koons, B.A., Burrow, J.D., Morash, M., & Bynum, T. (1997). "Expert and Offender Perceptions of Program Elements Linked to Successful Outcomes for Incarcerated Women." Crime and Delinquency, 43, 512-532.

Lamb, W. (2003). Couldn't Keep it to Myself: Wally Lamb and the Women of York Correctional Institution. New York: HarperCollins.

Mauer, M., Potler, C., & Wolf, R. (1999). Gender and Justice: Women, Drugs, and Sentencing Policy. Washington, DC: The Sentencing Project.

Mauer, M., & Chesney-Lind, M. (2002). "Introduction." In M. Mauer & M. Chesney-Lind (Eds), Invisible Punishment: The Collateral Consequences of Mass Imprisonment. pp. 1-12. New York: The New Press.

O'Brien, P. (2001). Making it in the "Free World": Women in Transition from Prison. New York: State University of New York Press.

Petersilia, J. (2003). When Prisoners Come Home: Parole and Prisoner Reentry. New York: Oxford University Press.

Richie, B. (2002). "The Social Impact of Mass Incarceration on Women." In M. Mauer & M. Chesney-Lind (Eds.), Invisible Punishment: The Collateral Consequences of Mass Imprisonment. New York: The New Press.

Rubinstein, G., & Mumakal, D. (2002). "Welfare and Housing—Denial of Benefits to Drug Offenders." In M. Mauer & M. Chesney-Lind (Eds),

Invisible Punishment: The Collateral Consequences of Mass Imprisonment. pp. 37-49. New York: The New Press.

Shane, S. (June, 2003). "Land of the Free has the Most Behind Bars." The Star-Ledger, p. 1.

Travis, J. (2002). "Invisible Punishment: An Instrument of Social Exclusion." In M. Mauer and M. Chesney-Lind (Eds.), Invisible Punishment: The Collateral Consequences of Mass Imprisonment. pp. 15-36. New York: The New Press.

Marylee Reynolds, PhD, is a professor of sociology and criminal justice at Caldwell College, in Caldwell, New Jersey. Dr. Reynolds developed the criminal justice program at Caldwell College. She teaches a number of specialized courses in sociology and criminal justice, including a course on the criminal justice system and women. She is the author of From Gangs to Gangsters: How American Sociology Organized Crime, 1918 to 1994. *Her research interests include organized crime; the death penalty; women and crime, and race, class, and gender discrimination in the criminal justice system.*

On Teaching Women's Prison Writing: A Feminist Approach to Women, Crime, and Incarceration

Amanda Davis

The overall position of women in our nation's correctional facilities might be described as grim at best. Currently, more than 140,000 women are confined in prisons and jails nationwide, representing a nearly seven-fold increase since 1980. A Bureau of Justice Statistics special report reveals that nearly 1,000,000 women were under the care, custody, or control of correctional agencies in 1998 alone (Greenfeld & Snell, 1999, p. 1). Women now comprise the fastest growing population group entering America's correctional facilities, even though their offenses are predominately nonviolent in nature. With the swift passing of mandatory minimum sentencing laws across many states, a number of recent shifts in law enforcement, and the increasing use of incarceration as a first response to crime, indications are that the rise of female prisoners will be slow to decline. Their growing presence continues to raise critical questions concerning how we best go about approaching and responding to the needs of incarcerated women in our teaching, research, and daily lives. Perhaps never before have these issues been more pressing.

Even though female offenders are now given substantially more focus in academic research than was the case even five or six years ago, they are still underrepresented in most methodological frameworks, policy concerns, and course offerings—a persistent marginalization that seems to mirror in many ways the gender discrepancies present in most correctional facilities. So often deemed deviant and "bad" women, females sentences for crimes are seldom afforded parity in a system of justice they have little power in or access to, and this involves not only how gender affects the writing and administering of laws, but the treatment women receive while incarcerated as well. These disparities are often magnified in the lives of poor women and women of color, and they have a significant impact on their criminalization.

Intersections of race, class, gender, and nationality place poor women and women of color in especially vulnerable positions in the

justice system, in part because they are implicated by representations of minority deviance as well as cultural assumptions regarding womanhood and femininity. They also often lack the material resources that might provide for adequate legal representation or financially secure positions prior to entering prison. Statistics show that the imprisonment percentage for African-American women is almost four times their population proportion, and that African-Americans in general, like other racial and ethnic minorities, are the least likely to receive parole and the most likely to suffer from unfair sentencing practices, meager counsel and representation at hearings, and discriminatory convictions.[1] As a result, these women are often convicted more and sentenced to longer prison terms than their white male and female counterparts. A telling example of this disparity is that nearly two-thirds of women under probation are white, while two-thirds of those confined in local jails and state and federal prisons are minorities (Greenfeld & Snell, 1999, p. 7). These statistics in themselves call for increasing attention to be placed on the relationship between intersections of oppression and criminalization. It is an area deserving of much more scrutiny and analysis, and I hope to see feminist responses to incarcerated women continue to grow in practice and scope.

Women's Prison Writing

Although incarcerated women are sometimes referred to as a silent body, they have actually produced a remarkable number of autobiographical, critical, and creative texts that detail their experiences while imprisoned and the obstacles they often face. This has particularly been the case for many political prisoners, but women's prison writing in general has been present for decades even though it has seldom been widely received. We are fortunate in that several recent anthologies have made this writing more accessible, but we have yet to see this literature widely taught in criminology, literature, or other courses on a national scale.[2] As Judith Scheffler states, "The writing of women prisoners continues to reside in the margins of the literary canon—a curiosity, an anomaly, an oversight" (2000, p. xxxviii). This is a troubling omission, in part because such key questions are raised in prison literature concerning race relations, specific correctional practices, the preservation of relationships, gender roles and realities, work and economic status, and violence against women in multiple forms. While I do feel it is very important to see this work as diverse as the women themselves who wrote and are in the process of writing it,

these are some of the many themes that resound through a number of the texts and help mark it as a body of literature all its own.

I had the unique opportunity to design and teach a course centered on women's prison writing and the overall status of female offenders during the fall of 2001 at the University of Florida, titled "Incarcerated Women: Their Autobiographies and Prison Writings." The course was offered through the Center for Women's Studies and Gender Research, and drew a diverse body of students from nearly ten academic disciplines. While some were attracted to the course because of their interests in corrections or prior coursework in criminology, the majority of students came from other academic disciplines, such as psychology, sociology, journalism, and English. Many wanted to further their knowledge of women's studies, while others had substantially less (if any) exposure to feminist theory, women's studies, or gender research in an academic environment. The class was comprised, then, of a varied body of learners and knowers whose experiences and standpoints contributed to a dynamic classroom environment

In what follows, I describe how I went about designing and teaching the course across these various divides, including the approaches I took in teaching issues I continue to see as central to the overall position of incarcerated women. I have also included my syllabus, a weekly reading schedule, a short description of the assignments I gave students, and a bibliography of articles I assembled in the corresponding course pack. I have kept the overall structure of the course the same, but have changed a few of the readings in order to include recently published material that I feel would substantially add to the course when teaching it again. I also wanted to account for two autobiographies that have sadly gone out of print on the one hand, and several new collections in feminist criminology and women's prison writing that have appeared within the last two years on the other.[3] Since gathering materials across diverse disciplines can be challenging, my hope is that other instructors might find the following useful in creating their own syllabi focused on the important topic of incarcerated women and the texts they have written about their experiences while imprisoned in correctional facilities.[4]

Why Women's Studies?

With the total inmate population now at over two million; a correctional system that is continually plagued by rising recidivism rates, overcrowding, and unprecedented expenditures; and a long history

of racializing criminality that has contributed to the incarceration of more minorities and women than ever before, it is evident that an invigorated critical discourse capable of reaching across disciplinary boundaries is needed.[5] Women's studies, with its focus on the gendered meanings of varied experiences and its increasingly developed theorizations of intersections of race, class, gender, sexuality, and nationality, emerges as a field well-suited to examine many of the issues surrounding incarcerated women. In fact, it is difficult for me to even imagine approaching the position of women in our nation's correctional institutions without foregrounding the importance of these intersections and the effects they have not just on the prison population, but on public policy, public sentiment regarding offenders, and how we best approach teaching about incarcerated women more generally.

Women's studies is well-equipped to approach many of these challenging areas of inquiry, partly because it is interdisciplinary by nature and encourages thorough investigations of how gender informs not only our everyday lives, but our social, economic, and political institutions as well. Its investigations of how race, class, and sexuality are socially constructed and maintained also proves helpful in understanding constructions of deviance and criminality, especially in terms of how these constructions are represented in the public sphere. Women who commit crimes have historically been characterized as those who have departed from their sex, or have otherwise crossed gender divides establishing "appropriate" gendered behavior. As a result of this ideology, women who commit crimes today are often processed as deviant women who have acted against specific codes of conduct. But this is just one area that women's studies might be able to intervene in studies of female offenders and incarcerated women. Its questions concerning how knowledge is produced and received also make it particularly adept to negotiate the diverse terrain of female criminality and what our responses to the crimes women commit, their experiences prior to incarceration, and their incarceration itself could be.

What is a Feminist Approach to Women, Crime, and Incarceration?

One of the first questions many educators ask themselves when thinking about pedagogy is how course goals and objectives can best be achieved so that students can gain a thorough understanding of the breadth, as well as the specificity and the implications, of the material covered. I felt it was especially important to establish how we might

consider women, crime, and incarceration from a feminist approach in this class, not only because I had anticipated a diverse student enrollment, but also because of the physical realities of many incarcerated women's lives. Substance abuse, poverty, unemployment, physical and mental illness, and physical and sexual abuse frequently mark the lives of female offenders—factors that are often treated as inadequacies and seldom helped to any great extent within the prison setting.

Many correctional institutions, for instance, continue to offer vocational programs informed by gendered assumptions about female behavior and workplace potential. Although women who enter prison are normally among the most disadvantaged in terms of educational and vocational training, they seldom learn skills that will aid them in being self-supporting. Instead, they are often trained to focus on traditional, low-paying "feminine" skills, such as food services, sewing, laundry, and, sometimes, clerical work.[6] The few correctional rehabilitation programs that are offered for incarcerated women continue to be narrow in scope and are usually lacking in both intensity and duration. With budget shortfalls, even these programs are in jeopardy of providing services that are sorely needed by many incarcerated women, including mental-health services, addiction treatment, life-skills courses, and abuse counseling.

I held a discussion of feminism and women's studies during the first week of class so that everyone could gain more familiarity with the area, and then went on to describe what I felt a feminist approach to the issues we would be covering in class might entail—an approach drawn both from my research and my experiences teaching in a women's correctional facility. I was fortunate to have the opportunity to teach four classes per week to adult women and juvenile girls at a nearby correctional institution during part of the year prior to teaching this particular course. While I am unauthorized to write about those experiences here as a condition of my employment, teaching "inside" as it is so often called, certainly reinforced the concerns I had explored in my research.

I want here to outline at least the beginnings of a feminist approach to women, crime, and incarceration, an approach that has been advanced by the developing field of feminist criminology. The following list is certainly not meant to be exhaustive; admittedly, the varieties of feminism are vast, as are possible responses to issues surrounding incarcerated women. Yet, I believe detailing potential components of this approach might help establish some of the parameters involved in addressing women, crime and incarceration

from a feminist perspective. This approach would likely include the following:

A) A focus on the particular needs of female offenders, including a focus on such issues as rehabilitation and treatment programs, medical care and gynecological services, access to vocational and educational programs, parental visitation, and sexual abuse/counseling services. This would involve addressing the inequalities that are present between men's and women's institutions and working towards the creation and implementation of programs aimed at building self-sufficiency, self-esteem, better health, educational development, and expanded vocational opportunities. Since many incarcerated women have abused alcohol or drugs prior to their arrest, it would also likely work towards the implementation of drug treatment and support services both in correctional facilities and in communities nationwide.

B) An examination of how one's race, sex, class, nationality, and sexuality impact who is arrested and the sentence and treatment one receives. It would also identify corresponding social oppressions of racism, classism, sexism, and heterosexism as feminist issues. This examination would probe and be conscious of the differences among women, seek to better understand these differences, and be cautious of essentialized frameworks that promote programs and services based solely on the rationale that all incarcerated women have the exact same needs and come to prison from the same set of circumstances. It would also recognize that many women are penalized for representing an image of crime that associates ethnicity and/or poverty with innate criminal behavior or criminal tendencies, and it would work to remedy disparities in sentencing and treatment in regard to race, class, nationality, disability, or any other component of one's identity.

C) A growing dialogue concerning how processes of victimization and criminalization might be, and often are, intertwined for incarcerated women and juvenile girls.[7] This would involve acknowledging that many women are victimized physically, emotionally, verbally, and/or sexually before their incarceration, and working towards the establishment of community shelters, abuse counseling services, safe houses, and residential facilities across the nation so that women and girls can receive help and support regarding their abuse. It would also work to address women's victimization once incarcerated, and would advocate harsher penalties and victim services for those women who are physically violated, sexually harassed, or raped inside prison walls.

D) An analysis of how recent sentencing laws, shifts in law enforcement, and the formation of stringent penalties for drug use and sale have contributed to the rising tide of female offenders, including how they have affected women of color in particular. This would likely involve further investigation into who these laws serve to empower and disempower most, as well as how violations of corporate vs. criminal laws are processed in the legal and justice systems.[8] As a result, a feminist approach to incarceration would likely be skeptical of rising numbers of incarcerated women being explained solely through rapid changes in female criminal behavior, and it would be cognizant of how certain crimes themselves have been sexualized.

E) The profiling, researching, and studying of female offenders through a variety of methodologies. My hope is that this would include the recovery and legitimization of women's prison writings and personal narratives, including their autobiographies, essays, interviews, and creative work. Some of these methodologies are already in place and have contributed to the growing body of feminist research in criminology, while others have yet to be developed or used widely. A feminist approach would likely be skeptical of claims that promote or are drawn strictly from biological essentialism, and it would discourage the notion that biology is destiny. This could also involve additional analyses of how women have been regarded and written about in early criminological research, especially in terms of how traditional assumptions regarding gendered criminality have often been deconstructed and challenged in feminist criminology.

F) A recognition that the physical location of most women's correctional facilities severely limits parental /child contact for those women who have children. A Bureau of Justice Statistics report reveals that women under supervision by justice system agencies were mothers of an estimated 1.3 children under the age of eighteen (Greenfeld & Snell, 1999, p. 1). Thus, a feminist response would likely work to address and implement maternal programming and health initiatives, parental services and support, and prenatal and infant care in the move towards addressing how women and children can best be treated in environments that improve the health and well-being of both.

G) The encouragement of women offenders to become self-sufficient, a response that would likely see the breaking down of women in correctional facilities to be especially problematic. There is a powerful contradiction in society's expectations for women who leave prison to lead productive lives upon their release, and the opportunities to do so that they are usually afforded. A feminist approach to

much more information about the overall status of female offenders than they would have otherwise received. Students voiced on several occasions that they appreciated having this context, and many felt that the articles also contributed to their overall understanding and exploration of the material.

The first section of the course, titled "Women, Crime, and Incarceration: The Criminal Law and Women," examines women's status in the contemporary legal and justice systems as well as how they have been represented in academic research. I began the class with Susanne Davies' and Sandy Cook's "The Sex of Crime and Punishment" (1999), largely because they explore questions concerning how women have been particularly scrutinized and condemned for their offenses and imprisonment, and what some of the consequences of dominant masculine criminological perspectives have been for female offenders. The next essay, "The Criminal Law and Women" (1995), explores how criminal laws operate in the interests of the dominant class, details specific types of laws and theories of crime causation, and argues that the problems women face within the legal system need to be seen in terms of how they are related to broader issues in American life, such as sexism, racism, and capitalism, as they are "reflected in the "organization and administration of the legal system itself" (Sokoloff & Price, 1995, p. 12). Barbara Owen's "Women and Imprisonment in the United States: The Gendered Consequences of the U.S. Imprisonment Binge"(1999), examines the gendered implications of mandatory sentencing laws, the "war on drugs," the changing profile of women in U.S. prisons, and the consequences of imprisonment—work that she continues in large part in "Perspectives on Women in Prison" (2001). Collectively, these articles contest dominant criminological perspectives, situate female offending in terms of wider systematic barriers, and help their readers understand how imprisonment affects women in particular.

Since these readings helped establish additional context for the course, I wanted to then turn to some of the writing incarcerated women themselves have produced—writing that often expands upon and illuminates many of concerns found in the preceding texts. Bruce Franklin's Prison Writing in 20th-Century America (1998) is helpful in establishing a timeline of prison literature and situating its overall development. In addition to contemporary texts by incarcerated women, the collection also includes excerpts written by Agnes Smedley (1920), Kate Richards O'Hare (1921), and other female writers of the early twentieth century that helped students see how women have responded to the evolution of the prison system over time. Excerpts

from No Safe Haven: Stories from Prison (1999) and Women in Prison: Inside the Concrete Womb (1996), attest to the diversity of women's lives prior to and during incarceration, and thus helped students gain a broader awareness of how different women have situated particular experiences surrounding their imprisonment.

We then moved to Jean Harris's They Always Call us Ladies: Stories from Prison (1988), the first full-length autobiography read in class. Students were interested in nearly all aspects of this text, and we had many lively discussions on such issues as freedom, mental illness, prison and values, women and sexual crimes, and the establishment of space, order and routines. Elaine Lord's "A Prison Superintendent's Perspective on Women in Prison" (1995), was also highly useful in the class, largely because she writes about the same institution that Jean Harris was imprisoned at. The article also raises a number of important questions concerning the impact of incarceration on women with children, prior drug abuse, exposure to family violence, differences between male and female inmates and offenders, and our society's fear of crime. Thus, it intersects well with both the autobiographical and the critical texts studied in the first segment of the course.

The second section, "Black Women, Black Nationalism: The Politicization of Prison Culture," largely focuses on women involved in revolutionary struggle during the period of Black Nationalism. I felt it was important to draw attention to this historical period and social movement not only because an upsurge of prison literature was produced during Black Nationalism, but also because the autobiographies of Angela Davis (1988) and Assata Shakur (1987) are two of the only full-length narratives written by women who have been incarcerated that are widely available. This seemed to be a favorite section for many students, in part because the texts themselves are so dynamic. Both Davis and Shakur detail how their political affiliation in various movement organizations affected the nature of their imprisonment, and their texts address such critical areas as gender in revolutionary struggle, racialized representations of criminality and deviance, and routes to activism. Prefacing these texts with readings from the 1970 publication *The Black Woman* and a discussion of various aspects of Black Nationalism, also seemed to help the students situate the texts in terms of broader movements for liberation. Ending the section with Peggy McIntosh's "White Privilege, Color, and Crime: A Personal Account" (2002) offers students another opportunity to address how systems of both privilege and oppression can affect unearned advantages and disadvantages when one comes in

contact with the criminal justice system.

The third section, "Questioning the Justness of our System," builds off of the material covered in the first two sections, but also extends it by focusing on juvenile girls, images of Latino/a criminality and other racialized representations of deviance, stereotypes surrounding Asian Americans, and how our current prison system continues to grow rapidly even though recidivism rates have yet to substantially decline. We also read Joyce Ann Brown's *Justice Denied* (1990) in this section, which details her nine-year imprisonment for a crime she was later found not guilty of committing. Brown's text, like many of the other narratives written by incarcerated women, raises questions about the nature of accountability, individuality, and justice that many students wanted to explore further in their own writing and research. Her story is a powerful testimony of what many innocent individuals must endure when they are falsely convicted for crimes they had no part in, and it poignantly exposes the intersections between gender, class, race and criminalization.

We ended the course by focusing on some of the many poems and prose pieces that incarcerated women have written. The anthology *Doing Time: 25 Years of Prison Writing* (1999) is a collection of writings assembled from PEN's annual writing contest, and structures it contents under such themes as "Time and its Terms," "Routines and Ruptures," "Race, Chance, Change," "Death Row," and "Family." Other readings from *Undoing Time* (2001) and *Wall Tappings* (2002) have been added for when teaching the course again, as they too explore the themes and implications of women's prison writings. Students were also asked to bring in other pieces that they found while doing their own research for their final papers and projects, and many benefited from being exposed to the work they gathered and shared as well.

For their final projects, students had the choice of either writing a research paper on an issue directly pertaining to female offenders or compiling their own anthology of works written by incarcerated women. Students who chose the first option focused on such topics as sexual victimization within correctional facilities, the battered women's syndrome as a legal defense, possibilities for women's rehabilitative programming, and women's roles in political movements. They were asked to have their work supported by at least one full-length autobiography read in class, and to make connections to at least two articles we covered over the course of the semester. The connections they forged helped establish the relationship between critical and autobiographical texts, and encouraged them to think

through issues surrounding incarcerated women with even greater persistency.

Students who wanted to compile their own anthologies chose a number of diverse approaches to do so. One student, for instance, assembled a number of poems written by incarcerated women and paired them with song lyrics written by contemporary female artists that address circumstances surrounding female imprisonment. Another chose to write about poetry written by women on death row and how it responds to and intersects with our nation's notions of justice and accountability. Many students found simply finding this work to be challenging, but that challenge offered them a tangible reminder of how important recognizing and recovering women's prison writings can be. In all, their work reinforced one of the central themes of the course: questions concerning how to best respond to the needs of incarcerated women are not easy to answer, but they are critical ones to evaluate and study.

NOTES

1. See, for example, "Women of Color and the Criminal Justice System" by Coramae Richey Mann, and "Processes of Victimization and Criminalization of Black Women" by Regina Arnold in The Criminal Justice System and Women (1995), 118-135, 136-146 as well as Race to Incarcerate by Marc Mauer and The Sentencing Project (New York: New Press, 1999).

2. Recent anthologies include Wall Tappings: An International Anthology of Women's Prison Writings 200 to the Present, edited by Judith A. Scheffler (2nd Edition, 2002), and Couldn't Keep it to Myself: Testimonies from our Imprisoned Sisters by Wally Lamb and the Women of York Correctional Institution (New York: Harper Collins, 2003).

3. Stranger in Two Worlds (1986) and They Always Call us Ladies: Stories from Prison (1998) by Jean Harris were out of print when I taught the course, as was Justice Denied (1990) by Joyce Ann Brown. At the time of this writing, they are sadly still out of print. Students were able to acquire They Always Call us Ladies from online services that I directed them to, and a local copy center that specializes in course packs was able to make enough copies of Justice Denied for the students. Ideally these books would be widely available, but in the event that they remain out of print, these are options that did not add many additional costs. Recent texts include Images of Color, Images of Crime (Roxbury, 2002), Women, Crime, and Criminal Justice: Original Feminist Readings (Roxbury 2001), and Class, Race, Gender, and Crime (Roxbury, 2001).

4. I welcome instructors and professors to draw from the accompanying readings in devising their own syllabi. Please request permission from

author, however, before duplicating other portions of actual syllabus.

5. A July 2003 Bureau of Justice Statistics Bulletin compiled by Paige Harrison and Allen Beck reports that the United States incarcerated 2,166,260 persons at yearend 2002.

6. See, for example, Barbara Owen's "Women and Imprisonment in the United States: The Gendered Consequences of the U.S. Imprisonment Binge" in Harsh Punishment: International Experiences of Women's Imprisonment (1999, 81-98) as well as Christine Wilson's "Women Offenders: A Population Overlooked" in Higher Education in Prisons: A Contradiction in Terms? (Phoenix: Oryx, 1994, 139-152).

7. See Regina Arnold's "Process of Victimization and Criminalization of Black Women" in The Criminal Justice System and Women (1995, 136-146). She examines how young black women who have fled their homes from abuse—or have otherwise been structurally dislocated from primary social institutions— are often criminalized for such charges as truancy and vagrancy.

8. See, for example, Natalie Sokoloff and Barbara Raffel Price's "The Criminal Law and Women" in The Criminal Justice System and Women (1995, 11-29).

REFERENCES

Greenfeld, L., & Snell, T. (1999) "Women Offenders." Bureau of Justice Statistics Special Report (December), 1-15.

Harrison, P., & Beck, A. (2003). "Prisoners in 2002." Bureau of Justice Statistics Bulletin (July), 1-12.

Jamison, R. (1999). America's One-Million Nonviolent Prisoners. Center on Juvenile and Criminal Justice. May 2003 <http://www.cjcj.org>.

Scheffler, J. (Ed.). Wall Tappings: An International Anthology of Women's Prison Writings 200 to the Present (2nd Ed). New York: Feminist Press.

Sokoloff, N., & Price, B.R. "The Criminal Law and Women." In B. Raffel Price and N.J. Sokoloff (Eds), The Criminal Justice System and Women: Offenders, Victims, and Workers (2nd Ed.): pp. 11-29. New York: McGraw-Hill, 1995.

WST 3930 - Incarcerated Women: Their Autobiographies and Prison Writings

Course Description

In this class we will focus on what literary scholar Bruce H. Franklin has named one of the most extraordinary achievements of the 20th Century: the literature that has come from our nation's prisons. Here, we will concentrate primarily on longer narratives that have been written in or about prison by women, but we will also read a selection of their shorter narratives and creative work that can be

found in prison literary magazines and edited collections—writing that is particularly diverse in nature and scope. A significant amount of time will also be spent addressing the overall status of women incarcerated in U.S. correctional facilities. The course will be interdisciplinary in nature, and informed by some of the more recent feminist and critical scholarship emerging in criminology and gender studies today.

Although women have long been marginalized both in the discourse of crime and incarceration and in the practice of corrections, their rapidly increasing numbers (now exceeding the growth rates of men) have become one of the recent phenomena of our time, raising key questions concerning our nation's practice of corrections. Several of the most central issues generating discussion today in the field—racism, the body, medical care, access to vocational and educational programs, parental rights, the effects of mandatory sentencing, and the politicization of prison culture—are to be found in most of the texts under study here. We will read each text in conjunction with recent discussions that focus specifically on female offenders and the historical and political contexts under which these texts were produced. Doing so will help foster a better understanding of not only the social climate these narratives were written in and about, but also how they have been constructed.

We will also examine how this writing makes significant contributions to not just how we might think about the justice system, but world culture in general. Although many are familiar with seminal texts like the The Autobiography of Malcolm X, women's prison writing and incarcerated women more generally have received considerably less attention. Their testimonies, however, act as critical accounts of how our nation punishes its people and speak to a host of wider issues as they surface in larger society. The questions raised in these texts about race relations, justice, sexual identity, capitalist society, nationality, and gender roles (among others) make this literature extraordinary indeed.

Texts

Brown, Joyce Ann. Justice Denied. Chicago: Noble Press, 1990.
Chevigny, Bell Gale, ed. Doing Time: 25 Years of Prison Writing. New York: Arcade, 1999.
Davis, Angela. An Autobiography. 1974. New York: International Publishers, 1988.

Franklin, Bruce. (Ed.) Prison Writing in 20th-Century America. New York: Penguin, 1998.

Harris, Jean. They Always Call us Ladies: Stories from Prison. New York: Kensington, 1988.

Shakur, Assata. An Autobiography. Chicago: Lawrence Hill Books, 1987.

Course Pack of selected readings

Daily Schedule for WST 3930
Women, Crime, and Justice: The Criminal Law and Women

Week 1:

(M) Course overview
(W) Discussion on feminism and women's studies
(F) What is a Feminist Approach to Women, Crime and Incarceration? (discussion)

Week 2:

(M) "The Sex of Crime and Punishment" (course pack)
(W) "The Criminal Law and Women" (course pack)
(F) "Perspectives on Women in Prison" and "Women and Imprisonment in the United States: The Gendered Consequences of the U.S. Imprisonment Binge" (course pack)

Week 3:

(M) Introduction and Foreword to Prison Writing in 20th Century America
(W) Selections from Prison Writing in 20th Century America: "Cell Mates," from Crime and Criminals, "In Santa Cruz," and "The Gone One"
(F) Continued selections from Prison Writing in 20th Century America: "The Bus Ride," "Sing Soft, Sing Loud," and from Notes from the Country Club

Week 4:

(M) "Women's Pathways to Felony Court: Feminist Theories of Lawbreaking and Problems of Representation" (course pack)
(W) Selections from No Safe Haven: Stories of Women in Prison (course pack)

(F) Selections from Women in Prison: Inside the Concrete Womb
 (course pack)

Week 5:

(M) Begin Harris' They Always Call us Ladies and "A Prison Super-
 intendent's Perspective on Women in Prison" (course pack).
(W) Continue They Always Call us Ladies
(F) Continue They Always Call us Ladies.

Week 6:

(M) Finish They Always Call us Ladies
(W) "Feminine Fortresses: Woman-Centered Prison" (course pack)
(F) Excerpt from Laughing in the Dark: From Colored Girl to
 Woman of Color: A Journey from Prison to Power (course pack)
 Black Women, Black Nationalism: The Politicization of Prison
 Culture

Week 7:

(M) "Processes of Victimization and Criminalization of Black
 Women" (course pack)
(W) Discussion on Black Nationalism
(F) Preface to The Black Woman, "Who Will Revere the Black
 Woman?" and "On the Issue of Roles" (course pack)

Week 8:

(M) Begin Angela Davis' An Autobiography
(W) Continue Davis' An Autobiography
(F) Continue Davis' An Autobiography

Week 9:

(M) Finish Davis' An Autobiography
(W) Discussion and Brainstorming session on Final Project
(F) Begin Assata Shakur's Assata: An Autobiography

Week 10:

(M) Continue Shakur's An Autobiography
(W) Finish Shakur's An Autobiography

(F) "White Privilege, Color, and Crime: A Personal Account" (course pack)
 Questioning the Justness of our System

Week 11:

(M) "Out of Sight, Out of Mind: Girls in the Juvenile Justice System"(course pack)
(W) Begin Joyce Ann Brown's Justice Denied
(F) Continue Justice Denied

Week 12:

(M) Continue Justice Denied
(W) Finish Justice Denied
(F) "Latinos and Latinas: The Color of Skin is the Color of Crime" (course pack)

Week 13:

(M) "Asian Americans and the Black-White Paradigms" (course pack)
(W) "Gender Troubles: The Entanglement of Agency, Violence, and Law in the Lives of Women in Prostitution" (course pack)
(F) "Prisons: A Paradigm of Failure" (course pack)
Creative Sampling: Poems and Prose by Incarcerated Women

Week 14:

(M) Foreword, introduction, and section entries to Doing Time: 25 Years of Prison Writing
(W) Selections from Doing Time: "Arrival," "Where or When," "After Lights Out," "The Red Dress," and "Our Skirt" (course pack)
(F) Selections from Doing Time: "For Mumia: I Wonder," "Easy to Kill," "Write a Poem that Makes no Sense," and "After my Arrest" (course pack).

Week 15:

(M) Selections from Undoing Time: American Prisoners in Their Own Words: Forward by Jimmy Santiago Baca and "Freedom from Within" (course pack)

(W) Selections from Wall Tappings: Poetry by Carolyn Baxter, Barbara Saunders, and Diane Hamill Metzger (course pack)
(F) Last class. Final projects due.

Course Pack Bibliography

Davies, Susanne and Sandy Cook. "The Sex of Crime and Punishment." Harsh Punishment: International Experiences of Women's Imprisonment. Eds. Susanne
Davies and Sandy Cook. Boston: Northeastern University Press, 1999. 53-78.

Sokoloff, Natalie and Barbara Raffel Price. "The Criminal Law and Women." The Criminal Justice System and Women: Offenders, Victims, and Workers. Eds. Barbara Raffel Price and Natalie J. Sokoloff. 2nd ed. New York: McGraw-Hill, 1995. 11-29.

Owen, Barbara. "Perspectives on Women in Prison." Women, Crime, and Criminal Justice: Original Feminist Readings. Eds. Claire M. Renzetti and Lynne Goodstein. Los Angeles: Roxbury, 2001. 243-254.

———. "Women and Imprisonment in the United States: The Gendered Consequences of the U.S. Imprisonment Binge." Harsh Punishment: International Experiences of Women's Imprisonment. 1999. 81-98.

Daly, Kathleen. "Women's Pathways to Felony Court: Feminist Theories of Lawbreaking and Problems of Representation." Criminology at the Crossroads: Feminist Readings in Crime and Justice. Eds. Kathleen Daly and Lisa Maher. New York: Oxford UP, 1998. 135-156.

Girshick, Lori B. No Safe Haven: Stories of Women in Prison. Boston: Northeastern UP, 1999.

Watterson, Kathryn. Women in Prison: Inside the Concrete Womb. 2nd ed. Boston: Northeastern University Press, 1996. 147-171.

Lord, Elaine. "A Prison Superintendent's Perspective on Women in Prison. The Prison Journal 75,2 (1995): 257-269.

Hannah-Moffat, Kelly. "Feminine Fortresses: Woman-Centered Prisons?" The Prison Journal 75,2 (1995): 135-164.

Gaines, Patrice. Laughing in the Dark: From Colored Girl to Woman of Color – A Journey from Prison to Power. New York: Doubleday, 1994. 106-129

Arnold, Regina. "Processes of Victimization and Criminalization of Black Women." The Criminal Justice System and Women. 1995. 136-146.

Bambara, Toni Cade. Preface. The Black Woman: An Anthology. Ed. Toni Cade. New York: Mentor, 1970. 7-12.

Lincoln, Abbey. "Who Will Revere the Black Woman?" The Black
 Woman: An Anthology. 1970. 80-84.
Beale, Frances. "Double Jeopardy: To Be Black and Female." The
 Black Woman: An Anthology. 1970. 90-100.
Bambara, Toni Cade. "On the Issue of Roles." The Black Woman: An
 Anthology. 1970. 101-110.
McIntosh, Peggy. "White Privilege, Color, and Crime: A Personal
 Account." Images of Color, Images of Crime. 2nd ed. Eds. Cora-
 mae Richey Mann and Marjorie S. Zatz. Los Angeles: Roxbury,
 2002. 45-54.
Chesney-Lind, Meda. "Out of Sight, Out of Mind: Girls in the Juve-
 nile Justice System." Women, Crime, and Criminal Justice: Origi-
 nal Feminist Readings. 2001. 27-43.
Rodriguez, Luis. "Latinos and Latinas: The Color of Skin is the Color
 of Crime." Images of Color, Images of Crime. 2nd ed. Los Angeles:
 Roxbury, 2002. 33-37.
Kim, BongHwan. "Asian Americans and the Black-White Paradigms."
 Images of Color, Images of Crime. 2002. 153-158.
Sanchez, Lisa. "Gender Troubles: The Entanglement of Agency, Vio-
 lence, and Law in the Lives of Women in Prostitution." Women,
 Crime and Criminal Justice: Original Feminist Readings. 2001. 60-76.
Watterson, Kathryn. "Prisons: A Paradigm of Failure." Women in
 Prison: Inside the Concrete Womb. 1996. 335-354.
Baca, Jimmy Santiago. Foreword. Undoing Time: American Prison-
 ers in Their Own Words. Boston: Northeastern UP, 2001. ix-xii.
Howard, Jennifer. "Freedom from Within." Undoing Time. 2001.
 198-206.
Baxter, Carolyn. "On Being Counted." Wall Tappings: An Interna-
 tional Anthology of Women's Prison Writings 200 to the Present.
 2nd edition. Ed. Judith A. Scheffler. New York: Feminist Press,
 2002. 109-110.
Saunders, Barbara. "The Grievance." Wall Tappings. 2002. 112.
——. "A Life Worth Living." Wall Tappings. 2002. 113-114.
Metzger, Diane Hamill. "Panoptiocon." Wall Tappings. 2002. 116.

Amanda Davis is currently working on a dissertation focused on
autobiographical texts written by incarcerated women. She is a Ph.D.
candidate in the Department of English at the University of Florida, where
she teaches courses through the Center for Women's Studies and Gender
Research. Her research interests include women's autobiography, prison
writing, feminist theory, and literature and theory by women of color.

In My World

Yomaira Ramos

in my world
people die on the street
sell drugs
to make money for their kids and families
steal cars to go places
and shoot up their space
they pawn their mother's jewelry
and blame it on the kids
in my world
life's a bitch
I can't even buy me a fifty-cent soda
without getting stripped
raped and hurt
babies and more
complications
no remorse
trouble in school
trouble on the street
that's why I'm in a facility
moms aren't there
fathers disappear
I hear this bullshit
that he does crack
can't get on the right track
well what about me
and all my needs
my hurt, my tears?
people who left me?
what about my world?
I can't enjoy
I lived it
fucked it
made sure I had fun
in my world
I played some cards
that tell me my future

and when I saw my life
it was full of confusion
manipulations and more

that's what's inside
my world

Yomaira Ramos *is sixteen. She entered "the system" at age eleven and has been on probation, in detention, day programs, and residential treatment since then. Her mother was thirteen when she gave birth to Yomaira, and her sister birthed a baby at age twelve. She is a resilient, strong, talented young woman and has a wonderful sense of humor. This is her first published work.*

We Few Teachers

Patricia Roth Schwartz

"a poem should always have birds in it"–Mary Oliver

In the maximum-security prison in Auburn, New York,
as we walk, escorted by crisp-shirted stiff-faced guards,
belted-on radios crackling, from the main building
through the floodlit yard past the raucous steep
cellblocks, the rambling stands of workshops, motor pool, kitchens,
to the school, underutilized now, of course
since the government decided our tax dollars
better spent on "collateral damage," more jails,
where we few teachers now volunteer, I watch
sparrow after small sparrow dart and hop,
perch, peck, fly, brazenly oblivious
to the sheer concrete, the coiled razor wire,
the bulge-eyed armored heads of the towers
like giant lizards looming above us
ready to pounce.

Patricia Roth Schwartz *is a poet, fiction writer, teacher, and herbalist,
who lives on her 35-acre property, Sage Thyme Haven, in New York's Finger
Lakes. Her work is widely published in small press journals. She has been
facilitating a poetry workshop in Auburn Correctional Facility, a maximum
security prison, for three years. Currently she is writing a full-length manu-
script of poems about the history of Auburn Prison from 1821 on, to be per-
formed in Rochester, NY as a readers' theater in November 2004.*

Prison Visit

Ruth Marie Nolan

I worried about the finger searches
the guards made up your ass
while I sat quietly on hot hemorrhoids
in the smoky visitor's room,
helping you write the list
of gifts I was to bring:

chocolate chip cookies,
black ballpoint pens,
blank letter-writing stationary,
tiny exacto knife tip blades
hidden beneath my long fingernails
that you could exchange
for a carton of cigarettes.

The TV was too loud,
stuck on some old rerun,
and all the guys turned to stare
as you jammed my hands
between your legs,
saying you had a present for me.

I left reluctantly
through four sets of iron doors,
wearing borrowed polyester,
feeling I'd made the evening news.
My hair stank of Marlboros,
and I was sad about the years
you'd be locked up in blue
for shooting your best friend dead,

and all the while,
your unborn baby
kicked and stretched inside me,
A red volcano ready to erupt,

a hot bullet ricocheting
through the chambers
of my hollow heart.

Ruth Marie Nolan *is an Associate Professor of English at College of the Desert. She is the author of "Wild Wash Road," a poetry collection. Her poems have also appeared in Pacific Review, Dry Ground, and Dialogue Through Poetry, 2003 & 2004. Her poetry has been shaped by her years of life in the Mojave Desert, along with "a series of whitewater-river type adventures." She currently lives in Palm Desert, CA, with her fifteen-year-old daughter.*

Women Writers' Workshop (for L.K.)

Tara Betts

I had to stop my heart
when the gate swung open
so I could display identification
walk past cyclone wire and 20-foot fences
step around duck shit while
watching ducks flit and sputter on the moat
stretched along the length of fence
I approached every week
This routine
This perimeter

Inside the grip of brick and steel
chokes a teeming mass of women
Cook County Jail
where even heat stifles

I meet women in classrooms
with slits for windows
Some posters encourage them to read
another outlines the 12-step program
Rules posted everywhere

These women share stories
crafted and emptied on hoarded paper
with coveted pens

Women who know what it means to trade your body for hunger
Women who was tryin to feed they babies
Women who stabbed their man
because they couldn't stand his fist drumming
on their faces again

Women who just got they G.E.D.
Women who be mothers
Women who be girlfriends and wives

Women who want grilled cheese sandwiches
so they press bread on lights overhead

Women who stumble over words they read
who show each other how to say the words
who fill me up with their laughter
who gossip about who did what on the tier
Women who have a wife on the tier
Women who write letters to the boyfriend
whose name is tattooed on their neck
Women that you don't ask why they're here
Women who await court dates so they kick
through doors
like blaxploitation flick heroines and hermanas de la raza

So I stop my heartbeat when I see myself in what these women do.
My pulse slows down to death inside
because I want them to follow me
out these doors, these gates
past the ducks
So they can sleep in beds with sheets they chose
have the luxury of spending
too much time and money at the diner
they can walk to when they feel like it

Knowing the wind itself affirms
they are beautiful, intelligent, capable
as polished steel bent to architectural perfection
despite what statistics say
in spite of who touched them in unhealed memory
despite arms that should have held them gently

These women rip beating, veined flesh from their chests
Consider me worthy to look it over and give them advice
when they have taught me to be humble

As a tribute for their sacrifice
a shield that dams my tears
I stop my heart from beating
for a moment.

Tara Betts *is a writer, educator, and performer who has taught writing workshops at Cook County Jail and Cook County Juvenile Detention Center. She is an advocate against the prison industrial complex. Her work appears in Bum Rush the Page, Poetry Slam, Spoken Word Revolution, ROLE CALL, and HBO's Def Poetry Jam. Her website is www.tarabetts.net.*

Writing Is

Barrilee Gispert Bannister

Writing is a way to pass time, to escape
the confines of prison, and the debili
-tating ailments of prison life. If I can
write about what happens in my world,
and about what I am surrounded by on
a daily basis-I can in some way put on
my boxing gloves and enter the rink,
and in many ways fight and win-be
cause writing helps to life the reluc-
tance to attack-the corruption, decep-
tion, disorder, intimidation, oppres-
sion and violence that not only plagues
the prison system, but a lot of other
things on this planet, and inside my
mind. It is a way to free myself, and
share with others my thoughts; opin-
ions; ideas; likes; and dislikes et cetra.
Writing to me-is freedom, like that of
a bald eagle soaring high in the sky.

*Barrilee Gispert Bannister is a 29-year-old devoted wife and mother who
has been incarcerated in the state of Oregon since May of 1995 under
Oregon's unjust mandatory minimum law "Measure 11" for first-time
offenders. While incarcerated, she has had first-hand experience with the
autocracies within the prison system, against which she actively protests in
order to end prisoner abuse and rape by prisoner officials. She is currently
working on a book about her experiences in prison which is due to be
published upon her release.*

This Body Of a Crime

Rob K. Baum

I was afraid
I was alone
Hereafter I will always be afraid & alone
When the darkness
when the silence
when the human nature
of an approaching shadow
tears my heart into jagged pieces
to cut my teeth

In the language of cases & rules
I am neatly transcribed
tucked in sweet dreams
amid the files

Fear gives me significance
already I am textbook material
held down against the sheets
my flesh curling back
again the winds of anger disbelief & shame

They call me a rape
but I say it was done to me
I have a name
my own body apart from this one

I am the body of a crime
discovered by the league of men
fingers greedily probing the innermost
but despite all this
I still think I am more
woman than statistic

You want bruises
the smell of flesh on record
a fracture to knit in the folder

wounds for release
You want hysteria
my bleary face in profile
& perhaps missing buttons too
mysterious threads
slithering & unravelling in your drawer

& yes I fought
& no I did not fight
There was a gun
there was a knife
or there was no weapon but fear & betrayal
the damned inequity of my own genetics

Your inferences are obvious
& insulting
Your concern is admirable
especially on paper
& those pills which make me sick
develop human guppies
another medical victory

You will ask for blood
& I will give you more
more blood more answers
more bloody answers
until everyone is satisfied
I will nourish myself on memory
too vivid
even for cross reference

I am your rape
but I have a name
a body apart from this one
plundered
for its remaining loot

The crime is yours

Rob K. Baum *answered rape crisis hotlines in California and advocated for battered women and children in the Arctic. Rob writes poetry for print*

and performance, and plays with strong, desirable roles for women, especially
lesbians. A movement practitioner at Monash University (Australia), Rob's
research includes gender and performance theory, Holocaust studies, and
feminist phenomenology (subject of her book Female Absence: Women, Theatre
and Other Metaphors).

Field Trip

Sharon L. Charde

The guard wanted us to line up in twos
saying It's easier to see bad things happening
that way. We shivered in the late March air
coatless, walking on the prison pathways
to our first event. Cinder block—women
in handcuffs shuffling to other places
in this monstrous compound, each with their
very own guard. Our women were waiting,
all seven— Jennifer, Juanita, Jillian, Brenda,
Sue, Lisa, and Tabatha—in green plastic chairs,
the kind you would put out on a summer patio.
They had formed a halfmoon, and we set up
the other half carefully away from theirs, though
I would have gone closer if I could. Their eyes
never left us, we were their recreation today,
their break from lock down.

I settled into my molded chair, the girls fanning
out from me into a dark half-circle. The stories begin—
the stories I can't get enough of—Jennifer's baby born here,
her in shackles, Tabatha's children seen only through
the thick glass of the segregation cell for years. She worries
that they're on crack now without her. Brenda slouches
towards us—Huh, my gang—I'd take a bullet for them but
where are they when you're in here? she glared hard at the girls—
No where, she said. Jillian's eyes snapped each one naked,
she sneered, One guard to 76 of us, so we take what we want
when you're younger, weaker; they sell roommates
here for rape, to do your laundry. Juanita, a big woman
in for murder, tells of 24/7, years of it, meals shoved
through slots in the door. Sue, her blonde hair pulled
high off her narrow face, prison uniform loose on her
lanky frame, shares selling herself, being beaten, broken,
high on heroin. Lisa says, There's no comfort here.

I don't want them to stop, I want to stay here,

eat with these sisters, share their cells, their touch.
I am home
safe in the house of my childhood, in its long narrow hall ,
all the doors slammed shut.

Sharon L. Charde *is a psychotherapist and writing teacher who has been published in many journals and several anthologies, and has won a number of awards for her poems. She has also edited and published a chapbook,* I Am Not A Juvenile Delinquent, *the product of her weekly writing workshop at Touchstone, a residential facility for adjudicated teen aged girls in Litchfield, CT. Sharon lives in Lakeville, CT, with her husband of 40 years.*

Don Sabo, Terry A. Kupers, and Willie London's *Prison Masculinities*

Jason L. Mallory

The U.S. prison system has long been critiqued for its perpetuation of racism and classism, but only relatively recently has the "Prison Industrial Complex" begun to be widely regarded as a patriarchal institution responsible for reproducing sexism, homophobia, and violence against women. *Prison Masculinities* echoes the emerging sentiment among theorists and activists that imprisonment must be understood as an issue with important dimensions of gender and sexuality. Among the more than two million people currently incarcerated in the U.S.—a country with the highest incarceration rate in the world—the vast majority of prisoners (92%) are men, most of whom are poor men of color. The contributors to this anthology are composed of people with a wide variety of experiences with incarceration, such as prisoners, former prisoners, a philosopher, a psychiatrist, a sociologist, attorneys, a political scientist, and prison educators. While they each present their own unique perspective on the prison crisis, they all argue that the growing phenomenon of mass incarceration cannot be fully understood and critiqued without examining how masculinity functions both behind bars and in society as a whole.

In the introductory essay, the editors begin by problematizing ordinary notions about male gender identity and expression. They argue that the logic of the most dominant form of masculinity in the U.S., "hegemonic masculinity" (p. 5), is inherently anti-feminine (and, by extension, anti-woman and anti-gay). Hegemonic masculinity dictates that to "display weakness is unmanly" (p. 12), men must not "do anything that will make other [people] think you are gay, effeminate, or a sissy" (p. 10), and men must always "be ready to fight, especially when your manhood is challenged, and act as if you do not mind hurting or even killing someone" (p. 11). Using variations of this masculine ideal as a touchstone in all areas of life, men then employ these gender expectations to rank themselves in relation to other men and women. It should not be surprising, therefore, that male prisons, as any other intensely homosocial institution, manifest and reproduce some of the most extreme effects of society's patriarchal male socialization.

After these basic premises about feminist theories of masculinity have been articulated, the essays that follow provide the theoretical and practical bases for a radical and comprehensive critique of institutions of male imprisonment. An essay by the late Stephen Donaldson, the first male survivor of prisoner-on-prisoner rape to come forward publicly, is one of the best examples of integrating feminist theories with the lived experience of imprisonment. He describes how stressful, overcrowded prison conditions combined with overt racism and patriarchal status hierarchies create fertile ground for rape and other forms of prison violence. Since U.S. prisons, according to Donaldson, are "the most sexist (and racist) environments in the country, bar none" (p. 118), men in prison are likely to become more violent, racist, and sexist while incarcerated. This possibility is especially disturbing in light of the fact that 75% of men entering prison for the first time are convicted of nonviolent crimes (p. 8). James W. Messerschmidt argues that for many under-privileged men "crime may serve as a suitable resource for showing that they are 'manly'" (p. 68), so forcing men to "accomplish gender" in combative, violent ways while incarcerated only serves to encourage the types of anti-social acts that may have contributed to criminal behavior before imprisonment.

Several essays describe, often in graphic detail, how thousands of young, otherwise nonviolent men are forced to survive in brutal, unsafe prison environments. In such harsh prison conditions, prisoners must often choose between fighting (and sometimes killing) others or succumbing to sexual predation and physical assaults. One particularly moving essay about prison sexual violence, written anonymously and entitled "The Story of a Black Punk," describes the horror and shame that an African American male survivor of prisoner rape experienced as a sexual slave, or "punk," to white rapists. "[The rapist] told the rest of the inmates that I got turned out [i.e. raped] and they beat me badly in front of the other guys," he writes, and then "[h]e topped his beating off by raping me and established my identity. . . as the 'nigger punk'"(p. 129). Psychiatrist Terry A. Kupers argues that, in the hyper-masculine culture of most male prisons, one is "either a 'real man' who subdues and rapes an adversary or he is a 'punk'" (p. 115).

The fact that the U.S. prison system does not prevent, and in some cases may even encourage, the daily humiliation and victimization of the most vulnerable, young, and nonviolent members of male prisons is repeatedly contextualized as a feminist issue. These authors argue that, for feminists who are working to change men and

the oppressive social structures that reproduce patriarchal domination, what takes place in male prisons ought to matter. There are serious social consequences for women when systems of punishment exist that encourage the brutalization of mass numbers of young men and train them to adopt the most violent and predatory forms of masculinity. Prison educator and sociologist Don Sabo suggests that men's "efforts to weave webs of domination through rape and physical intimidation in prison also reflect and reproduce men's domination of women in the social world beyond the walls" (p. 64). In her essay, "The Wall of Silence: Prison Rape and Feminist Politics," Susanne V. Paczensky warns of disastrous social repercussions from training entire generations of young men to behave violently and aggressively in prison. She writes that since "[m]ost of the men who have been brutalized in prison will be released only to act more violently against women and children" (p. 136), it is imperative that the feminist movements begin thinking of all prisoners, not only the growing number of women prisoners, as worthy of support and outreach.

Aside from illuminating the problems of oppressive forms of masculinity and their role in prisons, this volume has the potential to effect significant transformations in how men in prison are perceived by society. *Prison Masculinities* succeeds in dismantling the barriers of stigmatization and stereotypes that all too often separate those behind prison walls from those on the outside. A poem by a woman who simply calls herself "Alice" describes how she carried on a loving relationship with an incarcerated man, even though she was forced to struggle against the social stigma that accompanies anyone who cares about people in prison (pp. 145-147). Angela Y. Davis, one of the most important figures in the contemporary movement in the U.S. to abolish prisons, offers an essay that seeks to deconstruct the racism and classism inherent in discussions concerning male criminality. By interrogating the race, class, and gender dimensions of popular conceptions of "criminal" and "prisoner," Davis provides an explanation as to why African American males can make up almost half of all U.S. prisoners yet constitute less than 7% of the entire U.S. population (p. 35). Her argument is that at least part of the reason why communities of color suffer from the worst effects of incarceration is that "the combined terms 'black' and 'male' have become virtually synonymous with 'criminal' in the popular imagination" (p. 36).

Prison Masculinities, in my view, effectively demonstrates that the issue of men in prison is a pressing feminist issue. For those who research and teach subjects related to theories of masculinity or fem-

inist issues in criminal justice, this anthology will be invaluable as a
rich source of theories and analyses. Similarly, for those working to
abolish and/or reform prisons, this work will be valued for contribut-
ing to a sense of urgency to long-standing demands for social justice
in the prison system. Perhaps most importantly, however, these essays
provide a rare space for humanizing people in prison and rethinking
deeper assumptions about the nature and justification of punish-
ment. By giving a voice to men who have been silenced and stigma-
tized through incarceration, and those who love and support them,
Prison Masculinities provides an opportunity to think critically about
imprisonment in a way that rejects the media hype and oppressive
societal stereotypes about prisoners. Only after challenging the ide-
ologies that support mass incarceration and condone prison violence
is it possible to connect with the real lives and struggles of millions of
women and men that exist at the heart of the U.S. prison crisis.

***Jason L. Mallory** is currently writing a dissertation on the political
justifications of punishment in the Social, Political, Ethical, and Legal
Philosophy program at Binghamton University (SUNY). He can be contacted
at jmallor1@binghamton.edu.*

Elisabeth L. Beattie and Mary Angela Shaughnessy's *Sisters In Pain: Battered Women Fight Back*

Joseph P. Paté

L. Elisabeth Beattie and Mary Angela Shaughnessy give a voice to battered women in their book *Sisters in Pain*. *Sisters in Pain* narrates the accounts of seven women who have experienced years of abuse from the people whom they were suppose to be able to trust; including fathers, husbands, boyfriends, mothers, and aunts. A common thread among all of these women is that they fought back against their abusers and as a result has served time in prison for involvement in their abuser's death. In addition, the similarities and characteristics that are observed in each of the case studies illustrate how the crimes that women commit mirror their lives.

The similarities and characteristics drawn out from *Sisters in Pain* include: women's roles in society, the value of women in society, the response of social institutions to the women, and the women's experiences as victims and survivors. When observing each of the case studies in this book, the reader is able to notice that although each situation is unique, the experiences that these women went through contain many similarities. Perhaps most important are the roles of women in society and also the value that women hold in society.

The roles that society places upon individuals not only shape how people behave, but also how they are treated and valued. In our society one can observe that women are given the roles of mothers, caretakers, and protectors. Furthermore, given that our society is patriarchal, one can conclude that women are seen both as inferior to and dependent on men. The case studies in *Sisters in Pain* demonstrate the reality of these characteristics.

A majority of the women discussed have fulfilled their societal roles of being mothers and as a result they exhibit behaviors that are associated with motherhood. A specific behavior is protecting her children. As their life histories unfold, the reader notices that the women place themselves in the path of their abuser in order to protect her children. For example, Teresa Gulley Hilterbrand states, "If I knew he was going for one of the kids, he'd have to kill me first,

'cause that's when I acted like a maniac. I went for him, [and I said,] 'You ain't touchin' them" (p. 90). Each of the women suffered abuse as a result of protecting their children, a terrible consequence of conforming to the role of mother.

In addition to the roles of women, it is important to recognize how women are valued in society. As stated earlier, women are less valued and are often taught that they need a man to survive. Montilla Seewright "was taught to consider herself nothing without a man" (p. 174). Furthermore, at the end of Sherry Pollard's section, the authors make the comment "what a world . . . wherein female children are still raised to think that they and their dependants can't survive without a man" (p. 59). It is because of these roles and values that society has constructed that women are taught to remain with abusive partners— to remain submissive to their abusers wishes—in order to be a good kid, a good wife, a good mother, or faithful to God.

Although carrying out their social roles limited much of what these women could do to protect themselves from abuse, there were several social institutions that time and again failed to help. Two of these social institutions encountered these women over and over again and appeared to do little, sometimes nothing, to help her escape her situation. They are the police and the hospitals.

Not one of the case studies in this narrative was absent of contact with the police and there were various reasons given by the police for not getting involved. Sherry Pollard's husband was a police officer and when she went to his boss he said that Danny (Sherry's husband) was only going through a phase, just hang in there (p. 43). Karen Stout was told by Military Police that she was raped in the "wrong place" and that her complaint wasn't worth the cost to the government (p. 70). Teresa Gulley Hilterbrand was told that her situation was just a domestic problem and after some sleep it would be all right (p. 89). Sue Melton's husband had many officer friends as a result of being in the National Guard (p. 112). "Law officers continued to ignore what they termed the Marcums' domestic disputes" in Margie's case (p. 124). The police told Tracie English that they couldn't do anything unless they actually saw her father hit her (p. 137). And finally, a friend of Montilla Seewright's husband was able to stop a warrant from being served on him (p. 167).

Even with the police failing to recognize the abuse that these women were suffering, the hospitals also share some blame. Each woman had suffered injuries that needed hospital attention on many occasions, injuries that should have immediately raised a red flag to professionals. However, most of the times the hospital staff treated

the women and released them without any further inquiry. Actions by the hospital and police institutions could have been the saving grace—a saving grace from both more abuse to the woman and/or perhaps even the eventual death of the abuser.

The women also faced many inadequacies of the social institutions after their offense. Some of them were not read their rights, some gave statements under the influence of drugs or alcohol, and others didn't have a lawyer present at the time of arrest or questioning. The lawyers also didn't accurately inform them of plea bargains or charges; they were not allowed to bring up the abuse in court and the juries often were unfavorable. The criminal justice system was not working for the best interest of the accused by any means.

Aside from the roles of women, their value in society, and the response of social institutions, something that is also very important to point out is that these women were victims of abuse for very long periods of time before they actually became offenders themselves. Each women described in *Sisters in Pain* had endured sexual, physical, and mental abuse that originated very early on in their childhood, perhaps limiting their ability to escape the abuse that lingered throughout their adult lives.

It is important to recognize that the "sisters in pain" were all victims, as well as survivors. This lengthy period of victimization would eventually come to a head and result in them becoming offenders. The "sisters" all endured regular abuse and had their lives threatened frequently by their abusers. It is interesting, however, that even though these women feared for their life and put up with extreme pain, none of them actually premeditated a plot to kill their abuser. The actual killing occurred either at the hands of another individual or as a result of instinct or accident. Also interesting is that many of the women feel guilty and/or regret that their abuser was killed.

The crimes that people commit are often reflections of that individual's life. This is true for male and female, all races and ethnic groups, and every social class. The case studies that have been presented in *Sisters in Pain* support this argument; more specifically it supports that women's crimes mirror women's lives. Through observing each case separately as well as collectively, a reader is able to see that the crime that has been committed is a reflection, a mirror image, of their lives.

The lives of the "sisters in pain," Sherry Pollard, Karen Stout, Teresa Gulley Hilterbrand, Sue Melton, Margie Marcum, Tracie English, and Montilla Seewright, have all been shaped by the roles that society has constructed for women, by the value that society has of

women, by their being both victims and survivors, and by the responses of the social institutions. It is safe to conclude that all of these characteristics worked together to create the lives of these women, and ultimately, to the crime that they have been convicted of.

From the case studies, the reader is able to see that the roles that society constructs for women places them in an inferior position, a position that causes a dependency on men. The reader is able to see how society values women, that women need to be a good wife, a good mother, and remain faithful to her vows and to God. The reader can see how our social institutions fail to protect these women, how they dismiss the situation as a family problem that can be slept off, or just another emergency-room patient. And finally, the reader is able to see that the women's experience as a victim is very much a part of her being an offender, that after a certain point one cannot tolerate anymore. These "sisters in pain" are indeed just that, in pain. The experiences that they have undergone will always remain a part of their life. And it is through their voices in this book that this "small group of thoughtful, committed citizens can change the world. Indeed, it is the only thing that ever has" (Beattie and Shaughnessy, 2000, p. xi).

Joseph P. Paté *is currently a graduate student studying Negotiation, Conflict Resolution and Peacebuilding at California State University Dominguez Hills. In addition, he works as an advocate for victims of domestic violence. His current research project was conducted while completing his undergraduate studies in Sociology at State University of New York, Potsdam College, where he was a Departmental Scholar and a member of Alpha Kappa Delta, the International Sociology Honor Society. The current research project examines the argument that women's crimes are often a mirror of women's lives. Paté's research interests are in the area of how race, gender, social status and/or age of an individual affect their experience with the criminal justice system. Following graduation from California State University, he plans to pursue doctoral studies in the area of sociology/ criminology or law.*

Cheryl Miller and Michelle Oberman's *Mothers Who Kill Their Children: Understanding the Acts of Moms From Susan Smith to the "Prom Mom"*

Catherine Cerulli

As I write this review, the national and local newspaper headlines are reporting stories about mothers who have killed their children. The mothers do not fit into a homogeneous group. Rather, their stories are unique, their mental health histories varied and their overtures for help sometimes numerous. *In Mothers Who Kill Their Children*, authors Cheryl Meyer and Michelle Oberman have done a tremendous job in helping readers understand the complexity surrounding mothers who kill their children.

Most recently, in Buffalo, New York, a mother with a mental health history reached out to numerous friends expressing her concerns that she could not care for her child. These pleas for help were left unanswered. Likely, the individuals to whom she reached out never would have predicted the fatal outcome. The police had intervened with the mother moments before she took her daughter's life. Upon their departure, the mother killed her child in a violent manner by slamming her daughter's head on the sidewalk (McDermott, 2004). Perhaps the responding officers did not have the requisite mental health training needed to make a quick assessment. The question that resonates is not why the mother killed her child, but rather what societal infrastructure is missing to prevent this tragedy and others like it?

In Mothers Who Killed Their Children, the authors codify such tragic scenarios into five typologies (filicide related to an ignored pregnancy; abuse-related filicide; filicide due to neglect; assisted/coerced filicide; purposeful filicide and the mother acted alone). They tracked salient variables across cases including the mother's age, child's age and gender, details related to the event itself, histories of domestic violence, mental health, substance abuse, socioeconomic status, and others. Through utilizing electronic search engines to

identify the national sample, the authors identified 219 cases they categorized into the above noted typologies. Prior to discussing their subjects, the authors provide an encapsulated history of filicide demonstrating that societies have long grappled with filicide. "There is every reason to believe that infanticide is as old as human society itself, and that no culture has been immune"(p. 1). However, this historical finding is of no comfort to communities as they grapple to find answers in the face of horrifying filicides.

I reviewed the population of family homicides in a mid-Western state. Of 38 homicides committed by family members, some included parents who killed their children. After reading scores of files, case reviews, autopsies and criminal justice records, I was struck by the complexity of the cases in which mothers killed their children. Interestingly, family homicides were adjudicated more leniently than those cases perpetrated against intimate partners, acquaintances, or strangers. Although outraged by these deaths, the criminal justice system professionals must utilize their state's murder statutes, which in this state require "intent". In such homicides against children, it is difficult for police and prosecutors to prove the required mens rea. Criminal justice professionals must be able to prove a mother intended the death of her child, beyond a reasonable doubt; this hurdle can be confounded by intervening factors such as mental illness, depression or other salient issues. Yet, despite the complicated factors that surround these tragedies, mothers who kill their children, such as Andrea Yates, are publicized as monsters by the media.

Upon reading transcript portions from the Andrea Yates's trial, we soon learn of her unstable mental health, coupled with her suicide attempts, hospitalizations and attempts to seek help for herself and her family (Denno, 2003). Andrea Yates's case could have provided our nation with a "teaching moment" about addressing the fragile state of people suffering from mental illness. Yet, the opportunity was lost as the media branded her as a poster child for postpartum depression, somewhat ignoring and at times minimizing the other issues that compounded her situation. We have yet to learn the impact of this media frenzy on women subsequently self-identifying as suffering from postpartum depression and seeking help. Mothers may want to distance themselves from Andrea Yates upon discovering negative, or sometimes homicidal ideations, regarding their newly born children.

The authors of *Mothers Who Kill Their Children* do not leave the reader feeling helpless and unable to act on this important issue. Rather, the final chapters provide concrete examples of how an inter-

disciplinary approach to the problem can lead to innovative inter-
vention strategies. However, communities often face the challenge of
securing the much-needed players at the organizing table. Advocates
for mental health and medical providers may believe the court and
correction system discretionary decision makers will not hear their
voices, often as the desperate mother's voice is unheard by multiple
service providers as she self identifies herself as a threat to her own
children.

All medical, legal and community service providers should read
Mothers Who Kill Their Children in tandem with Deborah Denno's arti-
cle, "Who is Andrea Yates? A Short Story About Insanity" (2003).
Reading Andrea Yates confession provides a dramatic illustration of
one typology of the women described in detail by Cheryl Meyer and
Michelle Oberman. These works are a call to arms – a call for society
to accept the psychological burden women embarking on mother-
hood feel, and the variables within and beyond their control that
determine their abilities to parent.

REFERENCES

McDermott, M.M. (2004, May 29). "Cause of Baby's Death Uncertain."
 Democrat & Chronicle, B1.

*Catherine Cerulli, J.D., PhD, maintains a joint appointment as the
Director of the Laboratory of Interpersonal Violence and Victimization
(LIVV) with the Department of Psychiatry in the School of Medicine and
Dentistry at the University of Rochester and the Director of Research at the
State University at Buffalo School of Law Family Violence Clinical Program
she co-found in February 1992. She was formerly an Assistant District
Attorney in Monroe County, New York, where she created a special
misdemeanor domestic violence unit. She has been working on issues
surrounding domestic violence and child abuse for 19 years and worked
in a variety of capacities addressing domestic violence including a shelter
hotline worker, a counselor, a legislative analyst and a professor.*